THE
PHOENIX
YEARS

THE PHOENIX YEARS

Art, Resistance, and
the Making of Modern China

Madeleine O'Dea

PEGASUS BOOKS
NEW YORK LONDON

THE PHOENIX YEARS

Pegasus Books Ltd
148 West 37th Street, 13th Floor
New York, NY 10018

First Pegasus Books hardcover edition October 2017

ISBN: 978-1-68177-527-2

10 9 8 7 6 5 4 3 2 1

Printed in the United States of America
Distributed by W. W. Norton & Company, Inc.

For John Brennan
and
Hugh O'Dea
(1962–2003),
with love

CONTENTS

A NOTE ON CHINESE NAMES

Chinese names consist of a family name and a personal name.

The family name is placed before the personal name: thus Xi Jinping's family name is Xi and his personal name is Jinping.

In the index to this book, Chinese people's names can be found by looking up the family name.

A guide to the pronunciation of each significant Chinese name in the book can be found beside its listing in 'Dramatis personae' on page 299.

BEIJING 1986

The meeting had not been easy to arrange.

I had told him I would call him, forgetting for a moment how hard that would be. Of course he didn't have a private phone—who did in China back then? Wryly he gave me the number of one of the 'public phones' at the end of his street. They were flimsy handsets perched on rickety tables outside storefronts and kiosks. You could use them for a few cents, and if you were a local you could receive calls on them, too, as long as the person who answered was willing to go down the alley to fetch you. They were just as likely to hang up, though, especially if the caller was a foreigner.

After a week of listening to the line go dead I was ready to give up, but on my final try I heard a grunt of assent and the sound of the phone clattering onto a table. Then, as I waited, the sounds of the street: random scraps of conversation I couldn't understand, a bicycle bell, a tubercular cough. And then it was him. We arranged to meet in two days' time.

It was February 1986, the Year of the Tiger and the eighth year of China's great experiment in 'opening up and reform'. In December 1978 paramount leader Deng Xiaoping had begun liberalising the Chinese economy, loosening the chokehold of collective farming on the agricultural sector, allowing a few green shoots of private enterprise, and inching open the door to Western investment.

It was an experiment that over succeeding decades would lift more than half a billion people out of poverty, transform lives and make China the second-largest economy in the world; but on Beijing's bitterly cold streets that winter signs of change were still few. People hunkered down in padded army-surplus greatcoats and caps with the flaps turned down, like de-mobbed soldiers. The coats came in two colours, army green or navy blue, with brown fake fur trim and leather-look buttons. I chose the blue. I had bought a pink puffer jacket at Beijing's state-run Friendship Store on my arrival in January 1986, but discarded it as soon as I could. China was embracing change, it was true, but out of doors people still practised the art of blending in.

It was indoors that things were changing. Behind its age-old grey façade, Beijing was opening up.

I first met him at a party at the Friendship Hotel, a sprawling compound in the west of the city where China housed what it liked to call its 'foreign experts'. The place had been built for the Soviet advisers who poured into China after the founding of the People's Republic in 1949. But the two Communist behemoths had quarrelled and split in the 1960s, and now the hotel buzzed with Westerners—French, Italian, American, Canadian, British, Australian, New Zealanders—drawn in by Deng Xiaoping's open-door policy.

The experts were people who had (or claimed to have) skills the country needed: teachers, technical specialists, business advisers, and a whole United Nations' worth of 'polishers', who laboured to smooth out the clotted language of translated texts in foreign-language propaganda magazines like *China Reconstructs*, or in the mind-numbing 'news' items issued hourly from the New China News Agency (Xinhua). I was writing for *The Australian Financial Review* at the time, but, unlike other foreign journalists who were housed alongside diplomats in the centre of the city, I was lucky enough to be living with the experts, who worked side by side with Chinese colleagues and whose Friendship Hotel was just streets away from the country's leading universities.

In the 1980s the Chinese authorities did everything they could to keep foreigners and locals apart. The compounds for diplomats and journalists were strictly policed, and any Chinese person gaining entry had their identity card checked, recorded and passed back to the authorities—a big deterrent to casual contact. In theory, the same was true for the Friendship Hotel, but there was a whiff of anarchy about everything that happened there, and with the least bit of sangfroid a young Chinese walking arm in arm with a foreigner could enter the gates with anonymity intact. A Westerner in a taxi could ferry a whole carload of Chinese friends into the grounds without trouble.

By the time I arrived in January 1986, the Friendship Hotel was at the centre of Beijing's burgeoning bohemia: there were no rules about who could talk to whom; there were no off-limit topics; and a Chinese person who hung around after the sun went down on a Saturday could be drawn into the hotel's most celebrated attraction: a Western-style party. You didn't need an invitation, you just shouldered your way into the room, along with aspiring artists, writers, poets, musicians, students, teachers, experts, journalists and diplomats, to drink Beijing Beer and brightly coloured alcoholic punch, to dance to eclectic mix tapes on a Sony Walkman hooked up to cheap speakers, and to discuss anything from the 'necessity of Nietzsche' to the sexiness of the Chinese women's volleyball team, while falling quickly and sometimes falling hard for whoever you found yourself drinking with.

We were at the halfway mark of a decade that would take us from the dawn of Open China to the tragedy of Tiananmen Square in 1989, but at that moment no one knew where the limits would be or where this heady road was taking us.

On that Saturday at the Friendship Hotel, it was his girlfriend I noticed first. She caught my eye with an abbreviated striptease that took her from army greatcoat to skinny black ski-suit to mini dress in just two fluid movements. She wore the only kind of stockings available

in China back then, the ones that stopped disappointingly at the knee—but the black stilettos she took out of her bag made up for that.

Her boyfriend wore *his* bag with the strap diagonally across his body and held tightly to his side. He was carrying something more precious to him than a change of shoes: it was a collection of photographic slides. He was a painter, and these were images of his work.

This was how I got to see Chinese contemporary art for the first time, on transparencies drawn one by one from a battered plastic sleeve and held up to a dim ceiling light at the Friendship Hotel. I remember peering at the first image, preparing to be kind. Within the tiny cardboard frame figures floated free—male and female, naked, untethered from ground and sky. These weren't recycled classical images or the socialist realism of Chinese official art, but something personal to the man in front of me, with his longish hair and weathered skin, in his early twenties like me, yet seeming much older and younger at the same time. People were dancing to Talking Heads' 'Life During Wartime'. It was our anthem that year, but as I looked at these images I seemed to hear the words for the first time: as David Byrne said, this wasn't just a party and we weren't just fooling around. I could see dozens of strange groupings around the room, discussing *The Interpretation of Dreams*, and Bob Dylan, Astro Boy and Kurosawa, 'Misty Poetry', and the banned ideas of a Taiwanese writer called Bo Yang who had skewered what he called 'The Ugly Chinaman'.

You could see the young diplomat falling for the aspiring punk rocker, the Californian gym instructor captivating the seemingly stitched-up cadre from the think tank, the poet looking on indulgently as his wife schemed her escape to the West with the foreign expert she'd just met, the scholar gratefully slipping into his bag a still-banned book about Western economics. You could see how the ground was shifting under Chinese society, how changes were beginning to play out that the country's leaders had never planned for and might not be able to control, no matter how desperately they tried.

But on the afternoon I arranged to meet him, as my taxi carried me along Chang'an (the Avenue of Eternal Peace), the capital's main artery, the city seemed as placid as ever. Around us streams of bicycles flowed along, and as I passed the Minzu Hotel, its clock tower blared out, as it did on the hour every day, a plaintive, synthesised version of 'The East is Red', the hymn of praise to Chairman Mao that every Chinese citizen knew:

The east is red, the sun rises.
From China arises Mao Zedong.
He strives for the people's happiness,
Hurrah! He is the people's great saviour!

We passed directly under the eyes of Mao's portrait on Tiananmen gate, before turning south into unknown territory and stopping on the fringe of the old neighbourhood of Xuanwumen where he waited for me.

He led me along a dog-legging route through the fifteenth-century alleyways that were the lacework holding old Beijing together. *Hutongs*, as they were called, defined China's old capital, their grey stone walls pierced at intervals by weathered wooden doors that opened onto four-sided courtyard houses. Each of these once housed a single extended family, but now they were run by Communist Party neighbourhood committees who allocated every square metre with relentless efficiency.

We walked past all the signs of the communal life of his neighbour-hood—heaps of cabbages preserved under quilts in the winter cold, the public bathhouse with its smell damped by the chill air, a man selling tomatoes and scallions from a cloth spread on the ground.

We stepped through a wooden entranceway into a cramped court-yard. Tucked into the far corner was his home, a single undivided space where he could cook, sleep, and paint. Water came from the public bathhouse up the street. For warmth there was a coal-burning black

metal stove which flued to the outside. At the right of the room was a tiny kitchen area, just a bench with two gas burners. Two large enamel basins stood on the floor, one filled with water, the other with dishes, both decorated with the symbol for Double Happiness. The single light, a bulb on a wire strung across the ceiling from the outside, was already on. The bed was pushed up against the far wall, converted by a coloured cloth into a day sofa, and flanked by a high shelf on which stood a pile of art books and newspapers, a stuffed toy and a small Italian flag. A finished canvas hung above the bed, while a stack of others leant against the wall under a shelf. Beside them stood a table crowded with tubes of oil paint, brushes in a jar, and a piece of board serving as a palette.

A minute after we arrived, his girlfriend returned with two bottles of Beijing Beer and a pocket-sized bottle of the lethal Chinese spirit called Erguotou. We drank our beer from glasses emblazoned with the logo of the Coca-Cola Company and with the ideograms for its Chinese name: *Kekou-Kele*. Every foreign brand that launches in China seeks name characters that are the perfect blend of euphony and good fortune, and Coca-Cola had nailed it: *It's tasty*, said the name, *and it's fun*.

I sat in one of the two chairs and faced the bed, studying the canvas on the wall. It showed three elongated figures, rising through the painting, their pale backs to us, their dark heads bowed. They seemed to have just left the ground, and were half climbing, half floating up a wall of russet-red paint. They were caught in the act of breaking free from Earth, but seemed lost, too, as if drifting into outer space. My friend sat smoking with his left hand under his right to catch the ash, while his girlfriend shared their single ashtray with me.

Thirty years have passed since that evening but I can still feel the warmth of that room, smell the coal dust and oil paint, taste the watery beer and strong cigarettes, remember the excitement of being somewhere that, as a journalist, I wasn't expected to be. By the end of that evening I knew I had stumbled upon something that would be

important to me, something that had previously been no more than an interesting sidelight to what I had come to China to write about.

I was there for the 'big story': how the opening up of China was revolutionising its economy; the growth of free enterprise; the smashing of the 'iron rice bowl' of assigned jobs and a home for life that had previously protected workers; and, most of all, the super-charged Chinese version of the Industrial Revolution which was transforming the lives and landscapes of hundreds of millions of people.

As development picked up speed, I was at times breathless at the scope and scale of the changes I was privileged to witness. Looking back, though, it is obvious that what was happening beneath the surface, in people's private lives, was just as revolutionary.

My two new friends were bohemians, but they were also pioneers. They had chosen to live the most marginal of existences. By dropping out of school and work they had cast themselves adrift from the web of support systems that came with a designated 'work unit'—housing, healthcare, pensions, a recognised place in the world. And they were unmarried, living in what was then an almost unheard-of arrangement that drew official disapproval and a measure of real risk. Just a few years before, in 1983, elements of the Communist Party, spooked by the bourgeois notions that were slipping through the economic open door, had launched an official campaign against 'spiritual pollution'. It was mercifully short, but brutal, arbitrary and frightening while it lasted. One never knew when another deadly ideological outburst like it might occur again, turning lovers into criminals and artists into saboteurs. And yet here were my friends, determined to make a big life for themselves in this tiny room.

They weren't alone. All across the city there were rooms like this, some more comfortable, some less; brightly coloured private worlds where people drank and discussed, read, painted and wrote poetry, and dreamt up ways to burrow into the cracks that were opening up in society, in pursuit of a new world.

The economic transformation I was following *was* momentous. But what was happening in those small rooms was momentous, too. It may have seemed just personal, a choice to drop out of school and paint pictures about feelings, or to wear a miniskirt and take up smoking, or to set up together as an unmarried couple and stake a claim to a private life away from the meddling of China's byzantine systems of social control, but the sum of such individual choices can drive group politics more effectively than public propaganda, just as the architects of the anti-spiritual pollution campaign feared. Three years after I sat in their home drinking beer and Erguotou, one of my two new friends would be helping wheel a plaster replica of the Statue of Liberty into Tiananmen Square at the height of the 1989 democracy protests, while the other watched events unfold from self-imposed exile in Australia.

When that moment came, China's government seemed perched on a precipice. How had it come to this? The truth is, Deng's reforms were a calculated gamble driven by dire necessity. In 1978, 30 years after the founding of the People's Republic, China was still mired in poverty. Early economic gains by the new Communist government were destroyed by Mao's fantasy of a Great Leap Forward in industrial production, which plunged the country into a famine that killed between 36 and 45 million people between 1958 and 1962. Then, still staggering from this blow, Chinese society was torn apart by the Cultural Revolution (1966–76), when the economy was all but paralysed, universities closed, millions were forcibly displaced, and at least 1.7 million people died, either directly through persecution or by starvation. By 1978 China's per capita GDP was no bigger than Afghanistan's and one sixth that of Brazil. Most galling of all, Japan, which had humiliated China for 40 years and invaded it in 1937 before crashing to a defeat that left it a smoking ruin in 1945, was now the world's second-largest economy.

The Maoist project had failed and things had to change. In truth, Deng had no grand plan when he began the reform process: famously

pragmatic, he called his gradualist approach 'crossing the river by feeling the stones'. But he certainly intended China to stay firmly within Communist Party control. Reform would be about develop-ment, not liberalisation. No doubt he knew there would be risks but, whatever he planned for, he couldn't have envisaged that just ten years after he launched his policy, the Chinese government would be facing a popular movement that would bring millions to demonstrate in the heart of the capital.

As that protest movement grew in the spring of 1989, those who believed that democracy would inevitably follow economic develop-ment saw their day of vindication coming. But China never follows the script that others write for it: the Chinese government survived the challenge by suppressing the protest movement with a savage military action that saw hundreds, perhaps thousands, cut down by the country's own People's Liberation Army. At the end of a year that saw almost every other Communist regime in the world fall, China's government emerged more in control than ever.

It was a victory, but it came at a cost. Western democracies were horrified, and for the next few years China was an international pariah. More serious, though, was the impact on the Chinese citizens who had been caught up in the mood of optimism that had swept the country in 1989—that is, a large section of China's urban class. Few of them had thought of overthrowing the regime: they were loyal to the ideals of the revolution, and during the democracy protests they had nursed an unformed vision of a more open, participatory society. The crushing of the movement flung many of them into a period of disillusion, apathy and depression, which finally hardened into a cynicism that still runs through China's society today.

Since 1989, China has pursued a course that many observers in the 1980s, both Chinese and foreign, believed would be impossible: a course of economic development without democratic reform. The Chinese Communist Party, for all its challenges today, still seems unassailable,

even though there is now a large private space in which Chinese people can live and express themselves without the state impinging.

The reforms launched by Deng have transformed China economically, socially and culturally. The lives of hundreds of millions of people have been changed forever. But the huge scale of these changes can make them peculiarly hard to grasp. Certainly you can track them in statistics: the biggest trading nation in the world, the second-largest economy on Earth, a one-time peasant nation in which a majority now live in cities. You can see them too, written across the faces of China's great cities: in the sprawl of Beijing with its supersized buildings and toxic air, growth spiralling out from its historic heart in ring road after ring road choked with cars; or in the sparkling neon glamour of Shanghai, revelling in its renewed claim to be the Paris of the East; or in the teeming anthill that is the manufacturing powerhouse of Guangzhou, which has all but submerged what was once a rural province, turning farmers into factory workers and fields into gated housing estates.

During this whole wild journey, from the earliest phase of economic reform and the open-door policy to today, the country's artists have vividly tracked its course. But they have not simply been spectators: looking back, what is striking is how closely intertwined the processes of artistic and economic awakening were for China.

When Deng launched his reforms at the end of 1978, Beijing was full of young people returned to the city from the countryside where they had been 'rusticated' during the Cultural Revolution. They were determined to make up for lost time.

In the late autumn and winter of 1978–79, despite the bitter cold, crowds started gathering at a wall just west of Tiananmen Square. There people posted their thoughts, ideas, complaints and manifestos—so many and diverse that this nondescript patch of urban territory soon earned itself the name 'Democracy Wall'.

One day in late December 1978, a group of young people pedalled up to Democracy Wall with mimeographed copies of the first issue of

their self-published literary magazine, *Today*. The 300 copies of that first painstaking print run sold out immediately, and although it contained poems by writers who would later be acknowledged as the most important of their generation, it was the magazine's cover as much as its contents that drew people to it.

The word 'today' was emblazoned at the top in Chinese and English, and below were the silhouetted figures of a young man and woman leaning forward as if breasting the tape at the end of a race. What struck people most was the daring choice of colour. The orthodox Maoist choice would have been red and white, but the young designer had chosen blue. One woman who saw it that day recalls that it was as if the magazine had fallen to Earth from another world.

Why blue? It's the colour of the sky, the designer told me 30 years later, and to him it meant freedom without limits. His name was Huang Rui. Sent to Inner Mongolia during the Cultural Revolution, he had returned to the capital with a dream of becoming an artist. He was sent to a leather factory instead, but banded together with some friends to create *Today*, and just a few months later he organised the first exhibition of Chinese contemporary art ever to be held in the country.

For nearly four decades China's artists have held up a mirror to their age, but they have not just reflected history, they have lived and breathed it too. In each succeeding decade a new wave of young artists has made art out of the dreams, hopes, excitements, reversals, contradictions and disappointments of their times. In the 1980s they revelled in a promise of infinite space and possibility, a society whose horizons could only expand; in the 1990s they dealt with the post-Tiananmen weight of despair and cynicism, and a new world in which money was the only guarantee of freedom; in the 2000s and beyond, a generation of artists who have only known the years since Deng's reforms, have explored the fallout from decades of growth and change, the new relations between the classes and the sexes, the rich and the poor, the

country and the city, environmental degradation, globalism and a renewed desire to define what it means to be Chinese.

When I think about how to relate the history of this period, I think of these generations of artists, and the picture of China they have painted, not just in their work but in their lives as well.

I think of the best-selling artist whose teenage years were overshadowed by the Cultural Revolution and his mother's mental illness, who enrolled in art school at the dawn of the Chinese avant-garde, and went on to create soulful images after 1989 that remain among the most iconic works of Chinese contemporary art today.

I think of another whose older sister died of starvation during the Great Leap Forward and who joined the army to escape his poverty, who survived a war thanks to his flair for painting propaganda for the troops, who was talent-spotted to study art in the capital and achieved success only to be exiled for refusing to forget what he'd seen in Beijing in June 1989.

I think of another, who rallied in Tiananmen Square with fellow students that spring, overwhelmed with excitement and hope, who left the country in despair after June 4, having performed one last desperate self-destructive act, and yet despite it all returned to live and work in Beijing, seeking in all his works to honour the spirit of the companions of his youth.

I think of the artist whose father created sculptures in tribute to Chairman Mao, who herself documents the dreams of factory workers, and creates online fantasy worlds for everyone to live in, where Tiananmen Square is turned into a swimming pool and Confucius is swept away in a flood.

I think of another, who, as a boy, played in a wasteland of decommissioned factories in China's frozen north, who dreamt of building

rockets and making art while his parents and all the adults he knew got laid off, and who grew up to find a success his family could barely understand while his home town rose again to claim a place as a centre of foreign trade.

I think of the one born in a desert oasis on what was once the Silk Road, whose works shimmer like mirages, saturated with the colours and images of a way of life that resists the 'development' that threatens to crush it.

I think of the one born in Lhasa, who studied in Beijing and embraced it as a second home and yet eventually was driven to take the road to Dharamsala, who found success in far away London and New York but dreams that one day soon he will return home to Tibet.

I think of the one whose feet are tattooed with leopard spots, who dreams of being a punk rocker but who nonetheless makes art that aches with the frustrated idealism of her generation and nostalgia for a China that is slipping away.

And I think of the designer who decided to create a blue cover for a poetry magazine in 1978, and went on to form a group of artists called the Stars, who later turned an abandoned military factory into a safe zone for art, who has seen his work criticised and banned, who has been evicted from his studio as a troublemaker only to create a new haven for himself less than a kilometre away, and who, through it all, persists with his work as if the most extravagant ideals of his youth are still within his grasp.

In this book I have braided these and other stories into an account of the last four decades in China, told not as economics, nor as politics, but as an emotional history of one of the most momentous periods of change the world has ever seen, written in the lives of artists like these—a group of people who have made it their life's work to see their country clearly.

As I set out to tell their stories, the *hutong* home where I sat with my two friends that late winter day in 1986 is gone, bulldozed in the

great clearance of the capital's historic districts in the early 1990s. Their old district is now just another boulevard of malls, hotels and restaurants, with cascading walls of glass and light, beautiful by night, but exposed and dusty by day. Both of my friends now hold foreign passports. One lives abroad but the other—the artist—has returned to live in one of the sprawling art villages that now ring Beijing.

The Friendship Hotel has been renovated for foreign visitors and the experts have long gone. It is a place to broker the kinds of deals that only those with the best connections can bring off.

Foreigners and Chinese can now party together in the thousands of bars that are spread throughout the capital. But some things haven't changed. Mao's portrait still hangs above the gate to the Forbidden City. And every day, 'The East is Red' still marks the hours on Chang'an Avenue.

I DO NOT BELIEVE!

In 1978 on a late spring day in the heart of Beijing, a nervous young man called Huang Rui closed the door of his bedroom and asked a young woman to strip to the waist.

He was 25, but having grown up in the puritanical world of Mao's China, he had never seen a woman naked in his life.

He was standing in his family home, a rundown house at one corner of a dusty courtyard wrapped within the grey maze of *hutongs* that encircled the historic centre of the capital. She stood barely an arm's length from him, in the room where he had first closed his door against his parents and the outside world.

Between them stood a canvas, patched together out of four pieces of cloth, primed and ready to be painted.

They looked at each other.

She saw a bookish young man with thick-rimmed glasses and pale features apparently untouched by the five years he had spent in the far reaches of Inner Mongolia toiling in the cause of Mao Zedong's Cultural Revolution.

He saw a woman from another age. Stripped to the waist and triumphant, she was a vision of freedom guiding a victorious people out of a time of tragedy. She was Eugene Delacroix's 1830 painting *Liberty Leading the People* come to life.

He worked in a leather factory, she on a construction gang build-
ing roads.

Together they were going to cross a line.

Two years before, in April 1976, Huang Rui had witnessed the begin-
ning of a revolution on a rainy spring day in Tiananmen Square. Today
the Tiananmen massacre of June 4 1989 looms so large that it blocks
out memories of earlier risings on that patch of ground. But what
took place in the spring of 1976, when tens of thousands of ordinary
Beijingers flocked to the square to mourn the death of Premier Zhou
Enlai only to be violently dispersed, proved a turning point for China.
Anger over decades of wasted hope and blighted dreams boiled over,
presaging both the fall of the Gang of Four (that coterie of hardline
Communists including Mao's wife, Jiang Qing, who had helped steer
Mao's Cultural Revolution) and the start of a new era for the country
under the leadership of Deng Xiaoping.

But on the spring day that Huang Rui invited the young woman
into his bedroom, the impact of those events in 1976, just two years
earlier, was still unclear. The officially approved 'verdict of history' was
that it had been a counter-revolutionary revolt and those involved had
been either deluded or criminal. But he knew it had not been like that.

He had been there.

On the evening of April 3 1976, Huang Rui had left his job at the
Beijing No. 3 Leather Products Factory and had headed with one of his
workmates for Tiananmen Square. It was two days before the festival
known as Qing Ming ('pure brightness'), the day on which the Chinese
traditionally honour their dead.

Premier Zhou Enlai had died that January after a four-year battle
with cancer. He had long been seen as one of the few good men in
the country's communist regime, one who had done his best to

mitigate the excesses of the Cultural Revolution, which had raged across the country for the previous ten years. A grand state funeral had been held for the elite in the Great Hall of the People in January, but the Qing Ming festival gave ordinary Beijingers their chance to mourn.

In the days before the festival on April 5, people came in their thousands to Tiananmen Square, the heart of the capital and its natural meeting point. They carried flowers and wreaths, banners and placards, and heaped them around the carved granite base of the Monument to the People's Heroes, which stood at the centre of the square.

The monument, a tall obelisk surrounded by revolutionary sculpture and inscribed with the calligraphy of Mao Zedong, stands opposite the Gate of Heavenly Peace (Tiananmen), on top of which Mao had stood, with Zhou beside him, to proclaim the founding of the People's Republic of China on October 1 1949. Those who came to the square in 1976 carried tributes of mourning not just for Zhou but for the ideals the monument had been built to celebrate, the dream of a republic truly dedicated to the people's welfare, a dream which less than three decades after its birth lay in ruins.

On those early April days in 1976 the monument floated in a sea of flowers and placards, posters and poems. There were expressions of grief, but also of anger. Some, in a clear reference to Mao, proclaimed that the 'Emperor's rule' was over. Others called for a return to 'genuine' communism. The crowd ebbed and flowed across the square, stopping to listen as people stepped up to speak.

Through the rainy streets to the square, Huang Rui carried a poem he had written, called 'The People's Grief'. When he arrived at the monument he decided to read it out loud.

As Huang Rui began he was scared, but he was excited too. Something wonderful was happening in the square that day. People were expressing how they felt, something they had not dared to do for years. When he finished reading he heard a voice calling from the back of the crowd: 'Read it again!' He knew the cry might have come from an

agent of the secret police, offering him more rope to hang himself with. Nonetheless he read it again. As he finished he let his workmate drag him away, but not before he had posted his poem among the others on the base of the monument. Anxious to avoid being followed, they hurried from the square, changing buses multiple times before arriving home late that evening.

When the Qing Ming festival dawned, Huang Rui's poem was gone, along with every other expression of the people's sorrow and anger. Not a scrap of paper was left, or a flower. China's hardline leadership, meeting in anxious session on the night of April 4, saw these tributes as a direct challenge to their rule. To allow them to remain at the centre of the capital, on the same square where Mao had rallied his Red Guards at the start of his Great Proletarian Cultural Revolution, was insupportable. By the time a new wave of mourners came to the square on April 5, the police had scrubbed the place clean.

The leadership of the People's Republic had successfully rewritten history many times before, but on this day the Beijingers who came upon the sanitised scene would not accept it. Thousands rallied in anger, and soon more than 100,000 people were milling in the square. Police cars were set on fire and government buildings bordering the square were breached.

As evening drew on, many were induced to leave by the veiled threats in a public broadcast which boomed in a continuous loop across the square. In the familiar tones of Beijing's party leader, Wu De, it warned those gathered there not to be 'duped by bad elements' intent on 'counter-revolutionary sabotage'. But a small group decided to stay. At 10 p.m. the security forces moved in and used batons and clubs to beat the crowd into submission. It was later announced that hundreds had been arrested, but others estimated that more than a thousand people were taken into custody that day. They were later convicted in mass trials or sent to camps devoted to 'reform through labour'. There were also reports of deaths that night which even now cannot be

confirmed. Years later, shortly after the Tiananmen massacre of 1989, an old soldier reminisced to a young former student about the day he hosed Tiananmen Square clean of blood. 'Don't worry,' he said hastily to the angry young man, 'I don't mean in 1989, I mean in 1976.'

Meanwhile the vice-premier of China, Deng Xiaoping, who was suspected of having supported the demonstrations, was stripped of all his posts. Deng had already suffered exile earlier in the Cultural Revolution; now he found himself once more on the wrong side of history as the hardliners around Mao prevailed.

As for Huang Rui, he escaped arrest on Qing Ming day, having steered clear of the square. But he soon came under investigation. The authorities printed 400 copies of his poem and issued it in the form of an arrest warrant. By the middle of the month he had been detained at his workplace. He was still being held there more than three months later when, on July 28, a devastating earthquake struck 160 kilometres north of Beijing at the city of Tangshan.

The official toll was 242,000 killed and 164,000 seriously injured, but the early reports from the area ranged as high as three times as many. A city that was home to 1.6 million people was sucked from the map as hundreds of thousands of buildings collapsed. The quake was felt 740 kilometres away in the ancient capital of Xian, and in Beijing buildings swayed and cracked.

In the face of such a tragedy the whole country was pressed into the cause of recovery and rebuilding. Huang Rui's factory could no longer waste resources supervising just one man and he was released.

The crackdown on the Qing Ming demonstrators in April 1976 would prove to be the last bloody act of Mao's reign. The Tangshan earthquake signalled a change of era, as such natural disasters had traditionally been thought to do.

On September 9, at the end of a boiling hot summer, Mao Zedong died. The man who had led China's communists to power and who had proclaimed the People's Republic some 27 years before, the person who

had transformed the country and then led it into the serial disasters of the Great Leap Forward and the Cultural Revolution, was dead. Less than a month later Mao's wife, Jiang Qing, and the other members of the Gang of Four, were under arrest.

The fall of these four, who at their subsequent trial were held responsible for all the excesses of the Cultural Revolution and for other crimes which might more properly have been laid at Mao's door, at first seemed to cement the power of the chairman's chosen successor, the colourless Hua Guofeng, who had expertly sidelined his only true competition, Deng Xiaoping.

But Hua didn't understand how fundamentally the Cultural Revolution had changed China. After years of chaos it simply wasn't possible to return to the old rhetoric. When he announced that he would be guided in government by the 'two whatevers'—whatever policy decisions Mao had made and whatever instructions the great man had given—Hua's moral authority began to unravel. His time at the top was brief: within two years Deng Xiaoping would force him into early retirement.

Even before that happened, people in the countryside had started taking matters into their own hands. In both the desperately poor eastern region of Anhui and the fertile central province of Sichuan, farmers had begun to work their own private plots of land, turning their backs on Mao's communes. A new provincial leader in Sichuan, Zhao Ziyang—an economic reformer who was to ascend to the presidency in the 1980s—let the farmers have their heads, and directed that 15 per cent of communal land could now be farmed privately. State industries were also freed from strict control. The results of these once-heretical policies were startling. Grain production jumped by a quarter and industrial production soared.

Other signs of change soon appeared. Deng Xiaoping returned to Beijing in 1977, and in the same year the academics, scientists and professionals who had been banished during the Cultural Revolution also

returned and the universities reopened. The rehabilitation of hundreds of thousands who had fallen foul of Mao's radical agenda had begun.

Like many in Beijing, Huang Rui was restlessly reading the signs. He had been just sixteen when he was sent to Inner Mongolia in 1969, one among millions of teenagers who by Mao's decree would be 're-educated' in the countryside. In that bleak landscape he had finally lost his faith in the party, and their Great Helmsman Chairman Mao. It was there, too, that he resolved that he would make his future as an artist.

Huang Rui had studied Chinese painting as a child, learning the basics of ink and wash at the age of eleven, but in the Inner Mongolian capital, Hohhot, he discovered an ethnic Mongolian painter who lived under house arrest but welcomed the young man who stole time to visit him and learn about oil paints. In Inner Mongolia, Huang Rui also met a young poet called Bei Dao, who was trying to create a new poetry, much as Huang Rui was looking for a new language of painting.

On his sanctioned trips home to Beijing, Huang Rui sought out books on Western art. His choices were pretty limited, as the Impressionists and all who came after them were banned. Even so, the Western art he uncovered was a revelation for him. He sketched out exercises in anatomy and perspective in a small plastic covered notebook that he carried with him everywhere. The pages became crowded with drawings of muscled limbs, with calculations of perspective and compositions, all sharing the faint ruled pages with poems and diary entries recording his days in a lonely landscape far from home.

When he finally returned to Beijing for good in 1974 it was as a factory worker, assigned to the Beijing No. 3 Leather Products Factory. But whatever the state might decree, he was already an artist, if passion and determination meant anything at all. He thought that there must be many people like himself in the capital, kids who had grown up in the ideological straitjacket of the Cultural Revolution but who

were now disillusioned and determined to find a way of making their own destiny.

In April 1976 on Tiananmen Square he saw thousands of them in action. They were driven underground again afterwards, but he knew now they were out there. A few months later in a library tucked behind Beihai Park in the centre of Beijing, he found an image that could honour their cause.

In an old book of Western painting he came on a reproduction of Delacroix's *Liberty Leading the People*. Sublimely romantic, the work depicted Liberty as a beautiful bare-breasted woman, brandishing the flag of the French Revolution as she urged the people to fight on even as the bodies of the fallen were heaped around her.

Suddenly, Huang Rui saw a way of depicting the events of spring 1976 in Tiananmen Square, of reimagining the people's defeat as a victory, with the figure of the woman leading the crowd and standing as a rejection of everything that had gone before.

As soon as he met her, Huang Rui knew she was what he needed.

She was tall and strong, beautiful and restless. He had met her through Bei Dao, the radical poet who had befriended him in Inner Mongolia. The best friend of Bei Dao's young cousin, she was on the fringes of Huang Rui's band of friends, all alumni of the Cultural Revolution, all on edge for change. The daughter of doctors, her education thwarted by the Cultural Revolution, she now worked as a labourer on a road gang. When he told her what he wanted, she didn't hesitate.

It was the spring of 1978, four years since Huang Rui had returned home, two years since he had joined the Qing Ming demonstrations in Tiananmen Square in April 1976.

On a warm spring day she came to his house and he took her to his bedroom. He had assembled a canvas out of scraps that he had

scrounged and primed with glue, 1 metre by 1.2 metres of rough cloth on which they planned to make their own version of history.

Even 35 years later Huang Rui blushed when he tried to describe to me how he felt that day, seeing a woman naked for the first time, weighing the danger of painting an event that was condemned as criminal, knowing that even to paint a nude body was forbidden. Excitement? Embarrassment? Fear? Exhilaration? Relief. Relief that they were brave enough to see the line they were crossing and step across together.

They worked through the warm days of spring, in the small room heady with the smell of turpentine. He was working from instinct. He had never seen a real Western painting or attended an art class, but his Mongolian mentor in Hohhot had passed on the techniques of oil painting he himself had learned from Russian instructors in the 1950s.

Huang Rui mixed the paints—cool, sad greys, blues and greens, and the warm colours of flesh and light. His composition was focused on the Monument to the People's Heroes around which the demonstrators had gathered in 1976. In his painting the monument would seem to split apart as his vision of Liberty rose through the centre of the frame, while below, a new monument seemed to coalesce, made up of the uplifted, pensive faces of the demonstrators.

On a spring day in 2013, he showed the painting to me. He had titled it *April 5 1976* for the date of the demonstration all those years ago. He traced the joins where the pieces of canvas had been glued together, criticised his brushstrokes and naive technique. In September 1979 he had hung it on the railings outside the National Art Museum of China as part of the first-ever exhibition of contemporary art in the country. Now a Hong Kong museum wanted it for their collection, and he had finally consented to sell it.

I asked him what had become of the girl in the painting. He said he wasn't sure. They had become lovers, but when she wanted to get married, 'She frightened me away,' he laughed. To him, it seemed at

odds with the bravery that had brought them together. I thought (but did not say) that marriage might have seemed to her another route to freedom.

Just a few months after Huang Rui finished his painting, in the late autumn of 1978, it was announced that the official verdict on the Tiananmen demonstrations of 1976 had been reversed. What had been condemned in 1976 as a 'counter-revolutionary riot' was now re-badged as a display of patriotism. The news travelled through Beijing like a shock wave. It was as if they were finally being given permission to breathe again. And breathe they did.

If you wanted to portray the history of the People's Republic of China with a diagram, one way to do it would be to draw a waveform across the page, a series of peaks and troughs, like the image on an oscilloscope. Each peak would be a period of freedom and openness, each trough a crackdown—often a savage one—by the government. One of the most famous of the upswings is the Democracy Wall period in the northern autumn and winter of 1978–79.

Just west of Tiananmen Square, near the busy intersection with the bustling street of Xidan, was a low grey wall that didn't seem to belong to anyone. It ran for around 200 metres from the intersection, set well back from the street on the north side of Chang'an Avenue. A number of bus routes stopped nearby and its grey expanse had long been a place where people would post small ads and notices, confident they would be seen by scores of passers-by.

From spring of 1978 people had occasionally risked posting more daring texts on the wall, and around the city it became known as a place where you could catch a rare glimpse of free speech. But when the news broke that the verdict on the Qing Ming demonstrations had been reversed, overnight the wall became a kind of massive social

media site, its bricks covered in paste and paper and hand-inked calligraphy, as people with no access to the airwaves or the official press plastered up handmade posters proclaiming their hopes, their criticisms, their appeals for justice, and their ideas about the path China should now take.

Night after night the pavement beside the wall thronged as hundreds and then thousands of people gathered to discuss the posters in open forums, debating everything from the separation of powers to the rising price of dumplings, condemning the Cultural Revolution, and, daringly, Mao himself, calling for freedom, and for the Communist Party to become a true servant of the people.

All of Huang Rui's friends came to the wall, and most of his workmates, too. His girlfriend, the goddess of Liberty, joined the crowd, now modestly bundled in a blue padded army coat against the cold. Bei Dao made his way there too, even though he was still exiled to a job far from the capital. The crowd was full of people their age, former Red Guards who had been blessed by Mao in the early days of the Cultural Revolution for their adolescent revolutionary fervour, only to be rewarded with years of exile far from home.

But the crowd was not limited to the young, or to the educated, or even to the urban. People came from the countryside, also armed with petitions—whole families arrived, from grandparents to babies in arms. Just a few hundred metres down Chang'an were the red walls of the Forbidden City, and next to it Zhongnanhai, the 'New Forbidden City' where China's leadership all lived. There was no reaction from those quarters. Did silence mean acquiescence?

As one of the bitterest winters in years closed in, the posters and discussions became more daring until one day in early December 1978 a young man called Wei Jingsheng, a former soldier who worked as an electrician at the Beijing Zoo, posted the most famous manifesto ever to cover the grey bricks of what had become known as Democracy Wall. He called it 'The Fifth Modernisation'.

To us the title seems prosaic, but to those gathered at the wall it was incendiary. For years China's leaders had been declaring that to grow and be strong the country needed to pursue the modernisation of agriculture, industry, national defence, and science and technology. Even the recently rehabilitated and soon to be ascendant national leader Deng Xiaoping had nailed his colours to the mast of the 'Four Modernisations'.

And now this young man was arguing that all four would amount to nothing without a 'Fifth Modernisation'—democracy.

You do not need to be an expert in Chinese history to appreciate the power of 'The Fifth Modernisation'. It is one of the most electrifying political polemics ever written, as stirring as any of the writings of the architects of the French or American revolutions.

'The people should have democracy,' Wei wrote. 'When they call for democracy, they are demanding nothing more than that which is inherently theirs. Whoever refuses to return democracy to them is a shameless thief more despicable than any capitalist who robs the workers of the wealth earned with their own sweat and blood . . . Democracy, freedom and happiness for all are our sole objectives in carrying out modernisation. Without this "Fifth Modernisation" all other modernisations are nothing but a new promise.'

He wrote that the time for slogans was over and that the people should not be fooled again:

> I urge everyone to stop believing such political swindlers. When we all know we are going to be tricked, why don't we trust ourselves instead? The Cultural Revolution has tempered us and we are no longer so ignorant. Let us investigate for ourselves what should be done!

Even today it is exhilarating to read what Wei wrote over a single winter's night in 1978. We are so used to hearing the argument that

democracy is a Western concept to which China isn't suited, so used to nodding at the Chinese government's assertion that without a single party to run things the country would break up in anarchy, that it is almost a shock to be called out by Wei Jingsheng's confident assertions.

'Let us rally together under the banner of democracy. Do not be fooled again by dictators who talk about "stability and unity",' he wrote. 'Fascist totalitarianism can bring us nothing but disaster. Harbour no more illusions; democracy is our only hope. Abandon our democratic rights and we shackle ourselves again. Let us have confidence in our own strength. We are the creators of human history.'

Wei Jingsheng was only 28 when he wrote 'The Fifth Modernisation', but twelve years of hard living had brought him to this moment. He had grown up privileged in Beijing, the eldest child of a high-ranking Communist Party official. In 1966 Wei had become a Red Guard, embracing Mao's call for a Cultural Revolution. Falling foul of the struggles that broke out between different factions of the Red Guards, he went to live for a year in the province of Anhui where his family had their ancestral home. It was there that he finally saw the devastation that had been wreaked across the countryside in the early 1960s by Mao's Great Leap Forward, a drive for rapid industrialisation that led to famine and tens of millions of deaths.

Like so many of his generation of urban youth, the Cultural Revolution meant the end of illusions, and the dawn of cynicism about the slogans that had distorted their lives. 'I felt as if I had woken from a long dream,' he wrote later. In 1969, as others of his generation were being sent to the countryside, his family connections secured him a berth in the army, where over four years of service he learnt more about the true state of his country. He served as a squad commander in the pitifully poor north-west of the country, where he found himself defending public granaries from starving mobs. He served side by side with peasant soldiers who told him more about the desperation of life in the countryside.

On his return to Beijing in 1973 he was assigned a job as an
electrician, and this was his identity when he stepped forward to
Democracy Wall to post his call for China to finally stand up and
claim democracy for itself.

Wei Jingsheng was Democracy Wall's greatest hero, and within
a year he would become its most famous victim.

In that fevered season in Beijing there was another place in the city that
was drawing people in their thousands, another sight in its own way as
liberating as Democracy Wall.

That autumn of 1978 an exhibition from France had opened at the
National Art Museum of China. Its bland title—'Nineteenth-century
French Rural Landscape Painting'—gave no hint of its extraordinary
impact.

For us in the West, the works of the Impressionists and those who
followed—modern masters such as Van Gogh and Cézanne—are so
familiar that we can only connect intellectually with the shock they
caused more than a century ago in Europe. But in communist China
not only had the works never been shown before, their study had
been banned.

And so, by a strange trick of history, a century after these works had
revolutionised Western art they were going to revolutionise Chinese
art too.

Huang Rui stood in the crowded gallery. It was like being at the centre
of the world. Everyone he knew was there. Each day he came back to
find the gallery thronged with people his age, and many like him were
returning again and again.

For decades Chinese art had been so flat, formulaic and—quite the reverse of Madame Mao's prescription to be 'red, bright and shining'—pallid.

Now there were these paintings, imbued with a passion that radiated off the canvases. Huang Rui imagined that he could still smell the paint. It was a vision of another world that they had been assured could not exist.

Finally he could really see how to paint. It wasn't about mixing colours in the Russian way, blending them to a heavy darkness. It was about building up texture and depth, capturing not just the subject but the mood. It was about touch.

Thirty-five years later, Huang Rui laughed when he described this to me and clapped his hands. The joy of that first moment of recognition was still in his voice. He had found what he had been looking for—independence, beauty, texture, touch—and he would never forget it.

A few weeks later Huang Rui crouched over his bicycle on the outskirts of the city, breaking the law again. In those days every bicycle in the country was registered and could be linked to its owner by a number plate. Huang Rui was furtively altering the number on his plate to cover his tracks, and with him were two friends who had done the same. They were Bei Dao and another poet, Mang Ke.

Over the previous three days and three nights, they had laboured with four other friends in a rundown house on the fringes of the city, printing out the first issue of a magazine. Under a dim light with the windowpanes shrouded with cloth, they had cut wax stencils by hand. Painstakingly they had etched words and drawings in the wax, and then placed the stencils one by one into a levered mimeograph machine. They had squeezed the ink through the stencils, printing sheet after precious sheet, until the stencils disintegrated and the pages

became illegible. Finally, they had bound 300 copies of their magazine by hand, 60 pages in total, under a blue and white cover. The title of the magazine was *Today*.

The publication was unlicensed by any 'proper authority', and so illegal. Now, on December 23 1978, they would publish it on the streets of Beijing. Just weeks before, they had still been passing their poems and stories within their group in handwritten copies, to be shared and discussed within the secret world they had created for themselves during their teens. For years they had been used to hiding in plain sight, playing the role of revolutionary youths as their cynicism deepened. Now they were going above ground.

What had happened in Tiananmen Square at Qing Ming in April 1976 had been a turning point for all of them, yet, since the fall of the Gang of Four that same year, it felt like they had been holding their collective breath. Now the Beijing spring had finally arrived. What they were seeing at Democracy Wall spurred them on. Fresh ideas, free ideas, were being posted up every day, and ordinary people were jostling to read them. And no one was stopping them!

For years the only truth these three had held to was that which they found within themselves. Now their magazine's editorial almost shouted from the page: 'History has finally given us the opportunity to sing aloud the song that has been buried in our hearts for ten years . . . The difficult task of reflecting the spirit of the new era has fallen onto the shoulders of this generation . . . What is past is already past, the future is still distant. To our generation only today is today!'

Now they were ready to launch. The only way to do it was to travel Beijing and paste the magazine up page by page at key points around the city. The only transport they had was their bicycles: hence the spy craft with the number plates. They had debated whether to carry out their mission by day or by night and had finally agreed that daytime was safer. In the dark night of a Beijing winter it seemed more likely that one or all of them could simply be made to disappear.

Despite the bravado of their editorial and the consoling light of day, they embraced each other in farewell before they set off.

On that freezing winter day, Huang Rui, Bei Dao and Mang Ke rode through Beijing, the ancient capital where they had grown up, pasting up copies of their magazine. They rode from the far east of the city where they had printed their precious copies, to the far west where Beijing's most prestigious universities spread their campuses towards the Old Summer Palace. They rode through a city that was almost free of cars, where snow formed drifts capped with coal dust, where they could see their breath and hear the creak of their bicycles alarmingly loud on the city's flat grey streets.

From the university district they circled down to join Chang'an Avenue, and riding east towards Tiananmen Square they stopped on the corner of Xidan to post their magazine on Democracy Wall. Finally they arrived outside the offices of the People's Literature Publishing House. It was the monolithic state institution which for 30 years had set the agenda for published literature in China. *Today* was the first unofficial literary magazine to appear in the country since the founding of the People's Republic.

The next day passers-by could read mimeographed notices standing out cheekily against the stolid grey concrete pillars of the Publishing House, announcing the publication of *Today* and directing interested readers to Democracy Wall.

A few days later, when the three friends rode their laden pedal carts up to Democracy Wall, the entire edition of 300 copies sold out immediately.

Through the last days of 1978, Bei Dao, Huang Rui and Mang Ke crisscrossed the capital, checking all the places where they had posted *Today*. Everywhere they found knots of people crowded around their pages, discussing them aloud. They had put up extra pages so people could leave their comments anonymously if they wished, but there had been no need: people talked openly because—miraculously—for those few brief months they were no longer afraid.

It was the first time they had heard their words in the mouths of strangers. It was exhilarating. For more than ten years they had held on to the sound of their real selves, the voice deep inside of them, even as they were forced to chant slogans day after day. Theirs was the generation that had plunged from the heights of idealism—of a fervour perhaps only a teenager can feel—to the depths of disillusion. Cynicism ran through them like a scar. And yet somehow they had protected inside themselves something real. This is what they offered up in the pages of *Today*.

When these three had sat down to choose what they would publish in the very first issue of their magazine, they knew they had no right to expect it would last beyond its first printing. It was possible that they would be arrested before they ever printed a second issue. And so for that first—and possibly last—edition, they each chose a kind of personal manifesto.

Huang Rui's was a manifesto in colour. He knew he was an artist, not a poet, and his statement was the cover of *Today*: an image of two young people breasting the tape in a race for a new world, an image rendered in the colour of the boundless sky.

For Mang Ke, his manifesto would come in the form of a poem about the transformative power of poetry itself:

I am a poet.
I am a rebel shadow
Let it be ripped to bits,
So the blood dripping down can reflect a patch of light.
I am a poet.
I am the sheet of blood-stained paper.
Let it be passed around and read
So that hearts are closely linked
... I am a poet,
I am history's witness.

Bei Dao's poem, 'The Answer', was destined to become one of the most influential in contemporary Chinese history. Ten years after it first appeared in *Today*, its lines would be emblazoned on students' banners as they rallied in Tiananmen Square in 1989. Bei Dao had written it soon after the events of Qing Ming 1976.

The most famous stanza of 'The Answer' reads:

Let me tell you world,
I—do—not—believe!
If a thousand challengers lie beneath your feet,
Count me as number one thousand and one.

It was a whoop of defiance that would become an anthem for a generation. His confidence in the face of the crackdown on the Qing Ming demonstrations in 1976 would echo again ten years later, even as the tanks patrolled the streets of Beijing after the bloody crackdown of June 3–4 1989. It proclaimed a belief that, in the end, however long it would take, history was on their side, on the side of youth and those who opposed, not those who oppressed. His poem assured them that it was they who were the inheritors of China's long history, not those who ruled from inside the red walls of the New Forbidden City, Zhongnanhai:

A new conjunction and glimmering stars
Adorn the unobstructed sky now:
They are pictographs from five thousand years.
They are the watchful eyes of future generations.

When the authors of *Today* were later denounced, their work would be condemned as 'incomprehensible', 'misty' and 'spiritually polluting', lacking in the patriotic flourishes that the authorities deemed 'realistic'. What the authors' critics really hated, of course, was how realistic the work actually was, how recognisable to their generation.

During the Cultural Revolution some seventeen million urban youths had been sent away from their homes to learn revolution from workers and peasants in the countryside. What they learned instead was how much they had been lied to. There was no socialist utopia out there, there were no farms and factories full of apple-cheeked smiling souls serving the revolution. Instead there was poverty, exhaustion, frustration, and the all too fresh memory of famine.

It was 1969 when the teenaged Bei Dao, Mang Ke and Huang Rui left Beijing to be 're-educated'. At the time they knew nothing of each other and they were bound for different places. Huang Rui travelled north to the bleak expanses of Inner Mongolia, while Mang Ke hitched a ride on a horse cart south to the marshlands of Baiyangdian Lake in the neighbouring province of Hebei. Bei Dao travelled further south to work construction on an electrical generation plant some 300 kilometres from Beijing. But while they were away each began to write poetry—even Huang Rui, who later gave it up for art instead. And it was through writing that they would find each other.

So who were they, these three who made history in that brief Beijing spring?

Bei Dao was the 'aristocrat' among the three, tall, thin and naturally serious. His upright carriage could even make his Mao suit look smart. He had grown up within a charmed circle in Beijing, his father high up in administration, his mother a doctor. His parents had sent him to the best schools in the capital, where he rubbed shoulders with the children of the political elite. Yet as a teenager he chafed against his privilege. He found his prestigious school stifling, and was hopeless at the subjects like mathematics and science that they prized.

When the Cultural Revolution began in 1966 he needed no persuading to become a Red Guard. He escaped school and ran wild for the next three years with his Red Guard troop, as they scrapped with other factions and rampaged through the city. He led raids on public

libraries and on the homes of people who had—only a short time
before—been part of the honoured elite.

At first he and his friends followed the correct Red Guard line: they
were there to destroy books that smacked of 'bourgeois liberalism'. Art,
poetry, foreign and ancient literature, all of these should be rooted out
and burnt. If they must carry things away, they should loot only books
on war and revolution, choosing the kinds of titles they thought likely to
meet with the approval of Chairman Mao himself. But soon Bei Dao and
his friends found themselves searching instead for what was forbidden—
Western literature in translation or Chinese classical culture—building a
secret library that they would draw on in the years ahead.

Bei Dao was only nineteen when he was sent away, and he was
almost thirty by the time he broke cover with his writing in *Today*. But
in the intervening years he had devoted himself secretly to the vocation
that he discovered almost as soon as he arrived on that desolate con-
struction site 300 kilometres from home in 1969—to honour the
experience of his generation as a writer.

Mang Ke was born to wear a leather jacket. Unlike Bei Dao, who
wore his Mao suit with scrupulous correctness, Mang Ke slouched
into his, pushing his hands deep into his trouser pockets till his jacket
bloused up around his waist, like Bob Dylan making his way down a
windy street in New York on the famous album cover.

And like Dylan, Mang Ke was a boy from the North Country.
He had been born in the industrial city of Shenyang, deep in that part
of China once known as Manchuria. At the age of six his family moved
to Beijing, but he carried with him ever afterwards something of the
toughness of his home town. Shenyang remains the capital of China's
heavy industry, and it was once a real capital as well, the last base of the
Manchus before they crossed the Great Wall to take Beijing and found
the Qing dynasty in 1644. Mang Ke is not a Manchu but he has never
lost the air of an outsider nor the glamour that allowed him to wear a
Mao suit coat as if it was a flying jacket.

In the Baiyang marshlands, where he went in 1969 at the age of eighteen, he quickly gathered around him a group of exiled youths who, like him, aspired to write. Over the following years, even as they remained underground and unpublished, the poets of the Baiyang marshes became famous within a secret network of youngsters throughout the country who circulated poems and stories in hand-written copies.

Bei Dao sought Mang Ke out in those years in the marshlands, as did their contemporary Chen Kaige, who would later become one of the great filmmakers of the new generation, directing *Yellow Earth* and *Farewell My Concubine*, and winning the Palme d'Or at Cannes in 1993.

In those years all sorts of forbidden books circulated, many in translations that had—bizarrely—been authorised for private study within the Communist Party by Madame Mao herself. They were meant to stay within this charmed circle of cadres, but inevitably they leaked out, were pirated and passed from hand to hand.

Of all these books perhaps the most important to these exiled youths was a translation of Jack Kerouac's *On the Road*. And of the three friends, it was Mang Ke who best embodied the spirit of that counterculture classic. While Bei Dao was a natural writer and Huang Rui an aesthete, Mang Ke was a born bohemian. He was the only one among them who seemed to have found something truly beautiful in exile, discovering a rough beauty in the marshlands and the villages that spoke to his native sensuality. Years later when he wrote a novel about his experience, he called it *Wild Things*, puzzling readers long inured to bitter descriptions of Cultural Revolution exile with his accounts of a bucolic world of sex and misbehaviour. He has never lost that slouching walk, even now when he's had a real leather jacket for more than 30 years and his hair is completely grey. His hooded rather languid eyes have never faded, nor his outsider glamour.

Huang Rui, on the other hand, would have looked like an intellectual no matter how he wore his Mao suit. Tall and thin, with studious glasses and a soft-covered book rolled into one of his coat's patch pockets, his suit drooped like a scholar's robe. He was the youngest of the three. He was only sixteen when he went to Inner Mongolia, full of dreams of art, literature and music.

Huang Rui's dreams were secret ones that would have scared his parents. His father had studied engineering on the campus of what is now Peking University. He had had dreams, too, founding his own factory in the year Huang Rui was born in 1952 when the People's Republic was young. But in 1956 the factory had been compulsorily acquired, along with all the private property in the nation, in the year every Chinese school child knows as the date on which capitalism (supposedly) died.

Gradually, Huang Rui's father was stripped of authority until in 1959 he was reduced to the status of a simple worker in the factory he had once owned.

If ever there was a Chinese generation who was destined to dismiss the experience of their parents, it was Huang Rui's. For all that he respected his father, he would be looking for guidance elsewhere. He would seek it inside himself, in the books he discovered secretly and in the friends he would share them with. Meeting Bei Dao two years after he was exiled from Beijing would be a turning point. In the older and more confident young man, already committed to his life as a poet, Huang Rui would recognise something of himself. They would be friends for life. And through Bei Dao he would meet Mang Ke.

At the time, none of the three could imagine how influential they would become. Years later, when China's most famous dissident Liu Xiaobo, winner of the 2010 Nobel Peace Prize, was writing about what influenced him most deeply in his formative years, he cited the poetry of Bei Dao and Mang Ke and the art of Huang Rui.

Despite all the ways in which they differed, on that day in 1978 when the three of them posted the first issue of *Today* on the grey walls of Beijing there was one thing they were all agreed on: they wanted nothing to do with politics. Their revolution would be personal. They had spent years burrowing inside themselves to find what, despite years of indoctrination, was still real. They didn't want to follow leaders any more, they wanted to put their faith in themselves.

And yet, for all that they tried to avoid politics, it would run through everything they did. Because to even attempt to avoid politics in those days was a political act. And however much they wished to avoid it, politics would find them in the end.

But that was a realisation that lay ahead of them. In their first editorial, they wrote: 'As the dawn rises from the bloodshed, we need colourful flowers, flowers that truly belong to nature, flowers that truly blossom in people's hearts.' Flowers might seem an odd preoccupation for three harbingers of the avant-garde, but these were people whose whole lives had been dominated by propaganda: literature and art had been harnessed to it. The idea that a flower could just be a flower meant everything to them.

Politics had destroyed so much of what was beautiful and splendid in their country, and, even in their short lifetimes, it had killed millions of people. Politics had sent them away from their homes in their teens, had made reading and writing dangerous pursuits, had twisted people's brains so much that they hardly knew how to recognise what was real. *Today* would stand against politics, because the cold fact was that politics had made a mockery of their idealism.

When they had gone to the country in 1969 they had still believed in Mao and his revolution. Even Huang Rui, who nursed secret doubts, had been captivated as a child by his country's revolutionary imagery of rockets heading for the skies and trains decorated with red flags steaming into the future. All three had been Red Guards—even Huang Rui had gone to Tiananmen Square to be 'blessed' by the chairman in

the summer of 1966. They had stood in the square under the August sun, beating the sky with their Little Red Books. They had swayed in a sea of teenagers all dressed alike, as Mao celebrated their role in his Great Proletarian Cultural Revolution. Whatever they felt over the next three years of that revolution, of the pitched battles, the looting and destruction in the capital, they still went to the countryside trusting that once there they would find the socialist paradise they had been told so much about. But they only discovered that politics had made fools of them.

Of all the events that eroded their faith in the party, few had a more corrosive effect than the strange episode now known as the 'Lin Biao incident'.

A brilliant military commander, Lin Biao was a key architect of the Communist Party victory over the Nationalist forces in the civil war that ended with the establishment of the People's Republic in 1949. He became a crucial ally of Mao Zedong and was named as his designated successor in 1969. Few figures in the party's leadership were more respected.

Then, in September 1971, Lin was killed in a plane crash in Mongolia in circumstances that to this day remain a mystery. Whether he had planned to assassinate Mao and then tried to flee to the Soviet Union (the official story) or was running away because he feared a purge, the impact was devastating for the party. The first official reaction was silence, but word of the event quickly leaked over radio broadcasts from Mongolia. That was how Huang Rui found out: listening to foreign broadcasts was illegal, so naturally he, like tens of thousands of other curious young people, did just that every night.

Even as the news ricocheted around the world and the Soviet Union sent experts to their client state of Mongolia to examine the crash site, no official statement came from the Chinese capital. It would be a month before party cadres around the country were called to secret briefings to be told the official story of Lin Biao's 'treachery', and another month before that tale was made public.

The Chinese people were accustomed to political reversals of fortune. They had nodded at the downfalls of plenty of once-powerful men. But Lin Biao? As they heard the news for the first time almost every one of them had a Little Red Book in their pocket, and now they were being asked to believe that the person who had assembled that bible, the man whose name and words were on its frontispiece, was a traitor. And not just a traitor but a man who had chosen the hated Soviet Union as his refuge.

Over the years following Lin Biao's fall, the Chinese government would try again and again to massage this story to make it more plausible and less damaging. Later they would find Lin a convenient scapegoat for all sorts of excesses of the revolution. But for many ordinary Chinese the fall of Lin Biao was the end of innocence and the beginning of cynicism.

In the poor southern province of Guizhou, the students at the local school in the small town of Duyun had grown used to being asked periodically to hand in their history textbooks to their teachers, and have them returned a little later with pages missing. Down there they had no money for new books, and so page by page they saw hero after hero ripped from the official account.

'We saw Marshall Peng Dehuai, and Deng Xiaoping removed this way,' one of these students recalled later. 'And then President Liu Shaoqi. But then we were asked to hand up our books to remove all trace of Lin Biao!' He told me that the moment when he ran his finger down the ragged inside spine of his text book from which his teachers could no longer be bothered to even remove the pages neatly was the moment that he decided he would never again place faith in official history. The student's name was Guo Jian, and we will meet him later in this story.

In the autumn of 1971 as the Communist Party cleaned up after the Lin Biao incident, they probably did not recognise how deeply the event had wounded them. Madame Mao rallied her fellow members of

the Gang of Four into a campaign to 'Criticise Lin Biao and Criticise Confucius' and the population seemed to respond, but under the surface flowed a new mood—one that would explode at the Qing Ming Incident in 1976 and then find full expression at Democracy Wall. Years later the imprisoned dissident and Nobel Peace Prize recipient Liu Xiaobo would remember the Lin Biao incident as the moment when his generation first began to think for themselves.

On the day before Bei Dao, Huang Rui and Mang Ke rode through the streets of Beijing posting copies of *Today* on the city walls in December 1978, the Central Committee of the Chinese Communist Party concluded a key meeting in the capital. Deng Xiaoping had finally triumphed, clearing the way for his grand experiment in the reform and opening up of China.

His ascendancy had been given a major push by the events at Democracy Wall. The fervour could have been made for him. Posters were denouncing his rivals and calling for the rehabilitation of his allies. Democracy Wall also demonstrated what he had been arguing behind closed doors—that the country was ripe, indeed clamouring, for change, and something must be done to harness energies that could run out of control.

Since his return to Beijing in 1977, Deng had pushed for the rehabilitation of exiled and imprisoned intellectuals and officials, not just those who had suffered during the Cultural Revolution but also those whose persecution dated back as far as 1957 when Mao had cracked down on a period of open liberal debate by launching the Anti-rightist campaign.

Deng was looking to gather around him the kind of people who could implement his pragmatic vision for the future of China. He saw a path to recovery for China in opening up to Western know-how

and technology. He had seen during his time in the countryside what could be achieved by granting some level of autonomy and personal responsibility.

Deng was no democrat, and he would have been appalled by some of the sentiments being expressed at Democracy Wall. But when the United States reporter Robert Novak asked him in November 1978 for his opinion of what was happening there, Deng endorsed it, knowing he was sending a message.

He had a date with President Jimmy Carter in January 1979 and he had no intention of spoiling the image of the newly open society he planned to promote. The United States should have no fear of sharing its expertise, its university places and its money with China.

When his remarks to Novak reached people at the wall, the news was greeted with wild cheers, even though Deng had also cautioned that he did not personally agree with all that was being said there. That night, thousands marched from the wall to Tiananmen Square in triumph, chanting 'Long live the people! We want freedom! We want democracy! Carry forward the April 5th movement!'

The 'April 5th movement' was the label the Democracy Wall activists gave themselves as inheritors of the spirit of the Qing Ming demonstrations two years earlier. Deng would ride the energy of the witnesses of that day and use their passion at Democracy Wall while it suited him. Later he would put them down without compunction.

It is now commonly said that it was Deng Xiaoping who sparked China's modern reforms. But there is an argument to be made that the biggest push for change came not from above, but from below. As Liu Xiaobo wrote on the 30th anniversary of the events at Democracy Wall, people like Mang Ke and Bei Dao changed China by galvanising the latent energy of the population: 'These spontaneous popular forces for reform,' he wrote, 'were rooted in the human longing for freedom and justice, not some slogan of the rulers, and once they got going they were hard to turn around.'

Now firmly in control of the government, Deng honed his message and used it to marshal confidence in his new policies. He endorsed an old slogan of Mao's which was itself taken from a traditional Chinese saying dating back to the first century. As they plotted their path into the future, Deng said, the Chinese should 'seek truth from facts'. This slogan would become his mantra, repeated endlessly to indicate that pragmatism, not ideology, was now the watchword.

As a slogan, it did not soar, but it worked. For farmers around the country it promised a return to some autonomy, and over the following decades it would revolutionise their lives. To technocrats and intellectuals it seemed to say that in future it might—in an inversion of the old Maoist phrase—be 'better to be expert than red'.

And for a while it chimed with the people at Democracy Wall, too—the poets and artists of *Today* and the bolder aspiring reformers such as Wei Jingsheng. For wasn't that what they themselves were doing, honouring what they believed to be true, rather than the received truth of ideology?

And for the seventeen million young people who had been sent to the countryside during the Cultural Revolution, it seemed to promise a return to normality, a chance to come home and get on with a life they could choose for themselves. For some it would even promise the chance to go abroad.

As Deng got on the plane to the United States in 1979, Huang Rui and his friends were determined to push things as far as they would go. For Huang Rui that meant seeking out a band of brothers who could do for art what *Today* had done for literature.

For now, his painting of Liberty, his secret tribute to the spirit of Qing Ming 1976, was hidden under a sheet in his bedroom.

But its time was coming.

THE STARS

On the first day of 1979, a joint communiqué established full diplomatic relations between the United States and the People's Republic of China. The détente reached between President Nixon and Mao Zedong in 1972 was bearing fruit under the presidency of Jimmy Carter. On January 28 Deng Xiaoping boarded a plane for the United States.

His visit, so vital to his strategy of securing American knowledge and investment, was a resounding success.

A series of powerful images defined Deng Xiaoping's trip: Deng applauding the Harlem Globetrotters at the Kennedy Center, Deng admiring the astronaut training facilities at NASA, Deng chatting amiably with President Carter and former President Nixon at the official reception at the White House. Deng had insisted that Nixon be invited to the party, and the sight of him at ease with two such powerful figures enhanced the message of his ascendancy back home.

But the moment that captured the most attention in both countries was when the diminutive Deng (who was only 4 feet 11 inches tall) donned a huge Texan hat at a rodeo outside Houston. There was something about the ease of the gesture, his ability to have fun with something that could have made him look ridiculous that confirmed him as being both comfortable with the West and effortlessly in charge. Today visitors to the National Museum of History in Beijing will search in vain for any meaningful mention of the Cultural Revolution or the

Great Leap Forward but they will find (in its own sealed display case) that Texan hat.

For President Carter, though, it was Deng's performance behind closed doors that left the deepest impression. At a specially convened private meeting, Deng coolly outlined China's plan to launch a military strike against Vietnam. He was dispensing with decades of mistrust, taking the United States into his confidence and inviting its tacit support for what he believed was a common goal, to curb Soviet influence in Asia.

China had always regarded its fellow communist state of Vietnam as a 'little brother', but a series of incidents had soured their relationship. Incursions into China along their common border were increasing, and ethnic Chinese in Vietnam were being expelled from the country. In late 1978, Vietnam shocked China by signing a treaty with the Soviet Union, and a month later compounded their offence by invading Cambodia, a regional ally of China.

Vietnam argued that the invasion was imperative in order to oust Pol Pot, whose genocidal regime had turned Cambodia into a charnel house and was threatening Vietnam's own security. But to China the Vietnamese action was brazen interference by a Soviet pawn in China's sphere of influence—part of a Soviet plot to encircle China from the south.

Deng told Carter that China planned a 'limited' punitive campaign to pull Vietnam into line. Carter, just three years on from the United States' humiliating withdrawal at the end of the Vietnam War, counselled Deng about the dangers of a military and public relations calamity. But he stopped short of opposing the plan outright, and Deng flew out of Washington determined to go ahead.

The army was his power base, and he was concerned at how much its involvement in the ten chaotic years of the Cultural Revolution had cost it, both in training and respect. It was a long time since it had mounted a serious military campaign, and Deng

thought that action in Vietnam would give the army a chance to come back into its own.

It proved to be a massive miscalculation, one of the few that Deng was to make during his time in power. On February 17, 1979, waves of Chinese troops crossed the border into Vietnam, attempting the kind of shock and awe that had served them so well, if so bloodily, in the Korean War 29 years before. But China's tactics failed to draw the Vietnamese army north to fight. Nor did the Vietnamese command move any of their forces out of Cambodia. Instead, battle-hardened Vietnamese militias mauled the Chinese, using the guerilla tactics they had perfected in their long wars with the French and the Americans.

Within days of the invasion both sides had suffered heavy casualties. By the time China began to withdraw on March 6, they had neither forced Vietnam out of Cambodia nor demonstrated China's military superiority.

The main phase of the war was over within a month but the border skirmishes would continue for the best part of a decade. Before hostilities formally ended in 1989, thousands of Chinese soldiers would lose their lives and tens of thousands would be injured.

China's official announcement of the conflict was only made once China's troops had completed their withdrawal on March 17, and foreign journalists found themselves scrambling for information and seeking out any sources with army connections. The Democracy Wall activist Wei Jingsheng was one, and he happily shared what he believed to be common knowledge with at least one journalist. It was a decision that would cost him dearly.

In early 1979 the voices at Democracy Wall were multiplying and organising, even as rumours of a crackdown began to spread. When Deng Xiaoping returned to China, the wall was barely three months old, but already dozens of unofficial magazines and several other walls acting as platforms for dissent had appeared around the country.

While *Today* remained strictly a literary magazine and avoided political discussion, many of the new publications were different. A friend of Huang Rui by the name of Liu Qing published *April Fifth Forum*, which adopted the stance of a respectful adviser to the government. Liu believed they had Deng Xiaoping's support and advocated a gradualist approach to political change.

Wei Jingsheng had no time for gradualism. In January 1979 he launched *Explorations*, which was by far the most radical publication to appear at Democracy Wall. The journal posed deep and uncomfortable questions. Why was China still so poor despite 30 years of communism? Why were women so exploited? Why were there so few opportunities for ordinary people to live a meaningful life? And in a provocative foray into investigative journalism, Wei published an exposé of conditions at China's most infamous political prison, Qincheng.

Nobody who was in Beijing during that extraordinary year of 1979 has ever forgotten it. The universities, which were deserted wastelands during the Cultural Revolution, had come alive again. Restored, too, were the teachers, many of whom had been brutally persecuted during the Cultural Revolution.

A young People's Liberation Army (PLA) officer and aspiring artist named Hu Ming arrived back in Beijing on furlough in the spring of 1979 and was intoxicated by what she found. During her service with the PLA she had had her share of challenges and excitement. She had ridden the meadows of the far western Turkic-speaking province of Xinjiang on horseback, and had gone into the earthquake-ravaged city of Tangshan as a documentary filmmaker in 1976. Yet even 30 years later, when asked to write about life in the capital in 1979, she couldn't contain her excitement.

'Beijing in 1979 is an eternal spring in our memory,' she wrote. 'Dancing in the spring rain were many young hearts! They were manic, free and pure.' She listed all that was new, strange and exciting that spring: portable tape recorders, foreign film weeks, the music of

Jean-Michel Jarre, leather jackets, Frédéric Chopin, dancing with boys, and queuing all night for tickets to *Swan Lake*.

Most exciting was that the capital seemed to be full of young people like herself who dreamed of creating art. 'Everywhere, at cross streets and at the railway station, at the long-distance bus station, you would find groups of people riding bicycles or walking with painting gear strapped to their backs.' She was finding a whole world of kindred spirits who had been invisible before.

She soon entered the orbit of *Today*, as her best friend Shao Fei had met Bei Dao and fallen in love. Meanwhile Hu Ming realised her own dream by securing a place at the art school in the nearby port city Tianjin. But as she remarked wryly later it was those artists who didn't get into art school—people like Huang Rui—who would prove to be the masters of her generation.

Huang Rui had sat the entrance exam for the prestigious Central Academy of Fine Arts but missed out. So he continued his art education as he had started it—ferreting out art books in libraries and tracking down retired painters to be his mentors.

Finally he discovered an art course for workers at the Beijing Working People's Cultural Palace, east of Tiananmen Square. There he encountered another talent as passionate and iconoclastic as himself, a young man called Ma Desheng, who had contributed two woodblock prints to the first issue of *Today*. Ma's work was a million miles from the stock state-approved imagery of smiling workers and peasants: it had more in common with the stark vision of German expressionists like Käthe Kollwitz.

A ferociously energetic figure who had spent a lifetime on crutches after suffering childhood polio, Ma Desheng was the ideal collaborator for Huang Rui. Both men had a vision for a new kind of Chinese art. Both kept works hidden away at home that needed to find an audience. Both were in search of others like themselves, who worked humdrum day jobs but created art at night because

it was the only thing they wanted to do. It was just a matter of finding them.

As winter turned to early spring, barriers to artistic expression seemed to be melting away, but it was a different story for political dissent. In late March 1979 came a well-sourced rumour that, in a secret speech to the party leadership, Deng Xiaoping had called for a crackdown on Democracy Wall.

In just a few short months the wall had grown into something that to the government looked worryingly like an organised movement. Publishers of unofficial journals appeared to believe it was their right to be part of the reform process, and were encouraging people to discuss political issues and problems themselves.

In pursuit of economic reform, Deng was happy to harness the energies of intellectuals, scientists, officials and even entrepreneurs, all of whom had been sidelined and humiliated during the Cultural Revolution. But political decisions, and even political dialogue itself, were to remain a matter for party control.

Faced with the near-certainty of a government crackdown, the Democracy Wall community split on the question of tactics. Wei Jingsheng wanted to denounce the government's plans in writing; Liu Qing, co-editor of *April Fifth Forum*, counselled caution.

Wei Jingsheng decided to go it alone. On March 25 he returned to Democracy Wall to post what would be his final essay, its title an urgent question: 'Do we want democracy or a new autocracy?' In it, he warned of the danger that Deng could become another dictator. 'History tells us,' he wrote, 'that there must be a limit to the trust placed in any one person.'

Three days later new regulations appeared, banning any expression of opinion that did not adhere to the Four Cardinal Principles:

socialism, the dictatorship of the proletariat, the leadership of the Communist Party, and Marxism-Leninism and Mao Zedong Thought.

The next day Wei was arrested.

It was a terrible blow, which stopped most activists in their tracks. But even as the hammer came down on political dissent, China's painters, writers and poets persisted in probing the *artistic* limits, and the response of the leadership was more tentative. Into this vacuum, Huang Rui and his friends were only too happy to venture.

On a warm evening in May 1979, dozens of young people arrived at a dilapidated office in eastern Beijing. The space was only one and a half little rooms on the corner of a dusty courtyard behind a deserted Buddhist temple, but it was a symbol of the success of *Today*.

It was just five months since Huang Rui had ridden out across the snowy city to post the first issue of the magazine. Things had moved fast since then. *Today* was now being read all over the country. They were publishing 1000 copies an issue, but that was only a fraction of their audience. Every day brought letters from readers recounting how they were sharing their single copy around a dormitory, an office, or a group of friends. Copies were being posted on noticeboards and on other democracy walls, and being read aloud in parks and in homes. Every week brought contributions by young poets, writers and artists from around the country.

The magazine's office had originally been home to Liu Qing's mother, who had vacated it so that her newly married younger son would have somewhere to live with his bride. But the son insisted that the *Today* crowd, whom he idolised, should take the space instead. He moved into his university dormitory while his wife stoically scoured the city for new digs.

Mang Ke slept in the half room, his plank bed converting into a sofa for meetings during the day and into a desk for the mimeograph at printing time. The office quickly became a place of pilgrimage for young poets, artists and dreamers.

Tonight the place was crowded for a strategy meeting for an unprecedented event in the history of the People's Republic. They were planning an exhibition of work by the outsiders of Beijing's art world, a little band to whom Huang Rui and Ma Desheng had reached out, who revelled in the official no-go areas of art: the personal, not the political; the realistic, not the rosy; the experimental, not the traditional.

The team that came together in the smoky room may have been untutored, but it was bursting with talent. There was Ma Desheng, who made angry, virile, technically masterful woodcuts; Qu Leilei, whose fine ink portraits were rich with personal imagery; Yan Li, a new friend of Huang Rui's, who painted brightly coloured takes on cubism; and Wang Keping, whose powerful, politically pointed sculptures in scavenged hunks of wood were the very antithesis of safe official orthodoxy.

As the meeting got down to business, their first decision was the name of their group: they would call themselves 'the Stars'.

The Stars? For a group of art school rejects? Actually, this wasn't a boast; it was a sly political joke with a touch of the poetic. They had all grown up being told that the only heavenly body that mattered was the sun, and the sun was Mao Zedong, whose solar radiance was celebrated in poems, songs and paintings. Now the Great Helmsman was gone. 'Only when the sun has set,' said Huang Rui, 'can you see the stars.'

Their second question was where to exhibit. In Beijing in 1979 there were no private buildings. Even the *Today* office was unauthorised and technically illegal. You could hold a poetry reading in a park and you could post a magazine on a wall, but an art exhibition needed a space of its own. To use a space you needed a permit, and to get a permit you had to be a member of the Artists Association. But the Stars weren't members—that was the whole point of being the Stars.

They eventually found a solution, and they would go on to mount their exhibition. But the whipsaw reaction of the authorities would expose divisions in the Chinese leadership over reform strategy. To some, taking the shackles off artistic expression was dangerous. It was all very well to liberalise the economy, but Democracy Wall had shown where free thought could lead. Shouldn't art be reined in as well? The turbulent way in which that question played out— and is still playing out today—assured the Stars a permanent place in history.

The meeting determined they should seek out the chairman of the Beijing Artists Association, Liu Xun, and ask for his advice. He might not be able to help them, but he would understand the delicacy of their position.

Liu had spent a decade in jail after being trapped by Mao's infamous 'Hundred Flowers' movement in 1956. Mao had called for intellectuals and artists to engage in open discussion of the country's problems: 'Let a hundred flowers bloom, and a hundred schools of thought contend!' Mao believed that the discussions would find a natural centre of gravity: after all, socialism was the only logical solution to human problems and contradictions, and finding new pathways to that conclusion would be a healthy thing. In the event, debates headed in directions that shocked the leadership, with open discussion of the merits of democracy. Mao shut down the movement, but not before taking careful note of who had written what. Liu Xun was singled out in the Anti-rightist campaign in 1957 and imprisoned during the Cultural Revolution. He was only rehabilitated after the return of Deng Xiaoping to the capital in 1977.

So, in the early summer of 1979, the Stars met with Liu Xun and showed him their work. As an oil painter with a taste for the iconoclastic, he was excited by what he saw and immediately offered to help.

But almost straight away it became clear that, despite Liu's goodwill, it would not be simple. Each of the 23 artists in the exhibition would

need to declare their details, their occupations and their 'political status' in advance. And it would not be until the next year that they would be able to secure an official exhibition space, if at all.

The Stars felt they couldn't afford to wait. There were already too many omens that this exhilarating moment of liberty in their lives might be short-lived. Wei Jingsheng had been in custody for two months and there was no word of his fate. Criticisms of the party had been outlawed, and Democracy Wall was now a gloomier, less edgy place. True, *Today* continued to thrive, and every day new books, new music and new people were turning up in Beijing. But, despite this, they could feel a chill in the air.

So they decided—secretly—that they should move now and forget about a space: they would exhibit in the open air. The show would be in autumn, the capital's most beautiful season, and would coincide with China's national day—on October 1—when the nation would be celebrating the 30th anniversary of the People's Republic.

Then came the question of where to exhibit. Democracy Wall was too chaotic. The Old Summer Palace, a melancholy ruin north-west of the city, had atmosphere but was too remote. The forecourt of the China Radio building at the far western end of Chang'an Avenue was perfect, except that it was a bastion of the propaganda ministry and would not tolerate them for a moment.

And then they realised that the solution had been hiding in plain sight. They could show at the National Art Museum in the centre of the capital. Come late September, the museum would have an official exhibition of Chinese art in honour of national day. This would be the establishment's choice of the works that best represented that moment in history. The Stars would display their counterpoint to this, on the railings of a large garden just to the east of the building. They would open on September 27 and run for one week.

As the day drew close they began to spread the word among their friends. And then on September 26 they rode out to the universities,

through the city and to Democracy Wall, posting a notice calling on people to come and see the Stars.

September 27 was a perfect Beijing autumn day, which meant the weather was as beautiful as you could find anywhere in the world. The 23 artists gathered early, bringing their works on pedal carts and on the backs of bicycles and then tying them to the garden railings with twine. Altogether 150 works were hung that day. Huang Rui's secret painting of the year before was on display for the first time, dappled by sunlight shining through the trees.

Beijing was a small place then. Most people lived within what is now called the Second Ring Road, which follows the course of the old city walls that were torn down in the 1950s. Within that perimeter news spread fast. Office workers arrived with their shopping and their children in their arms, students rushed there after school. People worked their way quietly, intently along the railings, examining each work in turn, and stopping to read the Stars' manifesto:

> We, 23 art explorers, place some fruits of our labour here . . .
> The shadows of the past and the light of the future overlap to
> form our multi-layered lives today. We live on with determi-
> nation and remember every lesson we have been taught. This
> is our responsibility.

A group of students gathered, laughing with shock at Wang Keping's sculptures. One piece, carved from the rung of a broken chair, showed a shrunken, distorted figure, its outsized arm and hand thrust towards the sky, brandishing a little book. Titled *Long Live the Emperor*, the work's target was unmistakable, as was the artist's contempt for the era it depicted. More visceral still was a work he called *Silence*. A carved face stared out, one eye blacked out and a large wooden stopper in its mouth.

Nearby hung a Ma Desheng woodcut of a farmer and his oxen plowing a darkening field. The figures were tiny and exposed in a shaft

of light under the gaze of a gigantic figure. It was titled *Rest*, and the irony was obvious—there would be no rest for the farmer this side of the grave. In interviews, Ma Desheng later made no secret of his anger at the party's hypocrisy over China's peasants. He had seen enough of rural life during the Cultural Revolution to know its grinding poverty, and to see through the cant of urban cadres who glorified the peasantry but whose own lives were paradises by comparison.

The political edge to Huang Rui's work was gentler. Apart from his commemoration of the April 1976 Qing Ming demonstration, he had hung two paintings of the ruins of the Old Summer Palace. Known as the Garden of Perfect Brightness (Yuanmingyuan), the palace complex, stretching for 857 acres beneath Beijing's Fragrant Hills, had been the favoured home of the Qing imperial family for 150 years. It was a place of legendary beauty, its Chinese style pavilions and gardens interspersed with Italianate follies designed by the emperor's Jesuit advisers, complete with whimsical musical clocks and curlicued marble archways.

In 1860 French and English troops razed the entire complex at the height of the Second Opium War. The palaces were never rebuilt and in 1979 the lonely ruins were an ambiguous witness to whatever version of history it seemed correct to subscribe to.

Huang Rui painted the ruins repeatedly in 1979, each time investing the stones with something new. In the first Stars exhibition he hung two paintings of the same stand of ruined columns, stark against the sky. In the first, which he called *Last Will and Testament*, the sky was a smouldering coal black, the sun blood-red. In a second painting the columns stood against a blue sky filled with clouds amid green pastures, and the shape of the columns had shifted slightly so they seemed like couples embracing in the sun. This painting he called *New Life*.

Today the Communist Party has preserved the ruin of the Old Summer Palace as a reminder of the humiliation heaped on pre-revolutionary China by foreign powers. But in 1979 Huang Rui claimed

it for his generation. The ruins seemed to show that you could survive utter destruction and in the aftermath find new hope. For a generation that had come through the Cultural Revolution, the meaning was clear.

In a tree by the railings of the museum Huang Rui had hung an old exercise book on a string with a pencil attached as a visitors' book in which the artists encouraged people to write their impressions of the works. That day a person who called himself 'an elder' wrote that in the paintings he found 'fresh and robust strength emerging from ruins amidst rotten grass. Young blood, bright colours, vibrant brushwork. Ah!' he exclaimed, 'your art enlivens this old man's heart.'

When Liu Xun arrived, he was unperturbed by the Stars' impatience and their cheek at exhibiting without permission. Surrounded by a crowd he toured the exhibition smiling at what he saw.

On the same day, the show was visited by Jiang Feng, chairman of the China Artists Association and dean of the Central Academy of Fine Arts. He was a veteran of the political struggles of the 1930s and '40s, and had been repeatedly imprisoned for his fealty to the Communist Party. After the founding of the People's Republic he had pioneered the teaching of oil painting and the expansion of art education beyond the universities into high schools. But after the Hundred Flowers campaign he was labelled a 'rightist', stripped of his posts and sent into exile. Like Liu Xun, he had only just returned to Beijing.

When he stood among the young artists and their works that day he only had three more years to live and he acted like he knew it. He was excited and had no intention of discouraging the Stars. 'Art exhibitions in the open air are a fine thing,' he declared. 'One can exhibit inside an art gallery, and one can also exhibit outside the gallery. Artists rise from within the art academy, as well as from outside it.' He then briskly instructed the museum curators to accommodate the Stars' works within the official grounds where they would be safer.

That night the Stars partied on Beijing Beer and Erguotou, and pooled their funds to buy bowls of cabbage noodles. Their friends from

Today toasted their success. The second day of the exhibition went as well as the first. Hundreds of people were stopping by to see the Stars' works, and others arriving for the official exhibition at the museum also came over to loiter in the sun and pore over the works. It was like a dream.

Then they woke up.

On the morning of September 29, Huang Rui arrived at the exhibition to find all the billboards for their show torn down. In the park was a group of provocateurs who taunted the artists and the others who had gathered to see the show. Earlier that morning the local Public Security Bureau (China's police force) had sent 100 officers to the National Art Museum to seize the works and post a notice that the exhibition had been banned. The edict was backdated to the opening day, September 27, to make the show look doubly illegal.

Liu Xun was appalled. He invited the Stars to meet with him at the Huafang Zhai, a beautiful pavilion in Beihai Park to the north-west of the Forbidden City. Beihai had once been part of the imperial pleasure gardens built around the capital's Northern Lake, but had been opened to the public after the fall of the Qing dynasty in 1911. The pavilion where the Stars went to meet Liu Xun was beautifully decorated and built around a lily pond. Wang Keping remembered later that the lilies were beginning to shrivel as autumn was drawing in but the water was still sparkling. It was here that the Beijing Artists Association had their official exhibition space, in four separate halls built around the courtyard.

Liu Xun took the artists through the calendar for Huafang Zhai and offered them a date later in the year. They accepted, and tried to see it as a victory. After all, a few weeks earlier there had been no place for them in the official schedule and now they had a chance to hang their work in one of the loveliest spaces in the capital. It was a big step up from park railings in the open air. Yet, as they left they couldn't help feeling it was the wrong call.

They met that night with their friends from *Today* and the editors of other unofficial journals like *April Fifth Forum*, run by their friend Liu Qing. The editors had been excited by the Stars' success, especially because the arrest of Wei Jingsheng and the muzzling of Democracy Wall had cast a pall over the reform movement. Somehow the compromise of the Huafang Zhai show didn't seem enough. After all, Liu Qing argued, the Stars had done nothing illegal in the first place. Didn't the constitution protect freedom of speech, publication, association, assembly and demonstration? In the Stars' case, Liu Qing saw a chance to make a stand. He and his co-editor Xu Wenli suggested they hold a demonstration on national day, October 1.

Huang Rui argued against it. He wasn't scared, he said later, it was just that he hated politics, and preferred the quicksilver path they had taken to date. In his view, 'artists should use art to win'. But the others disagreed. Wang Keping felt they had a responsibility to speak up for others. They had made a stand for artistic freedom with their exhibition, and they could not just roll over now. Ma Desheng also argued strongly for a public protest. Outnumbered, Huang Rui agreed. And so they began to plan the first demonstration for freedom of speech ever held in the People's Republic of China.

Once committed, Huang Rui realised that as one of the founders of the Stars he must take a leading role. They drafted a declaration condemning the Public Security Bureau's actions, and requesting that the Beijing government 'correct' them. The next morning, they posted their declaration on Democracy Wall and sent a copy to the Beijing Communist Party Committee. Another copy was sent to the highest legal authority in Beijing, giving notice that the Stars intended suing the Public Security Bureau for infringing their rights.

That afternoon, their patron Liu Xun came to beg them not to go ahead. After his long years in jail he knew only too well where this could all lead. But the Stars were too fired up to back off. Together they decided on the slogans for their march. Liu Qing, the co-editor of

April Fifth Forum, proposed 'Fight for political democracy! Fight for artistic freedom!' Wang Keping wisely counselled against parading the word 'fight' through the streets, and they agreed that Liu Qing's banner should say, 'We want political democracy! We want artistic freedom!'

The next morning, October 1, they gathered in the rain at Democracy Wall. Huang Rui read the text of their complaint and then Ma Desheng, wearing his trademark worker's cap, issued a vociferous call for action. (Before the march he had emptied his pockets of everything he owned and said goodbye to his parents, not knowing when he might see them again.)

Before they commenced, Huang Rui made one final gesture to art over politics. He had created a Stars logo, a stylised red rocket shooting through a blue sky and piercing the moon. He fashioned it into fabric badges and fixed one on the jacket of each of the Stars, as a statement of their allegiance to a new ideal.

With a big crowd falling in behind them, they set off, Huang Rui and Wang Keping in the lead with Ma Desheng swinging along beside them on his crutches, his hair matted by rain and exertion. With them marched Bei Dao and Mang Ke and their friends Liu Qing and Xu Wenli, along with the editors of all the main unofficial magazines. The whole nascent push for freedom of expression in China was on the move. They had planned to head up Chang'an Avenue to the Beijing government headquarters but a police cordon blocked their way, so they took a winding route to their destination, singing the national anthem of the People's Republic and 'The Internationale'. By the time they reached the government headquarters an hour later, their ranks had swelled to a thousand.

Once there, Ma Desheng addressed the crowd again, speaking of the need for democracy. Xu Wenli, the co-editor of *April Fifth Forum*, also called for democracy and denounced the abuses of power he had seen. All the speakers pointed out that the new constitution of 1978 guaranteed their rights of freedom of speech, assembly and association.

These were rights that would be pointed to over and over in the years to come.

Among those inspired by the Stars' actions that day was a young Liu Xiaobo, a student at the time. In an article published 30 years later, he would draw a direct line from the events of that day in 1978 to the resurgent movement for human rights in China in the Olympics year of 2008. He, too, pointed to the words in the Chinese constitution that were in such conflict with the actions of the leadership. By the end of 2008 he was under arrest, and twelve months later he was sentenced to eleven years in prison for 'inciting subversion of state power'. In 2010 he became the only Chinese citizen to be awarded the Nobel Peace Prize.

At the end of their demonstration, the Stars and their friends flung hundreds of copies of their statement into the sky to drift into the hands of the crowd. That night they celebrated the news from Liu Xun that their exhibition would be allowed to reopen at the Huafang Zhai on November 23.

It was the third time that the little group around Huang Rui had made history: first with the publication of *Today*, then the Stars exhibition, and finally the national day demonstration for freedom of expression. In those early days of Deng Xiaoping's China, it seemed that making history was something that the young and the brave could get used to doing. But then just two weeks later, Wei Jingsheng was brought to trial.

When Wei Jingsheng's trial began at the Beijing Intermediate Court on October 16, he was charged with 'selling state secrets to foreigners' and

'engaging in counter-revolutionary agitation'. It was a double charge of treason: in such a situation there was never any doubt about the verdict.

Wei's requests for witnesses to speak on his behalf were ignored and his lawyer was never given a copy of the indictment or told when the trial would take place. So Wei defended himself.

There is a photograph of Wei in court, his head shaved as if he had already been found guilty, his face bent to his notes. It captured his situation well—the hopelessness of his position and the indomitable, studious determination he brought to handling it.

The evidence of selling state secrets came down to the transcript of Wei's interview with Reuters in early 1979 in which he talked freely about the Sino-Vietnamese War. Wei argued that nothing he said came from any special source other than common rumour in Beijing, and the details he provided, such as the name of the commander of the Chinese forces, could hardly have caused any strategic harm. In summing up, he said: 'First, I had no intention of betraying the motherland. Second, I supplied the enemy with nothing at all. Third, I gave my friends no official secrets, either national or military. Thus the prosecution's accusation that I committed treason is unfounded.'

His defence took no account, of course, of what a sensitive subject the botched Chinese campaign against Vietnam was, particularly as it had been Deng Xiaoping's pet project.

On the charge of counter-revolution, Wei took a bolder line, arguing that as full democracy must be the ultimate aim of revolution, it was those who imprisoned him who were the counter-revolutionaries, not he. It was his duty as a citizen to critique and discuss the system. 'If one insists on hearing pleasant criticism only and demand its absolute accuracy on pain of punishment, this is as good as forbidding criticism and banning reforms altogether.'

Which, of course, was the point. Deng, like Mao, was only interested in criticism as a means to an end that he already had in mind. It was fine to let a hundred flowers bloom occasionally to fight off

opposition in the party or advance your own agenda, but in the end neither Mao nor Deng was interested in a running commentary from the masses. Leadership was for leaders.

Although Wei's trial seemed a pre-ordained exercise of power by a monolithic state, the reality was more complicated. Like so many of the events of that period, the Wei Jingsheng episode exposed leadership tensions over freedom of expression that would resonate for years to come.

We now know that Hu Yaobang, a protégé of Deng and later his choice for general secretary of the Communist Party, argued against punishing Wei Jingsheng. The lead editor of *People's Daily* at the time and a long-time collaborator of Hu Yaobang wrote later that Hu had argued for Wei's rights following his arrest, stating: 'I support anyone exercising their democratic rights under a socialist system. I hope everyone can enjoy the greatest freedom under the protection of the Constitution.' In this he echoed what would be Wei's own argument, but then Hu went further to presciently warn his colleagues: 'I respectfully suggest that comrades do not arrest people who engage in struggle, still less those who merely show concern. Those who are brave enough to raise these problems, I fear, will not be put off by being thrown in jail.'

Eight years later, in 1987, Hu Yaobang would himself fall victim to China's long struggle over internal dissent. He was forced to resign as general secretary and issue a humiliating self-criticism after he counselled compromise with a student protest movement that had sprung up the previous year. It was Hu's death two years later that would spark the greatest challenge the Communist Party would ever face—the Tiananmen protest movement of 1989.

When those 1989 demonstrations broke out, Wei Jingsheng would not be there. At the end of his one-day trial on October 16 1979, he was sentenced to fifteen years in prison.

Three decades later I sat at a dinner table in Beijing while a middle-aged Chinese artist tried to explain to a young American that China, too, had had its Vietnam War. Puzzlement turned to irritation as the younger man assumed that there was some mistake in the translation. Finally, the artist jumped to his feet and rolled up his trousers to reveal a left leg that was furrowed like a twisted tree. It was a bullet wound he had sustained as he crossed the border into Vietnam in the first days of the war. There was a moment of embarrassment among the Chinese at the table. The young American had learnt a new fact of history, but the Chinese were reminded that this was something they were never supposed to know. The war that had sent Wei Jingsheng to jail 30 years before was now deeper than a secret. It had been forgotten.

All along the tracks out of town they were holding up flaming torches in farewell.

It was a pitch-black night late in 1979, and Guo Jian was heading for Kunming, the capital of Yunnan province. It lay a few hundred kilometres from his home town of Duyun in Guizhou, one of the poorest provinces in China. Kunming was a major city with good transport links to the Vietnam border, and it was the mustering point for new army recruits like Guo Jian. Around him were the other boys who had enlisted. For all of them, joining the army had seemed like an adventure and a way out of poverty. But now as they looked at the faces of their families in the torchlight, some of the boys were crying. Perhaps they were spooked by the leatherette seats in the carriage. Soldiers travelled in goods trains, everyone knew that. Did first-class travel mean they were going to die?

The army needed them to keep the border with Vietnam safe. The opening phase of the war with Vietnam had ended when the Chinese

army had crossed back into China in March that year. But having poked the hornet's nest, the army found themselves caught in a sniping, skirmishing border tussle, and facing the constant possibility of retaliation for their ill-planned invasion.

Guo Jian kept smiling for much longer than his fellows, smoking a cigarette and reflecting on the luck that had finally got him into the army. Before the war broke out he had tried to enlist but they had rejected him. He passed the physical; that wasn't the problem. He would only find out later that it was his background that had been held against him. His grandfather had been a small landholder and had enjoyed the respect of the Nationalists who ruled China before the revolution. But now the army needed soldiers, lots of them, and when the recruiters rolled into town that year there was no way a keen young man like him would be passed over for a little thing like class background.

He'd been driving trucks since he had left school and he hated it. To say he had graduated would be an exaggeration, since he hadn't spent much time in class. Nevertheless, he had learnt some important things at school. He had watched his history textbook thin out as purged former 'heroes' disappeared; his faith in official pronouncements disappeared with them. He had also learned that he could draw. When his parents first saw him using the margins of his books as a sketchpad they made him stop, but his teacher encouraged him. A bookish urbanite who had been sent to the countryside for being a rightist, his teacher knew talent when he saw it. He spoke to Guo Jian's parents and from then to the end of his school days Guo Jian was free to draw on whatever spare paper he could get, which was usually the white spaces in his textbooks.

By the time he caught the train that day at the end of 1979, Guo Jian knew the only thing that really mattered to him was art—that, and his school sweetheart, who kept telling him how disappointed she was that he wouldn't make anything of himself. Joining the army, he hoped,

would impress her. And as for art, he could draw anywhere, couldn't he? And he owned a sketchpad now.

About 40 kilometres outside Duyun they stopped at a siding and were offloaded onto a goods train. In the crush he lost sight of everyone he knew and as he sat in the dark he finally felt scared. He could feel something changing in the air as the train travelled south. After hours in the cramped, noisy darkness the train reached the end of the line and they transferred to trucks.

All around him he heard different dialects. Some were from his home province of Guizhou and the neighbouring one of Guangxi, but that day was the first time he heard the singsong tones of Cantonese and the harsh northern dialect of Hebei. He found out that in the army, Mandarin would be the lingua franca. Like most of the recruits, Guo Jian's grasp of the official national language was pretty sketchy.

At the same time as Guo Jian was heading for the border, the Stars exhibition was re-opening in Beijing, as promised, in Beihai Park. It was late November; the lilies had all sunk below the surface in the courtyard pool at Huafang Zhai and the water was thickening with ice.

The Stars had never received an answer to their complaint about the police who had shut them down back in September, but three days after Liu Xun finally confirmed that their exhibition would go ahead, the *People's Daily*—the official mouthpiece of the Chinese Communist Party—announced the exhibition in their pages. The Stars were not going to receive a direct reply to their complaint, but there was no mistaking the message they were getting through the *People's Daily*.

In those months it had become clear that words could be dangerous, but it seemed that there was still room to manoeuvre in this new China of Deng Xiaoping's. A new decade was about to begin and the Stars thought maybe, just maybe, it could belong to them.

On opening day people queued out the door in the bitter cold. Men in fake fur army hats and women in thick headscarves clapped their hands together to keep warm, chatting to strangers in the queue. Work by all 23 artists was back on display, the number of pieces swollen slightly to 163. Liu Xun and Jiang Feng visited again, and this time a host of other older artists came too. These elders—many of whom had suffered terribly over the previous two decades—wanted to show their support for the coming generation. Present on the first day was Wu Guanzhong, who had studied in Paris in the years after the Second World War and had pioneered the teaching of Western modernism on his return to China after the founding of the People's Republic. Now he was fighting for the right to promote this tradition again after his years in the wilderness.

The Stars put out their visitors' book again and it quickly filled with the comments of excited visitors. 'Your hearts are full of human dignity,' wrote one, 'and are the conscience of the nation. History will leave a magnificent page for you, because people will not forget you.' Among the hundreds of other entries:

Thanks to the Stars exhibition I have seen human dignity with my own eyes!

You are indeed the stars of a new culture . . . you have used brushes and engraving knives to create new pictures for the people; you are pioneers of a new culture.

Over the course of the exhibition they counted more than 30,000 visitors; 9,000 bought tickets on the final day of December 3.

The Stars were thriving in a world of ambiguity, where the interpretation of their works was left to others, and no words of theirs lay ready to trap them. Hating politics as he did, this was somewhere Huang Rui was happy to be. But even as success was all around them, he had received a sickening reminder of how narrow the line was

between success and disaster. Just a few days before, his friend Liu Qing, co-editor of *April Fifth Forum*, had disappeared.

Liu had stood beside them from the start. His family had lent *Today* the space for their office, he had helped the Stars draft their complaint to the police and helped organise their demonstration. On the day of their march, he had walked beside them in the rain and spoken passionately on their behalf, and now he had disappeared into the system like Wei Jingsheng had done eight months before.

Liu's crime was simple: he had dared to publish a transcript of Wei's defence at his trial. A journalist had slipped *April Fifth Forum* a clandestine tape made at the trial and they had printed it up in special handbills, which they then posted on Democracy Wall and sold in the streets nearby on November 11. That day police arrived quickly to rip the transcript from the wall and confiscate the handbills, detaining also the people who had been selling them. Liu Qing had gone to the local Public Security Bureau that same evening to complain and now no one knew where he was.

Huang Rui thought about where he was, in this beautiful pavilion that had been built for an emperor, in an imperial pleasure garden that was now a public park. Nearby was the library where he had first seen Delacroix's *Liberty Leading the People* in a battered book. Now Western art books and magazines had begun to flood in. He had seen the works of Cézanne and Van Gogh, and had stood as close to them as the visitors to the Stars exhibition were now standing to his own paintings.

Things were opening up ahead for him, but it seemed that things were at the same time closing up behind him. The Democracy Wall movement was dying, while the Stars were rising. It didn't seem to make a lot of sense.

Almost a year after they had pasted up the first pages of *Today* on the walls of Beijing, Huang Rui was beginning to understand that avoiding politics was almost as difficult as ever. Politics didn't dominate them like it had during the Cultural Revolution, but their fight to be

authentic to their own experiences, to express what they actually felt, was also a political choice.

They had been trucked to the middle of nowhere and told to make camp. They slept in a deserted rice silo, deserted because there were no farmers in this border region any more. Guo Jian had grown up in a subtropical world, but the dense foliage and choking humidity here was something different. Even though they were still some kilometres from the Vietnam border it felt like another country already.

After a few weeks he was picking up Mandarin quickly, along with a host of other dialects. His commanding officer was from Nanjing so understanding Mandarin was imperative. Even so, it was hard to know what was going on. The training regime seemed designed to frighten them rather than teach them anything. Or maybe, he had started to suspect, that was the point. They were constantly warned of the threat of 'Vietnamese spies' crossing the border. Time after time they were roused from sleep for night manoeuvres. Their rifles had no ammunition, so no one was sure what they were supposed to do if they ran into a spy. When they asked, they were told to use knives or martial arts. Since no one had trained them in hand-to-hand combat, this wasn't a comforting answer. And yet the conflict was real. Soldiers were being killed not far from their camp. After dark, the young recruits, most of whom had lied about their age to get into the army, cried in their tents.

Somehow Guo Jian was singled out for better things. At the end of three months, he had been chosen for training as a signals officer. This meant promotion, of course; but better still, signals officers got to work the camp's radio.

He was told the radio was strictly for military use, but how, he reasoned to himself, was he going to learn how it worked if he didn't do a little channel surfing? Soon he was up half the night chasing

frequencies, smoking local tobacco from a Yunnan pipe, too excited to sleep.

His other duty was regimental secretary, storing the gear of men who were being sent to the front. Each of them would write a letter to their families before they went and he filed them carefully away. Every week they were leaving but it seemed like they never came back. One day a really gung-ho type, a guy he'd met on the first day he'd arrived in camp, turned up full of heroic tales of the fighting he'd seen, invalided back to base with just a small wound to his leg. It was a relief to have someone return, as Guo Jian had started to feel like no one ever would, or if they did their wounds would be too terrible to look at. A few days later the military police came to get the wounded returnee. It turned out he had shot himself in the leg, desperate to escape the front.

They started to issue all the soldiers with a form, which they were told to fill out with their name, their parents' names and their home address, and then in the space provided just a few words about how they were ready to die for their country and how proud they were. The army had decided it was better to get these ready from the start, rather than leave it up to the soldiers to write letters themselves. Guo Jian filed these away, too.

When he could he would draw, mostly portraits of the other soldiers. By the time he left the army he had drawn almost every soldier he knew. Later he would reflect that this period provided more valuable artistic training than anything he was to pick up at university. His superiors began to notice his talent and he was given a sideline duty of painting propaganda posters for the troops. A new Chinese year was dawning: 1980, Year of the Monkey, a year for the brave, the clever and the quick. A year that would suit Guo Jian well.

He kept on listening to the radio when he could, 'to keep his skills up', as he put it. And he did have a feel for it: he could chase a frequency through the air and once he found it, hold on to it.

One day he heard a woman's voice coming over the radio, sweeter and lovelier than anything he had ever heard. She was singing in Mandarin, a song he would later discover was called 'Small Town Story'. Her voice was so clear, yet soft, that it made him long for home like he never had before.

That night he picked up the 'yellow novel' he had been reading. A piece of soft pornography posing as a romantic tale, the book had been passed from hand to hand among the recruits. It was contraband, but all the more titillating for that. Guo Jian had been gripped by it, but now as he tried to read it again it seemed empty. There was no romance or passion here: he had heard that instead in the voice, and once heard it was unforgettable.

The name of the singer was Deng Lijun, although most people round the world knew her as Teresa Teng. She was a Taiwanese performer whose exquisite voice and achingly romantic delivery made her a megastar in the Chinese diaspora in the 1970s and '80s. Her music was never played on the radio in China because her Taiwanese background made her politically radioactive, but when cassette players became an affordable item in markets around the country, bootleg Deng Lijun tapes would make her a household name there.

Years later Guo Jian's generation would coin a joke based on the similarity of Deng Lijun's family name to Deng Xiaoping's: 'Was it Deng Xiaoping who transformed China at the end of the twentieth century? Not Deng Xiaoping, it was Deng Lijun.' It was a joke with an edge of truth. Thirty years after he first heard her voice, China's leading dissident and Nobel Prize laureate Liu Xiaobo would reflect on the way the singer had changed his generation. Deng Lijun's songs, he wrote, 'took a generation of Chinese youth by storm, reawakening the soft centres of our beings. They dismantled the cast-iron framework of our "revolutionary wills" and caused these to collapse . . . and they revived sexual desires that we had long repressed into the darkest recesses of our beings.' No doubt it was for these reasons more than her

Taiwanese background that the Chinese government would try to ban Deng Lijun's music repeatedly from the late 1970s till her tragic death in 1995.

Out on the border with Vietnam in 1979, Guo Jian knew nothing of this. He only knew that he was desperate to hear her again, and from then on he spent night after night chasing her up and down the frequencies as her unforgettable voice faded in and out.

It wasn't long before he realised that the strongest signal broadcasting Deng Lijun came from a country that he had barely heard of—Australia. In those years Radio Australia's transmitters beamed its signal from a flat plain near the farming community of Shepparton, Victoria, all the way north to China, where it was heard loud and clear from Yunnan, where Guo Jian was based, to the far western provinces of Xinjiang and Tibet, north to Inner Mongolia and Beijing and east to Shanghai and Guangzhou.

Radio Australia's Chinese service loved Deng Lijun. She performed in Mandarin, Cantonese and English and her Mandarin delivery was regarded as the most perfect in the world, with a clarity that was unsurpassed. And so they played her every hour and Guo Jian soon learned when to listen for her. It became his guiltiest pleasure, and when the officers weren't within earshot he would share it with his comrades in arms, holding fast to the frequency, chasing it when needs be, smoking his Yunnan pipe and watching the smoke drifting up into the sky.

As the extraordinary year of 1979 drew to a close, China was at the beginning of a decade that in many ways was more free than any before or since in the history of the People's Republic. The 1980s took China from the beginning of Deng Xiaoping's great reform and opening up to the tragedy of Tiananmen Square, along the way fuelling the most extravagant dreams of what China could be.

The story of China's transformation would not belong simply to the men within the red walls of Zhongnanhai. It would be told in the traditional rice basket provinces of Sichuan and Anhui, where impoverished farmers returned to tilling their own fields, growing new crops and developing side industries, pioneering the reforms that would power China's development through the 1980s. Told, too, by workers moving to the city, taking a chance in places like the sleepy fishing village of Shenzhen, which had just been declared a Special Economic Zone and would become one of the richest cities in China. And told in thousands of factories across the Yangtze and Pearl River deltas, which would light an economic blaze through south China that would stun the world. And told by young people setting courses in life that just a few years earlier would have seemed impossible.

The beginning of the 1980s found me deep in a dried out summer, a student of history at the Australian National University in Canberra. I was tuning into the radio, too, but not to Deng Lijun. The sound of the year for me was the Clash. I had no thought of young men fighting in a war I'd never heard of, listening in to a sound that would change their lives.

For me, China was a blank then, a place of unpronounceable names and incomprehensible history. The Iceland of the Vikings was more real to me. I had read all the sagas, dreamt of their ships. The decision of some of my friends to enrol in Asian studies I regarded as eccentric, and the choice of Chinese by others was simply mystifying. There was only a handful of the latter that I could identify on campus. One of them was the older, bookish, bespectacled and, as it turned out later, ambitious future Australian prime minister Kevin Rudd.

It wasn't that I was uninterested in the world but it was the war in Afghanistan that was obsessing us in the summer of 1979–80. It was the war we tend to forget now, the Soviet invasion at Christmas 1979 to shore up a friendly government.

Democracy Wall in Beijing lived and died without my knowing. By the time the Soviets entered Kabul, the wall had been closed down forever. In December 1979 the Chinese government finally brought it to an end, just over a year since it had first begun to be a focus for dissent. They announced a new wall would be established in a far off park, where people could post their thoughts any time they wished, as long as they applied for a permit. Over the old wall they built a floodlit advertising billboard.

In 1981, having graduated from university, I boarded a plane for Europe for the first time. As it happened, my journey took me via Taiwan. I walked the streets of Taipei in confusion; it was a polluted and depressing place then, still under martial law, not at all the vibrant city it is today. Yet in those few days I started to feel the stirrings of the fascination that would eventually fuel my three-decade-long relationship with China. In the National Palace Museum I stood in awe in front of the Song dynasty (960–1279) hanging scroll *Travelers among Mountains and Streams*, seeing in that ancient painting how much more of the world there might be out there to know.

A few days later on a beach in the far south of Taiwan, near the port of Kaohsiung, I came across some Chinese characters that someone had scrawled in the sand with a stick. I stood looking for a while, as if staring for long enough might unlock their meaning. Suddenly I realised it didn't matter. I was there myself, and so I carved my name on this foreign beach with the end of a piece of driftwood and looked out across the Taiwan Strait towards mainland China where—for all I knew—there was someone standing on a beach right now writing in the sand like me.

As I stood on that beach the 1980s were underway. Huang Rui, and many like him, had already put behind him events more powerful than I would experience in my whole lifetime.

And as the sun went down over an army camp near the border with Vietnam, a young man my age was tuning in to Australia on the radio, blowing smoke rings into the sky and hearing the voice of Deng Lijun singing to him as if from another world.

VERY HEAVEN

Bliss was it in that dawn to be alive,
But to be young was very heaven!

<div align="right">William Wordsworth, 'The French Revolution as it Appeared
to Enthusiasts at its Commencement'</div>

On a sweltering summer day in 1984, in a provincial capital far from Beijing, a young man was running fast across the dusty ground of the compound where he lived. His face was beading with sweat under his cropped hair and behind his thick-rimmed glasses. But no one was chasing him and no one was running away. He was running for pure joy. His name was Sheng Qi.

He was only nineteen but in his semi-uniform of neat pants and a crisp white short-sleeved shirt he seemed even younger. Looking at him you would never guess that he had just pulled off his first act of studied defiance of his loving, hardworking parents. They were both engineers, anxious, earnest servants of the People's Republic, and he was their only son. They had hoped he would follow in their footsteps, but it was from that very aspiration that he was running. In his hand he held a letter that would release him. He was going to Beijing to study art.

It's not that his parents didn't know how to dream. His father had grown up in the countryside and had studied hard for a chance to

forge a new destiny through university. His mother had grown up in Shanghai and in that city's faded glamour had glimpsed something of what the world might hold. Together his parents had been pioneers in this city of Hefei, the capital of the rural province of Anhui where Sheng Qi had been born. They had helped build the new government buildings, the sports stadium, and the main theatre.

They were proud of their work, but they also saw how dangerous it could be if your ambitions led you away from the strictly utilitarian. There was too much politics in China, they told the young Sheng Qi, study hard at your mathematics. In a country where the most innocent cultural pursuits could get you into trouble, it was safest to be a technician. During the Cultural Revolution, even engineers like his parents had to endure endless political meetings that stretched far into the night, while at home Sheng Qi and his young sister hid lonely and frightened under the bed covers.

His father had tried to sell to his son the romance of engineering. When Sheng Qi was a young boy in the late 1960s he had been taken to see the newly completed Nanjing Bridge. This was an engineering triumph of the times, a road–rail span stretching thousands of metres across the Yangtze River, making possible the long-held dream of a Beijing–Shanghai train link. Sheng Qi still remembers his father ushering him into an elevator, which would, he breathlessly explained to his son, transport them to the summit of the bridge's tallest pylon. But at the top, passengers were prohibited from getting out, so Sheng Qi's engineering adventure was nothing more than a stint in a metal box that took him back to where he had started from.

Sheng Qi received his acceptance letter to art school in Beijing in 1984, six years into the reform and opening up of China under Deng Xiaoping. In year zero of that experiment—1978—Sheng Qi's family had still been writing down every cent they spent into a small lined book each day, exerting painstaking control against the fear of running out of money before the end of the month.

Despite their tight budget, they had, in fact, been relatively secure, with both parents in professional city jobs. Out in the countryside things had been much tougher in those years. Anhui had traditionally been one of the food baskets of China but in the late 1970s it was mired in poverty. Decades of communal farming, disastrous irrigation projects and the catastrophe of the Great Leap Forward had devastated rural life.

The scars of the Great Leap ran particularly deep there. Around China between 36 and 45 million people died between 1958 and 1962, sacrificed to Mao's fantasy of a Great Leap Forward in agricultural and industrial production, symbolised by his demand that China overtake Britain in steel output within just fifteen years. Agricultural production broke down under the pressure of forced collectivisation and the diversion of farmers to steel production. The result was not a Great Leap Forward but a Great Famine, the greatest tragedy the country had ever suffered.

In one district, Fuyang, to the north-west of Hefei, some 2.4 million people died out of a population of eight million in the three years from 1958. Throughout Anhui province many more died of starvation or disease, and in the violence that welled up amid the chaos. At the end of those years the trees stood like skeletons, their leaves and bark stripped for food by people who, at the end, would eat the earth itself to staunch their hunger.

Perhaps it's no surprise, then, that it was in desperately poor Anhui that a group of farmers first took the risk of throwing off the communal system and taking individual responsibility again for the land.

In December 1978, in a small village called Xiaogang to the east of Hefei, eighteen farmers gathered one night to sign a secret pact. After years of pitiful harvests that had turned the villagers into beggars, they had decided to divide their communal land into family farms again. They would farm their plots separately, and although each farmer would still reserve a set amount of grain for the collective and the state, anything

above that they would keep for themselves. The land would remain in state ownership, as it still does today, but the farmers would once again guide its destiny.

One by one, each dipped his index finger into red ink and made a mark beside his name. They vowed that if any of them was to be arrested and punished, the others would take care of their family. The document still exists, preserved today in the National Museum in Beijing, the red fingerprints like bloodstains on the fragile page.

By the next harvest the village's output had soared and their secret was out. It had been a desperate gamble to stare down the party's ideologues, but the farmers were on the right side of history. In Beijing, Deng Xiaoping had secured his grip on power the same month the Xiaogang farmers made their secret pact, and his pragmatic leadership favoured the loosening of government controls to drive enterprise and productivity. By the time Sheng Qi ripped open the envelope to his acceptance letter from Beijing in the summer of 1984, almost 100 per cent of China's farmers had followed the lead of the villagers of Xiaogang and taken control of the land again.

The breakup of the communes would lead not just to bigger harvests and the fading of the spectre of hunger, but also to experimentation with new crops and side enterprises in manufacturing and services, driving an extraordinary transformation in the lives of the 80 per cent of China's population that then lived in the countryside. In the 1980s more than 150 million people in China would be lifted out of poverty, a phrase which fails to convey the real truth—that the farmers lifted themselves out of poverty, through the passion with which they pursued new opportunities and their creativity in finding new ways to exploit their resources.

It was a revolution that would change the whole of China beyond recognition. It would transform the countryside and the cities, as surplus farmers left the fields to seek their fortune far from their rural homes. They would go not just to feed the exploding demand for labour,

as China transformed itself into a major manufacturing and trading power, but also to start their own businesses. By the time Sheng Qi took his own journey to the capital, the urbanisation of China was well underway.

At the end of the summer of 1984 Sheng Qi took the nine-hour journey in a 'hard seat' carriage to take up his place at college in Beijing. 'Hard seat' is what the Chinese call third class, and you need to be lucky and fast on your feet to get a seat at all. It's an uncomfortable but convivial way to travel. On the journey Sheng Qi met a friendly young soldier, happy to share his knowledge of the world with the star-struck aspiring artist. Sheng Qi had nurtured a kind of hero worship for soldiers since he was a child and was excited to find himself talking to one. He asked his companion to tell him about Beijing. The soldier laughed and asked Sheng Qi to imagine China as a bald man's head on which one single hair grows. 'Beijing,' he told Sheng Qi, 'is that hair!'

Disembarking at the teeming Beijing Central Station, Sheng Qi saw a series of tables dotted around the concourse. Each of the capital's universities and colleges had established outposts at the station to greet the new students arriving from around China. After registering, he was given the number of the bus that would take him to his school. His adventure had begun.

He couldn't know it then, but it was an adventure that in a few short years would lead to disillusionment, horror and a moment of excruciating despair that would change his life forever. Thousands of young people like Sheng Qi were treading the same path, and 1984 was the year when everything started to change faster than had ever seemed imaginable.

To understand what it felt like to live through the 1980s in China, it helps to think about the 1960s in the West. The decade followed a similar trajectory: a slow start followed by rollicking middle years of white hot excitement, when anything seemed possible. Dreams could be big in the 1980s in China and idealism was sky-high. The eighties

saw the birth of rock and roll in China and the beginning of a sexual revolution. But just like the 1960s in the West, the 1980s ended in violence and bloodshed for China. As France had the events of May 1968 and the United States had Kent State, China was to draw down the curtain on the decade with one of the darkest episodes in its history.

Early that same year in the far western province of Xinjiang, in a city further from the sea than any on Earth, a young man slipped away from the noise of the carpet factory where he worked into the quiet warmth of a wool dyeing room. Here, where the heavy woollen skeins seemed to absorb every sound, he had made a nest to study for his exams. It was so peaceful there that sometimes he felt he could hear the blood running in his veins. Inside this cocoon he dreamed of far-off Beijing where he hoped he would become an artist. His name was Aniwar.

He had been born in the oasis town of Karghilik on the southern fringe of the Taklimakan Desert at the heart of Xinjiang. Karghilik had once been an important way station on the southern Silk Road, where traders would gather before tackling the mountain passes into India. In the 1980s the old culture still persisted in the town of richly coloured carpets and watery ikat silks made by hand, jewel-like tiles and intricate adobe brickwork, shady pergolas heavy with grape vines in summer, and pomegranates, apricots and quinces picked from trees watered by snowmelt from the Karakoram.

The sky stretches vast above your head in Xinjiang, whether you are in the baked ochre oases of the south or in the rich pastures of the north where nomadic herdsmen still range. One-sixth of China's territory today is contained in this western province, an area three times the size of France. Buried in its shifting sands are mummies, lost cities and other remains of people who have long since disappeared from history, whose very origins are unknown.

These lands came late to China, annexed by the Emperor Qianlong in the 1750s. The name that was later chosen for them, Xinjiang ('new territories'), proclaimed their separateness within a nation that had hitherto been relatively homogenous. With the taking of Xinjiang, China drew 'the other' inside its borders. The nation became multicultural and, from that moment on, more difficult to control.

For millennia before the eighteenth century the people of Xinjiang had dealt with China as traders, adversaries and sometime subjects. They had long supplied China with its treasured jade, while their position at the heart of Central Asia delivered them guardianship of China's roads to and from the west. Just as silk made its way westward through Xinjiang's oases, Buddhism made staging posts in those same oases on the way from India into China. Objects as classically Chinese as Ming dynasty (1368–1644) blue-and-white porcelain only became possible when cobalt blue glazes made their way from Persia to China through the oases of Xinjiang.

Turkic people first came to Xinjiang in the mid-sixth century when the Kök Türks rode out from Mongolia to establish sway over a territory that stretched as far as Afghanistan and northern India and into what are now the lands of Uzbekistan, Kirghizstan and Tajikistan. They mixed with the Indo-Europeans who had come before them and began to forge the distinctive culture that still animates the region today. In Xinjiang the predominant ethnic group are the Uighur people, but they share the province with Kazakhs, Kirghiz and Tajiks, whose ethnic brothers have established independent states along China's borders. The Uighur mother tongue is Turkic, and closely similar to many of the languages of Central Asia. So Xinjiang's cultural and linguistic ties are closer to its western neighbours than to China. Overlaying the Turkic culture is Islam, which arrived in Xinjiang in the tenth century, carrying with it another set of traditions and loyalties that deepened Xinjiang's cultural distinctiveness from China.

By the time Aniwar was born, Xinjiang was no longer a crossroads.

The mountain passes to the west were closed and Xinjiang no longer traded with the outside world. All roads instead led to Beijing and, from 1949, although its provincial capital was some 3700 kilometres away, Xinjiang ran on Beijing time.

Now reading for hours in the quiet of the wool dyeing room, Aniwar was securing his passage to Beijing. In the same month that Sheng Qi took the train from Anhui to the capital, Aniwar would be boarding one, too.

Even as the summer of 1984 would find young people like Sheng Qi and Aniwar arriving in Beijing high with excitement, it would see Huang Rui leave.

The early years of the 1980s were tough for Huang Rui and his fellow Stars. The initial triumph at being able to stage their exhibition had given way to a series of reversals, and finally a real fear about what kind of future they could make for themselves in China.

At first things had gone well. The Stars had garnered support among many of the older artists and had been accepted into the official Artists Association. In the autumn of 1980, Huang Rui and Ma Desheng had set off on a lecture tour around China, visiting 30 cities and talking to art students and teachers about the Stars exhibition and their vision for art. At one college, the Sichuan Fine Arts Institute in Chongqing, more than 800 students came to hear them speak.

Back in Beijing in the spring of 1981, visiting celebrities such as the composer Jean-Michel Jarre and his actress wife Charlotte Rampling sought out the Stars, and discussed collaborations with Huang Rui. The Stars and their friends held parties in the ruins of the Old Summer Palace, where young Chinese and Westerners danced together among the fallen stones. There was excitement both inside and outside China about where reform might lead.

But not everyone was excited. Conservative party ideologues like the propaganda chief, Deng Liqun, saw danger in the spread of notions like 'individualism' and 'humanism' into Chinese intellectual life: he saw them as antithetical to the acceptance of party control. Criticism of artists, writers and intellectuals with 'bourgeois' ideas began to ratchet up.

Today had been banned at the end of 1980 while Huang Rui and Ma Desheng were still on the road, and, as 1981 wore on, the Stars found their newly won membership of the Artists Association cancelled and their landmark exhibition criticised. They could feel themselves being forced underground again, as they were denied a public space in which to work and exhibit.

As the economy opened up in the early 1980s, corruption and crime also flourished. It was easy for conservatives to link this to the 'pollution' of bourgeois thought. In August 1983 a nationwide crack-down on crime was launched, followed a few months later by the official campaign against 'spiritual pollution'. Law enforcement around the country was encouraged to 'strike hard' against 'hooliganism'; within a few months, tens of thousands of young people had been sentenced to 'reform through labour' in far-off prison camps, and thousands more had been executed for ill-defined crimes. Propaganda suggested a slippery slope from Western hairstyles, clothing and dancing, to pornography, theft and violent crime.

Huang Rui and his fellow Stars felt their world closing in again. In August 1983, an exhibition by Huang Rui, Ma Desheng and Wang Keping was shut down after just a few days, and the police took to dropping in on them at home. Meanwhile the poetry of their friends Bei Dao and Mang Ke was denounced as 'misty', incomprehensible and enslaved to Western ideas. The term 'Misty Poets', intended as a criticism, quickly became a badge of honour.

The anti-spiritual pollution campaign only lasted three months, its hysterical tone causing so much negative publicity outside China and

fear within that Deng Xiaoping was convinced to call it off. But the damage was done: Huang Rui was exhausted. He had seen the wheel turn once too often. Hope and excitement in China seemed inevitably to be followed by repression and disappointment. He needed to escape the cycle.

In the autumn of 1982 he had met a young Japanese woman, Fujiko Tome, who had come from Osaka to study in Beijing. Less than a year later they married. 'I had never thought of getting married before,' he told me years later, 'but I realised I needed to get out of the country.'

By early 1984 both he and Wang Keping had decided to leave China. Wang Keping had also married his foreign girlfriend, a young teacher from France. The two friends would head for foreign cities at opposite ends of the world. The night they told Ma Desheng, he wept. A year later he too would choose exile abroad.

Huang Rui boarded the plane for Osaka at the height of summer 1984 with no idea that within months the wheel would turn again and set off what would be the most exhilarating period in Chinese contemporary history. It would last barely five years but it would shake the country to its core. Before it ended, Huang Rui would find himself back again in Tiananmen Square.

In 1984 an aspiring artist called Gonkar Gyatso was also leaving Beijing, but he was heading back to his home town of Lhasa after four years as a student in the capital. His time in Beijing had been a revelation, and he was determined to create an artistic life for himself in the city of his birth.

When he had first come to Beijing in 1980 he had, as he told me, been 'very Red', one of the Communist Party's true believers. His father was an army man, born in the town of Amdo in Qinghai province on the Tibetan plateau. He had arrived in Lhasa with the People's

Liberation Army (PLA) in 1954 when the Dalai Lama still lived in the city. Gonkar's mother was a passionate communist. Before the PLA entered Tibet in 1950 she had lived in a kind of servitude that she considered akin to slavery. Under Chinese administration she had been given the opportunity to study and her gratitude ran deep.

His father's military connections ensured that Gonkar and his sister would see out the turbulent sixties and early seventies in relative security. In 1979, at the age of eighteen, he had secured a steady job working as a museum guide in Lhasa, and it was there that his enthusiasm and lively intellect caught the attention of some visiting artists from Beijing. They encouraged him to sit the exams for art school, and he was accepted in the summer of 1980.

It wasn't long after he started college in Beijing that he realised that the real excitement was outside the school gates, not in the classroom where he was studying Chinese traditional painting. There was plenty of art to see—and he was fascinated by the exhibitions of Western art that were beginning to arrive in China—but it was the books that captured his imagination. In those years Chinese translations of Western books were coming thick and fast. He loved reading about Western art, but it was Western philosophy that really spoke to him.

Sartre and Nietzsche impressed him, but it was Schopenhauer who inspired him. 'Even after finishing university I kept reading him, his theories really chimed with me, his sense of man's loneliness and struggle. He awakened the desire in me to search for something spiritual.'

When he had first arrived in the capital he had felt secure in his identity. 'Before I went to Beijing I had no concept of myself being Tibetan and other people being Chinese. I was very ideological, a real Communist, but soon I began to feel a real clash in my heart, and in my head. I suddenly realised, *I'm Tibetan, I'm not Chinese*, and the philosophy books really helped me consider these questions and to connect with spirituality, which I'd never been exposed to before.'

He had grown up in a period when religious expression was heavily repressed, and he had never seen a Buddhist shrine. But in the early 1980s under Deng Xiaoping, the practice of religion was no longer deemed a crime, and religious tolerance was enshrined in the Chinese constitution.

In 1983 on a visit to Lhasa he came upon his grandmother worshipping quietly at a small shrine in her home. Gonkar was 22, and he experienced for the first time the heady smell of incense and the sight of the curls of perfumed smoke rising before a statue of the Buddha.

By the time he graduated in 1984 he was anxious to get home again. The time in Beijing had been exhilarating, but also painful. During these years his whole sense of himself had been overturned. Now he was ready to get out of the classroom and discover what it really meant to be Tibetan. He hoped that back in Lhasa he'd be able to find out.

Guo Jian hesitated at the door of a darkened studio. It was early autumn 1985.

He had been in Beijing for a few weeks now but he still hadn't found what he was looking for. Maybe he would find it tonight.

He still couldn't quite believe he was here, in Beijing, 2000 kilometres from his home town in Guizhou.

He had left the army in 1982 after three years in uniform, but little seemed to have changed when he got home. His girlfriend was still refusing to marry him. She couldn't understand why he had no ambition to join the Communist Party, and was pressing him to go to university. To Guo Jian, it seemed impossible. He had hardly been to school, and although the universities were, in theory, now open to all on merit, he couldn't imagine how he would ever pass the exams. All he could do, he thought, was to continue to draw and paint, and trust that his talent might lead him somewhere.

It was a stroke of luck that took him to Beijing. In early 1985 he was walking with his sketchbook when he ran into one of his old teachers. She was talking to a woman who turned out to be a visiting art professor from Beijing, who took one look at his sketches and asked to see more. As it happened, she was a scout from Minzu University, a college in the capital aimed exclusively at China's dozens of ethnic minorities. Guo Jian was one of them: his ancestry was Buyi, an ethnically distinct group scattered across three provinces of southern China. At Minzu University, the woman explained, there was a handful of places for students wanting to study art. It was for one of these places, as it happened, that Gonkar had been chosen five years before.

Later that year Guo Jian found himself in a crowded room in the provincial capital, Guiyang, one of 100 applicants competing for a single place at Minzu University. After two days they had winnowed the competitors down to twenty and on the third day they were set a final test. They were each to create a composition inspired by one of the four seasons.

All around him his rivals started turning out scarily polished compositions of snowy winter mountains and autumn harvests. Guo Jian chose spring, but instead of birds and flowers he drew an old man coming home from the market just before Chinese New Year, lugging a mirror. On this the man would write—as an old tradition dictated—his wishes for the new year. Wizened with age and smoking his pipe, it was this old man and his air of unquenchable optimism that got Guo Jian into university in Beijing.

He had travelled for two nights and three days to reach the capital. As his train crossed the Yangtze River Guo Jian saw for the first time the open plains of China's north. The mountains of Guizhou always seemed to him to block the view. You could look and look, he told me, but never see beyond them. Now he could see for miles and he liked it.

Arriving at university he found himself on a campus filled with people from parts of China he had hardly known existed. In his dorm

room alone there were students from Xinjiang, from Inner Mongolia, and a tiny county called Mohe, which was as far north as you could go and still be in China, where winter lasted half the year and the Northern Lights played across the sky.

In his first weeks he'd gone to some parties but they were all rather staid. Somehow he hadn't yet found the door into the world he had dreamt was out there ever since he first heard Deng Lijun sing.

And then he had got the invitation that had led him to this door. Easing it open, it seemed at first that the room was totally dark. There was music playing and in the distance a small red light was glowing. As his eyes adjusted to the dark he saw people dancing, smoking, lying on the floor.

This was alarming. Just a year ago he had been painting propaganda posters for the anti-spiritual pollution campaign. Even in remote Guizhou the campaign had seen scores of young people imprisoned and some even executed for activities just like those going on in this room. Guo Jian backed away but someone pulled him back. 'Don't worry,' they said, 'we're all artists here.' If this was meant to reassure him it wasn't working. Then a group of girls dragged him towards the dance floor. He was older, he thought, he was meant to be a class leader, and his teachers expected him to be serious. But the girls seemed to know he wasn't that kind of guy. He knew it, too. He wasn't that kind of guy.

It was the first night he ever heard Western music and the first time he danced to it, the first time he drank Erguotou. And it was the first time he tasted red wine, which they shared out of a single cup while they rolled cigarettes in scraps of newspaper.

Even today the sound of Western music brings back to him the taste of printer's ink, tobacco and red wine, the sorghum reek of Erguotou, and the scent of the single brand of shampoo that all the girls used in those days.

Later Guo Jian couldn't remember exactly what music he heard that night, but every song was new. In those years the West came to

China on cassette tapes, mixed by foreigners before they left home and copied for their new Chinese friends. Homesickness weighted these collections towards the iconic, to the anthems and the classics. And so, in the soundscape of mid-eighties China, 'Sounds of Silence' mixed with 'Hotel California', 'Life During Wartime' with 'Brown Sugar', and 'Beat it!' with 'Like a Rolling Stone' and 'Je t'aime . . . moi non plus'. The history of Western rock and pop became the soundtrack for Beijing's 'summer of love', romantic, allusive, sexy, poetic and subversive. Even today drunken reunions in China can erupt late in the evening into slurred renditions of John Denver's 'Take Me Home, Country Roads', while 'Sounds of Silence' plays on a continuous loop for ice skaters on the Forbidden City's frozen moat.

That night Guo Jian stepped inside the underground culture that would be his true university for the next four years. From then on he committed to a helter-skelter journey of discovery, ignoring the course laid down for him by his elders, following connections where they led, looking for new worlds in art and literature and life. And around the country hundreds of thousands of other young people would do the same.

The host of the party that night was Aniwar.

He had arrived in Beijing just a year before Guo Jian, and found that the Minzu University was the perfect base for exploration. It was an academy of outsiders, their ethnic origins marking them out from the Han Chinese majority. The neighbouring big institutions like Peking University and Renmin (People's) University might have been in the intellectual vanguard, but Minzu was edgier.

By the time Guo Jian met him, Aniwar already had a reputation as the 'king of cool'. 'I think he was born cool', Guo Jian reminisced to me one day. 'He was just so avant-garde, so far ahead with the music he

was listening to, and the way he dressed. And he was making connec-
tions with foreigners way before the rest of us.'

On the weekends Aniwar and his friends would organise parties
in their class studio on campus. They would spread the word to people
they thought would be interesting, even stopping individuals they
liked the look of on the street. It was natural that they would ask Guo
Jian, this young guy from the south who still wore his army uniform.
And every weekend there was a standing invitation to the young
women who modelled for their life classes.

These women were pioneers. Nude modelling had been banned
during the Cultural Revolution and it was only in 1984 that life classes
were once again allowed in art schools. In that first year there were
just three young women in Beijing who took up the challenge. It was
still the era when people worked in assigned jobs; theirs was in a state
factory, but it was the kind of place that Deng Xiaoping's reforms would
soon put out of business. The girls pulled wages of around 40 yuan a
month simply to clock on and read the papers. For art school model-
ling they could get 8 yuan an hour and an entry to the avant-garde.
It was no contest.

They modelled for each of the colleges in Beijing, and were couriers
for the gossip of the burgeoning Beijing art world. They took on the role
of model/muse for Aniwar and his classmates, keeping them in cigar-
ettes, buying them canvas if they couldn't afford it and mothering them
with advice. Paid by the hour, they arrived early and left late. They would
doze on the sofa they posed on, and fix their hair in the beautiful antique
mirror that was rumoured to have come from the Forbidden City.

The spacious campus of Minzu University had run a little wild
during the Cultural Revolution, and abandoned buildings were scat-
tered at the corners of its ruined grounds. Aniwar and two of his friends
decided to take one over for a project.

Their idea was to create a world apart into which other people
could enter. All three were painters but they had no interest in staging

a formal exhibition. Instead they wanted to create a space for the imagination, a three-dimensional artwork using sound, light, colour and scent. They didn't have the vocabulary to describe what they were doing or the background in Western art to know, but they were arranging one of China's first art installations. Wisely or not, they went ahead without official permission.

The building they chose was perfect: cavernous, empty, and a long way from their teachers' classrooms. They carpeted the concrete floor with fallen leaves and lit the corners of the room with candles. They hung their paintings high on the walls at odd angles. Feeling something was still missing, Aniwar selected a dead tree branch and placed it high in the rafters and brushed onto its gnarled surface a single line of pigment.

When they were ready, they spread the word as they had for their parties, inviting their friends and roping in strangers from the street.

The opening was a sensation. They had created a soundscape with an ethnic-Korean drummer, a Tibetan singer and a lutenist from Xinjiang. It was like no music that anyone had ever heard. The space teemed with people, and a woodland scent rose from the crushed leaves, while shadows went leaping up the walls as the candles flared and guttered. People stayed for hours, captivated by the music and the warm light, the oddly hung paintings and the forest ambiance. When the last visitor left, the artists bedded down on the floor among the leaves.

Fine Arts in China, a critical magazine that was itself only a few months old, was enthusiastic. The university authorities weren't. 'You're not here to make art,' the three were told. 'You're here to learn!' Under orders to close the space, the students sought out the biggest padlock they could find, so that if people leaned hard on the door they could still look through the gap into the space within, where the forbidden world lived on.

Early in 1986 *Fine Arts* invited Aniwar to publish his statement on the project. He wrote: 'We do not want to follow any school of thought

or painting. We simply hope that our successes or our failures will be of our own making.'

It was the spirit that drove a lot of things in those years. All over China people were trying to make their own decisions and find their own way, not just in the universities, but on the farms, and among the burgeoning group of independent traders who were beginning to change the face of the cities. People wanted to be themselves. More dangerously, many of them wanted to be heard.

Guo Jian stood in the crowd pressing up against the stage waiting for the concert to start. He'd taken a risk to be here. At the door a stony-faced clerk had registered his name and checked his details against his identity card, while a stream of foreigners flowed past him into the hall unchallenged. Direct contact between ordinary Chinese and foreigners was discouraged, and making Chinese register was a form of silent intimidation. Guo Jian had spent long enough in army administration to know things like this always ended up on your file, but he no longer cared enough to be cautious.

Ever since the night of the party, he had been chasing connections. He was always sneaking off from school to see new exhibitions before they were closed down. He had been to Aniwar's show and was amazed. He couldn't understand where all these ideas were coming from. He stopped painting and started reading. Suddenly it seemed like every book in the world was available. He'd pick them up one after another in the markets, or from a guy selling off a pedal cart by the side of the road. Lu Xun, Nietzsche, Sartre, Freud's *The Interpretation of Dreams*—new books would come so rapidly that he never seemed to finish one before another demanded his attention.

The whole of Western modernism was coming at China in a rush. Revolutions in thought long assimilated into the Western canon broke

over them in waves. The whole of twentieth-century art was telescoped, too: Cubism, Expressionism, Warhol and Dali were jumbled into whatever patterns Guo Jian and thousands like him felt like making. Just like the mix tapes of Western music, Western culture arrived in China in a glorious mash-up that gave it a new vitality.

Among his teachers Guo Jian found one true iconoclast. Still in his twenties, the teacher guided him to art he might never have found on his own, like the tortured erotic works of Egon Schiele. He gave him his first real education in Western music as well, spinning cassettes for him and tracing the influences of Prince, the Police, the Eagles and the Beatles.

All over Beijing, young Chinese musicians had started putting their own rock acts together. It was only a matter of time before one of them broke out, but no one was prepared for the impact of Cui Jian when he arrived. He had written a hit that was being sung from one end of the country to the other, and now Guo Jian was standing in the surging crowd, waiting for him to take the stage.

In the early eighties, Cui Jian had been a classically trained twenty-something trumpeter with the Beijing Philharmonic Orchestra when a friend sat him down with some mix tapes of American rock. Cui Jian went straight out to buy his first guitar and by the mid-eighties he and his new band were playing the capital's sketchy bar scene. Then, in May 1986, at the age of 24 he took the stage at a nationally televised concert for peace at the Beijing Workers Stadium. Dressed in a traditional high-collared tunic like a Qing-dynasty guitar hero, he played 'Nothing to My Name' for the first time. Chinese rock and roll was never the same after that.

It was 'Nothing to My Name' that Guo Jian and everyone else had come to hear that night, and when the first shimmering chords floated through the hall, the crowd went wild. The song's plaintive start is a lover's plea to a woman who spurns him. Through the first two verses he offers her his dreams and his freedom but she just

laughs at him because—in the words of the famous chorus—he has nothing to his name. Suddenly, a fiery instrumental duel breaks out between guitar and Chinese trumpet, and hope fills the final verse as the singer sees his lover's hands begin to tremble and her eyes fill with tears. The song ends with the soaring realisation that she will go with him after all.

'Nothing to My Name' was written as a love song, but its theme of alienation, its triumphant progression, and Cui Jian's Springsteen-like delivery turned it into something that spoke to Chinese youth about a lot more than a boy and a girl. Like all great rock and roll anthems, it had a simple lyric that caught the mood of the moment: just singing the chorus was a release for young people who were starting to wonder if the world they were living in could ever measure up to the one they dreamed of.

Guo Jian told me years later that 'Nothing to My Name' was the first song he ever heard that really seemed to be in a Chinese voice. And he wasn't alone. Coming home to Guizhou in the holidays he found his old school friends were singing it, too. They swaggered down the street at night, roaring drunk, singing it at the top of their lungs. It was how they felt, that they had nothing to their name, no direction and no way to express what they felt. And then this song had come along and they realised they weren't alone. Three years later students would be singing it in Tiananmen Square.

'I don't think it was by chance that Cui Jian came along when he did,' Guo Jian told me one day. 'At that time there was so much going on, new books, new ideas—the time was ripe. Cui Jian was conjured up by people's needs. You wanted to express yourself, you wanted to make a noise and Cui Jian brought us together to make a noise.

'He was our Bob Dylan.'

★

I first heard 'Nothing to My Name' sung a cappella in Mang Ke's tiny apartment one night in the early summer of 1986. Midway through a drunken dinner, a skinny guy with high cheekbones and weathered skin swayed to his feet and began to sing. At first I thought it was a folk song, as it had that kind of raw simplicity. But I soon knew this was no folk song. Around the low table people beat time, urging him on, and in the final verse they joined in: 'Oh! You *will* go with me! You *will* go with me!' It was exhilarating. We applauded and then toasted the moment with beer and Erguotou. I asked the nearest person to write down the lyrics for me in my notebook and I later spent hours deciphering the characters until I had my own rough translation. I carried the piece of paper with me for years, even after the events of June 1989 leached the words of all their triumphant joy.

Mang Ke's apartment was up several flights of grey concrete steps in a characterless building in a remote part of town. Harshly lit and minimally furnished, it was also one of the most exciting places in Beijing. Ever since he had first started writing poetry, Mang Ke had attracted people around him, but his work with *Today* had made him a legend. Bei Dao and Huang Rui had both left the country but Mang Ke remained. Aspiring artists, poets, dreamers and random foreigners sought him out and he received us generously, though not indulgently.

Conversation was always vital around him. Suddenly I found myself having to have opinions again on TS Eliot or Albert Camus or Nietzsche or Freud—subjects I hadn't felt passionate about since I was a teenager. Encountering them again in Beijing in those days, their works hit me afresh. It seemed like every foreigner was treated as an emissary; I found myself thinking more deeply about my own culture than I had ever done before.

Poetry came easily then, too. People got up to read their work as naturally as they would get up and sing. You would find yourself at poetry parties, the best of them held in the ruins of the Old Summer Palace beyond the university district beneath the Fragrant Hills.

A group of vagabond poets lived there, renting tumbledown rooms from farmers who cultivated crops among the fallen stones of what had once been a grand pleasure garden for the Qing emperors. You'd swig mouthfuls of burning strong Erguotou and lie on your back and look at the stars, the words reeling in your head. On warm nights you would sleep outside and in the morning cycle back into town in a dream. In those days I'd often find lines of Western poetry humming in my head, as powerful as if they had been written for that moment. On a seemingly endless loop came the famous couplet from Wordsworth's 'The French Revolution as it appeared to Enthusiasts at its Commencement':

Bliss was it in that dawn to be alive,
But to be young was very heaven!

It *was* bliss, and I missed entirely the warning in the title.

Leaving Mang Ke's place or the Old Summer Palace was always disorienting. On the surface the city seemed not to be changing at all. The stately bicycles still dominated the roads, clerks still napped, heads on their arms, on the counters of the state-owned stores, the Ministry of Foreign Affairs still held their surreally uninformative press conferences weekly without fail, and most of the city was shuttered and dark by 6 p.m. That was when the other Beijing came to life. In those years I often felt that my existence was a black and white movie that only flared into colour after dark.

Much of my journalistic round focused on the stream of businessmen, legitimate and carpetbaggers alike, who were flocking to China in search of a fortune, or on the revolving door of world leaders coming to pay court. Every few days a new national flag would be hoisted alongside China's on Chang'an Avenue, and *China Daily* would feature yet another headline hailing China's ties with yet another nation. One day it would be the Pakistan relationship that was going from strength to strength, then a few days later it would be New Zealand's

turn or Zimbabwe's. Queen Elizabeth II came calling, too. She arrived by plane but the royal yacht met her in Shanghai where she threw a lavish shipboard banquet, much to the chagrin of the trade officials of less favoured countries. Hard to compete with a yacht, they muttered.

Covering these visits could be fun—notably the Queen's arrival, which found me throwing back a super-charged gin and tonic at 11 a.m. at a special drinks party for the Commonwealth press corps—but there was a sense that most of the business stories in those days were going nowhere. It would be some time before foreign companies and governments discovered how best to work the angles to profit from China's opening.

But all of that was just a sideshow beside the momentousness of China's transformation. We were witnessing a movement of people and an economic upheaval to rival the Industrial Revolution. It was irresistible to look to history for clues as to what this might mean. Releasing farmers from the communes, promoting private enterprise and encouraging a free flow of workers to the cities and to the new 'special economic zones' seemed to guarantee a rise in Chinese people's autonomy and a loosening of the control of the Communist Party. We looked to countries like Britain where industrialisation had led to the rise of the middle class, the establishment of trade unions, a free media, non-government organisations and other hallmarks of a civil society, and ultimately to parliamentary democracy. Surely China would go the same way?

The opening up of China's economy and society became visible to us in small ways every day. A new freewheeling class of independent small traders known as *getihu* appeared across the city, repairing shoes and bicycles, tailoring colourful clothes made to measure, roasting sweet potatoes and chestnuts on upturned oil drums, and hawking candied apples, pinwheels and brilliantly coloured kites. Free markets popped up near the diplomatic compounds and out near the Beijing Zoo, selling clothes that had mysteriously slipped out of the export stream and onto

makeshift stalls on dusty patches of parkland, many of which sheltered a brisk black market in foreign exchange as well. Farmers would suddenly appear by the road selling types of fruit and vegetables that hadn't been seen in the city in decades. I can still remember the excitement when a pedal cart laden with strawberries was sighted trundling into town along the Third Ring Road. In the following days I ate strawberries everywhere. Today they are a regular part of spring in the capital but then they seemed like they came from another world.

We believed the flow of Western ideas and liberalisation was unstoppable. The anti-spiritual pollution campaign was officially condemned as a mistake, a piece of overreach by the old guard that had foundered once it was seen to threaten economic reforms and relations with the West. There was a freer tone in the media, too, not just in cultural magazines, but in bold experiments such as the *World Economic Herald* in Shanghai, which pushed for deeper reforms.

Adding to our optimism was that, as far as we could tell, Deng Xiaoping's leadership team was pragmatic and outward-looking, too. Both the general secretary of the Communist Party, Hu Yaobang, and the premier, Zhao Ziyang, wore their commitment to the open-door policy on the sleeves of their Western suits.

It was pretty clear that Hu Yaobang had run dead on the anti-spiritual pollution campaign, and that he welcomed, rather than feared, foreign influences. Zhao Ziyang had been an early pioneer of the reforms that had liberated China's farmers from the communes and he was known to favour giving more power to managers throughout the economy to run their enterprises without party interference. We believed we were witnessing the gradual retreat of the party from Chinese people's lives, both in policy and in the personal style of the leaders. Hu Yaobang was seen openly reading a newspaper at dull political events, while Zhao Ziyang was fond of golf. Zhao's daughter worked as an events manager at a Western hotel.

But in all our calculations we were too complacent.

We could see how profoundly Deng Xiaoping's reforms were exposing the hollowness of the communist project in China, laying bare how little it had achieved and how much had been destroyed in the process, but we failed to see how destabilising that would be. We could join in the jokes about the party's 'official verdict' on Mao Zedong that he had been seven parts good and three parts bad, laughing when our Chinese friends would say that surely the formula was the wrong way round. But we didn't consider how wrenching such a verdict would be for people who had grown up being taught to venerate Mao and honour the party. We didn't see how the disillusionment would hit the country's youth as they were told to put aside one set of ideals and be given nothing to replace them but slogans like 'to get rich is glorious'. I failed to hear the desperation in 'Nothing to My Name'.

They had stripped naked on a freezing day and bound themselves in surgical bandages, then draped themselves in white and black cloth. Dressed in the traditional colours of mourning they drenched each other in red paint, which dripped from their bodies like blood. In white, black and red, the colours of death and violence, they walked through the campus like mourners out of hell. As they walked they screamed out the names of icons of China's culture, the Great Wall and the Yangtze River, yelling the names as if those of the dead.

The performance happened in December 1986, at an art festival organised by Peking University. When four young students from off campus had offered to create an artwork, the authorities saw no reason to turn them down. But when they saw the result they were appalled. What did it mean?

Among the four students was Sheng Qi. He had arrived in Beijing in the late summer of 1984 hyped up with excitement, but he had quickly become disillusioned with art school. He had expected his

teachers to be how he'd imagined artists would be, with strong, creative, open-minded personalities, but they were just like his parents. They had the same haircuts and the same clothes. He had expected them to be exceptional but they were no different to every other adult he'd met. Many, in fact, were members of the Communist Party.

Realism was all the rage at his school then, or at least the approved version of realism. The teachers would take their students to the seaside or to some picturesque village in the countryside to capture real life. 'Real life!' Sheng Qi scoffed to one of his friends. 'Why do we have to do that? We grew up in the city, we have our own problems, our own life, why do we have to go to a village for inspiration? Inspiration is inside *us*, it's in our daily life. We don't have to go to some exotic place to find it!'

He started to ask himself what art really was, burying himself in books and tracing the movements that had driven Western art, seeking out the poets who had inspired him, like Mang Ke and Bei Dao, and meeting young artists like my friend from the Friendship Hotel party who had already dropped out of the system.

'All through our schooling we had been fed this revolutionary, romantic, heroic story and all of us wanted to be heroes. We wanted to make history, and be loyal to our country. We were told that our country equalled our government, that it equalled the state and we should be loyal to that. We had been brainwashed for more than twenty years! Yet deep inside we still wanted to be heroes, we still wanted to make history.'

It was clear to him that the system had to be broken but he had no idea how. 'At that time we didn't even have the basic knowledge or information about what society truly was. We had no point of comparison. We didn't really know about Western culture. All we knew was communist China.

'As students we were so powerless, we were so weak that we had to shout. Ordinary art would be meaningless, so we decided to make this kind of demonstration.'

Years later I asked him what they were mourning for that day. 'We were mourning for our culture, for traditional culture, for traditional morals, for the traditional philosophy of China.' The students felt they had lost so much which they had never had the chance to know. 'We chose the strongest colours, we shouted, we were extreme, all because we were the opposite, we were powerless—powerless and hopeless.'

That day they embodied a right to be seen that *was* extreme, and those who witnessed their performance were shocked. But in their basic motivation they were not alone. Around the country in December 1986 thousands of students were also mobilising to be heard.

The demonstrations began in Sheng Qi's home town of Hefei. Since 1980 students had been trying to exercise the limited democratic rights promised under China's constitution. That document established a four-tier system of people's congresses designed to represent Chinese citizens from the village to the national level. Delegates to the congresses at the county, provincial and national level were elected by the representatives of the tier below them, with representatives at the bottom tier elected directly by people at the village level.

In theory anyone could stand for election to these village congresses, yet despite students around the country waging successful campaigns for election in 1980, 1982 and 1984, the party had stepped in each time to impose their own candidates. In 1986 the students in Hefei had had enough. On December 5 and then again a few days later, around 3000 students rallied in the city under banners that recalled the words of Wei Jingsheng: 'No democratisation, no modernisation.' A few days later, 5000 students were marching in the industrial city of Wuhan in the neighbouring province of Hubei. Reports filtered in of protests in remote places like the far southern city of Kunming and the special economic zone of Shenzhen.

Two weeks later, on December 20, some 30,000 students marched down the Bund in Shanghai behind banners declaring 'Give us

democracy' and 'Long live freedom', while at least another 30,000 Shanghai residents rallied in support. By then the list of grievances had extended to issues such as corruption and broader calls for democracy and freedom of speech.

On the night of December 23, just hours after Sheng Qi and his three friends brought their own kind of demonstration to Peking University, protests broke out in the neighbouring university of Tsinghua, with thousands rallying in the university quarter. Over the coming days students from other campuses, including Peking University, joined in.

Peking University had a tradition of being in the vanguard of social movements. It was there in the early decades of the twentieth century that the New Culture movement was launched, seeking to free China from the feudal influence of Confucianism in favour of a new culture based on democracy and science. It was students from Peking University who rallied in 1919 against the Treaty of Versailles, which handed German territorial holdings in China to the Japanese. This was the trigger for the so-called May Fourth Movement, the leaders of which would go on to found the Chinese Communist Party. Less honourably, but more recently, Peking University had been a centre of action during the early days of the Cultural Revolution.

In the days leading up to New Year's Eve, posters went up at Peking University proposing that the students should rally in Tiananmen Square—a dramatic escalation. The posters argued that taking their protest to the heart of the capital would signal their intention to lead the promotion of democracy in China, as the government had failed to do so.

Everyone knew that a successful demonstration at the square would elevate the student movement to a different level. It was at Tiananmen Square in 1919 that the May Fourth Movement was born, it was there that the Red Guards had come to receive the blessing of Mao Zedong in the summer of 1966, and it was there that ordinary

Beijingers had demonstrated in mourning for Zhou Enlai at Qing Ming in 1976.

New Year's Day 1987 was one of the coldest days of a bitterly cold winter. Dozens of police staked out Tiananmen Square, and early that morning a water truck sprayed the flagstones to create a treacherous sheet of ice.

The students arrived in small groups and formed into lines near the square. They waited until they were several-hundred strong then rushed the police lines. But once on the square they couldn't manoeuvre on the ice, and within minutes dozens had been thrown into police vans.

That afternoon it seemed the students had been defeated. It was impossible to discover how many were under arrest and what they might be charged with. There was talk of a few students being taken away for 'education and interrogation'.

Back at Peking University thousands began to gather. Outraged at the arrests, students who had been reluctant to join the earlier demonstration determined that they should march again on the square to demand their classmates' release. At midnight they set out on the long march from the university district in the west to the centre of the city, their numbers swollen to around 5000. On the way, the news came through that their classmates had been released without charge and the students returned triumphantly to their campus.

In the immediate days following, the government no doubt thought they had pulled off a good result. They had given the students in Beijing a win, but not a substantive one. And with end-of-term examinations and Chinese New Year approaching, students across China would have little appetite for more marching. The government hadn't needed to engage directly with any of the issues, and they had bought themselves time to regroup.

But the students had made dissent visible again for the first time since Democracy Wall, and the uncomfortable message for the

leadership was that China's educated youth were significantly out of sympathy with the Communist Party's directions and ideals. In Shanghai they had seen how easily the students could make allies of ordinary citizens and workers, who may have felt less passionate about democracy but were concerned about the downsides of the reforms: inflation, income inequality and corruption.

Writing about the demonstrations in a piece for Australia's *Times on Sunday*, I found myself uneasy. I noted how the students seemed to have fallen in love with their own image in the glare of Western media attention. I could see how readily they picked up on the references and descriptions that the Western press used. The students saw themselves exercising 'people power', and standing for 'civil rights', and they could imagine how their struggle linked them with the Western student movements of 1968. I worried about how this might influence them in the future.

Nevertheless, when I filed the piece I felt relieved that the demonstrations had ended 'well'. But within less than a fortnight it was clear that they had not ended well at all. News filtered through of 'troublemakers' being arrested around the country, among them a young poet I had partied with at the Old Summer Palace just months before. He was no counter-revolutionary, just a romantic spirit with a penchant for Nietzsche who had been caught up in the excitement. Meanwhile high-profile and popular liberals such as the vice-president of Hefei's University of Science and Technology, Fang Lizhi, and crusading journalist Liu Binyan were sacked from their jobs and expelled from the Communist Party. It seemed that the authorities wanted to send a message to the students without risking attacking them directly.

Then on January 16 amid a rising tide of denunciations of the evils of 'bourgeois liberalisation', it was announced that Hu Yaobang had resigned and had been forced to make a humiliating self-criticism.

We did not know it then but Hu Yaobang had been vulnerable for a long time. As general secretary of the Communist Party he was

responsible for upholding the party's principles but, unlike the con-
servatives within the party and indeed Deng Xiaoping himself, Hu
did not consider liberalisation and the influence of Western ideas as a
threat. He repeatedly ran dead when asked to crack down on liberals
within party ranks, and had shown little zeal for the campaign against
spiritual pollution. Now the whole blame for the student demonstra-
tions was laid at his feet.

Scapegoating Hu Yaobang may have been satisfying to his con-
servative rivals, but to blame the demonstrations on ideological laxity
was to fatally miss the point. The government and the party itself were
facing a crisis of legitimacy. Economic reform promised greater pros-
perity and greater autonomy, yet for many students and city dwellers
such promises seemed remote. They were longing for greater control
over their lives, and for avenues to make their needs heard, and instead
were left frustrated and thwarted.

As winter turned to spring we hunkered down to wait out the
campaign against 'bourgeois liberalisation'. We were confident it
wouldn't last long. The reform and opening up of China's economy
required an engagement with the West and a retreat from ideology
and we knew that Zhao Ziyang, now installed as head of the party in
Hu Yaobang's place, was committed to reform.

My Chinese friends felt they'd seen it all before. They had lived
through the crackdown after Democracy Wall, and the anti-spiritual
pollution campaign, too. They would just have to fade back again into
an underground where they could continue to be free.

We Westerners assumed it would be a temporary reversal. We
believed we knew the way history was heading, and that time was on
the reformers' side.

Friends in the diplomatic corps advised me that it would be
a good idea to lie low for a while, and perhaps cut contact with my
friends in the underground. But I knew that without them I would lose
touch with what was really going on in the city. Through them, too,

I knew that I could get closest to the emotional landscape of the time. And anyway, they were my friends.

As a concession I decided to be more discreet. In a city where public transport stopped early and taxis didn't cruise the streets, I'd got into a habit of sleeping over at my friends' places at the end of evenings together, leaving in the morning once the work day had begun. In early 1987 I was no longer staying at the relatively free-wheeling Friendship Hotel but instead in the diplomatic compound at the western end of Chang'an Avenue. I knew that the guards on the gate and the lift operators kept careful note of our comings and goings. If I made a habit of not coming home at night they might start to take more of an interest in where I was spending my time.

Getting home at the end of an evening was easier said than done, with most of my friends living a long hike away from Chang'an Avenue where you could usually find a taxi at one of the hotels.

One night, as I made my way home with a friend through the empty streets, we saw an army truck lumbering towards us down the road. A little tipsy, we decided to wave it down. To our amazement it stopped. 'Where are you going?' the driver yelled down over the sound of the engine. We told him. 'Hop in,' he said cheerfully, 'I'll give you a lift.'

We scrambled up into the cab of the truck and set off. On the way he told us he was from the country and was now based in the west of Beijing out near the Fragrant Hills. Being in the army was OK, he said, though he liked driving best. At the compound he brushed off our thanks. 'Serve the people!' he replied with a smile, quoting the old Maoist slogan, and we all laughed. Later my friends told me that since the Korean War, soldiers were widely referred to as China's *zui ke ai de ren*—'the most beloved people'. Our driver's cheery generosity was a typical example of why.

Later I would wonder what happened to that young soldier, and where he had been in 1989 when the army rolled into Beijing. In the

spring of 1987 getting a ride home in an army truck just seemed like one of those things that could only happen in China, part of the endearing anarchy of the place. Now, like so much about the 1980s, it seems almost unimaginable.

A TERRIBLE BEAUTY

At noon on May 15 1989, the Soviet president, Mikhail Gorbachev, landed at Beijing airport. It was the first visit by a Russian leader to China in 30 years. Gorbachev had come to the Chinese capital for an historic summit, to bury the longstanding rift between the two communist giants.

In the early years of the People's Republic, Soviet money and expertise had poured into the country, transforming China's industry, infrastructure, arts, architecture and education. But within a decade the relationship had soured. China chafed at its role as little brother to the USSR, was disillusioned when Nikita Khrushchev (leader of the Soviet Union from 1955–64) failed to support China in its disputes with Indonesia and India, and rejected the Soviet notion of peaceful co-existence with the West. In 1960 the Soviet Union withdrew all its experts from China, abandoning hundreds of projects and taking with them the nuclear expertise they had promised to share.

Now in the spring of 1989 Gorbachev had arrived to pay court to China and its paramount leader, Deng Xiaoping.

It was a huge story, and media from around the world had flown in to cover it. Both communist leaders fascinated the West. Each with their separate programs to reform and open up their massive countries, Deng and Gorbachev had become poster boys for progress, each separately crowned as *Time* magazine's 'man of the year'. Their summit

was supposed to be a great moment in history; but history was to upstage it.

Reporters flying into Beijing found a city not in the grip of preparations for an historic summit, but in thrall to quite a different drama. As Gorbachev touched down, instead of columns of soldiers and photogenic children arrayed to meet him in the heart of the city, there were some 2000 students on a hunger strike and a half a million Beijingers lending them support.

Gorbachev was welcomed in a hurried ceremony on the tarmac at Beijing airport and forced to enter the Great Hall of the People on Tiananmen Square by a back entrance when he arrived to meet Deng Xiaoping. That week the media feeds from Beijing were full of the students' demonstrations, and the summit was reduced to a footnote. As a visiting CNN reporter put it in his broadcast: 'We came here to report a summit, and we walked into a revolution.'

In the square the students made posters in Russian greeting the Soviet leader, and petitioned the Soviet embassy for a chance to meet with the great man. Guo Jian, who had joined the hunger strike, read with excitement an article on the prophecies of Nostradamus that was circulating among the students. It claimed the Soviet leader's rise had been foretold and that it presaged massive change in both China and the USSR. Guo Jian wasn't superstitious but in those superheated days of May he began to wonder whether maybe it *was* all meant to be. Irrespective of prophecy, he was ready to stand up: 'All my life I had lived in fear and I thought by joining the demonstrations, by joining the hunger strike, that it was my chance to throw off fear. This was what we were fighting for. I just didn't want to live in fear any more.'

Meanwhile, Deng Xiaoping gathered the Chinese leadership at his home on the morning of May 17. The demonstrations had been going for a month and China had now been humiliated in the eyes of the world. The morning after shaking Gorbachev's hand and formally

ending the Sino–Soviet split, Deng Xiaoping made the decision to impose martial law.

The hinge year of Chinese contemporary history is 1989. Looking back you can see how events from the beginning of reform and opening up in 1978 rushed towards the denouement of June 1989, and how everything since can be seen in relation to that moment, either as a reckoning with, a reaction to, or a retreat from the time before.

Today people in China refer to 'before 1989' or 'after 1989' as routinely as an earlier generation in the West might have referred to before and after World War I. There is the same acceptance that June 4 1989 marked an end, after which nothing would ever be the same again.

The events of 1989, like World War I, were long in the making. They were coming from the moment Democracy Wall was closed down and Wei Jingsheng was imprisoned ten years earlier. Those actions had simply deferred the showdown between the government and the governed about what kind of nation China was meant to be. The students and citizens who rallied in Tiananmen Square in 1989 may have had only a hazy idea of what democracy might mean, but they knew what they wanted: greater respect from their government and a greater say in the running of their country. They wanted a dialogue, to no longer be treated as supplicants but as equals.

The demonstrations were sparked by the death of Hu Yaobang in April that year. As with the death of Zhou Enlai in 1976, Hu's passing would serve as both a catalyst and a cover. Tension had been winding tighter for more than a year. When Hu Yaobang died it was like the crack from a starter's gun, signalling that an event long anticipated could at last begin.

In the summer of 1988 the national network, China Central Television (CCTV), broadcast a series called *River Elegy*. Originally conceived as a conventional celebration of the Yellow River as the 'cradle of Chinese civilisation', the project was entrusted to an iconoclastic young director who transformed it into a blistering critique of the backwardness of Chinese culture, and a call to arms.

In *River Elegy* the Yellow River was presented not as a symbol of China's ancient civilisation but instead as a metaphor for its decline. The river was silted up and sluggish, the culture it represented sclerotic, moribund, insular and feudal, doomed unless it embraced modernity and openness, as represented by the West. China could not produce another great civilisation, the series argued, if it relied on its old ways. It needed to pursue industrialisation, free trade, greater economic reform and—it hinted—political reform, if it was to be reborn.

The iconoclasm did not stop with the Yellow River. The Great Wall, according to *River Elegy*, did not embody strength, but insularity and fear. The dragon—that greatest of Chinese symbols—was not noble and powerful, but tyrannical and cruel.

River Elegy was like a hand grenade thrown into the debate about China's identity. Two hundred million people watched it across the country and the Communist Party's official paper, the *People's Daily*, published the scripts in full. Scores of literary salons had been popping up in universities across the country to foster discussion about the future direction of China, and now *River Elegy* became a key text in stimulating debate and in engendering a sense of urgency and crisis. The series argued that in the absence of a middle class it was from China's intellectuals that the momentum for change should come. Students throughout the country believed that it was up to them to respond.

Conservatives in the leadership were appalled. It was clear that the series supported the reformers in the government: footage of Zhao Ziyang appeared when the series struck a positive or dynamic

note, while Mao Zedong was seen when the mood was dark. When CCTV wanted to re-broadcast the series later that year, major cuts were made but it was too late. The genie was out of the bottle.

1988 was a fevered year of surging inflation and increasingly visible corruption. Price reform had been botched, setting off panic buying and hoarding. People well placed in the system exploited the difference between state and market prices, making fortunes in the process, while workers' wages were being eaten by inflation. Across the country there were scattered strikes. Meanwhile, students discovered that a place at university no longer guaranteed you a job. The old system of job assignments on graduation may have been stultifying, but at least it had provided some sense of security. While people with connections scored lucrative jobs in the special economic zones, those without struggled to find decent jobs at all. A popular saying captured their predicament: 'As poor as a professor, as dumb as a PhD.' Everywhere there was a sense of agitation and stress. A frustrated population of Chinese youths looking for a place in the world were more than ready to answer a call to arms.

That 1989 should be a landmark year in China was almost over-determined. It marked 200 years since the French Revolution, 70 years since the launch of the May Fourth Movement, 40 years since the founding of the People's Republic, and ten years since Deng Xiaoping's triumphant trip to the United States, which had heralded China's opening to the West. It would prove to be China's 'year of living danger-ously' as the party and the people competed to seize the symbolism of the times.

In January, Fang Lizhi, the liberal scientist who had been sacked from his job and expelled from the party for his role in the 1986 student demonstrations, wrote an open letter to Deng Xiaoping. He proposed

that in honour of the anniversaries of the May Fourth Movement and the founding of the People's Republic, and in the spirit of the ideals of the French Revolution, an amnesty should be declared for political prisoners in China, and, in particular, that Wei Jingsheng should finally be released.

Wei had been in prison for ten years but he had not been forgotten. During the student demonstrations in 1986, posters had appeared, declaring rhetorically: 'If you want to know what freedom is, just go ask Wei Jingsheng.' He was no longer just a man but a symbol. A few weeks after Fang Lizhi published his open letter, Bei Dao rallied 32 writers, academics and artists to sign a petition in support. Addressed to the leadership of the National People's Congress and the Communist Party, it called for a general pardon of political prisoners and specifically the release of Wei Jingsheng.

The response from China's leaders was silence, while spokespeople down the food chain batted the issue aside. As China had no political prisoners, they said, there could be no question of amnesty.

Meanwhile passionate discussion about China's future bubbled up in the university salons. There were debates about deeper economic reform and democratic participation, about freedom of speech, and about corruption and nepotism. There were debates about the very nature of Chinese culture. At Peking University, the salons were often attended by Fang Lizhi, who expounded his idea that democracy was not something that could be handed down from above, but instead must be fought for from below. Among those who listened were students who went on to be leaders of the movement at Tiananmen Square.

Around the country scores of unofficial art groups had sprung up, too, from the tough Manchurian city of Harbin in the north to the sub-tropical special economic zone of Xiamen in the south. The young artists ganged together, encouraging each other to push the limits of their art. Much of the work was surreal or unnerving, or sometimes simply absurd.

The year 1989 was an anniversary for them, too. It was ten years since the Stars had hung their work outside the National Art Museum in Beijing. Now artists from around the country had been invited to exhibit inside the museum in a major show, boldly called 'China/ Avant-Garde'. The young curators had chosen more than a hundred artists and 250 works to introduce Chinese contemporary art to the nation and the world. The logo for the exhibition was a sign indicating 'no U-turn', signalling boldly in red, white and black that there would be no turning back now for China's avant-garde.

On the morning of the opening on February 5, giant exhibition banners were laid out on the steps of the museum, the 'no U-turn' logo standing out starkly on a dead black background. February is Beijing's cruellest month. In the dry cold, the skin splits on your fingers and static electricity crackles in the air. And yet despite the grim weather a large, excited crowd arrived in time for the opening at 9 a.m.

The main exhibition hall was dominated by a massive triple portrait of Mao, the standard image rendered in the tones of newsprint and overlaid with a grid, as if someone had produced an image of the chairman from an instruction sheet. It reduced the great leader from an icon to something that could be painted by numbers, a commodity.

Around the portrait there was a sense of chaos, as many of the works seemed to mock the very idea of an exhibition and the whole project of reform and opening up. In one corner an artist sat on a bed of straw surrounded by eggs and a banner with the word 'Waiting'. Around his neck he wore a sign that read 'To avoid disturbing future generations, no debates during the hatching'. Another artist set up a stall to sell shrimp and called the work *Big Business*. Soon hustled away by police for illegal trading, he returned later to put up a sign that read 'Closed for stocktaking'. Yet another threw condoms and coins into the air, which fell like confetti on some of the art works on display. The owner of one of them complained that the condoms were rendering his piece unrecognisable, a little ironic given his work was a pile of paper

pulp, claimed to be the result of putting *The History of Chinese Painting* and *The History of Modern Western Art* through a washing machine.

The list of artists involved reads like a who's who of today's upper echelons of Chinese contemporary art, their works in 1989 just hinting at the qualities that would one day make them famous. Among them was Zhang Xiaogang, who would become China's most famous artist, and who we will meet later in this story. All of these artists, however, even Wang Guangyi, whose portrait of Mao initially dominated the exhibition, were destined to be upstaged by a young artist called Xiao Lu.

Her work was titled *Dialogue*. Installed in a prime position on the ground floor of the museum, it comprised two phone booths, each with a mannequin inside. One was a man, the other a woman, both with their backs turned, both on the phone. Between the two was a table backed by a mirror, with a red rotary dial phone, the receiver off the hook. Two hours into the show Xiao Lu approached the installation, produced a pistol and fired two shots at it, cracking the mirror and plunging the hall into panic.

She later claimed that her act was not meant to be political, that she was simply expressing the impossibility of dialogue between men and women. But in China in 1989, 'dialogue' was a loaded word. A call for dialogue between the government and the people had been a key theme of *River Elegy*, and it was an idea that was also being promoted by Zhao Ziyang.

That Xiao Lu's portrayal of failed dialogue ended in gunfire gave her performance that day the status of a play within a play, the story of the Tiananmen movement acted out in a gallery before it had even occurred.

Marx wrote that history repeats itself 'first as tragedy, then as farce'. Here his maxim was reversed. In that year of 1989 the story of dialogue was repeated, first as farce, then as tragedy.

As for the exhibition itself, after Xiao Lu's intervention it was closed down. The curators gained permission to reopen a few days later, only

to be closed again for good after bomb threats. It hardly mattered: the exhibition already had its place in history, another way station along the road to the events of June.

On April 15 1989, Hu Yaobang died and the curtain rose. The students knew their history. They knew that mourning for Zhou Enlai had triggered the 1976 Qing Ming demonstrations, which were harbingers of the fall of the Gang of Four and the rise of Deng Xiaoping and the reform era. In their mourning for Hu Yaobang they saw their opportunity to make history.

Within hours of the news of Hu's death, posters were going up at Beijing's universities, mourning his passing but also demanding a reversal of the criticism that had accompanied his fall from power. By the morning of April 17 students across 26 of the capital's universities had held spontaneous memorials and the mourning posters had been joined by others launching scathing attacks on the current state of Chinese society. Wreaths and elegiac poems had already appeared around the Monument to the People's Heroes on Tiananmen Square.

After midnight on the night of April 17 a column of around 1000 students set out to march the 18 kilometres from Peking University to Tiananmen Square. Passing through the university district, they gathered another 2000 students, marching behind a banner proclaiming 'Hu Yaobang—the Soul of China'.

Arriving at Tiananmen Square before dawn, they hung their banner from the Monument to the People's Heroes and together sang 'The Internationale':

Arise ye prisoners of starvation,
Arise ye wretched of the earth!

If 'Nothing to My Name' would be the anthem to the student movement, 'The Internationale' would be its hymn. It was a song everyone knew—students, workers, ordinary Beijingers. By singing it they linked themselves to revolutionary movements around the world and to the noble history of struggle that had given birth to modern China. They would sing it often over the next fevered weeks, even as they were surrounded by soldiers and tanks on their last night in Tiananmen Square.

From this distance you can see how the whole tragedy played out from the moment of elation before dawn on April 18 to the desperate denouement in the dark hours before dawn on June 4. You can see the bad decisions, the bad luck, the forks in the road where a different choice would have changed the outcome. By the end, less than two months later, some students were speaking openly of dying for their cause, but on that spring morning in April they felt only excitement and self-confidence.

The students announced their demands, which they drew up into a formal petition. They asked for the affirmation of Hu Yaobang's views on democracy and freedom, for the repudiation of the campaigns against spiritual pollution and 'bourgeois liberalisation' and the rehabilitation of those who had suffered under them, for the public declaration of the assets of government leaders and their families, for freedom of speech and the press, and increased funding for education. The students then began a sit-in in front of the Great Hall of the People, the seat of China's 'parliament', the National People's Congress, to wait for a response.

Tension grew as the students waited. Some junior officials were sent to receive the petition but the students wanted to hand it to someone in authority. That night they dramatically upped the ante by moving their demonstration to the real seat of power, the leadership compound of Zhongnanhai just west of the Forbidden City. On the night of April 18 and then again on the night of April 19 some 2000 students stood at the gates of Zhongnanhai and, surrounded by spectators, called for

Premier Li Peng to come out and meet them. There were chaotic scenes as some surged towards the gates and were only held back with difficulty by lines of police.

Inside Zhongnanhai a split was already opening up in the leadership. In the face of concerns from the Old Guard, Zhao Ziyang argued that the students' stance should be considered patriotic, despite the actions of a rowdy minority, and that their right to memorialise Hu Yaobang should be respected. His premier, Li Peng, urged a hard line.

At base the split reflected a dramatic difference of outlook between the two men. Zhao Ziyang was interested in the potential for dialogue between the regime and the people as a way of advancing reform and the rule of law. Li Peng was aligned with the Old Guard, who were keen to put a brake on reform, re-establish old-style central planning and put an end to bourgeois liberalism. Li's approach was traditional and autocratic: the Communist Party equalled the people. What need was there to negotiate with themselves?

Back at the universities the situation was evolving fast. The students were already setting up independent organisations to lead their movement, turning their back on the official student bodies sanctioned by the party. The leaders of these new unions would become the face of the student movement in the following weeks—earnest, intelligent, passionate advocates whose prominence would earn them a place on the 'most wanted' list after June 4.

The official memorial service for Hu Yaobang was set for April 22 at the Great Hall of the People. The students began gathering on Tiananmen Square before dawn, their numbers swelling to tens of thousands as the service began. Inside the hall 4000 official mourners including Deng Xiaoping listened as Zhao Ziyang delivered the eulogy, which was broadcast to the silent crowd outside. At the end of the ceremony three students climbed the stairs to the entrance of the hall and knelt, the central figure holding aloft their petition, entreating Premier Li Peng to come out to meet them. It was a shocking

gesture. Petitioning on bended knee was an echo of China's imperial past and a dramatisation of the true balance of power in this nominal People's Republic.

The students knelt on the steps for half an hour but no one came. It would prove to be the first in a string of mistakes, when chances for dialogue and reconciliation were squandered. Many watching on were enraged that Li Peng would let the students humiliate themselves in this way and not respond. Many in the square wept. The students' kneeling figures, seeming so tiny on the grand steps, became a symbol of the indifference of the government and swelled the ranks of popular support for the students' cause.

The very next day, an even graver mistake was made. Zhao Ziyang left the country for a week-long state visit to North Korea, leaving Li Peng in charge. Allies in the leadership urged him to cancel the trip but he was concerned at the message of crisis that would send. Before leaving he believed he had won support from the leadership for his plan to address the student movement through serious dialogue between the government and the student leadership. But in the week he was gone the balance of power would move decisively to the hardliners and on his return he would never regain the upper hand.

Guo Jian did not see the students kneeling that day. Instead he was herded with his campus classmates to watch the official broadcast on television. The university administration was determined to stop their students from joining the demonstrations and had even locked the gates to the grounds, but when Guo Jian heard the students from Peking and Tsinghua universities marching past three days later, he just scaled the wall and jumped.

At first he walked along beside the marchers, not yet ready to join their ranks. The students had announced a mass boycott of university

classes, a strike that would last until their petition was answered. There were lots of police on the streets but he noticed that even they seemed to be supporting the students.

Once at Tiananmen Square he roamed around observing, yet still hanging back. But when he returned to campus he saw a notice calling for Minzu University students to march to the square and he immediately went to his class studio to paint a poster. After a bit of thought he decided on the simple slogan 'Long live teachers!' Surely, he thought, that wouldn't get him into much trouble. Although he tried to convince his classmates to prepare their own posters, as they set off he found a group of them trailing empty-handed in his wake, placing him in the unwanted role of leader.

They marched through streets lined by ordinary Beijingers, who urged them on, gave them the thumbs up, even handed them drinks. Arriving at the square Guo Jian tried to convince his classmates to return to campus instead of joining the sit-in on the square. He had a feeling that the police would be sent in to clear them that night. Despite his fear he decided to stay out himself, and he watched the dawn come up over the square without violence.

But in the morning came grim news. It had been broadcast overnight and now it was emblazoned across the front page of *People's Daily*. The mouthpiece of the Communist Party had delivered its official damning verdict: the student movement, the paper's editorial declared, was aimed at creating 'turmoil' in the country and must be resolutely opposed.

The use of the word 'turmoil'—*dongluan*—was chilling. The period of the Cultural Revolution was routinely referred to as the 'Ten Years of Turmoil', and the editorial had deliberately drawn a line between the students' actions and the worst events in Chinese modern history. To see the *People's Daily* headline shriek 'We Must Resolutely Oppose Turmoil!' was profoundly shocking, and frightening.

But if linking their idealistic movement to the horrors of the Cultural Revolution was bad, the rest of the editorial was worse.

The paper denounced the student movement as a 'planned conspiracy' by a small group of people to 'negate the leadership of the party and the socialist system itself' and to put at risk the whole project of reform and opening up. The students' demonstrations, independent unions and boycotts were all specifically condemned. The message had to have come from the top of the party, direct from the mouth of Deng Xiaoping. At the stroke of a pen, the students found themselves labelled as counter-revolutionaries.

'We were very scared when we saw the editorial,' Guo Jian told me, 'and we felt cornered. It made people want to stay in Tiananmen Square.' Everyone was talking about an expression in Chinese—'*qiu hou suan zhang*'—which literally means 'we'll settle up after the autumn harvest' but carries a menacing subtext of squaring accounts when the time is ripe. 'We believed if we left the square and went back to our campuses,' Guo Jian said, 'they might not come for us straight away, but in the end they *would* come.'

From April 26 on, the editorial became the primary consideration in the students' strategy. While it stood they could not simply return to campus, they had to press forward.

In China, Guo Jian told me, people know the best way to stay safe is to 'make something bigger, to be safe in a crowd, to find protection by being surrounded by other people'. The students decided to ramp up the pressure.

The next day students streamed out from colleges and universities all over Beijing, heading for Tiananmen Square. But this time they weren't alone. They were joined by their teachers, by journalists, and by the ordinary workers and citizens of Beijing, all angered by the editorial and chanting, 'Patriotism is not a crime!' By the time they reached the city centre their numbers had swelled to 100,000.

They marched under the hot sun, alternately singing and chanting, while people on the pavements applauded or pressed cold drinks and popsicles into their hands. The students carried collection boxes and found them stuffed with cash. When they reached the police blockade they simply pushed through it to the square and the police, though standing four deep, let them go.

As they flowed into the square they felt that April 27 marked a great victory. Their teachers were with them, and it seemed the people of Beijing were, too.

But now what?

Zhao Ziyang arrived back in Beijing on April 30. By this time around 90,000 students were boycotting their classes, no meaningful dialogue had been held, and the anniversary of the May Fourth Movement was looming.

The deep divisions in the leadership were now clear for all to see. Li Peng and his fellow hardliners had taken advantage of Zhao Ziyang's absence to convince Deng Xiaoping that the student movement was dangerous. At a special briefing at Deng's home, they played up the most inflammatory words and actions of the students, and convinced him that the movement concealed plotters seeking to stir up 'turmoil' to bring down the party and the whole socialist system. Having urged him to such a conclusion they then rushed to get it into print.

From the moment he arrived back in Beijing, Zhao Ziyang looked for a way to overturn the editorial. He knew that the only person who could sanction this was Deng Xiaoping. But Deng, he was told, was too ill to receive him.

At the time, Zhao Ziyang commanded a bare majority in the top leadership group of the party. On the five-man Politburo Standing

Committee he commanded three votes, and his rival, Premier Li Peng, had two. But Li Peng had powerful support among the Old Guard in the party, those 'elders' who had officially retired from public life but still exercised influence. Most crucially he now seemed to have won the support of Deng Xiaoping, on whom Zhao had previously been able to rely.

At a meeting of the Politburo Standing Committee on May 1 Zhao argued for more transparency and consultation in political life, for a guarantee of freedom of speech, and for a country that was 'truly governed by law'. Li Peng countered that stability must be assured before there could be any talk about reforming the political system.

Privately Zhao Ziyang tried to persuade Li Peng that the *People's Daily* editorial must be revised but he refused to budge. In the face of this, Zhao decided that he would play down the editorial by setting a new tone himself. On May 3 he gave a speech commemorating the anniversary of the May Fourth Movement. In it he specifically endorsed the patriotism of the students, the validity of their calls for greater political participation and their opposition to corruption. He doubled down the next day with a nationally televised speech along the same lines at a meeting of the Asian Development Bank, in which he specifically supported dialogue with the students.

On May 4 the students held another rally in Tiananmen Square. Again they marched there in their tens of thousands, flowing through the police lines like water. Again the people of Beijing turned out to support them with food and drink. The charismatic 21-year-old student leader Wu'er Kaixi was carried towards the square on the shoulders of his classmates waving a red flag, his flamboyance and exuberance capturing the triumphant mood of the day.

The students declared themselves the heirs of the 'great patriotic' May Fourth Movement, reiterated their key demands, and then announced their intention to return to classes and await the promised dialogue.

But even as Zhao Ziyang worked to calm the situation he was being undermined. Since before his North Korea trip he had been directing that there be dialogue with the students, but those tasked with the job by Li Peng were doing everything they could to block and ultimately destroy the process.

The students waited for more than a week for the dialogue to begin. Finally, out of frustration and fear, with no sign of dialogue in sight, they decided on a dramatic new course. On May 13 they announced a hunger strike. The students now listed only two demands: that the *People's Daily* editorial be repealed, and that the government hold televised talks with the students. They knew Mikhail Gorbachev was due to arrive in Beijing in just two days' time. Surely under this pressure the government would act?

The hunger strike was a fateful decision. When the students commandeered Tiananmen Square for this protest and refused to move aside even for the arrival of Gorbachev they doomed both their movement and the reformists led by Zhao Ziyang. Within days martial law would be declared, Zhao Ziyang toppled, and the clock would begin its countdown to the bloody climax of June 4.

And yet, the hunger strike would inspire the most extraordinary and beautiful days in the history of Beijing, as the city rose in solidarity. Teachers, parents, shop and factory workers, farmers, government officials, journalists, taxi drivers, even police marched in support of the students under banners which proudly proclaimed their occupations and workplaces. Even journalists from *People's Daily* marched under a banner that read: 'We did not write the editorial!' On May 17 and May 18, days five and six of the hunger strike, more than a million people marched in the capital. Tens of thousands of supporters from around the country flocked into Beijing and, for a few short days, censorship was lifted and the Chinese media reported freely on events.

These were the largest spontaneous demonstrations in Chinese history. They were not the organised massed rallies of the Cultural

Revolution, which had filled Tiananmen Square with ranks of hyster-
ical teenagers. These were hundreds upon hundreds of thousands of
individuals choosing to stand up in support of a movement that they
had taken to their hearts. For a brief moment it seemed that China was
on the verge of an extraordinary change.

Tiananmen Square turned into a mass encampment. Up to 3000
hunger strikers lay in makeshift tents or in the public buses that the
students had commandeered, while tens of thousands of supporters
thronged around them in the heat, breaking occasionally into song,
or dancing to music that blared out from portable tape recorders.

The music was punctuated by the wailing of sirens as ambulances
ferried collapsed hunger-strikers to hospital. The sight of medical
workers in crisp white uniforms, red crosses pinned to their sleeves,
carrying pale and painfully young students on stretchers to ambu-
lances was heartbreaking—and inspiring.

The strikers wore white headbands on which they had written
slogans in stark black ink. Guo Jian, who had joined the hunger strike,
chose an inspiring phrase he had read somewhere. He gathered, he told
me years later, it was a quote from some foreign writer: "'If I don't have
freedom, I'd rather die," I think that's what it said,' he told me. 'Give
me liberty or give me death?' I suggested. 'Yes, that was it!' he said.
As he lay in one of the buses, friends came by to sign his sweat-stained
headband.

My oldest Chinese friends—the young artist and his feisty girl-
friend who had entertained me in their tiny *hutong* home just over three
years before—were now living apart. He had chosen exile in Australia
at the beginning of the year hoping to make his way as an artist there.
She had remained in Beijing, holding true to her dream of a bohemian
life in the capital. The student movement took her by storm. 'It was so
exciting to feel really part of something for the first time,' she told me
later, 'to believe you could make a difference, that you could change
things, that you were making something happen, something for the

country.' Every day she met her friends in the square to discuss ideas. It was like an open-air university crossed with Woodstock. She sent a letter to her boyfriend in Australia predicting that the students would prevail. 'We will celebrate a great victory!' she wrote.

She was shocked to find Guo Jian among the hunger-strikers. He had seemed like such a quiet boy when she had first met him. It was amazing to see him transformed into an activist. But then that's what it was like in those days. People kept transcending themselves, like the ordinary Beijingers who came by every day to check on the students and to lend support. A rumour went around in those weeks that even the pickpockets were on strike in solidarity.

Sheng Qi also came to the square day after day. When Hu Yaobang died he and some friends were just about to open an exhibition, but on hearing the news they abandoned it immediately to go to Tiananmen. All through April and into the hot days of May he wandered there, excited, shocked, trying to make sense of it all. 'The students from Peking University and the others, their thinking was so advanced, so deep. I thought of what we art students had been concerned with, fighting propaganda art and so on. Such small things! I was so impressed by them.'

But as the weeks passed he also felt the pressure mounting as the city ground to a standstill. 'The buses had stopped running, and cars could no longer drive on the streets, and you could sense the danger building.' His parents kept writing, calling, beseeching him to come home. From far-off Anhui, maybe it was easier to see the danger.

In the square the students didn't yet feel afraid. They felt like heroes. They believed the country was on their side. Having the world's media focusing on them, too, was seductive.

Yet the ground had already shifted under their feet. Up until Gorbachev's visit they had the protection of the reformers in the government, in particular Zhao Ziyang. But in holding the square they had humiliated Deng Xiaoping and fatally undermined the moderate

position being urged by Zhao Ziyang. Gorbachev's visit was to have been Deng's crowning achievement in foreign affairs, with China's one-time Big Brother coming to Beijing to pay court. The students had robbed Deng of the official ceremonies that would have been so gratifying—Gorbachev inspecting a military honour guard in Tiananmen Square, Gorbachev with bare head bowed placing a wreath at the Monument to the People's Heroes. Instead the square belonged to the students and all the world's cameras were trained on them.

The day after he met with Gorbachev, Deng gathered the Politburo Standing Committee at his home. Zhao Ziyang again urged him to revise the *People's Daily* editorial to calm the situation, but instead Deng announced his decision to impose martial law. Zhao refused his support, sealing his downfall. His rival, Premier Li Peng, was put in charge of implementing the decision.

Martial law was not declared until two days later, and in those two days there occurred two extraordinary contrasting spectacles.

The first took place on May 18 when Li Peng finally met with student representatives at the Great Hall of the People in a nationally televised encounter. It was four weeks since the student petitioners had knelt on the steps of the building begging him to receive them, four weeks in which the student movement had engulfed the city and brought it to a standstill. But when he finally met them, Li Peng still showed no sign of actually listening. Instead he talked down to the students as if they were children, telling them that they must bring the hunger strike to an end immediately, and leave the square. He made no attempt to disguise his irritation when the students pressed their conditions, expressing impatience with such 'quibbling'.

The student leader Wu'er Kaixi, who had collapsed at the hunger strike earlier that day, came to the meeting in his hospital-issue striped pyjamas and carrying an oxygen canister. But he showed no sign of being cowed by the occasion. He spoke directly and vehemently to Li Peng: the students on the square would make their own decision

based on the government's response and their conditions were clear—the *People's Daily* editorial must be repealed and genuine dialogue established.

The sight of this young man in pyjamas going head to head with the dour, Mao-suited premier of China was electrifying. The confrontation between the government and the students had been playing out for weeks on the streets but now we saw it vividly made flesh. The students were rejecting the paternalism on which Chinese Communist Party rule was based, and demanding their right to be heard.

But much as I wanted to maintain my optimism, watching the broadcast I found it hard to fight a sense of foreboding. We had been mesmerised by what we had seen on the street, the swelling popular support, the passion of youth, the joy on the faces of the Chinese journalists finally getting a chance to do their jobs, and in doing so we had lost sight of the power imbalance between the students and the government. The power was not on the street with the students, but with this middle-aged man in a Mao suit shifting irritably in his antimacassar-draped armchair as the students pressed their case. And we didn't even know then that he held two trump cards: martial law was looming and his rival Zhao Ziyang was finished.

The second spectacle could not have been more different. In the early hours of May 19, the day after the student leaders met with Li Peng, a clearly emotional Zhao Ziyang came to the square to talk directly to the students himself. Speaking into a megaphone that a student passed up to him he implored them to end their hunger strike, which was now entering its seventh day. He told them he understood them, that in his youth his generation had also taken great risks for the revolution and in so saying made it clear that he respected their patriotism. He told them if they stopped, dialogue would definitely not be closed and many things could be resolved. They were young with their lives ahead of them, he said, and he asked them to think of

what the consequences would be if they continued. It was the nearest to a warning he could give.

When he finished, the students mobbed him for his autograph, passing up scraps of paper to sign, even pushing forward their pyjama sleeves for him to write on. But they did not heed his warning. It was the last time that Zhao would be seen in public. After June 4 he would be formally removed from all his posts and would spend the rest of his life under house arrest.

In those last days before martial law was declared, a very different kind of celebrity also came to Tiananmen Square—Cui Jian. 'Nothing to My Name' was the students' unofficial anthem, but on that day he chose to perform another song, which would in the years that followed become just as deeply associated with Tiananmen Square. It was called 'A Piece of Red Cloth'.

In this song Cui Jian tells of how someone blindfolded him with a piece of red cloth and then asked him what he could see. 'Happiness,' he replied.

They asked him how it made him feel. 'Comfortable.' It made him forget that he had no place to call home.

They asked him where he wanted to go, and he told them he wanted to follow them.

They asked him what he was thinking. He said: 'I want to let you be my master.'

Before he sang the song he called out to the students: 'Listen up! The person asking the questions in this song is not a girl, it's the government!'

It was the government that had blindfolded them, he was telling them, it was the government that wanted them to find happiness in seeing the world their way.

In those spring days the students had thrown off the blindfold; they could applaud Cui Jian's words and sing along. But before long most would be wearing the blindfold again.

On the morning of May 20 martial law was declared.

Army units had begun to advance on Beijing from all directions the previous night, but ordinary Beijingers once more rallied to protect the students. Makeshift roadblocks were thrown up at key intersections leading into the centre of the city, and tens of thousands of people surrounded the convoys, stalling the troops in the suburbs. A group of independent traders set up a motorcycle squad they called the Flying Tigers, which zipped around the city bringing news of troop movements back to the students in the square.

The student leaders called off the hunger strike but clashed over what to do next. Wu'er Kaixi, for all of his fieriness, pushed a moderate line, urging the students to withdraw—for their own safety, but also to undermine the rationale for martial law and give the reformers a chance to regroup.

But the more radical voices in the movement argued that to give up the square was to give up their power. One passionate student leader, Chai Ling, who had risen to prominence during the hunger strike, argued that the square was the students' only stronghold and to give it up meant certain defeat. It was her argument that prevailed. In the days leading up to the final crackdown, Chai Ling would become one of the most recognisable voices in the movement, rallying the students to defend the square, resisting arguments to withdraw.

In the days after martial law was declared many Beijing university students did return to their campuses, but this left the square dominated by students from outside the capital. More than 50,000 of them

had arrived in Beijing in the days before martial law. Those recently arrived craved their time in the sun.

Just as martial law was declared, a new element had been introduced to the protests, one that was particularly threatening to the government. A group of workers had announced the establishment of an independent workers' union at Tiananmen Square. This raised the spectre of the Solidarity trade union in Poland, which had fought a gruelling ten-year battle with the Polish communist regime, and had just wrung an agreement from the government for parliamentary elections (scheduled, ironically enough, for June 4). The balance in China slid even further away from moderation.

As army units remained stalled in the suburbs of the capital, some soldiers actually partied and sang revolutionary songs with the local residents. Around the city Beijingers extended small acts of kindness to the soldiers, bringing them food and drink, and they showed little urgency to move on to take control of the centre of the city.

On May 23, in an extraordinary act of defiance of the martial law order that banned all demonstrations, once again one million people rallied in Beijing, waving placards that read 'Long live democracy' and 'Freedom for the press'. In the square, vendors sold Beijing street snacks and soft drinks and a party atmosphere descended across the city, seemingly making a mockery of martial law.

But the square was becoming more squalid in the heat and the sense of stalemate sapped the students' resolve. Moderates among the student leadership again urged a move back to their campuses to regroup. On May 27 this moderate position was carried by a vote of the key student leaders, but almost immediately afterward the more radical among them changed their mind and declared they would stay after all. The students on the square, the majority of whom were new to the protest, supported the radicals enthusiastically. It was one more missed chance.

'There were people who were really trying to achieve something,' Guo Jian told me later, 'and others who were just trying to make things

worse. I was trying to make people believe we had already achieved things and we didn't need to sacrifice ourselves there. But, if you said that, people thought you were scared, or you were a traitor.'

Meanwhile, Deng Xiaoping had rallied the support of army commanders around the country, directing each to send seasoned troops to Beijing to augment the greener ones that were in a holding pattern in the suburbs. Soon there would be some 200,000 troops surrounding the capital, rivalling the number that had been mobilised during the war against Vietnam ten years before.

As May drew to a close, despite the resolve of the radicals among the students, it seemed that their occupation of Tiananmen Square was petering out of its own accord. Many Beijing-based students had returned to campus, while some of the outsiders were beginning to leave too. But in these last days before the crackdown, two further events would again bring Tiananmen Square to life.

My friend sat in a corner of the studio watching intently. The student leaders on the square had asked the Central Academy of Fine Arts to create something special to inspire their fading movement. Now after three days' work by dozens of students the project was taking shape.

She had watched as the young artists formed the giant pieces of the sculpture out of wood and polystyrene and then swathed them in white plaster. The sculpture's face was visible now, along with its flowing hair, upstretched hands and the torch they held. She was a goddess, a goddess of democracy. Her features seemed vast; she had been designed to stand more than 10 metres tall. Tall enough to stand eye to eye with Mao Zedong's portrait above Tiananmen Gate.

They brought her to Tiananmen on the back of three pedal carts late on the evening of May 29, to whoops of excitement from the square. Overnight they built a scaffold and then raised each piece into place.

Before noon the next day the young artists made their last touches, smoothing the goddess's hair and her flowing robes with fresh plaster. Meanwhile, news had spread throughout the city of this strange apparition at Tiananmen and by noon the square once again hummed with people. The art students had delivered on their promise, and had fanned the movement into flame again.

They had also delivered an extraordinary provocation. There was no mistaking that their goddess was the sister of the Statue of Liberty. The students had brought a symbol of a foreign power into the very heart of China's capital and set her face and her flaming torch towards Mao. This theatrical, reckless act was yet another gift to the hardliners. In the previous few days, Li Peng had commissioned reports from the Beijing government and the security services on the 'true nature of the turmoil' and Western 'infiltration', aimed at demonstrating that the student movement was a front for a foreign plot to overthrow the party. Now the students had provided the perfect cover image for those reports.

Huang Rui had been watching the demonstrations unfold for weeks on his television in Japan. He understood only too well why the students would want to occupy Tiananmen Square. He knew the excitement of rallying at the heart of Beijing, but he also knew how badly it could end. As June approached he could see the students were in trouble. Finally, he couldn't just watch any more. He gathered together as much money as he could in donations and flew to Beijing.

On June 2, Li Peng met with Deng Xiaoping to brief him, the other party elders and the Politburo Standing Committee. Based on the reports he

had commissioned, Li Peng painted a frightening picture of a student movement infiltrated by CIA agents and intelligence operatives from Taiwan, of turmoil whipped up by an alliance of Western and domestic 'reactionary forces' bent on the destruction of the party and socialism. Foreign students, journalists and diplomats were all part of the plot, as was the United States broadcaster the Voice of America. Even the Fulbright Program was implicated, accused of using academic exchange as a means of 'spiritual infiltration', aimed at drawing the country into the United States' bourgeois web. These foreign forces were in league with 'black hands' within China who hid behind university posts, think tanks and private companies to promote their reactionary ideas and manipulate the students.

In Li Peng's briefing the new independent student and worker associations were all 'engaged in underground activities to overthrow the government'. He spoke of their secret oaths and attempts to instigate mutiny among the martial law troops. Tiananmen Square had been occupied to provide 'a frontline command centre for the turmoil', a base for counter-revolutionary propaganda and for assaults on the party and the government, a place from which they would direct their final showdown. To achieve their purpose, the student occupiers had gathered around them 'terrorist' groups like the Flying Tiger motorcycle brigade and trampled on the sacred and solemn space of Tiananmen.

There was no mention of the students' longstanding calls for dialogue and the reversal of the editorial. Their real aim, Li said, was the overthrow of the government. In fact, he said, the students had even drawn up a list of officials marked for execution. His briefing did not explain how a small group of students had managed to manipulate millions of their fellow Chinese to support them. It did not acknowledge that the students who remained on the square might simply have painted themselves into a corner, that under the threat of the *People's Daily* editorial they were too frightened to abandon Tiananmen.

Deng Xiaoping's mind was made up. 'Stability must take precedence over everything,' he said, so Tiananmen Square must be cleared. There were no dissenting voices. The moderates on the Politburo Standing Committee who had earlier argued against martial law—Zhao Ziyang and Hu Qili—had already been removed from power. Qiao Shi, who had abstained during the martial law debate, now fell into line. Later that day the order was given for troops to begin their advance on the city centre.

Overnight on June 2 an attempt was made to infiltrate large numbers of troops into the city wearing plain clothes, while their arms were brought into the city in unmarked vehicles. Although a number of soldiers and arms reached their rallying points around Tiananmen Square in this way, a traffic accident late that night in the west of the city exposed this manoeuvre and by the early hours of June 3 students and ordinary Beijingers had converged again on the main intersections leading into the city to set up roadblocks. Army vehicles were overturned, tyres were punctured, soldiers scattered. Buses carrying groups of soldiers and weapons were surrounded and stopped. A group of demonstrators discovered a bus filled with armaments just near Zhongnanhai and police and soldiers teargassed the crowd to regain control of the vehicle. All through the day on June 3 tension mounted as large crowds gathered in the streets near the square, bringing traffic to a standstill.

In the square itself a last, somewhat theatrical attempt to engage the government was playing out. On June 2 a group calling them-selves the Four Gentlemen announced a new hunger strike on the square. The 'gentlemen' included Taiwanese-born pop star Hou Dejian and an iconoclastic critic called Liu Xiaobo. These two men were both stars in different ways. Hou Dejian was handsome, famous and

fresh from Hong Kong where he had played a benefit concert for the student movement alongside the beloved diva, Deng Lijun. Liu Xiaobo was popular in student circles for his passionate critiques of Chinese culture and for his vehement belief in the need for intellectuals to get involved rather than commentate from the sidelines. In years to come he would become China's most famous prisoner of conscience.

Liu Xiaobo had been in New York when the demonstrations had begun, but he could not resist coming home to participate. Over the weeks he had helped the students out in various ways, and tried to give them counsel, particularly on the need for them to legitimise their leadership through democratic elections, but he now felt it was time to put himself more firmly on the line. He and his fellow 'gentlemen' called for martial law to be lifted, dialogue to be renewed, and for an embrace of democratic principles on all sides. The square soon filled again with people eager to witness this new spectacle.

But it was all too late—there was no one left in power who had any interest in compromise. In Zhongnanhai the fierce resistance to the entry of troops to the city on the night of June 2 and this new hunger strike only served to harden the leadership's resolve. Late in the afternoon on June 3, the leadership agreed to use 'any means necessary' to put down what was now described as a 'counter-revolutionary riot' in the capital. Deng Xiaoping made just two stipulations: the square must be cleared by dawn on June 4 and that there was to be no blood shed on the square itself.

On June 3 Huang Rui wandered uneasily near the square. He was booked to fly out the next day. When he had first arrived in Beijing in late May he had found the situation chaotic, but he had not felt the foreboding he felt now. He had had this bad feeling in his gut before, in April 1976 before the mourning demonstrations for Zhou Enlai

had been broken up by the militia. Tiananmen Square was a symbolic space—in 1976 and again now there was a fight between the government and the people to control it. History told him who would win.

Out in the university quarter, Aniwar had been noticing her for days: a girl crying by the university gates as the students left for the square. She was the last person he expected to see cry. She used to come to his parties, and dance all through the night. Now she stood day after day, crying by the side of the road.

'Why are you crying?' he asked.

'Because they won't be coming back,' she said.

He thought it was ridiculous. What reason was there to think that? Later he would remember her and realise how much this sad young Cassandra had understood.

On the night of June 3, Guo Jian was in the square when the word came. 'People came running in, shouting, "They're shooting! They're shooting!" but in the square it was still quiet.' He decided to head west to see for himself. He pedalled fast down the Avenue of Eternal Peace with a classmate by his side towards the western suburbs and the major intersection of Muxidi. Surely they were firing rubber bullets, he thought. The army wouldn't shoot Chinese citizens.

Since early that night an announcement warning people to stay off the streets had been broadcast on a continuous loop, on radio, television, on PA systems throughout the city and on university campuses.

But instead of staying in their houses, tens of thousands of Beijingers were converging on the major intersections leading into the centre to man roadblocks. For two weeks they had kept the troops out of the city. That night they planned to do the same.

But on the night of June 3 they would face a very different army to the one they had encountered two weeks before. Regiments had been bolstered by seasoned troops from around the country. Tens of thousands of infantry, backed up with artillery and tank units, were under strict orders to reach Tiananmen Square by 1 a.m. on June 4 and have it cleared by dawn. The soldiers carried assault rifles loaded with battle-field ammunition.

The 38th Group Army entered the city from the west, along the grand east-west axis that becomes Chang'an Avenue—the Avenue of Eternal Peace.

It might have been expected that the 38th would have had some sympathy with the citizens and students of Beijing. Based near the capital in the neighbouring province of Hebei, they had connections within the city and some Beijing students had even done their military reserve training with them the previous summer. In fact, in the weeks before the final crackdown, the commanding officer of the 38th, Major General Xu Qinxian, *had* challenged the order to impose martial law. When his corps rolled into Beijing on June 3 he was under arrest.

Under new command the 38th proved the most zealous that night in carrying out their orders. Perhaps his predecessor's insubordination made the new commander all the keener to prove his loyalty, or maybe it was because the resistance to the troops was greater in the west of the city, but whatever the reason the 38th Group Army's entry to the capital proved the bloodiest of that bloody night.

When they met the first roadblock on the east-west axis at Gongzhufen, they initially used tear gas and rubber bullets to push back the crowd. Then, as the crowd reformed and finally stood in a wall

thousands strong, the infantry dropped into battlefield formation and opened fire directly into the crowd.

From then on they followed the same ruthless pattern: ineffectual attempts at riot control followed by deadly force. Later the government would claim that the army had had insufficient riot gear to control the crowds that night, making the use of live fire unavoidable, but the deciding factor on the night was not resources but the order that they must reach the square by 1 a.m. They were on a deadline and nothing was to be allowed to stand in their way.

The bloodiest engagement anywhere in the city that night was at Muxidi just two kilometres further along the road to the square from Gongzhufen. Muxidi is now, as it was then, a comfortable residential area, dotted with high-rise apartments housing senior government officials. Those apartments overlooked the bridge where Beijing citizens and students once more tried to stop the soldiers' advance.

The crowds had pushed buses across the road and armed themselves with bricks and broken-up concrete with which they battled the anti-riot brigade who arrived first on the bridge. Beaten back, the brigade was replaced by soldiers who rushed across the bridge in waves, firing into the crowd. Each time they fired, the people scattered only to regroup. Slowly the soldiers pushed the people back across the bridge, firing repeatedly into the crowd, who still tried to fight them with whatever fell to hand. Soon at least a hundred people lay bleeding out on the street.

The residents of the apartment blocks cursed the soldiers from their windows, yelling 'Murderers!', 'Fascists!', 'Bandits!' and raining objects down on their heads. And so the soldiers began to strafe the apartments, too. At least three people died at home that night, one of them while fetching a glass of water by an open window.

Once the infantry had cleared the bridge, armoured personnel carriers, trucks and tanks drove across behind them, heading east towards the square. In their wake some citizens erected fresh

roadblocks and set them ablaze, while others rushed the dead and dying to the nearby Fuxing Hospital. On the road where the army vehicles had passed lay the tangled blood and flesh of some who were beyond salvation.

The 38th rolled eastwards, stalked by a crowd who followed at some metres' distance. The soldiers fired into the crowd whenever they felt challenged, whether by Molotov cocktails, rocks or with shouts, as they moved inexorably towards the square.

As Guo Jian rode nearer to Muxidi with his classmate, he could hear the sound of gunfire but it still sounded to him like fireworks. He couldn't believe they'd be using live ammunition. But as they got nearer he began to see the dead and wounded by the side of the road and he knew: *This is real now.*

They rode up beside the Fuxing Hospital and from there Guo Jian could see smoke from the burning roadblock at Muxidi. Armoured trucks and tanks were rolling towards them out of the haze. He watched in horror as soldiers fired directly into the crowd. They weren't firing wildly, they were taking aim, firing, manoeuvring, then firing again. It was exactly like when he was in the army. These men were firing as they had been trained to do in battle.

Guo Jian and his classmate ran down into the entrance of the hospital and found the foyer awash with blood. The wounded from Muxidi and beyond were being brought to the hospital in a constant stream, on the backs of pedal carts, on bicycles, on anything that could serve as a stretcher. Beside the entrance, where bicycles were normally parked, bodies lay in a pile.

Guo Jian longed to do something heroic but he felt paralysed. He sat down on a chair inside the door, his classmate slumped beside him. 'And then a doctor came out and said "We need help, come with

me" and he took us into a room where we almost slipped in the blood. There was so much blood, I couldn't look at it and so I just looked at the doctor.'

'He told me he needed someone to take out the dead bodies to create space for the wounded coming in but I just couldn't do it. I walked out, it was too much for me. I thought, *I don't want to be a man!*, and I sat down again feeling so guilty. Then I heard someone say they needed people to carry in the wounded from the street and I thought, *I can do that!*'

The wounded were lying where they'd been shot. The army was still passing by. Guo Jian and the other volunteers waved white cloths as they went to lift the first person from the road.

'We carried the first guy back to the hospital. His blood was running out like water. He was alive then but I don't know if he survived. Then we went out again to collect the next person. But this time the soldiers started shooting. We scattered but one of us was shot. After that we knew there was nothing more we could do.'

Nothing they could do, they thought, but ride west to their campus and warn their classmates not to come to the square. On the way they passed Muxidi. In an apartment block overlooking the bridge they saw an old lady standing on her balcony screaming down at the soldiers who were still rolling into the city below her. 'She was yelling "Fascists! Fascists!" and the soldiers fired straight at her. Then she was quiet. Later her neighbours carried her body down into the street.'

They rode on until they reached their university, where they could tell them what they had seen.

My friend made her way up towards Chang'an Avenue from her home in the *hutongs* south of the square. It was past midnight. Earlier that night she had been in the square and afterwards had walked aimlessly

through the streets nearby with a young student friend. They had been seized with a kind of restless energy for days. What was the government going to do? They knew something must happen, but what?

It was such a warm night and after hours of walking she had finally conceded to her friend that her new fashionable shoes didn't fit her after all. She would have to go home and change them. He'd be fine on his own, he said. They agreed to meet back at the intersection of Chang'an Avenue and Xidan, west of Tiananmen Square.

But now as she neared Chang'an Avenue she heard a sound like fireworks. But she knew it wasn't fireworks. The broad avenue was lined with people, thousands standing by the road watching the army roll eastward towards the square. In the distance there was a glow of fire from burning roadblocks. She searched for her friend but couldn't see him. The street was bathed in a strange light, the glow of fires mixing with the beams from the decorative street lamps into an orange glow. The troops were rumbling up the avenue on packed lorries, their helmets glinting in the light, shooting as they came. As the first truck passed her she saw that under their helmets the soldiers' faces were young, and many of them looked scared. Pedal carts were speeding up the street ahead of them with bloodied people lying crumpled across their wooden trays. And yet the crowd stayed, lining the avenue.

As they stood there, like an audience in a ghastly parody of a patriotic parade, someone began to sing. It was 'The Internationale'. The words rang out:

Arise ye prisoners of starvation,
Arise ye wretched of the Earth!

All around her people began to sing, and she sang, too. They sang it as loudly as they could, this anthem of the oppressed, as the soldiers rode past. They sang not far from where Wei Jingsheng had once upon a time

posted his plea for democracy on an ordinary wall. They sang where they had demonstrated in the weeks before, buoyed with excitement. They sang even as the trucks were followed by armoured personnel carriers, and then by tanks, as the air filled with the guttural sound of an army turning their city into a battleground.

Up ahead was the square where they would never go again with pleasure, a place that in the weeks before had truly felt like public ground, a place where the last demonstrators were now waiting by the Monument to the People's Heroes for the final confrontation.

And as she sang her eyes fixed on a single child's shoe lying discarded on the ground, soaked with blood.

By 1.30 a.m. the army was surrounding Tiananmen Square. Units had pushed up through Beijing from the north, south, east and west, joining those already sequestered within the buildings lining the square. Each unit had encountered resistance, each had answered with deadly force. Now they sat and waited for the next move.

For a couple of hours wounded demonstrators had been arriving at the square. Yet thousands of demonstrators still clustered around the Monument to the People's Heroes. They still clung to their role as heroes, all the more reluctant to leave now that all across the city people were dying in their cause. As in the weeks before, a debate broke out between those urging retreat and those who wanted to stay. Hou Dejian exhorted the students to leave. Enough blood had been spilled that night to awaken the people, he said, and the students had already shown that they were not afraid to die. They need not do more. But the student leader Chai Ling refused to direct the students either to stay or to go. This, she declared, should be their choice to make. Finally, Hou Dejian and Liu Xiaobo decided to try and negotiate safe passage for the students.

It was almost 4 a.m. when the two men drove in an ambulance up to the army lines and presented their offer to an officer. If the army would agree not to shoot they would organise the students to leave the square. Their offer was accepted but they were told to hurry. Deng's dawn deadline was dictating the course of events.

The students then held one final vote. The question to leave was to be decided on the voices. When the vote was called the shouts to stay sounded just as loud as the votes to go. The student leader who called the vote declared it a vote to go. Later, he explained why. Those wanting to go would be embarrassed to yell too loudly, he reasoned, while those wanting to stay would be all the louder in their bravado. So if both sounded the same it must be a majority to go. And so they began to leave.

The army was already moving in on the students by this time, pushing towards them slowly with their guns at the ready. There was no time left to debate. The student leaders performed one last service, insisting the students drop any weapons they might have and leave in orderly lines. The students retreated under the banners of their colleges, singing 'The Internationale' and holding hands. Behind them the goddess of democracy toppled to the ground. The tanks took up their positions on the square. The army had delivered it to the government once more.

It seems Deng Xiaoping got his wish that morning, and no one was killed within the square itself. It was a distinction that the government would make much of in the days, months and years that followed.

But even China's official figures recorded hundreds of deaths and thousands of injuries outside the square as the army prosecuted its mission. Figures initially released by the Chinese Red Cross, but then retracted, suggested thousands had died, as did a melancholy news

report by Radio Beijing broadcast on the afternoon of June 4. In the immediate aftermath, BBC journalist Kate Adie, who produced some of the most compelling reporting on the massacre, reported a figure of 1000 killed based on sources within Beijing's hospitals. The most exhaustive attempt to count the dead was undertaken by Canadian historian Timothy Brook, who visited Beijing in the months after June 4. Based on contemporaneous reports of casualties counted at a number of Beijing hospitals, he arrived at a figure very near the initial Chinese Red Cross figure of 2600 dead.

The true figure may never be known. But the sheer diversity of those who died speaks to the indiscriminate nature of the army's actions, and refutes the government's claims that the majority of those who died were 'counter-revolutionary rioters'. Children died as well as pensioners in their homes, pedicab drivers were shot while trying to deliver the injured to hospitals, as were ambulance drivers. Deaths reached into the highest government circles, too. The chauffeur of one of the elders was killed, as was the son-in-law of a senior official of the National People's Congress: he was the man at Muxidi shot while fetching water by a lighted kitchen window.

The actions of some of the bereaved also speak to the immensity of the tragedy. A father carried the body of his four-year-old son around with him for days after June 4 showing his wounds to anyone who would look. University students paraded the bodies of their slain classmates around the campuses of Tsinghua, Peking University, the People's University and the Beijing Language University. At the Chinese University of Political Science and Law, students laid out the body of one of their classmates on a table and surrounded him with ice, keening for him.

The violence did not stop once the square was cleared. Many more people were killed in the hours that followed. An official report to the leadership told of one particularly cold-blooded attack on a group of students making their way home to their university on foot, having

earlier evacuated the square. A tank charged into their group, killing eleven instantly.

Despite the danger, as the terrible day of June 4 wore on, Beijingers continued assembling near the square to pay witness to what had occurred and to protest. All through that day Western journalists watched horrified from their vantage points in the Beijing Hotel just east of the square as soldiers fired point blank into small crowds of people who gathered to curse the soldiers. Dozens died in broad daylight on the Avenue of Eternal Peace.

The number of military casualties during the crackdown is also uncertain. There is no doubt that soldiers died in the action, some brutally murdered by the crowd. The official toll announced in the days immediately following June 4 counted 23 soldiers dead and 200 missing. Later research by a Chinese historian, Wu Renhua, identified fourteen military deaths, of whom eight had been killed in direct fighting with demonstrators. In the absence of a full public accounting for the bloodshed, the details of these soldiers' stories, too, are missing from history.

Like millions of people around the world, I watched the events unfold on television.

I had left China the summer before on a high. The chill that had fallen on the city after the removal of Hu Yaobang had been replaced by an almost feverish atmosphere of excitement. At the start of the year, I had witnessed with some amazement the first open press conference ever held during the National People's Congress; although the rest of the proceedings had taken place behind closed doors, people close

to the government seemed to welcome the chance to discuss China's situation openly.

River Elegy had been broadcast in the weeks before I left, and it seemed no one could decide which was more extraordinary—the argument it contained or the fact that it had been broadcast at all. My own belief was that it was inevitable that China would ultimately embrace some kind of democracy. Yes, there would be reversals, as there had been in 1979, 1983 and in 1987, but in the end these would only be brief setbacks.

When students and ordinary Beijingers began to fill the square in the spring of 1989 I felt that the energy and passion I had experienced in Beijing's underground was finally breaking cover. This is what I had seen behind closed doors, I thought, a sense that the entire society had to change, a longing for a role to play in what could be a great venture. And there was also just a longing for colour, excitement, romance. I'd seen people singing Cui Jian in their homes, and now they were singing him in Tiananmen Square.

As the weeks passed I watched events unfold, gripped by every twist. When the *People's Daily* editorial was issued I felt a chill of fear that was instantly replaced by excitement at the bravado of the students, and, more importantly, of the ordinary people of Beijing. I watched almost with disbelief when Chinese journalists, who I knew as cowed and depressed by their designated role in state propaganda, suddenly took to the streets to demonstrate and later began to actually report what was going on.

Even as the weeks wore on and the stalemate became more evident I was still excited, still hopeful that it would all end well. Martial law was a shock but when Beijingers flooded into the streets to reason with the soldiers and they in turn consented to be stopped, I began to believe that the government must surely recognise that only a political solution could work.

Even on the evening of June 3 as I watched the news pictures of soldiers yet again being prevented from entering the capital, I believed

it would be OK. Surely the People's Army would never turn on the people. I believed the longstanding propaganda as much as any Chinese citizen. The army were the 'most beloved' of people, after all.

I had invited friends to dinner at my home in Sydney on June 4, not realising that it would turn out to be a wake. All through that night as we drank much and ate little I tried hopelessly to call Beijing. Over and over I called the apartments of friends in the diplomatic compounds, hoping they would have news of the friends who we knew had been in the square and who we had no way of contacting.

The very first Chinese friend I had made was at my house that night. Three and a half years since he had taken me to his *hutong* home to see his paintings, he was now a Sydney-sider. Given a chance to come to Australia earlier that year for an artists' exchange, he had chosen not to go back. His girlfriend, my friend, had been in the square every day. Now he sat pale and terribly still, watching me as I tried every phone number I had.

In the days that followed we rode a rollercoaster of hope and despair. Rumours circulated of dissension in the army, of some units facing off against others on the outskirts of Beijing. Rumours, too, that the government might fall. It would be five days before there was any sign of the leadership and in those days we dared to wonder.

On June 5 we had a moment that brought a kind of comfort, even joy, as we watched a young man stand in front of a row of tanks rolling down Chang'an Avenue. In his neat white shirt and dark pants, he seemed to stand in for all the Beijingers who had faced down the army for so long.

In those days I watched the footage from Beijing over and over again. The flare of tracers across the sky, the soldiers with rifles cocked stalking across the square silhouetted by fire, the goddess of democracy crumbling to the ground, the students leaving Tiananmen in the grey dawn light flashing peace signs and hugging each other, and the terrible footage of the injured being rushed to hospital, the pedal carts

that once might have carried spring strawberries speeding down the street laden with the dead and dying.

As before, I found a line of poetry stuck in my head. This time it was Yeats, and his famous poem, 'Easter 1916', about the Easter Rising in Ireland against the British. He, too, had seen ordinary people transformed by events:

All changed, changed utterly:
A terrible beauty is born.

Two months later Sheng Qi caught the train back to Beijing. He had left the capital before the end of May, his parents' pleas finally too hard to resist. The news on television had told of a bloody riot in which soldiers had been lynched by an angry mob. People arriving home in Hefei from Beijing told a different tale, of citizens slaughtered on the streets.

On the train were two obvious army types, but they were in mufti. Since Sheng Qi had been a kid he had dreamed of being one of them. As a child he'd even borrowed a uniform from a cousin who was a soldier and had himself photographed in it. He'd loved that photo. And now soldiers were hiding their uniforms away.

Once on the streets of Beijing, evidence of what had happened was all around him—in the bullet-scarred walls along Chang'an Avenue, and in the eyes of the heavily armed soldiers who still patrolled the streets. The soldiers had hatred in their eyes, but also fear. 'They were too frightened to go into a public toilet alone,' Sheng Qi told me.

One evening he was riding his bike east along Chang'an Avenue from Xidan and was stopped by soldiers and questioned. 'They treated me as if I was an enemy. I had dreamed of being one of them and now they were pointing their guns at me. My dream collapsed.'

'I started to become sceptical about everything. I started to question everything, mistrust everything. I think it was a kind of sickness.

'It was then,' he told me, 'that I really understood Bei Dao's poem "I do not believe".'

Sheng Qi drifted through the days. Once he had felt part of a new generation. They were young and had believed they had a shining future. Now all seemed lost. He began an affair with a new girl. It turned out she had been wounded on June 4. She showed him the scars.

He had dreamed of being a soldier, a hero, an artist, but now it all seemed laughable. Five years ago when he had been accepted to college, he had run for joy. Now he felt heavy and old. He wished there was some way he could just cut himself free of the past, to cut time in two.

One day he found himself listening to the radio in the apartment where he was staying. Over the airwaves came the raucous banter of crosstalk, China's traditional form of comedy. Two comedians were going at each other hammer and tongs, out-punning each other in a rising cacophonic duel of sound. He started to laugh. He couldn't stop.

Suddenly he seemed to have soared high above himself. He looked down and watched the blood flow from his left hand. In the right he held a knife. He felt released, like his soul had jumped free of his body.

And his blood kept pouring from where in his madness he had cut his little finger clean away from his hand.

Elsewhere in the world the magic year of 1989 delivered on its promise. Two hundred years after the storming of the Bastille, revolution again swept Europe. The Berlin Wall fell and the communist governments

of Poland, Hungary, Czechoslovakia, Bulgaria and Romania were toppled. I watched with joy as the East Germans broke down the wall, and excitement as the Eastern Bloc crumbled. But I was also filled with sadness, and anger.

When the students first went to the square, I—like them—had not longed for the government to fall, but now I raged: how was it possible that all these other communist regimes could fall like ninepins and China's—which had murdered its own people—hardly seemed disturbed? Twenty years later a Chinese friend confided that it was only by thinking 'in ten years this gang of murderers will be swept away' that he had kept himself from going mad in those terrible weeks and months after June 4. In those days I tried to believe the same.

Twenty-five years later I asked Guo Jian what was the most frightening thing he confronted that night of June 3. Was it facing all the dead in the hospital, or trying to rescue wounded from the street?

He told me it was neither. What was scariest, he said, was realising that it could have been him riding into Beijing that day: 'I saw these young men in uniform, just like I had been, and I saw them shoot at unarmed people. And I thought, *if I was still in the army, I would have been expected to do these things. I would have been sent here to kill.*

'And you think, surely you would have resisted, but then you realise you probably would have followed orders, because that's what soldiers do. That's the thing that scares me most.

'Looking at them in uniform, firing and manoeuvring like I had been taught, I realised that up there on the truck was a young soldier, and he was me, and down in the street there was a student, and he was me, too.

'On that day I was killing myself.'

NOTHING TO MY NAME

Early in a new decade, a thirteen-year-old boy named Jia Aili went exploring in his gritty north-eastern town. He had discovered a marvellous new playground: factory halls where gigantic machines and intricate industrial equipment stood shrouded in dust, and not a living soul there to challenge him. On one unforgettable day, he made his way into a warehouse full of military aircraft, where half-built engines and disembodied wings waited for assembly crews that would never come. His town felt like paradise to him, but it was an industrial graveyard.

Jia Aili was born in Dandong in Liaoning province, a region once celebrated by Mao Zedong for its economic contribution as the 'eldest son of the nation'. Liaoning had industrialised early; rich in natural resources, it had been built up under Japanese occupation and in the early decades of the People's Republic it became the centre of China's heavy manufacturing. Under the communist system of state ownership and central planning, Liaoning's factories had at one time supplied more than 70 per cent of the nation's iron and 60 per cent of its steel, and by the dawn of Deng Xiaoping's era of reform, 10 per cent of China's medium and large state-owned enterprises were located in the province. These entities dominated life for the people of the region, supporting them from cradle to grave with work, housing, healthcare, retirement pensions, employment opportunities for their children, and even entertainment.

Employees in the north-east were the aristocracy of the workers' state, toiling for the grandest of the nation's central plans. But from the moment that China embraced Deng Xiaoping's new reform blueprint in 1978, the workers' influence waned. No longer was China focused on self-sufficiency and the nation's basic needs but on a new vision where the country would be the factory of the world, catering to the appetite of the West for consumer goods. These would not be produced in the old industrial towns of the north-east but in the newly tooled factories of the rising south.

By the end of the '90s millions would be thrown out of work in Liaoning province, among them Jia Aili's parents. Many of them found themselves without adequate pensions or much prospect of finding meaningful work, reduced to watching powerlessly while enterprises they had once considered their own were bankrupted and their assets transferred into the hands of those with power or influence—a new aristocracy which the workers had little chance of joining.

Tucked up in the region once known as Manchuria, bordering North Korea to the east and with Russia to the north and Mongolia to the west, the towns of Liaoning province could only dream of the opportunities opening up for China's southern coastal cities whose close neighbours were the booming economies of Hong Kong and Taiwan and whose ports looked towards Southeast Asia and beyond. It was there that Deng Xiaoping created the special economic zones, and it was to there that rural workers flocked from the communes in search of a new life.

Meanwhile, Jia Aili wandered in shuttered factories where dust danced in the shafts of light that fell on disused turbines and forgotten flying machines. Years later, crashed planes and ruined machinery would appear again like ghosts on the giant canvases that would make his name.

Three thousand kilometres south of Jia Aili's home, in the summer of 1992, five girls were involved in an intricate game in a garden. They jumped! They ran! They smiled! They stopped. Then they started all over again.

The girls weren't really playing, though they were pretending. In fact they were acting, and the older sister of one of them was directing. She had just done something daring. After a year studying in a hard-won place at university, she had dropped out to join China's infant advertising industry. Today she was shooting her first ad. It was for acne cream, and wasn't that enough to make any teen jump for joy?

Her little sister was delighted, but not by the prospect of clearer skin. For a few years now in her home in Guangzhou, she had been watching the advertisements broadcast from Hong Kong 120 kilometres away. Now she was learning how those ads were made, how to create, and how to fake. Her name was Cao Fei, and like Jia Aili she was destined to be an artist.

Cao Fei was born in 1978 and Jia Aili in 1979. They are both children of the era of reform and opening up. They have no direct memory of a time before Deng Xiaoping, no memory of Mao, no baggage from the Cultural Revolution. Their lives were shaped by the new revolution that started when they were born.

And yet, they did feel the echoes of the earlier era. Cao Fei felt it in the way her parents embraced new opportunities with such hunger. Her mother had spent the Cultural Revolution restoring propaganda films frame by frame so they could be sent out on tours to 'educate the masses'. Her father, a sculptor, had focused his talent on a single subject, Chairman Mao, so that the Great Helmsman could stand in yet another city square, at one more factory gate, in one more commune.

Now Cao Fei's parents were restored to their original occupations as teachers, and they were also free to take work beyond the doors of the academy. Her father took commissions for portraits of a vast new cast of characters: local heroes, pre-revolutionary historical figures,

even an influential foreigner with a curious name—Juan Antonio Samaranch—whom Cao Fei's father cast in bronze as part of China's campaign to win the favour of the International Olympic Committee.

Cao Fei's mother, in her spare time, began to create delicate prints depicting a kind of private life that just a few years before had been derided and condemned. She rejoiced in works that had no revolutionary meaning at all, dwelling on imagined pleasures as simple as a woman playing with a cat. Meanwhile, both parents buried themselves in the avalanche of new reading that suddenly became available— books about artists like Rodin, Monet and Picasso.

For Jia Aili the echoes of the past were more poignant. The new era made his parents redundant, and the grand economic plans for which they had toiled were gone. As Cao Fei's south boomed, Jia Aili's north was rusting away; as Cao Fei's parents saw new horizons opening up, Jia Aili's saw the things that gave their life meaning shuttered away in deserted factories. And yet the new era brought Jia Aili an opportunity that no one in his family had ever had before. At the end of the decade he would find himself at university, having sat the open exam that had been re-established by Deng Xiaoping in the early days of the reforms.

Cao Fei and Jia Aili were destined to be part of an 'in-between' generation, young enough to have escaped the dark experiences of the Cultural Revolution, but old enough not to take the shiny new China of today at face value. They would understand it had not been achieved without loss and pain. It is this subtlety of perception that marks these 30-somethings, and makes them, as Cao Fei remarked to me one day, neither natural optimists nor pessimists. 'We are always *leguan beiguan*—always optimism and pessimism together,' she said.

More than any other generation they represent the polarities of today's China, and even in their work they reflect the contrasting experiences of a single generation. As Jia Aili presents his melancholy vision of China in the time-honoured materials of oil on canvas,

Cao Fei creates her works on video, and on the internet, sending out her avatars to explore alternative worlds.

The 1990s—when Cao Fei and Jia Aili entered their teens—was destined to be the most wrenching of the decades since 1978, the most rapid period of change that China had ever experienced. Millions of people's lives would be transformed for better or for worse. As a way of life passed away in the north, a new one would open up in the south. Fortunes would be made that would open a gap between rich and poor that today yawns wider than ever. A middle class would begin to form, and a new, unspoken contract would be made between rulers and ruled. The terms were clear: 'We can make you richer than you've ever been. But political power must rest with the party alone.' China's security today still rests on maintaining the stability of that grand bargain struck a quarter of a century ago.

Cao Fei's home town of Guangzhou was to play a leading role in the transformation of China. Today the city leads a southern Chinese economy, based on the Pearl River delta, which accounts for almost 40 per cent of China's trade and 20 per cent of its GDP.

But during the 1980s Guangzhou itself developed only slowly, as a matter of deliberate policy. In the 1980s Zhao Ziyang had promoted the use of special economic zones as safe spaces in which China could experiment. In these zones foreign investment, private enterprise, and the creation of new export-oriented industries could be pioneered without risking the positions of the traditional leaders of China's industrial economy.

By the end of the 1980s the experiment had already proved an extraordinary success, attracting substantial foreign investment and local entrepreneurship. The leading special economic zone was Shenzhen. It had been barely more than a fishing village in 1980, but when declared a special economic zone it became a magnet for workers from around the country. Located just across the border from Hong Kong, Shenzhen became a kind of annex to the still British-administered

territory. Hong Kong businesses relocated en masse to Shenzhen in pursuit of cheaper land and labour, and the once ubiquitous 'made in Hong Kong' label would be overtaken by one reading 'made in China'. Shenzhen became known for its freewheeling atmosphere, while its venerable older brother Guangzhou, just 100 kilometres away, remained relatively staid and unmoved.

Then in the early 1990s Deng turned his attention to Guangzhou and to Shanghai, looking to these historically important port cities to help drag China out of the slump that had followed the events of 1989.

It might have been thought that Deng's ruthless actions in 1989 would have enhanced his position as the dominant figure in Chinese politics, but in the months following the crackdown he found himself instead on the defensive as his treasured economic reforms came under threat. Party hardliners who had long been suspicious of opening the economy and who hankered for the days of central planning argued that it was the speed and scope of Deng's reforms that had provoked the Tiananmen protests. They argued for a slower pace of growth, increased central control and stricter ideological purity.

The toppling of Zhao Ziyang and the purge of reformist voices inside and outside government left Deng all the more exposed, and a conservative low-growth strategy was accordingly endorsed. Arguments even began to be made that special economic zones should be abolished altogether.

These were frightening years for communist regimes. The toppling of the Eastern Bloc governments in 1989 was a grim warning of what might have happened in China, and the resignation of Gorbachev in 1991, followed by the break-up of the Soviet Union, was deeply shocking. In the new decade the world seemed to be tilting on its axis towards the capitalist West.

But Deng believed there was more to fear from low growth than economic reform. Only rapid growth, he believed, would help China escape the drag of its huge population and underdevelopment. No doubt he also saw that only by delivering a better life could the Communist Party's legitimacy be maintained. China had no choice but to ride the tiger.

Finally, in January 1992, he fixed on a plan to use his personal influence and charisma to go over the heads of the leadership in Beijing to re-start his reforms. He announced a 'southern inspection tour', travelling to Shanghai, Guangzhou and Shenzhen in order to assess their development.

The term 'southern inspection tour' (*nanxun*) was chosen carefully. It was used by the great Qing Emperor Kangxi to describe his six expeditions to the southern reaches of his empire in the middle years of his reign (1661–1722). With this echo of a lost era of Chinese glory, Deng was signalling the importance of his own journey. He aimed to draw attention to the success of Shenzhen and finally give his blessing to the long-dampened ambitions of Shanghai and Guangzhou to regain their historical positions as powerhouses of China.

At first the Chinese media ignored Deng's tour, reflecting the disapproval of the hardliners in Beijing, but before long his travels and his comments were being widely reported. As he travelled, he reiterated his view that development required that 'some should be able to get rich first' and observed sharply that 'ideology cannot supply rice'. Only reform and rapid development could save China from ruin, he declared. The low-growth policies being pursued in Beijing could only lead to stagnation.

The province of Guangdong, home to Guangzhou and Shenzhen, should, he said, move rapidly to take up its place alongside the four 'little dragons' of Asia—Hong Kong, Singapore, Taiwan and South Korea. In pursuing this goal, Deng directed, the achievements of Shenzhen should be taken as a model.

Deng's blessing was a key moment for Shenzhen. The special economic zone was always a target for attack at times of political upheaval. It had been singled out during the anti-spiritual pollution campaign in 1983, and its citizens had been denounced as 'gold-diggers' by hardliners in the government in the months after June 4. Shenzhen's gratitude to Deng is still on show in the city today. A huge billboard celebrating his blessing of the city stands on a specially dedicated square, depicting a disembodied, god-like Deng looming over a panorama of the city.

Deng's endorsement of Guangdong province and later Shanghai in 1992 would prove pivotal. Guangdong's capital Guangzhou and the port of Shanghai were cities laden with symbolism. They were places that had been built by trade. To elevate them to the centre of economic policy was to leave no doubt that reform and opening up were back in business.

In the aftermath of June 4 1989, the south of China and specifically Shenzhen held a different kind of symbolism for those who had demonstrated in Beijing. Shenzhen equalled hope. If you could get there, then Hong Kong and the rest of the world were within your reach.

In the days after June 4 the arrest of students and others who had been active in Tiananmen Square proceeded rapidly but for a few short days local police in Beijing defied the round-up, issuing passes for travel to Shenzhen to any student who applied. 'I had never seen the police be like that, so good,' Guo Jian reminisced years later. 'For a few days after June 4 there was a long queue outside the local police station in the university quarter and the police were going along the line saying, "Are you a student? Who's a student here? Come in! Come in!" And they were just handing out passes to all the students without question.'

On June 5 Guo Jian secured his pass to Shenzhen, but he couldn't bring himself to use it. 'I kept saying to my foreign friends, "I haven't done anything wrong," but they said, "It doesn't matter! You need to go!"' Finally he returned to the police station on June 8 for another pass, as his first had already expired. But the police were no longer welcoming students. 'They shooed us away really fiercely, but even in that they were trying to protect us. They knew if we queued up the soldiers would be able to pick us up easily.'

In the days, weeks and months that followed, thousands of people were arrested, but there was a groundswell of support for the students that enabled many of those on the most-wanted list to escape. Wu'er Kaixi and Chai Ling both took the 'underground railway' to the West via Guangdong, arriving in Hong Kong to be spirited immediately onto planes to France and then later to the United States.

Student leaders who did not manage to evade arrest were given prison sentences, but worker demonstrators were treated with particular harshness, with many being summarily executed.

Numerous soldiers were court-martialled, and, it was rumoured, some were even executed for refusing to participate in the massacre on June 4. Major General Xu Qinxian of the 38th Group Army was court-martialled and sentenced to five years in prison for his refusal to enforce martial law. Even today, at the age of 80, he is forbidden from visiting Beijing.

Guo Jian found a way to drop out of sight in the capital. Taking refuge first with a friend who had found shelter on a construction site near the university, a few weeks later he moved out beyond the fringe of the city to the ruined grounds of the Old Summer Palace. In the previous few years, a group of drop-out poets had formed a community there, renting dilapidated accommodation from the local farmers who raised

vegetables, pigs and chickens on land where the Qing emperors had once taken their ease. The farmers were more than happy to take money from the poets and, after Tiananmen, from young would-be artists, too.

This is how the Old Summer Palace became the site of China's first artists' village, and within a couple of years more than 200 aspiring artists were living there, including a roll call of future art millionaires of the next century.

In the wake of the Tiananmen crackdown many found themselves with demerits on their university records, unable to graduate, or assigned to the worst jobs. Guo Jian had been allowed to graduate because the professor who had talent-spotted him years before had pleaded his case, but his job assignment was a 'punishment detail', designing teapots in a remote mountain factory. He turned it down, and chose to hang at the Old Summer Palace, painting his own wry take on the China he saw around him, and selling the occasional painting to foreigners who came calling in search of what remained of the spirit of the '80s.

For it wasn't just China that had suffered a shock in June 1989, but the West, too. We had fallen a little in love with China in those spring days of 1989 and after the crushing of all that youthful hope, we kept on looking for clues to what remained and what might lie ahead.

In the spring of 1993, a year after Deng Xiaoping had sent his signal that China was yet again open for business, a very different kind of message was sent out across the world. An exhibition—'China's New Art, Post-1989'—opened in Hong Kong, and in a series of iterations went on to tour the world. It would give the West its first glimpse inside the hearts of the Tiananmen generation since June 4. The curators were Li Xianting, one of the organisers of the 'China/Avant-Garde' exhibition in Beijing in February 1989, and Johnson Chang, a Hong Kong–born

aesthete who had founded the world's first gallery of Chinese contemporary art in Hong Kong in 1983.

The two had been intimately involved in the burgeoning of Chinese contemporary art in the 1980s and were finely attuned to its new mood and direction. They saw early what would become obvious over the next decade, that contemporary art could provide a unique map of the emotional landscape of post–June 4 China, and with their new exhibition they set out quite overtly to explore it. They recognised, too, that this was one of those rare moments in history when art captured the spirit of the times with work of extraordinary quality. This was a generation that had experienced the Cultural Revolution in childhood, had grown up to enjoy the privilege of entry to university and the opening up of China to Western culture, had dreamed the wildest dreams during 1989 and experienced the most bitter disappointment, and would now confront the new materialism of a rising China.

Surveying the scene as they prepared their exhibition, Li Xianting and Johnson Chang identified three major moods among the young artists, and in naming them coined the vocabulary that would guide discussion of Chinese contemporary art into the next century.

The first movement they dubbed 'cynical realism': its exponents used detached irony and satire to capture the psychological alienation of the times. One of the leading cynical realists was Fang Lijun, whose portraits of disaffected youth yawning widely or blowing smoke straight into the face of the viewer would trigger multimillion-dollar bidding duels a decade later. Another was Yue Minjun, known for his grinning, mirthless self-portraits.

Secondly they identified a form of iconoclasm they called 'political pop'. This was a style of art that inserted communist icons, such as Chairman Mao, and the three pillars of socialism—workers, peasants and soldiers—into commercial imagery. Most pointed were the works of Wang Guangyi, whose massive triple portrait of Mao had caused such a stir at the 'China/Avant-Garde' show in 1989. Now he created a

series of paintings based on old Soviet-style woodcut posters, in which square-jawed workers and heroic soldiers were the centrepiece of spoof advertisements for Coca-Cola and Montblanc.

The last movement was the most subtle and the most poignant, and the curators called it the 'wounded romantic spirit'. To represent this mood they chose the work of a 35-year-old painter named Zhang Xiaogang.

The curators had been aware of Zhang Xiaogang's work since the early eighties and Li Xianting had included one of his paintings, a triptych called *Forever Lasting Love*, in the 1989 'China/Avant-Garde' exhibition. That painting had a symbolist bent, blending religious and ethnic iconography from East and West in a surreal eclecticism which captured the experimental nature of the 1980s' art scene. But as Johnson Chang prepared for the London opening of 'China's New Art, Post-1989', he received a letter from Zhang Xiaogang which brought news of work that was quite different. Looking at the photo that dropped out of the letter, Chang knew at once that he was looking at a real breakthrough. Fang Lijun had captured the cynicism of the age and Wang Guangyi its materialism, but, in his new work, Zhang Xiaogang seemed to have captured its grieving soul.

The painting was entitled simply *Family Portrait*. It depicted a man and a woman in drab workers' uniforms, the kind once worn across Chinese society, their faces shaded in half-light. Between them sat their small son, his features a lurid pink, one eye turned shockingly inward. Wandering across the canvas was a thin, barely perceptible red line, like a cord that bound the group loosely together.

Family Portrait (1993) was the first in a series of works—104 in all—that Zhang Xiaogang would paint over the next decade, and which became known as the 'Bloodline' series.

All were portraits, mostly of two or three figures posed solemnly in the style of family photographs taken during the Cultural Revolution. A muted palette heightened the unsettling effect of the other elements:

a translucent 'birthmark' hovering over some of the faces; the overlarge jet-black eyes against soft-toned skin; the blank, haunted expressions; and the wayward red thread that joined the groups together.

The images are full of ambiguity and dissonance: between reality and unreality, between peace and sadness, and between the conformity of the drab Maoist clothing and the individuality conferred by a turned eye or crooked teeth.

Zhang Xiaogang himself wrote that the figures in his paintings represent 'souls struggling one by one under the forces of public stand-ardisation', their faces 'bearing emotions smooth as water but full of internal tension'. To a Western eye the portraits immediately conjured a sense of sadness, a glimpse into the heart of a traumatised nation.

Johnson Chang told me years later that in the 'Bloodline' imagery he recognised a genuine 'breakthrough in the language of art. It was Western figuration that nonetheless felt Chinese.' With this new language, Zhang Xiaogang created works that speak equally as strongly to his own country as to the West. Indelibly associated with the time after Tiananmen, the 'Bloodline' series reflects a period of loss which in a real sense has never ended.

Today, 'Bloodline' is one of the most recognisable series in Chinese contemporary art, and one of its most prized. In 2014 a work from the series, *Bloodline: Big Family No. 3*, sold at auction in Hong Kong for $US12.1 million.

Zhang Xiaogang's childhood was marked by trauma. When young he had been terrified by the behaviour of his mother, who was only diagnosed as schizophrenic after he had grown up. His father tried to keep the family of four boys together but had little time for his youngest son. When Zhang Xiaogang was just eight years old the Cultural Revolution broke out and, in the ensuing chaos, his mother's behav-iour came to seem almost normal for the first time in his life. In 1979 at the age of 21 he entered university, one of the many young people given the chance by the reopening of the universities to competitive

examination. Despite his father's resistance he enrolled in art and it was at the Sichuan Academy of Fine Arts in Chongqing that Zhang Xiaogang first found a place where he felt at home. Not in the academy itself, which he found stultifying, but with the friends he made, and the private world of inspiration they created for themselves out of the works they made and the books and music pouring in from the West.

'When I was at university,' he told me, 'it was very academic, and conservative. I thought I needed to protect myself and my ideas from that, and I wanted to enhance my creativity and my feelings. So I inoculated myself against the conservatism with Western books and music. The music, the books and the art we made built up an atmosphere in which we could grow.'

From the moment he arrived at the academy he knew he wanted to be an artist and he persisted against all the odds and in the face of parental disapproval. At times he lived a hand-to-mouth existence but like all those who came of age in the 1980s he would look back later on that time with nostalgia.

Talking in his grand Beijing studio one day in 2014, he told me he still turned to Western music to create the atmosphere he needed to work. Inspiration still came from his first loves—Bob Dylan, Leonard Cohen and Pink Floyd.

Looking around his studio together we stopped for a while by a print hanging in a quiet corner, one of a group of small works he had created about the same time as the triptych *Forever Lasting Love* in 1988. It was hard to equate the artist he had become with the person who had created these whimsical and romantic works in the 1980s.

'After 1989, after June 4, everything changed,' he told me. 'I just didn't want to paint romantic things.'

'You couldn't?' I asked.

'I didn't have that feeling any more,' he replied quietly.

★

In the 1990s Zhang Xiaogang had the opportunity to leave China for the West but he decided to stay. To stay or to go was the great decision for many people in that decade. After June 4 Western countries threw open their doors to young and talented people from China. Many would follow the lead of artists of an earlier generation, like Huang Rui, Wang Keping and Ma Desheng, and leave China, believing that only abroad would they have the freedom to develop. Others, despite having ample chance to leave, would stay. Among the stayers were Fang Lijun, the original cynical realist, and Wang Guangyi, the pioneer of political pop.

But for others after 1989 it proved impossible to settle down again; among these was Sheng Qi.

His mother came to find him in the hospital in Beijing. For twenty days after he had severed his finger, Sheng Qi lay in a fever, an infection raging in his blood. He asked his mother not to cry when she saw what he had done, but she did so all the same. She took him home with her to Hefei to nurse him back to health. In the weeks that followed he sought out a Tai Chi teacher, hoping to find peace and regain his strength.

For two months he got up at 6 a.m. every day and practised Tai Chi with the old man. 'It was a kind of meditation, I guess,' he said. It was also a release. After two months he felt physically and mentally strong again. He also felt resolved. He could not stay in China. A friend in the Italian Embassy helped him with a visa application, and by the spring of 1990 he was on his way to Rome. It would be a decade before he returned.

Huang Rui in Beijing. Behind him is a work inspired by the 64 hexagrams of the I Ching. (Reproduced by permission of Judy Wenjuan Zhou)

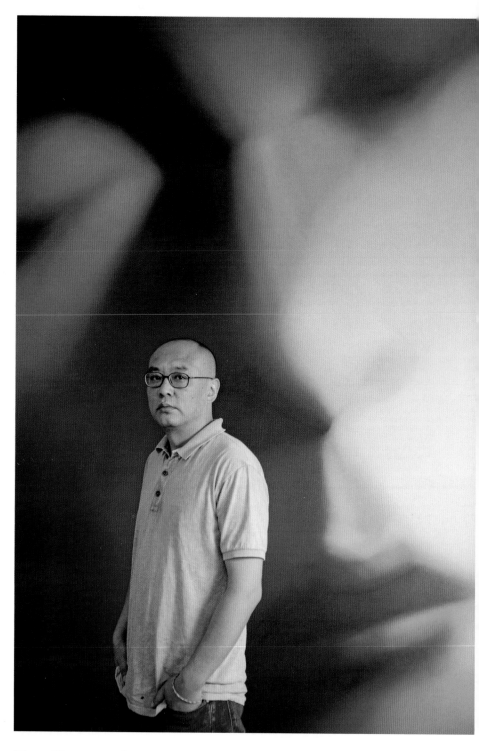

Zhang Xiaogang in his Beijing studio. (Reproduced by permission of Judy Wenjuan Zhou)

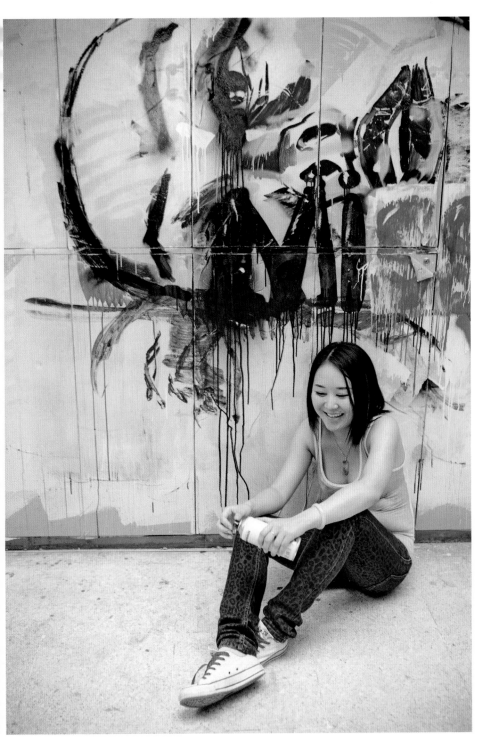

Pei Li at the Beijing Film Academy, August 2009.
(Reproduced by permission of Judy Wenjuan Zhou)

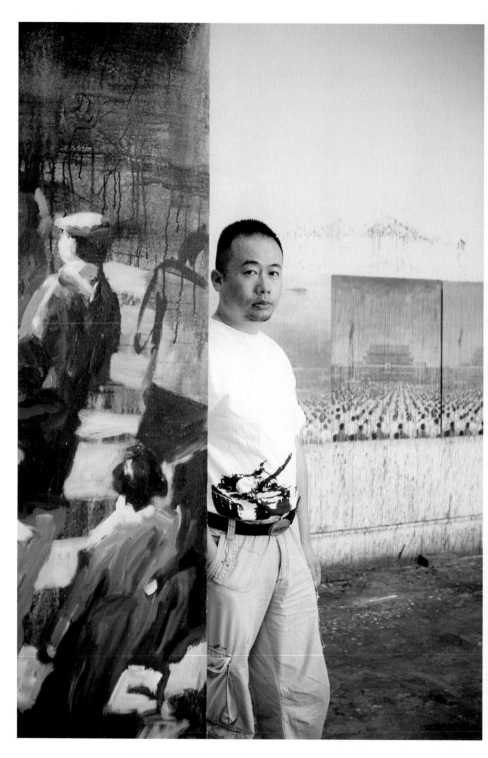

Sheng Qi in his studio in Beijing in 2009.
(Reproduced by permission of Judy Wenjuan Zhou)

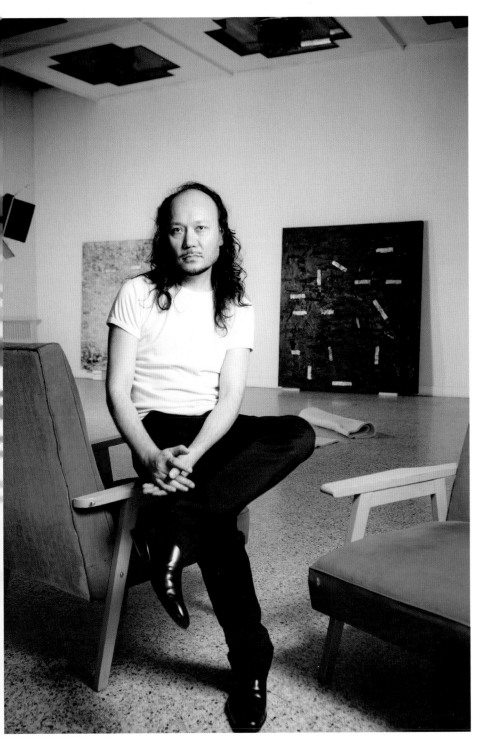

Aniwar in his Beijing studio.
(Reproduced by permission of Judy Wenjuan Zhou)

Jia Aili with his then unfinished work *We are from the Century*.
(Reproduced by permission of Judy Wenjuan Zhou)

Cao Fei with a still from her online work *RMB City*.
(Reproduced by permission of Judy Wenjuan Zhou)

Guo Jian in his Songzhuang studio, China, 2014. In the background is a version of his Tiananmen Square diorama. (Reproduced by permission of Wei Wanli).
Inset: Guo Jian (centre) and fellow hunger-strikers, Tiananmen Square, Beijing, May 1989. (Reproduced by permission of Guo Jian)

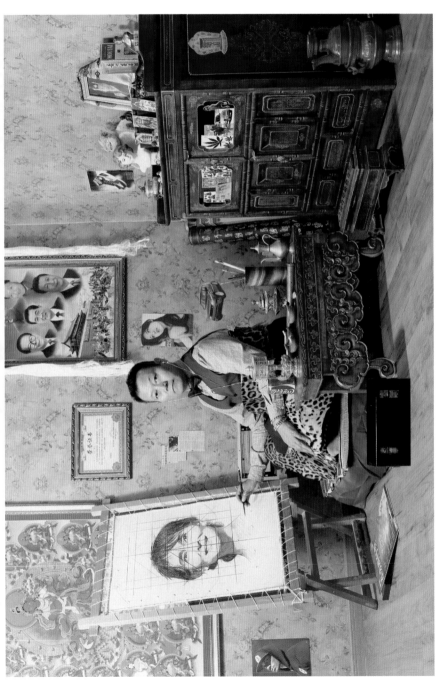

Gonkar Gyatso's self-portrait, *My Identity, No. 5*, 2014, envisaging the artist in a Lhasa studio.
(Reproduced by permission of the artist)

The Stars in their historic demonstration for freedom of expression, October 1 1979. Huang Rui (centre) walks beside Ma Desheng (on crutches). On the far left is Wang Keping holding an arm of the banner, which reads 'March in defence of the Constitution'. (Reproduced by permission of Liu Heung Shing, 1979. All Rights Reserved)

This 2006 work by Huang Rui spells out 'Long Live Chairman Mao!' in banknotes. *Chairman Mao, 10,000 RMB,* Chinese renminbi notes, acrylic, 2006. (Reproduced by permission of the artist)

Bloodline—Big Family No. 3, oil on canvas, 1995. A work from the famous 'Bloodline' series that made Zhang Xiaogang's name. This painting sold for US$12.1 million at auction in 2014.
(Reproduced by permission of the artist)

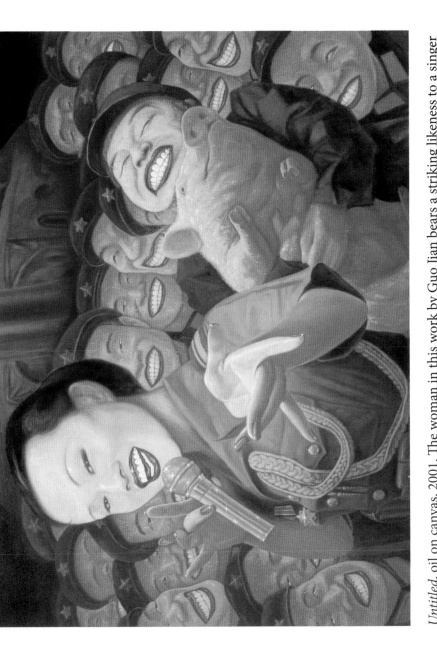

Untitled, oil on canvas, 2001. The woman in this work by Guo Jian bears a striking likeness to a singer whose name was linked with former General Secretary Jiang Zemin. (Reproduced by permission of the artist)

Cao Fei, *Cosplayers—A Mirage*, C-print, 2004. (Reproduced by courtesy of the artist and Vitamin Creative Space)

Jia Aili, *Nameless Days 2*, oil on canvas, 2007. (Reproduced by permission of the artist)

Aniwar, *Finding Something Lost*, lamb's wool felt, 2014.
(Reproduced by permission of the artist)

In 1992 Gonkar Gyatso would also leave China, but he was not heading for the West. Instead he would travel to India, to the seat of the Dalai Lama's government in exile, Dharamsala.

When he returned to Lhasa from Beijing in 1984 he found his home town transformed. It was full of colours, scents and sights that were new to him. The new policy of religious tolerance had brought Buddhist practice back into the open, while members of Tibet's 'old society' who had been persecuted and imprisoned during the Cultural Revolution—members of the religious orders and the old aristocratic class—had been rehabilitated. With the monasteries reopened he saw for the first time the true riches of Buddhist art. It was 'visually overwhelming', he told me.

Every day he would meet with friends in one of the city's teahouses, spending hours debating how they could make art that was about the real Tibet. The change in the city was both exhilarating and confusing.

'I saw so many contradictory things, things that contradicted what we'd been taught before. We'd been educated since kindergarten that the landlords, the aristocrats, the monks, the Dalai Lama—they are all bad guys, "bad elements". Then suddenly all those people are back. And they have become popular figures. Like suddenly you can see the Dalai Lama's photo everywhere, and you can actually buy his photo on the streets! You can see the monks in their robes, and the aristocrats, too, and the government is giving them back their land and their houses. It was just such a reversal.'

All the things he now saw around him made him wonder what Tibetan society was really like before 1959 when the Dalai Lama went into exile.

'I had this hunger to know more about my own history, but there was a kind of big blank. Nobody told us what things were really like before '59. The government version was that, before '59, Tibet was a very dark and very cruel society, but then suddenly when everything was opened up in the eighties and was aired it seemed like all those dark

things were actually positive. I realised there was no way to actually find out what was the real story and what was not. I had already realised when I went to Beijing that I was Tibetan not Chinese, and so now I thought, *So, if I am Tibetan, what do I really know about my tradition?*'

One day he came across some speeches by the Dalai Lama which had been smuggled on cassette tapes into China. 'When I listened, I thought, *if I can go and see him maybe he can give me some guidance.*'

In 1992 he flew out for Nepal. He had waited almost five years for a passport and permission to leave. His father had relations in Nepal, and the Chinese authorities finally granted Gonkar an exit visa for a family visit.

In Nepal his relations advised him how to get to Dharamsala. He must discard his Chinese passport, they told him, and take a bus to the Indian border with a group of other Tibetans. There he should approach the border guards, and when challenged he should just say 'Dalai Lama! Dalai Lama!' and that would get him into India. Gonkar threw away his hard-won passport and set off.

At the border it happened just the way his relations said it would. At the sound of the Dalai Lama's name, the guards waved him through.

And so it was that, in search of his identity, Gonkar became a refugee.

I returned to China in the autumn of 1993. I had begun working with the Australian Broadcasting Corporation (ABC) the year before, on a new television program called *Foreign Correspondent*. Over the next few years I would visit China numerous times to produce stories for the ABC, allowing me once again to track the changes in the country at first hand.

I had mixed feelings about coming back. I longed to be in the country again, but I also feared what I would find. I had received ample

reports of the gloom that had settled over China in the months after June 4 1989, the imposition of a new program of ideological purification, and of the many arrests. The sentences handed out, particularly to the workers who had been caught up in the demonstrations, were chilling. There was also news of the bulldozing of many of the old Beijing neighbourhoods, as if the city itself was being punished. These were the years when the bonds of collective ownership of real estate started to dissolve. It was the beginning of a gigantic transfer of wealth that was to create China's first generation of millionaires. Old residents were moved to high-rise housing on the outskirts of the city, while the *hutongs* where Beijingers had lived for hundreds of years were flattened for new developments. The fabric of Beijing would be altered beyond recognition during this decade, and it would only be in the 2000s that a movement supporting historical preservation would be heard.

Meanwhile, a steady stream of friends who had been active in bohemian or intellectual circles in China were arriving to take up self-imposed exile in Australia. They told of a stultifying atmosphere, of harassment by the police, of a sense of hopelessness.

And, yet, there were signs of life. The exhibition 'China's New Art, Post-1989' had arrived in Sydney in June 1993. There were exciting films coming out of China, too, like *Farewell My Concubine* (which took out the Palme d'Or at Cannes that May), a film which hid its political critique inside its sweeping historical narrative. Word came, too, of a new strain of 'hooligan literature', and a drop-out culture that spoke of a kind of passive resistance among the young.

By 1991 foreign money was again pouring into China. I was intrigued by the strategy behind Deng's 'southern inspection tour', especially his vision for Shanghai. In the 1980s I had got used to hearing of the Chinese government's determination to keep Shanghai down. The city had been deliberately bypassed when decisions were being made about where the Chinese economy would be opened up, and, for a decade, as the special economic zones in Guangdong province

boomed, Shanghai had laboured under the weight of out-dated state-run enterprises and central planning.

Suspicion of Shanghai ran deep. Its modern history was deeply entwined with the story of Western exploitation of China. At the conclusion of the First Opium War in 1842, Britain forced a series of commercial concessions on China, including the designation of Shanghai as a free-trade port. Standing at the mouth of the Yangtze, Shanghai was the ideal gateway to the rich hinterland of China's south, and an excellent platform for industrial development. By the early twentieth century Shanghai had become the most important financial centre in Asia and one of the great industrial and trading cities of the world.

But trade and industry were just part of the story. Shanghai was one of those cities, like Paris or New York, whose name you could conjure with. Shanghai spoke of glamour, opium, cheongsams and *chemin-de-fer*, of jade, silk and easy money. By the 1920s it had been crowned in popular imagination as the Paris of the East. The city became a magnet for gamblers, nightclub singers, White Russians, writers and people looking to create a new life. Noel Coward wrote *Private Lives* in a suite at the Peace Hotel and Margot Fonteyn studied ballet in the city with exiled Russian masters. The French Concession had gracious avenues planted with plane trees, while the British enjoyed tennis and the Long Bar at their gentlemen's club. Along the waterfront, known as the Bund, foreign banks, trading companies and foreign hotels raised grand granite edifices in the Western style—marble-floored and colonnaded, guarded by stone lions of stern British mien.

Shanghai was a place where fortunes were made and made quickly, and not just by Westerners. Shanghainese became famous for their business acumen; when the communists took over in 1949, many migrated to Hong Kong where they rose quickly to prominence as the leading business people of the colony. It can be argued that much of

Hong Kong's business success today was built off the back of displaced Shanghainese entrepreneurs.

Deng Xiaoping's decision to give Shanghai its head in the 1990s was thus a calculated one. He knew what visions the name Shanghai conjured for foreigners. What better place to declare as open for business than a city that the West already felt they had a stake in? What better way to lure the foreign investment the country so desperately needed than by offering entry to this fabled city?

As for me, and the new ABC China correspondent Sally Neighbour, we were hooked. Discussing what to do for our first story together for *Foreign Correspondent*, we couldn't get past Shanghai. An investigation of what was happening in the city basically chose itself. In September 1993 we were there.

Everyone told us to stay in the newly opened Hilton but we chose the Peace Hotel instead. With its dim lighting, musty, muddy-coloured carpets and somnolent staff, it had come down a long way from its original art-deco splendour. But this was where Noel Coward had stayed, and the grey-haired jazz band that played the lobby bar every evening was said to have first performed there before the communists came. Best of all, the Peace Hotel stood on the dress circle of the Bund, looking out over the Huangpu River that connects the Yangtze to the sea.

As the sun came up palely in the polluted sky on our first morning in the city, we watched a fleet of barges making their way upriver. They were laden with sand and cement, heading for the scores of construction sites around the city. We were there at the dawn of a building boom which, over the next few years, would create a whole new infrastructure of ring-roads, subway lines and a grand bridge across the river to a vast new development zone called Pudong.

Pudong was an ambitious project to be built on 350 square kilometres of rural land that had supported more than half a million farming households. It was planned as a financial and commercial centre that the leadership hoped would one day rival Hong Kong. On that autumn morning Pudong presented a strange sight. At its centre was the already completed Oriental Pearl TV Tower, decked with roseate orbs that gave the whole structure a kind of cartoonish feel, as if the design had been taken from *The Jetsons*. Around the tower, high-rise apartments, office blocks and factories were already taking shape, while farmers hung on in emerald patches of rice paddy between the construction sites.

As we looked out across the river at the future, the granite edifices of old Shanghai stood at our backs, while the sounds of a port city—the sad moan of the ships' horns, the cries from the bargemen, the hum of the engines—were mixed with the sound of a Strauss waltz issuing tinnily from a ghetto blaster. All around us on the elevated walkway by the river there were Chinese couples dancing. They came here, we discovered, at dawn every day to practise their steps—waltzes and sambas, foxtrots and cha-chas—with a proficiency most Westerners could only dream of. Young, middle-aged and old couples gathered each morning wearing natty tailored outfits and sharp shoes—two-toned lace-ups for the men, and black leather court shoes for the women, all slightly worn but otherwise well cared for. You could sense they, too, had held on to an idea of Shanghai that they wanted to live up to.

Over the next days we put together the pieces of our story. During business hours we followed the agenda laid down by the city's 'foreign affairs bureau', who assigned us two minders to dog our every step. After dark we pursued the encounters that would bring the story to life: the construction workers from the countryside now labouring through the night on the new city buildings; the young entrepreneur

who had escaped to the West after June 4 but had now returned to sell 'natural mud packs' to newly beauty-conscious Shanghainese; the investors in the recently established stock market swapping tips and forming syndicates; and the farmers in Pudong chasing one last harvest before the bulldozers moved in.

Huge swathes of old Shanghai were being razed for new developments and their residents were being rehoused across the river in Pudong. In those days, few people wanted to move to the new accommodation. We visited an informal 'housing exchange' where a broker sorted out people's living arrangements for a fee. He would find a person willing to trade down to less space to stay in old Shanghai, and put them together with someone who was happy to cross the river for a modern bathroom. It had once been the case that you had to live where you were put, in accommodation linked to your 'work unit'. But the old rules were gone, and ordinary people were making new ones to suit themselves.

The housing broker disavowed any financial motive for setting up the exchange. He kept trying to tell us he had established it out of a simple desire to 'serve the people', in the words of the old Maoist slogan. If anyone wanted to give him a gift of money out of appreciation, he said, that was just a happy bonus. Deng Xiaoping may have given his blessing to the idea of getting rich, but many people still thought it safer to keep one foot in the orthodox past while they dipped a toe in the future.

Down at the stock exchange people were happier to admit it was all about the money. The exchange had opened in 1990, trading shares in what were still majority state-owned enterprises. Issuing small parcels of shares became a favoured way for these enterprises to raise funds, bringing in investment without surrendering control.

In those days a number of small exchanges had opened around Shanghai, making it as convenient to buy stocks as to go to a betting shop in the West. The one we visited was housed in what had once

been a Russian Orthodox Church, but only we seemed to think this was funny. There we met a number of ordinary traders who admitted to doing well. Many were investing what were quite large sums in the Chinese context, and some spoke of their intention to put a third to a half of their savings into the exchange. Like small investors the world over, they seemed to have little sense that the stock market might ever go down.

A number of them also claimed to be working for others as well as themselves. One told us he invested on behalf of a whole syndicate of taxi drivers, having got into conversation with one of them on a ride home from the exchange. He claimed to take only a percentage when the stocks went up, and not a cent if things did not pan out. He told us he had hundreds of thousands of renminbi (RMB) under management, this at a time when the annual per capita GDP ran at only around RMB3000.

Although I was a little sceptical, I was reminded of the taxi driver syndicate years later when the Chinese billionaire—and former Shanghai taxi driver—Liu Yiqian rose to prominence as an art collector. With his wife Wang Wei, he has now built two sprawling private museums in Shanghai to house his collections of Chinese and Western art. Soon one of the star attractions will be a Modigliani nude that he picked up in November 2015 for US$170.4 million, at the time of writing the second-highest price ever paid for a work of art at auction.

As we made our way around the city it was hard to escape the sense of excitement that Shanghai was finally on the move again. Officially some 150,000 workers had flocked into the city to work on construction sites in 1993 alone, but unofficially the number of so-called 'migrant workers' fuelling the building boom was believed to be much greater. These workers came from rural provinces like Anhui, where the dissolution of the communes was creating a vast surplus workforce.

The work they did in Shanghai was backbreaking, with long shifts keeping construction going day and night, but the workers still felt they were stepping up in the world. One told us that if he had stayed at home he would simply have been a 'coolie'. Now he had his own money to spend and places to go and have fun. Moving to Shanghai had given him a kind of autonomy that not long before would have been impossible. 'Shanghai is a good place, full of money,' he told us, but then added with a laugh: 'It's easy to make and easy to lose.'

We wondered whether the government would be able to control a resurgent Shanghai, failing to notice what would become more obvious later, that much of the development in the city was being driven by the state itself, not private entrepreneurs. For all the talk, Shanghai was not going to become another Hong Kong, or even another Shenzhen. The ideas that had underpinned the economic reforms in the 1980s— that the productive forces in the country should be liberated through incentives to individual enterprise—were being downplayed post-1989 in favour of a new kind of state capitalism. In Shanghai foreign investment would be directed solely into state-owned enterprises, while Chinese banks would be encouraged to favour the state-owned sector also, leaving private entrepreneurs to raise money in a new, unregulated and risky 'shadow banking' sector.

The Shanghai we saw was on its way to being a leader again, but in a very different manner to its pre-communist past. The city was in the vanguard of a new approach to development that would end up defining the whole Chinese economy by the end of the 1990s. Shanghai would demonstrate how powerful the state could be in creating profits for itself when it exploited its monopolies, in particular over the ownership of land. Land grabs by the state, like those that occurred in Pudong (where traditional users of the land would be evicted with minimal compensation only to see the land-use rights re-sold at a massive profit), are now commonplace across China. Profits are turned towards new developments, infrastructure and services, but

also towards creating wealth for a well-connected few. Shanghai in the 1990s was where China's crony capitalism of today was born.

On our last evening in Shanghai, Sally and I decided to toast the city from the top of the Peace Hotel, with its stunning view across the river. In theory, the roof was out of bounds, but we ordered gin and tonics in the lobby bar and smuggled them into the lift to the top floor. We found a stairway to the roof and stood looking out, giggling like schoolgirls. Inevitably a hotel worker appeared and made a half-hearted attempt to chase us down into the hotel again. He gave us a short lecture about safety but you could tell he, too, was seduced by the view from the roof. As he withdrew he tutted with disapproval as he saw us leaning back against the dusty masonry. A couple of minutes later he returned, not to order us off the roof, but with collapsible chairs for us to sit on. The old spirit of the Peace Hotel clearly lived on in his heart.

Viewed from our eyrie the Pudong side of Shanghai was mostly dark, nothing like the neon-lit landscape that it is today, but the reflection of the ungainly pink spire of the Pearl TV Tower shimmered in the river. We recalled that the view from the tower was one of only two things our Chinese minders in Shanghai had been truly excited about showing us. The other was a 'very special' restaurant that they had been angling to take us to from our first hour together. Day after day we had blocked this suggestion: we had too much ground to cover to spare time for an interminable introduction to Shanghai's local delicacies. Finally, on the last day, we relented. It said more about the new Shanghai than anything else we saw that week that the 'very special' restaurant turned out to be the first-ever Chinese outlet of the fast food giant, KFC.

By the time we arrived to shoot our story in Shanghai in 1993, around 70 million people throughout the country had joined what would become known as the 'floating population', people who had been cut free by the dissolution of the communes. These workers would power the transformation of China over the next decade, building the sky-scrapers and the roads, the subways and the bridges, operating the machinery and manning the assembly lines that would turn China into the factory of the world. The displacement that had begun in the 1980s would accelerate through the 1990s at a stunning rate. By 1999 the China that had begun the great experiment in reform and opening up twenty-one years before would be almost unrecognisable.

The generation of which Jia Aili and Cao Fei were a part would come of age at the end of the twentieth century, having already experienced more change than most of us in the West would know in a lifetime. Jia Aili would witness the decline of the monolithic state enterprises, the cradle-to-grave socialism that had once guided the nation. He would see his parents made redundant while still barely middle-aged, but also find himself being given the chance to enter university—the first in his family to have ever done so.

Cao Fei would watch as her home town of Guangzhou spread out into the Pearl River delta, engulfing farmland and absorbing villages as it rose from smoggy backwater to a powerhouse of the Chinese economy. She would see her older sister morph from model student to advertising executive, turning her back on the most treasured am-bitions of her parents. As for herself, Cao Fei would begin to dream of and make art in a different world entirely, one that could be lived in costume, online, and eventually in a new virtual space called Second Life where there were no boundaries of age, geography or imagination.

The speed of change in this decade would rival anything before or since. At the end of it nothing in China would look the same, not even in the farthest reaches of the country. And at the end of the century a whole new reality had taken hold, where a divide between rich and

poor had been installed as a pillar of progress, where the idea of the state providing you with work, security and purpose had been consigned to the scrap heap, and where neighbourhoods that had existed for centuries were wiped off the map overnight.

Each year of the 1990s I would return to China, and every year I would experience the shock of non-recognition, of arriving at a place I had once known well only to find it simply wasn't there any more. For me it was sad, disturbing, even shocking; so what must it have been like for people who did not have another home to return to?

One day Zhang Xiaogang and I sat in his studio discussing some of his new works, sculptures of ordinary but obsolete objects—transistor radios, rotary dial phones, ink bottles, music cassettes—all rendered in bronze. He told me he had, not for the first time, lately been struck with nostalgia. He felt that was OK for a man in his fifties like him, but then he said how strange it was to look at the work of artists who were only half his age and recognise nostalgia in their works, too. He saw they were also making works recording the objects and scenes of their youth, and rendering them with romantic poignancy. He realised that for them, the things and places that in their twenties they should be confident would remain with them were already slipping away. 'To be Chinese in this era,' he told me, 'is to feel nostalgic when you are still quite young.'

WHOSE UTOPIA?

On February 19 1997 Deng Xiaoping died. He was 92, and had not been seen in public for more than two years. The last glimpse was an official photograph from October 1994. He was seated in an armchair, tucked up in a rug and wearing a cap against the autumn chill, watching the fireworks for the 45th anniversary of the People's Republic exploding in the sky over Beijing.

His passing had long been anticipated. Early in 1995, when I was working for *Foreign Correspondent*, Sally Neighbour and I had jumped the gun by two years, flying to China to produce what we intended as an obituary piece on the great man, who was rumoured to be at death's door.

We talked to a whole cast of characters on that trip in 1995, and learned how varied the experience of Deng's reforms had been for people, depending on where they lived, what they stood to lose or gain, or what vision of the future they nurtured.

There was the newly made millionaire, a high-school drop-out who had made his fortune in real estate while still in his twenties and was eager to share with us his taste for high-priced Scotch and luxury cars. He drove us around Tiananmen Square and up the Avenue of Eternal Peace under the eyes of Mao's portrait without a hint of embarrassment. He told us he had made a fortune transforming deserted factory buildings into smart office accommodation, and was now developing apartments for the new middle class.

Then there was the young pollster, at just 29 the head of his own company. Formerly a bureaucrat with the Ministry of Commerce, he had met an American executive from Gallup and thought there might be scope for a polling firm in China. He was right: one of his first customers was the Communist Party's propaganda department.

His company was in the middle of a major survey of the 'floating population' in Beijing, trying to understand more about the hundreds of thousands of former rural workers who had come from all around China to find employment in the capital. He described how they had congregated on the outskirts of the city, forming themselves into separate 'villages' depending on where they came from. There was the Henan province village, which specialised in rag picking, and the Zhejiang province village that was full of entrepreneurs running small businesses. And then there were the workers from Anhui, who laboured on construction sites and as domestic help. All of them had come to Beijing without permission, living on the margins with dreams of making a new life.

We interviewed dissident intellectuals who placed hope in the development of a civil society in China as an alternative path to democracy. They pointed to the nascent environmental movement, and to the non-government organisations which were beginning to appear, specialising in workers' rights or education for the poor. They took heart also from the rise of a more freewheeling and commercially minded media, with a new focus on personal pleasures like fashion and sport. The media kept clear of sensitive political ground, but there was a big market for crime news, and our informants explained how this allowed all sorts of titillating topics to be explored under the banner of 'law and order'.

Others we spoke to were less sanguine, such as the sociologist with the Chinese Academy of Social Sciences who had been studying the reforms since the 1980s. He warned of the fissures opening up in society as the new economy eroded the secure guarantees of socialism

and made workers more vulnerable. He believed workers and others should be able to form their own organisations, but knew the party wouldn't allow it. And yet it was heartening that he could at least float the idea, as he had in an article with the provocative title, 'How much reform can Chinese society bear?'

But we remembered the sociologist's pessimism when we met with a young woman whose husband, a lawyer and activist for workers' rights, was serving three years' hard labour for the crime of printing T-shirts bearing the slogan 'Labour solidarity is sacred'. She had been barred from seeing her husband for almost a year and had herself been detained for three months without charge. Even her attempts to send him mooncakes at the Mid-Autumn Festival had been denied. She seemed broken by this lack of basic decency and was angry that a slogan once embraced by the Communist Party was now seen as criminally subversive.

It was clear that China was a richer and more powerful country for Deng's reforms, and in the private realm it was freer as well. But it was also true that a lack of political reform had allowed corruption to thrive and left ordinary people vulnerable. The government's harsh tactics with even mild dissent were disturbing, too. And there had been no attempt at a reckoning with the tragedy of June 4 1989—something that would taint Deng's legacy in years to come.

The contrast between the anguished woman whose husband was lost to the prison system and the brash young real estate millionaire was so stark that it was hard to believe they shared the same generation and the same city.

The experience of economic reform for ordinary citizens was a profound shock—devastating for some and transformational for others.

Take the example of the signature reform of the 1990s, the corporatisation of hundreds of China's lumbering state-owned enterprises (SOEs). The shockwaves spread into all corners of Chinese society, bringing some regions to their knees and galvanising others, destroying the hopes and plans of millions and making a handful into millionaires.

Deng Xiaoping probably never said 'to get rich is glorious', despite this classic 1990s slogan being widely attributed to him. But he certainly did say that in the pursuit of development it was necessary to 'let some people get rich first'. By the end of the 1990s it was clear who those people would be.

Those with connections made a killing from the SOE reforms. They got in on the ground floor, working the angles in the sale of enterprise assets, or picking up shares in new commercial subsidiaries in advance of their listing on the Hong Kong stock exchange. Billions of dollars of state assets were transferred into such subsidiaries, effectively moving them from state to private ownership. Those with the best connections of all—members of China's elite families whose patriarchs had served as Mao's comrades in arms, a group popularly known as the 'princelings'—secured executive positions in the most promising of the newly corporatised enterprises, ones that commanded powerful stakes in key sectors like energy, communications or banking.

The SOEs had once been the backbone of the economy and the guarantors of the 'iron rice bowl' that protected Chinese workers from cradle to grave. Their new mission would be starker—to maintain state control of strategic sectors of the economy while cutting loose loss-making enterprises. Over six years from 1995 to 2001 the number of SOEs would be slashed by more than half and some 36 million jobs would disappear.

Shenyang was ground zero for the economic reforms which decimated the once proud industrial north-east. The capital of Liaoning province, Shenyang witnessed the long, sad death of the old system which had offered lifelong protection to workers.

In the late 1990s Shenyang and the whole province of Liaoning was wracked by unrest as pensioners and unpaid workers took their grievances to the streets. At that time it was estimated that more than a quarter of retirees' pensions were in arrears in Shenyang, while 23 per cent of the city's workers were owed wages. Roads were blocked, and government offices besieged. There were reports of riots and looting.

But even as protests multiplied those involved were careful to avoid any impression of being involved in an organised movement. They were diligent in presenting official petitions to the government for redress, focusing narrowly on their particular grievances and disavowing any wider demands. They described their protests as 'spontaneous', and avoided making common cause with people from other workplaces. The memory of what had happened to those who had tried to form independent workers' unions in 1989 was still fresh.

Yet anger ran hot over the corruption that was being exposed as the economy was transformed. As enterprises went bankrupt, workers sometimes caught a glimpse of how their assets had been stripped and diverted into private hands. In the provincial town of Liaoyang, some 85 kilometres from Shenyang, the workers' anger finally bubbled up into mass protests early in the new century.

The trouble began with workers at the Liaoyang Ferro-alloy Factory (or Liaotie for short). The workers at Liaotie had been petitioning the local government for help since 1998. Their wages and pensions were months in arrears and it was an open secret that management were illicitly transferring the assets of the enterprise for private gain. In May 2000, after two years of petitioning without response, 1000 Liaotie workers blockaded the Liaoyang–Shenyang highway in a desperate attempt to get the authorities to act and ensure their outstanding wages and pensions would be paid. Police broke up the protest, and even when the workers took their grievances directly to the city hall they still got no response.

The final straw came at the end of 2001 when Liaotie was declared bankrupt. All around them in the city, Liaotie's workers saw other

examples of bankrupted enterprises and workers like them being left without hope of recovering their back pay, or retirees their pensions. In March 2002 they took their action to the streets once more, with 30,000 workers rallying in front of the local government headquarters, the biggest demonstrations in China since 1989. The workers sang 'The Internationale' and protested the local government's lack of support for the workers and their complicity in the corruption. In an open letter they called for the payment of owed wages and pensions and the removal of corrupt officials.

A week later the protests had spread far beyond Liaotie and an estimated 100,000 workers rallied in the city.

By the time of that demonstration the authorities had already begun to round up the leaders of the movement. Two were charged with subversion; in January of the following year they were sentenced to four years and seven years in prison. Even when sentenced they remained unbowed, one declaring that he had no regrets and considered his seven-year sentence as 'a seven-year contribution towards democracy'. There was some satisfaction when soon afterwards the manager of Liaotie was put on trial for corruption, and drew a thirteen-year sentence.

During these years of upheaval Jia Aili had come to study in Shenyang. The Lu Xun Academy of Fine Arts was poignantly situated just next door to the once monumental industrial district of Tiexi. When Deng Xiaoping's reforms began, Tiexi was the country's leading industrial centre, and home to one million workers. Now Jia Aili watched as it hollowed out and became an industrial wasteland. Eventually even the emptied factory buildings disappeared. Razed to create commercial real estate, the factories were reduced to scrap, and a way of life passed away before his eyes.

Of course he had been witness to this demise in his home town of Dandong since he was a boy. 'The concepts of reform and opening up are two separate things for us people in the north-east,' he told me one

day. 'We experienced the reform but not the opening up. The 1990s was a very sad period, a very harsh period for us.'

Eight years after he arrived in Shenyang, Jia Aili would leave for Beijing and it would be there that he staged his first exhibition. It would be titled 'The Wasteland'.

For all the wrenching social impact of the SOE reforms, few at the time realised that corporatisation had a far-reaching upside as well. As SOEs shed their labour force they were directed to give up the stock of housing they had maintained for their workers. In the late 1990s, huge swathes of urban housing in China were privatised and the apartments sold to sitting tenants at prices well below market rates. In this way, tens of millions of Chinese were given the chance to acquire a property that appreciated in value over the next few years. Many leveraged their asset for more real estate, becoming landlords or even speculators, and changing the outlook for their children.

The result was a massive broadening of China's propertied middle class, their expectations and interests very different to the workers they had once been. It was as if, in the words of the economist and former Australian ambassador to China, Geoff Raby, 'Margaret Thatcher had come to China'.

In the year 2000 Cao Fei wrote her first email. It was her first encounter with the internet—a medium that as an artist she would soon make her own.

To get her message into cyberspace, she had to ask around among her friends till she found one whose parents had an email account. It was on their computer that she wrote her first 'artist's statement'.

She had been asked by a curator to explain the ideas behind her first film, titled *Imbalance*. She had made it the year before on a borrowed DVD recorder, casting her classmates at the Guangzhou Academy of Fine Arts into a study of 'restless adolescence'. Entered in a competition in Hong Kong, it had caught the attention of curator Hou Hanru, who chose it for a photography festival in Madrid.

Hou had been attracted by Cao Fei's filmmaking flair, the skew-whiff camera angles and tracking shots. But what struck me when I saw *Imbalance* years later was how free her classmates seemed to be, despite their adolescent angst, how mockingly they faced the world. The whole thing read like an advertisement for the pleasures of 'spiritual pollution'. All the things that had agitated the Old Guard back in 1983, all the toxins they had sought to expel from China—'pornography', drugs, gambling—were there, and not even as the main point of the film, but just as part of the background of these college kids' lives.

They were enjoying the luxury of adolescence—an indulgence that was still new to China—in a city that was booming and open to the world. Guangzhou was the capital of Guangdong province, which by the year 2000 was producing 42 per cent of China's exports and attracting the majority of the country's foreign investment. Workers flocked to the factories of the Pearl River delta, and by the turn of the century Guangdong province was home to a third of the 144 million workers who had by then left their villages in search of a new life.

The south was being transformed socially and physically, and this was the subject of Cao Fei's next project.

Through the 1990s she watched as her home town of Guangzhou grew, rolling out into the countryside, turning fields into factories, farms into condos. As Guangzhou grew it began to swallow entire villages whole. The farmers would lose their fields but keep their houses. Robbed of their old livelihood, they built tenements on top of their homes and set up as landlords, offering cheap accommodation

to the floating population of workers who had left other farms around China in order to find work in the city.

Villages that had once been home to three or four thousand people now housed ten times that number in these strange pockets within the city. Slipping down an alley off a main street you could find 130 such urban villages in Guangzhou, where the tenements crowded in so tightly that sunlight reached the ground only in shafts, and the old village life continued side by side with a whole new service economy for immigrants. Long-distance phone offices sat side by side with nail bars, dumpling shops and workshops that restored discarded white goods for sale. The landless farmers planted vegetable crops and raised chickens on their roofs. On feast days, traditional dragon dancers squeezed their way through the narrow alleyways. One of these villages—a place called Sanyuanli—became the subject of Cao Fei's first major documentary film (produced in association with her then boyfriend, the artist and writer Ou Ning) in 2003.

Like Jia Aili, Cao Fei saw the face of her home town transformed as she grew up. But while Jia Aili became obsessed by wastelands, Cao Fei was gripped by cities. In the new century she would return to urban landscapes again and again, creating whole fantasy cities on video, in animation and on the internet, while taking her camera out to explore real cities in her documentaries. In all of these she was working out how people live in these urban spaces, and while living there how they could still find a way to dream.

By the turn of the century, with more than 10 per cent of China's population on the move, many itinerants found appalling conditions in their new employment: exploitation was rife in the factories and much of the alternative urban work was dirty or dangerous. And yet those who came still believed they had made the right decision by leaving home.

In the factories of Guangdong, despite booming profits, non-payment and underpayment of wages was rife, as were inhuman hours of

work. At the turn of the century, research by the Communist Party Youth League found the majority of factory workers in Guangdong worked twelve to fourteen hours per day with rarely a day off. Conditions were particularly severe in the garment industry, where pressure to fill orders pushed conditions to new extremes. A new word, *guolaosi* ('overwork death'), entered the language to describe cases where workers dropped dead of exhaustion. The Chinese press reported twelve or more cases per year of *guolaosi* in the early years of this century, while deaths due to industrial accidents were reported as occurring at a rate of one every four days in Shenzhen during 1998. Incidents of serious injury were also common, with Amnesty International counting more than 12,000 such accidents in that same year in Shenzhen.

The special economic zone of Shenzhen was in the vanguard of China's transformation into a manufacturing superpower, its GDP growing by more than 30 per cent a year on average throughout the '80s and '90s. In the '90s Shenzhen would also become a pioneer in labour activism, as workers there tried to enforce the rights that were laid down for them in China's national labour legislation. These laws, which prescribed conditions such as maximum hours and minimum pay rates, were routinely ignored by employers, but in the '90s there was an increasing number of cases where workers would, often after Kafkaesque manoeuvrings through the system, achieve some limited redress. Some industrial actions began in almost comical circumstances, as happened in the case of an export textile factory recounted by the sociologist Ching Kwan Lee in her brilliant study of labour activism in China, *Against the Law*.

In this instance the workers were made aware of their rights when their bosses set out to drill them on the correct answers to give to a visiting inspection team from the factory's American customers. This was how they learnt of their entitlement to five-day work weeks, eight-hour days, Sundays off and limits on overtime—all entirely absent within their workplace.

China's Labour Law was enacted in 1994 but, like many other laws passed in the country since the beginning of reform, lofty ideals were not matched with the means (or often the will) to enforce them. Workers' frustrations over the inability to get what was legally theirs made Shenzhen infamous throughout the country as the worst city in China for labour disputes. By the turn of the century even conservative estimates suggested that there were hundreds of large-scale protests or strikes breaking out annually in Shenzhen.

Yet, despite the harshness of life in the cities, workers continued to leave the countryside in droves to try their luck. It is the dreams of these workers that have driven the urbanisation of China, turning a country where 70 per cent of people once lived on the land to one where more than half live in cities.

The notion of success in the city persisted because for most of those who came, despite all the difficulties they faced, they did end up better off. Most earned more than they would ever have been able to make at home. This was money that could be remitted to their families or used to fund vocational study or investment in a small business. Then there was the intangible, but exhilarating, gain that they made—a sense of control over their own destiny.

Cao Fei's father recruited many of these rural itinerants to work with him on the massive sculptures which he was now being commissioned to create. Cao Fei spent hours hanging out with them, listening to the stories of their floating lives. The workers told her how they would fake their identity cards, lowering their age over and over again, as the young always found it easiest to find work. She was fascinated by their stories and curious about their dreams, which she put at the centre of her art when she made the documentary *Whose Utopia?*

She spent six months in a Guangdong lighting factory charting both the minutiae of the work and the fantasy lives of the employees. In *Whose Utopia?* the workers pirouette in tutus among the machines, play electric guitar, sweep through store rooms in evening dress, and

dance like Gene Kelly across the shop floor. Young workers look out dreamily over the rooftops of the city and don T-shirts with the slogan 'My future is not a dream'. For Cao Fei the message of her film was clear: even when life is difficult or boring for people, their dreams can give them some power.

But when *Whose Utopia?* was released, audiences saw it as a commentary on the cruelty of capitalism, the fantasy elements inserted to highlight the workers' wretchedness. She was hoping that they would see something more complex. When she talked to the workers, she discovered that rather than feeling exploited, they felt lucky to have escaped poverty in the countryside for a job where they could help their families and themselves. Cao Fei was wry when she told me this, pointing out that it was important to not just see issues from a 'correct line perspective'.

Despite my natural cynicism as a journalist, I knew immediately what she meant: I had been there myself. In 1996 I had teamed up with ABC TV's new China correspondent, Jane Hutcheon, to tell the story of China's floating population. We had decided to look at it through the eyes of a young rag picker from Anhui who we had found living on the fringes of Beijing. He had sunk all his resources into a pedal cart on which he scoured the city collecting cardboard, plastic bottles, cans and every other kind of rubbish that could be turned into cash, selling it on for tiny sums to professional recyclers one rung up the economic ladder from him.

Yet he was managing to house and feed his wife and child on the money he was making, as well as sending some funds home to his parents and saving a little, too. When we travelled back with him at Chinese New Year to his home in a hardscrabble village in the heartland of Anhui, we saw him greeted like a hero and glowing with happiness at his parents' evident pride. We saw the benefits his remittances had brought—in the quality of the food his parents ate, and in the improvements to their house. Nearby we saw the local version of a mansion

being built. It was owned by a man known as 'Mr Shanghai' for the city in which he had made his fortune. In this village everyone but the old or the very young had either left for the cities or were planning to do so. It was hard to deny the power of the urban dream.

Further up the economic ladder from China's floating population were young people with an education, looking for routes to success in the new economy. For many, the solution was *xia hai*.

Meaning literally 'jump into the ocean', *xia hai* is Chinese slang for going into business. But it also implies taking a chance, jumping out of the box you'd been put in, swimming free. Deprived of the place in the nation many of the Tiananmen generation might have dreamed of, blocked from work in the bureaucracy or in academia, or simply finding these paths too frustrating, they embraced business instead.

It was one of the ironies of the 1990s that while much of the youthful idealism of the 1980s had disappeared, the reforming economy created opportunities that sparked a boom in youth culture across urban China in the new decade. Rock music exploded, and fashion followed, as did bars, cafés and restaurants that opened late, bringing life to the cities that had once been shuttered and dark at 6 p.m. Gay culture became more visible, as did the guys and girls we called *liumang*. *Liumang* was Chinese for 'hoodlum', but these *liumang* were much more than that. They were punk and grunge, rock and pop, they were whatever the official culture did not want youth to be. Like outlaws in a Hollywood Western, they were avatars for their generation's alienation; they were cool. It didn't hurt that a whole range of things that people liked to do (like extramarital sex) were branded as hooliganism under Chinese law, and hooliganism was (till 1997) a crime.

In Beijing filming our Deng Xiaoping 'obituary' in 1995, we were surrounded by the *xia hai* spirit. It was there in the characters we

interviewed, and it was there among many of my friends, too. One couple I knew paid the bills with the husband's salary from his assigned job teaching oil painting at an art college, while the wife ran a thriving business selling trinkets and beautifully forged ration tickets on the side. With the cash she earned they rented part of a courtyard house deep in the centre of the city where they could make art, preside over an open-door salon, and escape the college's prying eyes.

Then there was the painter I'd last seen hanging out at the Old Summer Palace artists' village, living from hand to mouth. At that time, he had agonised to me about the creeping commercialisation of the art scene and the need to stay true to his ideals as a painter.

When I next saw him in 1995 he had opened a chic restaurant in the middle of Beijing's Sanlitun embassy quarter and was planning to expand into a chain. He was the first of my friends to tell me his ambition was to make enough money to one day be a person of influence. Only then would his generation really have a chance to 'change China'.

This was quite a common sentiment in those days among the young entrepreneurs who were doing well. 'Get rich and change China' was almost a slogan.

And so, in the 1990s, the children of revolutionaries would become crony capitalists and one-time workers would become middle class, the south would boom and the north would rust, and one-time idealists would go into business.

Many creative artists, though, still preferred to live on the edge in one way or another. For some, keeping their heads down just wasn't in their nature. In the year after June 4, Cui Jian performed his song *A Piece of Red Cloth* in a series of high-profile concerts, each time putting on a red blindfold before he began to sing. As a result, he was banned

from playing in Beijing for the whole of the '90s and his music was blacklisted on TV and radio.

Many others just wanted to fly under the radar and make art. At the end of 1994, after months of rising tension, the police broke up what was left of the artist village at the Old Summer Palace. For several months before the crackdown, artists had been leaving the village in search of new places where they could live and work, some even heading abroad. Many moved out to a village called Songzhuang in the neighbouring province of Hebei. Meanwhile, inside Beijing, a new colony of artists had established themselves in a workers' village on the city's eastern fringe. They christened the place 'East Village' in homage to the eponymous bohemian district in New York.

These artists were a special breed, and the East Village precinct (now long gone) nurtured some of China's finest art talents. Those who set up there were interested in pushing themselves to extremes. Their performances ranged from the gender-bending and sexually provocative work of Ma Liuming, to the masochistic feats of endurance of Zhang Huan. These events, held for small groups of friends and critics and photographed by their fellow artist Rong Rong, eventually attracted the attention of police. Ma and Zhang were both arrested, with Ma spending three months in detention for 'distributing pornography'.

Zhang Huan later wrote that his work at the time was aimed at 'experiencing the authentic existence of adaptability and endurance'. The most infamous of his performances was entitled *12 m²*, named for the dimensions of the noisome village toilet in which he sat for an hour, naked and covered in honey and fish oil, giving himself over to the attentions of swarms of flies. Rong Rong's photographs of the performance, showing Zhang shaven-headed in the half-light, have the stoic beauty of a Renaissance painting of a martyr.

The day Zhang was arrested he was attempting an even more painful feat, hanging naked in chains from the rafters of his studio,

blood dripping from a tube inserted in his arm onto a heated hotplate below. The smell of burning blood and the sizzling of his sweat as it dripped onto the hotplate made the piece almost unbearable to watch, let alone perform, and yet he persisted for an hour.

In 1997, just before Zhang Huan left China for New York (and eventual international art stardom), he joined with a group of 46 itinerant workers to create a piece called *To Raise the Water Level in a Fishpond*. The workers waded into a large fishpond, where Zhang finally joined them, carrying the young son of the owner of the pond on his shoulders. The achievement behind this oddly poetic work— that together they had managed to alter the level of the water—was negated by the fact that, as Zhang put it, theirs was in the end 'an action of no avail'.

When the police broke up the artists' village at the Old Summer Palace, Guo Jian decided to leave China altogether. He had been there at the start of the village and he was there for the end. It was time to go. 'I just wanted to be able to express myself in my art and I knew that wasn't going to be possible in China,' Guo Jian told me.

In the months previously the police had visited him. They seemed to know everything about him, including the fact that he already had a visa for Australia. 'They said to me, "If I were you, I'd go to Australia and never come back."' Then, a week before the village was broken up, a soldier in uniform turned up to see him. Guo Jian didn't know him but the soldier spoke with the accent of his home town. He told him he had a message for him: to get out of the Old Summer Palace. 'He told me, "This place is not going to be allowed to survive, go anywhere, but don't stay here!"' It seemed that the army was reaching out to him. They knew he had once been one of them and they wanted him to know that they were still keeping track of him.

Before he left for Australia he travelled south to see his parents. One day he sat down with his mother to tell her he was leaving. She took the news hard. 'She kept asking me, "Why? Why do you want to go away?"' Suddenly there was a noise in the street that he knew well. The rumble of a convoy of trucks and the bark of a loudspeaker signalled a grim parade: doomed prisoners were being driven through the city on the way to the execution ground. He had heard that sound with sickening regularity during the Cultural Revolution when mass shootings would be held on every major holiday or festival. ('Even on Children's Day!' he had once grimly recalled.)

As the trucks rolled by, the loudspeakers blaring out the crimes of the condemned, he turned to his mother: 'Do you hear that, Mum? If I don't go, one day I could be on that truck.'

In the early years of the 1990s many aspiring artists leapt at the opportunity to leave China, creating parallel tracks for the development of the contemporary art movement. Many Chinese artists rose to prominence in their new home towns—New York, Sydney, Paris and London—where they joined the Western art system of commercial galleries, museums, biennales and art fairs. Meanwhile, a different kind of art scene evolved in China. There was almost no infrastructure to support contemporary art, so artists retained their independence and learnt to manage their own careers. They represented themselves in their limited dealings with the market, and with the Western curators who eventually came calling.

The artists banded together in the artist villages, staging informal exhibitions and 'happenings', pushing each other and themselves. They teamed up with rock musicians and filmmakers, dancers and actors, writers and bar owners to create an alternative world, far removed from what passed for 'official culture' and sanctioned forms of entertainment.

'It's funny,' Aniwar said to me one day not long ago, 'during the '90s we were so down on everything, feeling it was such a comedown from how things were in the '80s, and yet looking back you can see it was actually a really great time for art, for life. Every week a new bar would open, there was a lot of drinking, a lot of music.'

In the same way that the '80s in China echoed the '60s in the West, the '90s were a bit like the '70s. It was a decade that people continually declared inferior to what had gone before, while ignoring how much deeper contemporary culture was becoming, how fiercely artists were mining the emotional terrain, and how determinedly people were working to allow contemporary culture to sustain itself and to grow.

In those years Aniwar's one-room apartment became an oasis in Beijing. He would leave his door unlocked and most nights ten or twenty friends would congregate for a party, dossing down at the end of the evening on the bed that sat at the centre of the room, or curling up on the Xinjiang carpets that softened the chill of the floor, while Aniwar painted deep into the night.

In those years he was creating his own language of colour and light that distilled icons from his homeland of Xinjiang into richly coloured curves and strokes that kaleidoscoped across the canvas.

He had come to the capital of China from a place so far away that its capital sits at the 'pole of inaccessibility' of the Eurasian land mass, the point that is farther from the sea than any other in Europe or Asia. In Xinjiang, ancient oasis towns confront the immensity of the Taklimakan Desert and the soaring peaks of the Karakoram.

Aniwar had grown up saturated with colour and light. His earliest memories were of sunlight strobing through the leaves of the poplars that colonnaded the back roads of Xinjiang. He remembers being lifted up to face the intensity of a limitless blue sky, watching the play of colour flashing on his eyelids when he closed his eyes.

Arriving in the monochrome Beijing of the 1980s had been a

shock to his senses, and it had even leaked into his dreams, turning them black and white for the first time in his life.

Aniwar's paintings, at first figurative and as the decade progressed increasingly abstract, sought to capture the exhilarating meeting of the human and the cosmic that the vistas of Xinjiang can offer. As the decade came to a close his canvases became richer and more assured. With decorative borders that suggested the woven oriental rugs of Xinjiang, the paintings took on the quality of magic carpets to another world.

In 2000 he showed them in the Courtyard Gallery in Beijing, then the leading contemporary space in the city. He chose an entry in his diary from 1989 to describe what he believed was the purpose of art: 'It is not only to stimulate and to excite people; on a deeper level it is also to help them forget their agitation.' Perhaps more than any other artist from the 1980s he retained something of the pure spirit of that decade's bohemia, a dedication to art for art's sake, beyond politics. In going deeper, his work didn't get darker (unlike that of many of his peers), it got freer. As he once said, 'If you allow yourself the quiet of mind to follow your instincts, art rewards you with a huge space and within it you can do as you wish.'

Recently Bao Tong, who was Zhao Ziyang's secretary and long-time adviser during the 1980s, gave his verdict on the legacy of Deng Xiaoping. Under a form of house arrest even today, after being imprisoned for seven years after the Tiananmen crackdown, Bao Tong has become one of contemporary China's most mordant critics. His verdict? 'The upshot of Deng's revolution was that those with significant power got significantly rich, those with modest power got modestly rich, and those with no power remained in poverty.'

This verdict is too sweeping, and too tough.

True, the gap between the rich and the poor, between the rust-belt north and the booming south, and—most worryingly—between the city and the country, had become enormous by the end of the '90s. And although the booming economy had given millions of people the chance to aim for a better life, workers remained vulnerable in a system that was stacked against them and where corruption was rife. While huge numbers of people became property owners for the first time, they would also find that their rights mattered little if their property stood in the way of development.

But for all that, there is no question that by the end of the 1990s China had been transformed. The state had largely completed its retreat from private life. Permission to marry was no longer in the gift of your 'work unit', and extramarital sex was no longer illegal. Neither was homosexuality. For those with any money at all to spend, life in the cities was infinitely more comfortable, more colourful and more fun. Creative life may have been less idealistic than in the '80s but the work of artists, writers and musicians was connecting with their society at a level that was both intense and profound. They were also finding a way to build their careers beyond the control of the state. In 1999 artists such as Zhang Huan and Ma Liuming, who had been arrested for their work in the middle of the decade, found themselves feted at the Venice Biennale thanks to their ability to attract the attention of Western collectors and curators.

In each year of the 1990s, 25 million people were lifted out of poverty. They may not have been lifted far by Western standards, but it was hard to discount the experience of people like Mr Xiao, the rag picker from Anhui whose home we had visited. Before we left him he had confided his ambition. He was saving up to become a chauffeur. And when he did he planned to save as hard as he could so when his son grew up he would be able to see him through university. The point was not that he had that dream, it was that we couldn't deny that it was within his grasp.

In 1999 Zhang Xiaogang moved to Beijing to live, leaving behind his adopted home of Chengdu and his birthplace of Kunming. When he arrived, he told me, he realised what was most essential for him to understand if he was to succeed. 'If you want a new life you need to forget the past,' he told me. 'It may seem like a contradiction to suffer the pain of putting aside your old life in order to experience the pleasure in the new, but you must.'

During the 1990s the whole Chinese nation seemed to take this advice. In order to go forward they put aside the past and embraced forgetting. The 1980s was dead, a new century was in front of them; they had to go forward and not look back.

BEIJING WELCOMES YOU!

I called the number on the lamppost and waited on the corner as instructed. It was late autumn but still warm, the scholar trees lining the quiet street heavy with golden leaves. Across the road a man was mending shoes under a red and yellow umbrella. Street traders were still everywhere in Beijing. That was one thing that hadn't changed.

One of the many things that had changed was that everyone now had a mobile phone. Mine, which I had just used to set up my street corner assignation, was a pale blue Motorola bought second hand in the market: I was told later that probably meant it was stolen. (Just a few weeks after that a pickpocket lifted it, completing the karmic circle.)

A motor scooter drove up onto the sidewalk and parked beside me. Two twenty-somethings in padded jackets and tight trousers dismounted and handed me a card. These were the 'mobile real-estate agents' I was waiting for. They listened gravely to my wish list and assured me they could find me just what I was after.

When I arrived in Beijing in the spring of 2004 I had no intention of moving back to China. I had spent the previous four years freelancing out of Europe but had returned home to Australia at the end of 2003 after a family tragedy. My little brother had died in a senseless accident,

after which my life abroad seemed pointless. But once I returned home I found I couldn't settle down there either. A friend in Beijing suggested a holiday in China as a circuit-breaker. Miserable and sceptical, I got on the plane.

As soon as I touched down in Beijing I knew I wanted to stay. There was a sense of excitement and possibility that I hadn't felt since the 1980s. So many of the people I knew who had left after 1989 were back in the country, drawn by a burgeoning economy and by the sense that other less tangible things might once again be possible.

On the first day, my friend told me there was an art opening that we must go to and that on the way he wanted to show me something else—an art district called 798.

Both parts of the program sounded strange to me. The last time I'd lived in China the only art openings I knew of had either been visited by the police or been held in a private venue, such as a diplomat's apartment. And the idea of an 'art district' sounded unlikely. I knew the artists' villages, of course, but the word 'district' suggested something more solid.

Discovering the 798 district that day was a revelation. It existed in a region behind the airport expressway, which had once been (literally) off the map. In the 1980s official Chinese maps had showed the district as empty space, but the CIA map of Beijing that American friends liked to hang on their walls identified it as a complex of military factories covering half a square kilometre.

For more than 30 years the area was home to up to 20,000 workers who laboured over military components in soaring Bauhaus spaces. The factories had been designed in the 1950s by East German architects who were then in thrall to their native modernist style. The arching saw-toothed roofs were set with windows angled perfectly to catch the natural light, even in the darkest days of winter, while simple rib buttresses supported the curving walls, leaving the spaces airy and open.

Deng's reforms started closing these factories in the late 1980s. By the time I arrived, the workers had long gone, but revolutionary slogans in huge red characters ('ten thousand years to Chairman Mao!') still shrieked out over silent machinery.

On that rainy spring day in 2004, the district was still being colonised. Sculptors from the Central Academy of Fine Arts had taken over some spaces at its fringes, and a bookstore, Timezone 8, had set up in what had once been a workers' canteen. At the centre of the district was the 798 factory itself, which was being developed as an art gallery, and tucked in beside it was a café. As it turned out, both the art gallery and the café were projects of an artist whose name I'd heard but was yet to meet—Huang Rui, who had co-founded the Stars a quarter of a century earlier.

Huang Rui had moved into the district two years before and with a group of other artists had developed a manifesto for what they wanted to create there. The document rang with all of the idealism of the original Stars: 'Here the ideal of the avant-garde will coexist with the flavour of the past, the notion of experimentation will be emphasised together with social responsibility, and spiritual and financial pursuits will prevail simultaneously.'

When he moved into 798 in 2002 Huang Rui had only recently been allowed to return to China. He had attempted a homecoming in the early 1990s but had soon attracted the attention of the police. The artistic performances he designed around essential elements like fire and water were considered provocations by the authorities, their very subtlety suspect. To the authorities, Huang Rui and his work were a dangerous throwback to pre-1989 China. In 1995 he had been deported back to Japan and barred from returning until the new century.

Now he was determined to create what he later described to me as a 'safe zone' for artists in the capital. He believed the key was to make 798 renowned both for its creativity and its commercial success. This would become his great project in the early years of the century, for

which he spearheaded a battle to save the district from the wrecking ball in a city where the developers were now king.

Today 798 is a celebrated part of Beijing's cultural landscape and a template for similar districts across the country. Since 1979, contemporary art had survived in the half-light of grudging official tolerance. What won its security was commercial success.

In the first decade of the twenty-first century the Western art market embraced Chinese contemporary art, and by 2006 was delivering million-dollar prices for works that had been created in the dark period post-1989. China's cultural authorities sat up and took notice.

But that was still a couple of years in the future when I wandered with my friend through the half-deserted factory buildings of 798 in 2004. In fact, there wasn't a lot of art to see. Outside the café stood a kind of rocket ship made of bathroom fittings, and inside were some silkscreen prints which punned on the fact that the English word 'China' sounds like the Chinese phrase for 'demolish that'.

On a corner of one alley, though, we discovered a sculpture that remains for me the icon of the 798 district. It is a bronze of a model worker, legs akimbo, arm thrust forward in a traditional propaganda pose. But the extended fist, instead of wielding a hammer, brandishes an artist's paintbrush. The sculpture (which still stands in 798 today) seemed to me a perfect 'up yours!' to the dead ideals of Maoist art. I took it as a sign that the China I loved was alive and well. Having seen it I couldn't resist being part of it.

As a base for my second sojourn in China, I applied to work with China Radio International (CRI), part of the country's extensive state-controlled media. As a foreign journalist, I had spent a lot of time tunnelling under China's protective propaganda wall, and I was intrigued by the idea of seeing how things worked on the other side.

Apart from that I was interested in the chance to work with young Chinese journalists, which I was told was a major part of the job.

I assumed that as soon as they ran the usual police check on my application the job would be off the table. Over the years of reporting and producing stories from China I had had my fair share of brushes with the police and had built up a healthy file with them. But the job offer came through and by October 2004 I was armed with a work visa and on my way back to China. Two months later my husband joined me.

When I'd lived in China in the 1980s there'd been no question of foreigners renting privately. We were all corralled in compounds of one sort or another, like the diplomatic quarters or the Friendship Hotel. Private apartments didn't really exist, as most urban housing was controlled by the 'work units' to which all city dwellers were supposed to be assigned. But that had all changed in the 1990s with the state-owned enterprise (SOE) reforms and the privatisation of urban housing. It wasn't long before enterprising property owners started to tap the expat market.

When I arrived at CRI, the management was just beginning to experiment with the idea of their foreign experts renting privately. The Friendship Hotel—where they'd been used to housing them—had begun charging market rates and it was clear CRI could save money by giving us an accommodation allowance instead that would cover the rent on a modest apartment.

I decided to look for a place in Beijing's western suburbs, not too far from the centre of town but on a subway line that would take me to the CRI headquarters. As this was not a fashionable part of the city for foreigners, the local English language listing magazines were no help in finding a place, which is why I found myself peering at lampposts in

my target neighbourhood, copying down the numbers of people who were offering likely accommodation.

My 'mobile real-estate agents' had no office. What they had were contacts, mobile phones, a motor scooter and chutzpah. They charged a month's rent as a fee, to be split between the landlord and the tenant. They showed me a handful of places, all, as I would learn later, owned by employees (or former employees) of the Department of Railways.

I finally settled on a tiny one-bedroom place in a nine-storey block on a leafy street. My landlord still worked for the railways. He had bought his assigned apartment when he got the chance, and had a separate home elsewhere, courtesy of his wife. Along with most of his neighbourhood he had transformed himself from ordinary worker into landlord, thanks to the SOE reforms.

The place was bare-bones accommodation by Western standards—the kitchen was a gas ring beside a tiny sink—but it was sunny and quiet. My landlord explained that I would get excellent phone, internet and television reception, and that proved to be the case. It was only some months later that I realised this was courtesy of the western districts army base located nearby. The army, naturally enough, put a premium on efficient communications.

The railways department still dominated the area in many small ways. At 7 a.m. they would broadcast a jaunty tune aimed at getting us out of bed and exercising before the day began. They ran various public education programs, on issues such as drugs or AIDS, and organised blood drives. The railways theatre troupe was also hanging on in the neighbourhood, still treading the boards of the dedicated theatre for which my street was named. It was called the February 7th Theatre, commemorating the date of an historic rail strike in 1923 which had been violently put down.

Rivalling the patriotically named theatre as a local landmark was the new Eternal Peace Shopping Centre, which sold everything

from German whitegoods to Australian wine and which teemed with shoppers day and night.

Once I was settled in and had got to know the neighbourhood, I went—as instructed by CRI—to register with the police at the local Public Security Bureau (PSB). It didn't go well.

The policewoman on the registration counter looked at my passport with alarm. I had been in the country for almost three weeks! There was no question of processing my registration. I was asked to wait. An hour ticked past, then two. I watched a steady trickle of miscreants being hustled through the front door and into the basement. I started to wonder whether I would soon be heading down there myself. Through the glass entrance, I watched carefree citizens strolling in the sunlight. Freedom was metres away, but the police had my passport. So I waited.

Finally the front door swung open to admit a 30-something man in a crumpled raincoat who reminded me of the eponymous detective played by Peter Falk in *Columbo*. This helped me relax. So did the interview room, which was on an upper floor and not in the basement.

My Detective Columbo was the 'foreigners' liaison officer' brought in from PSB headquarters to handle my case. He explained to me the law in relation to foreigners and the various ways in which I had broken it, most notably by failing to report to the PSB within 48 hours of my arrival in Beijing. I tried to pass the buck to CRI, who clearly hadn't grasped how important it was for foreigners to register promptly, but he explained that this was my responsibility. He presented me with a copy in English of the relevant law and asked me to read it aloud. My voice started to falter as I came to the part about the applicable fine of RMB200 for every day that I was late in registering. Quick mental arithmetic told me that my first month's salary at CRI was going straight back to the government.

Again I pleaded ignorance, but he checkmated me easily: 'Just like in your country, ignorance of the law is no excuse.' But he then went

on to explain that there was another way to handle things. If I would consent to write a sincere self-criticism the fine might be waived.

I was familiar with self-criticisms. A favoured remedy for wrong-doing in the People's Republic, it requires you to put down on paper all the ways in which you have transgressed and to beg the forgiveness of the authorities. I had written a few of them during my time as a journalist in China: the key to success is not to hold back.

I sat down to write under Columbo's watchful eye. I acknowledged that ignorance of the law was no excuse and stated that I understood how much I had let down the People's Republic and its laws by my carelessness. I sincerely apologised. He read it over and suggested a few additions and finally declared himself satisfied. My contrition was noted, the self-criticism would be put on my file and there would be no fine applied. I was effusive (and genuine) in my thanks.

Accompanying me back to the registration desk, he suddenly stopped. He had neglected something terribly important, he told me, and rubbed his forehead in annoyance at his forgetfulness. This was always the moment in *Columbo* where the trap would snap shut, so my heart started to pound. He reached into his pocket, removed a black plastic wallet, and flipped it open to show me. It was his police badge.

My friends told me later that it had been a requirement for years that police show their ID before questioning anyone, but they very rarely did. There was something about this officer's fidelity to the regulations and the earnest way he had asked me to study the text of the relevant laws that seemed significant. Could it be that even the police were responding to the new mood of the times?

The idea of China as a nation governed by the rule of law had been part of the rhetoric of Deng Xiaoping's reforms since the beginning. But it was only in the late 1990s that the rhetoric began to take shape in the

real world. In 1996 the Lawyers Law was passed which established that lawyers were no longer to be considered servants of the state but independent professionals. In the late 1990s a number of cases focusing on individuals' rights were taken up by these newly independent practitioners, who drew particularly on the Administrative Procedure Law passed in 1989, which for the first time allowed people to sue state agencies over their decisions, and also on a consumer rights law that was passed in 1993. In 1999 and then again in 2004 the Chinese constitution was amended, first to enshrine the rule of law and later the protection of human rights.

By the time I arrived back in China in 2004 a new breed of what were called 'rights lawyers' had come into being, professionals who focused on key cases where the rights of an individual or group had been infringed. They generally worked pro bono, supporting themselves with other paid work within their practice or as members of a university faculty.

The rights lawyers did not shrink from the most difficult or unpopular of clients and cases. Within weeks of my arrival, I heard of lawyers defending members of the outlawed Falun Gong sect and farmers who had been dispossessed of their land. Others were taking on the cause of investigative journalists, or workers who were alleging exploitation by their employers.

Some of these lawyers used the media, both local and international, to publicise their cases, or organised small-scale protests, while others were more low key. Meanwhile, the role of the internet in taking cases to the court of public opinion was growing.

A quarter century of reform had created multiple stresses across Chinese society. Breakneck development had revealed an underlying weakness in the gains that had been made by China's farmers and the new urban middle class.

The reforms of the late 1970s had given farmers control over their land, but it had not given them ownership. As China urbanised, more

and more farmers were finding their land threatened by development. Compensation when land was compulsorily reacquired by the state was often pitiful and all the more so when compared to what the land fetched when the rights were sold on to developers.

Meanwhile, urban dwellers were discovering their newly acquired homes could be vulnerable, too. If they lived in areas ripe for re-development they could find themselves homeless and hopelessly under-compensated. The corruption that attended such land grabs added to the sense of grievance. Property could also be threatened by rampant industrial development or pollution.

Workers were vulnerable to exploitation in the nation's booming factories, and those in the floating population found themselves toiling in urban centres without any of the rights of residency that their city-born neighbours enjoyed—notably access to subsidised health services or to education for their children.

These were the issues the rights lawyers were tackling, and they were teaming up with investigative journalists, a growing number of NGOs, and new associations of workers, residents and other interest groups.

Few talked about it in so many words, but I was excited to see in their efforts the building blocks of a civil society emerging, some-thing that could serve as a counterweight to the monolithic role of the Communist Party in representing the will of the people. Once again I allowed myself to imagine China as a more vibrant, open and plural-istic society.

Of course, this vision had appeared before and evaporated in dis-appointment or worse, but two things gave me hope this time. The first was the weight of history. Most of these new players had been active in the student movement of 1989; now in their mid-to-late thirties they were moving into positions where they could influence society.

One of the most prominent of the rights lawyers was Pu Zhiqiang, who had never made a secret of his activism in 1989. He rose to

prominence as a lawyer in late 2004 when he took up the defence of a pair of investigative journalists who had exposed the brutal exploitation of farmers in Anhui and who had been sued by a local party boss for their pains. Pu had effectively turned the tables in that case, and no conviction was ever recorded against the journalists. This was the first of many freedom-of-speech cases that he would take pro bono over the following years while supporting himself as a commercial lawyer.

In 2006 he wrote about the need to live in a way that honoured the sacrifices of 1989. 'If I just slouch along through life, taking the easy route, what do I say to the spirits of those murdered "rioters" of seventeen years ago?' he asked. 'Our Tiananmen generation is now in middle age; we are in positions where we can make a difference. Do we not want to?'

The other powerful new factor was the internet. Liu Xiaobo, a tireless reform advocate who had served nineteen months in prison after 1989 and had been jailed twice more in the 1990s, wrote about the excitement of discovering the web on returning home from prison in 1999. At first he didn't see the point of the new gadget his wife had installed in their apartment. But he soon realised that the computer connected him to the world and to his fellow citizens in a way that hadn't been possible before, and he became convinced that in China the internet would be a decisive liberating force.

It suddenly seemed that I'd picked an exciting time to come back to China. And I wasn't the only one to feel that way.

In the late 1990s and early 2000s, many in the Chinese diaspora decided to take a chance on China again. Having achieved qualifications and experience in the West, they came back to participate in a country that seemed to be opening up once more. Among them were many of the artists who left China after 1989.

For Sheng Qi it was an 'animal instinct' to return, to see his family, to smell the familiar smells, to hear his native tongue spoken around him. He had served a nine-year apprenticeship in the West and returned confident in himself as an artist.

He had drifted in his first years away, through three years in Italy and a stint in Paris, before he moved on to London in 1992. Arriving there he determined to learn everything he could about Western art, spending long days in London's museums studying the work at close quarters. At first he supported himself pushing a yum cha trolley in Chinatown but soon discovered a better way to make a living nearby. For the next six years Sheng Qi created charcoal portraits for tourists in Leicester Square, 'hanging out with the alcoholics and the homeless, being warned by the police'. After four years he won a place at the prestigious Central Saint Martins art school. By the time he got his Masters degree in 1998 he was developing a reputation as a performance artist, but even though his work was often provocative or extreme he wasn't yet dealing with his most provocative act of all.

In the years abroad Sheng Qi got used to hiding his mutilated left hand in his pocket, nervous that people would see what he had done. But on his return to China he was determined not to hide it any more. 'It was ten years before I finally realised that my left hand with its missing finger had become part of my identity, the severing of my finger my unique act. I began to photograph it. It was then I realised that personal history could also embody the history of a society.'

Sheng Qi's *My Left Hand, Me* (2000) will probably always be his most famous work. It is part of the collection of the Museum of Modern Art in New York and has been featured many times in books about Chinese contemporary art. It is beautiful, sad and shocking.

In the photograph his hand stands out strongly against a deep red background, the place where his little finger should be an unsettling void. In the palm of his hand nestles a tiny black and white photo. It shows him as a very young boy, smiling shyly beneath his army cap, innocent of everything that lies ahead of him.

By creating this work, he was bidding for recognition of the wounds of a time still unacknowledged in China's official history. Innocence

and violence are united in this 'self-portrait', as they were at Tiananmen Square.

And yet it would be four years before the photograph would be critically recognised. When he showed it to the artists and critics he knew in Beijing they reacted coolly, as if the image meant nothing. Today it's easier for him to understand the discomfort behind their indifference; but that doesn't make it less galling to recall how one critic put aside the image with hardly a glance, shoving it to the side of the table they sat at, letting drops of water fall on it as he poured out their tea.

In 2004 Sheng Qi sent the image to New York to be part of a large exhibition of Chinese contemporary work at the International Center of Photography. There it struck a chord and it was chosen as a cover image for the show. And so it entered contemporary art history, four years after it was pushed out of sight on a crowded table set for tea.

In 2004 Gonkar Gyatso visited China for the first time since he had taken the road to Dharamsala twelve years earlier. He had spent four years in the Dalai Lama's 'capital', studying Buddhism and the traditional art of *thangka* painting. He had fallen in love with the city. Everyone—the monks, the citizens, even the Dalai Lama—lived so close together. 'It was amazing to see a whole society run by Tibetans. When I arrived I was interviewed by the Tibetan Security Bureau; everywhere there were Tibetans, it was very refreshing for me.' But after a few years he realised he had to move on. He was dedicated to being a contemporary artist and that couldn't happen in Dharamsala; 'Understandably, the whole society there is quite conservative, they really want to hold on to their traditions and don't want to change.' In 1996 he headed to London where a British artist he had met had helped him to secure a place at the Central Saint Martins art school.

He had arrived in London just in time to see the explosive 'Sensation' exhibition, featuring some of the most outrageous headline grabbers from the art collection of advertising guru Charles Saatchi. Among them was the now-legendary shark in formaldehyde by Damien Hirst, and a tent covered in people's names and titled *Everyone I Have Ever Slept With 1963–1995* by Tracey Emin. The show galvanised Gonkar. 'I was blown away. Before, in all the training I had done both in China and in Dharamsala, and in all the books about art that I had read, I had understood that there was a boundary between what is art and what is not art, but after I saw the "Sensation" show, that concept was completely smashed. I realised everything can be art. There is no limitation.'

He began to look for ways to make his ultimate inspiration—the figure of the Buddha—more accessible to Western audiences, liberated by the idea that he need no longer use the conventional means of artistic expression that he had relied on up to then. But before he could move on he knew he must first deal with the question of his own identity as a Tibetan Chinese.

The year before he visited Beijing in 2004, he had finally completed in London a photographic work called *My Identity*. Over four panels he depicted the four identities that had defined him during his years as an artist. In the first he presented himself as a traditional Tibetan painter, creating an intricate *thangka* of the Buddha; in the second he was a good communist, reproducing a standard image of Chairman Mao; in the third he was a refugee, honouring the image of the Dalai Lama; and lastly he appeared as a contemporary 'Western' artist, apparently shorn of all ethnicity in a white-walled studio confronting an abstract canvas.

With this work he believed he had finally laid to rest the search for identity that had obsessed him since he had first left Lhasa to go to university in Beijing. 'I felt as if a huge weight had been lifted from my shoulders,' he told me.

On the way to Lhasa from London in 2004 he stopped in Beijing and walked the streets, astounded by how the city had changed.

He went to visit his alma mater, the Minzu University, but he could not find it. The area around the original site had been transformed, the old rambling gardens in which the university had stood long since sold off for development. Even the entrance to the university had moved to a different street. In the end he gave up the search.

He wasn't ready yet to consider returning to China for good. It would be another twelve years before he would be ready to try again to make his home there.

In 2005 Guo Jian joined the stream of artists returning to China from the West. He had been in Australia for more than ten years, making a living as a house painter, brickie's labourer and gardener, all the time working on his art, which led to a series of exhibitions that established his name. He had developed a strong, almost pop, style, which he used to brilliant effect in a series of works that undercut the propaganda images of military life. His soldiers weren't ideal specimens of socialist rectitude, their dreams were erotic, not patriotic, and in his paintings their minds were filled not with famous victories but with girls, food and fun.

He settled in well in Australia; he liked its casualness and what he saw, after living in Beijing, as the tranquillity of its urban spaces. Where most visitors to the inner Sydney suburb of Newtown would see grittiness, he noticed the planter boxes full of flowers and the friendly people on the street. The live music scene was humming in those years and so almost every night after his language class he would go out and see a band. He found it easy to make friends and was amused when the local branch of the Communist Party of Australia tried to bring him into their circle. 'They were always asking me to sing them a Chinese revolutionary song and, of course, I wasn't going to do that! So one day

I finally said, "Hey listen up, this is a Chinese revolutionary song," and I sung them Cui Jian's "Nothing to My Name".

By the time he returned to Beijing his paintings had entered the collections of the National Gallery of Australia and Queensland's Gallery of Modern Art, and he had become an Australian citizen, but for all his success he was attracted by the thought of what he could achieve in China. He wanted to try his hand at sculpture, and Beijing offered the studio spaces and the technical know-how that he needed. And he missed his family, his friends, and the food.

Within months of arriving in Beijing he had teamed up with two other artist friends from his native Guizhou province to launch a restaurant, Three Guizhou Men, which quickly became a favoured canteen for the art world in the capital. The restaurant business was a popular second string for artists at the time. Huang Rui had pioneered this with his café in 798, and 'cynical realist' Fang Lijun had followed, opening a chain of restaurants specialising in food from Yunnan province. In the new century, contemporary art was safer than it used to be, but it didn't hurt to be in business, too.

At Three Guizhou Men the partners naturally hung their work on the walls, but Guo Jian soon found his own work made his fellow owners uncomfortable.

His painting seemed innocent enough—it shows a group of ordinary soldiers, grinning broadly as they are serenaded by an army entertainer. One of the soldiers holds a pig ecstatically to his chest, as the chanteuse, resplendent in her dress uniform, looks the viewer straight in the eye, hair shining, teeth sparkling, her glossy red lips and nails glittering in an unseen spotlight.

The singer commanding all the attention in Guo Jian's painting bore a striking resemblance to Song Zuying, who for more than a decade had been a star of the Spring Festival Gala, the variety show broadcast each Chinese New Year on the national television network. The gala is the pinnacle of officially sanctioned popular culture in China and

there'd long been speculation about how Song Zuying came to secure this plum gig year after year. Some said she had been talent-spotted by President Jiang Zemin himself when he was in power, and she was also rumoured to be his mistress. Whatever the truth, her run on the gala went on for more than twenty years.

Hanging in a prominent position by the restaurant entrance, the painting began to attract attention from customers, who swapped knowing remarks about what the soldiers might *really* be smiling about. One day a friend of Guo Jian's turned up to dinner with the head of the China Artists Association in tow. 'You know that painting could get you closed down?' the official remarked, and laughed at his own joke. Guo Jian knew a warning when he heard one. The painting went back to his studio.

The young journalists I worked with at CRI were bright and well informed about Chinese affairs. They were also keen to improve their craft and wonderfully responsive to advice.

Part of my job was to read the English-language news, using material prepared by my colleagues. I decided to use these slightly wooden scripts as an opening to talk about the elements of good writing. Try to keep the language fresh, I urged them; don't get trapped in a formula. One night, half an hour before airtime, I handed back a report from the weather bureau about how temperatures around the country were falling at the end of summer. 'See if you can brighten this up,' I said to the young woman who was on duty with me. She returned a few minutes later and put a new script into my hand.

'Coolness is creeping over China,' it began. 'There's a feel of fall in the air.'

This gem of accidental poetry quickly became my mantra, because in those early years of the century, China *was* becoming very cool,

as thousands of foreigners were discovering. There was a crackle of excitement not just in the alleys of 798 and on the banks of Houhai, the once sleepy back lake to the Forbidden City in Beijing, but in the rooftop bars of Shanghai's Bund and the tree-lined streets of the city's old French Concession. A new breed of Chinese urbanites were colonising the old spaces of their cities, opening cafés and bars, clubs and small shops, creating a new infrastructure for a city life that was open and colourful and cool.

At Houhai you could look out across a lotus-filled lake where at the turn of the previous century Chinese poets had floated their wine cups on the water, and listen to poets of the coming age—punk rockers from the capital, or folkies from the loess plains of Shaanxi—while chatting to a bar owner who slept in a loft he'd constructed in the rafters and who shared his life with a dozen street cats he'd adopted as pets.

Around Beijing small clubs were opening up, providing entry to the alternative music scene every night of the week. You could see the all-female punk band Hang on the Box, whose lead singer looked like Debbie Harry and sang like Sid Vicious, or the crazed folk rockers Glorious Pharmacy, or the wild-haired Askar whose Xinjiang band Grey Wolf summoned up the spirit of the Silk Road and of the eagles that soared above the Karakorum. Independent recording labels were starting up, too, or you could buy music downloaded direct to a CD by a local enthusiast in a hole-in-the-wall shop in a *hutong* off Houhai.

For much of the 2000s the visas that allowed young foreigners to keep hanging on in China were quite simple to get. People would arrive on holiday and wangle work or business visas through a grey market of intermediaries. Then they would stay on, banding together with locals to launch pizza parlours or clubs, play bass in bands or pick up bit parts in TV dramas, launch listing magazines or small fashion labels, front real-estate companies or foreign galleries, and use sheer chutzpah to score jobs or business opportunities that would be out of reach at home.

The authorities knew the visa system was loose, but they seemed to be making the correct calculation that these freewheeling foreigners were putting a lot more into Chinese urban life than they were taking out.

I felt the winds of change at CRI, too.

The station was still firmly part of the propaganda system, but there was a group of young managers who were quietly pushing to make it a bit more than that.

There was the one who headed up CRI English Online, who always came in early so that he could get in ahead of the official directives and make his own decisions about what stories to highlight on the website. There was another who took me aside when I first arrived to chat about stories I'd produced at the ABC. He was the one who told me that the CRI leadership had certainly seen my police file before hiring me. It hadn't put them off, he told me, because they were looking for real journalists now, people who could bolster their own efforts to train their staff to be more professional.

A few months in, they suggested that a Chinese colleague and I start our own weekly talk show, riffing on whatever news story of the week we decided to choose. One week, news of Elton John's nuptials sparked a lively show on same-sex marriage, while in another, the tragic news of the execution of Australian Van Tuong Nguyen in Singapore led to a no-holds-barred debate on the death penalty.

In private moments, two of the middle managers confessed they had been in Tiananmen Square in 1989. They didn't match the radicalism of the rights lawyers or even of their younger selves, but their daily attempts to improve the professionalism of what they did and to expand the space for journalism marked them out as different from their older superiors.

Meanwhile, every day I found subjects being covered in the official media which had once been tantamount to state secrets. In the 1980s we would hear of industrial accidents only rarely, and always months after the event. Now the scandal of the accident-ridden Chinese coal

industry was exposed on a monthly basis, putting real pressure on the government to improve safety. Natural disasters were covered in real time along with their devastating effects—this in a country which had once erected screens along a railway line heading east from Beijing so passengers could not see the destruction wrought by the Tangshan earthquake of 1976.

Of course, we still worked under tight boundaries and were reminded every day where they lay. There were key topics to be handled with extreme care, if at all. We foreigners called them the 'three Ts': Taiwan, Tibet and Tiananmen. On these subjects the correct line was clear and to be stuck to at all costs.

Tiananmen was the great unmentionable. On the day that Zhao Ziyang died in 2005, the official government newsagency issued a one-line announcement from which no one in the official media deviated by a syllable. All that day, work went on in the CRI office without discussion, even as above our heads the monitors tuned to the foreign news feeds showed an endless stream of footage of Zhao's final address to the students in Tiananmen Square and of the massacre that followed days later. But as I made my way to the kitchen to make coffee that afternoon I noticed every one of my Chinese colleagues was silently reading the coverage of Zhao's passing on BBC.com.

In 2006 Liu Xiaobo wrote an important essay, 'To Change a Regime by Changing a Society'. In it he talked of how change can progress via actions in 'countless small environments', even ones located inside the 'belly' of the authoritarian regime. For a few short months I saw that happening inside the belly of one of China's great beasts, the propaganda bureau. It didn't last even as long as the eighteen months I worked there, but it was just one of many straws in the wind in the early 2000s that convinced so many that it was worth betting on change.

★

And the Olympics were coming.

Beijing's big moment was scheduled for August 2008. In the years leading up to the event, there was much discussion about whether the Games might be a watershed moment for China. In South Korea, it was said, the looming occasion of the Seoul Olympics had accelerated that country's move to democracy. Could China be in for the Olympics Effect itself?

The leadership had a different vision. The Olympics was to be the nation's grand 'coming out' party, marking their final ascension into the club of major powers. China had become a member of the World Trade Organization in 2001 and was set to become the world's second-largest economy by the end of the decade. Now the Olympics would be a chance to put the nation on show.

Aware of China's lingering image problem (which had scuttled their bid for the 2000 Games), the leadership crafted a pitch that highlighted the nation's ancient culture and its tradition of hospitality. The official Olympic song was a saccharine earworm called 'Beijing Welcomes You!' featuring a cavalcade of Chinese stars exhorting the world not to stand on ceremony and to step right in. 'To know us is to love us' seemed to be the message.

By mid-decade I had decided to stay and find out what 2008 would have in store. I wasn't to know it, but the Olympics would again confirm what Gorbachev's 1989 visit to China had already taught us: that long-planned 'historic moments' can be upstaged at the last moment . . . by history.

ISN'T SOMETHING MISSING?

In 2008, at 8 p.m. on the eighth day of the eighth month, two thousand and eight bronze drums sounded out across Beijing's Bird's Nest stadium, and the Olympic Games began.

China was meant to have done away with superstition when Mao Zedong founded the People's Republic in 1949, but six decades later no one was bothering to pretend any more. Why not stack the odds in the home team's favour by invoking the power of eight, the luckiest of Chinese numbers?

It certainly did the trick. The stunning opening ceremony went flawlessly, and by the final day of the games the Chinese team had topped the gold medal count for the first time in Olympic history. It was the successful climax of years of meticulous preparation, and the source of two weeks of immense patriotic pride.

But the Olympics are rarely the moment of national transformation that its boosters predict. That was certainly true in China, where two much more significant events had occurred just months earlier, at unscheduled dates and times, without warning and with terrible consequences.

At 2.28 p.m. on May 12 2008, an earthquake measuring 7.9 on the Richter scale hit the south-western province of Sichuan. The quake's epicentre was in Wenchuan County, a mountainous region on the edge of the Tibetan plateau just 80 kilometres from the provincial capital,

Chengdu. For two minutes the ground shook and the earth split open for 240 kilometres along the fault line. In the quake and its aftermath some 69,000 people died and another 18,000 were declared missing.

The tragedy galvanised the country. Ordinary Chinese rushed to help, donating record amounts of money, and, in a nation traditionally reluctant to give blood, queuing at blood banks across China. People jumped on planes and trains or hit the road to Sichuan to volunteer. Young people gave up their jobs to go to quake-ravaged villages, like one young friend of mine who told me this was finally her chance to do some good in the world. None of it was driven by the government. It was inspired and organised by ordinary people rising to what they believed were their responsibilities as citizens. The internet played a key role in spreading information, organising efforts and inspiring people to take part.

For the Chinese media, too, it was a moment of truth. Hundreds of journalists converged on the site from around the country, determined to report on the spot despite regulations restricting them to their home provinces. Their determination was inspiring, and more impressive still was the quality of the reporting, which brought the disaster power-fully to life.

Nor did these journalists shrink from what quickly became a central question: why had so many schools collapsed? The tremor destroyed more than 7000 classrooms and killed well over 5000 children. In town after town the pattern was the same: the local school lay in ruins, while many nearby structures survived. Soon a disquiet-ing theory took shape: corrupt officials had creamed off construction funds, and children had been sitting in 'tofu buildings'—shoddily built structures that didn't meet the earthquake code.

It wasn't long before the authorities reasserted their control of the media. Instructions went out to stress the official narrative— of brave troops rescuing survivors and delivering aid under the direct leadership of Premier Wen Jiabao. Overnight, the faces and voices of

grief-stricken parents vanished from China's screens. Instead, Wen Jiabao was everywhere, personally directing platoons of soldiers one minute and calling out messages of hope to trapped people the next, then turning up at hospitals to comfort the injured.

The celebrated dissident artist Ai Weiwei had arrived in Sichuan ten days after the disaster and quickly took up the schools issue. In an attempt to document the scale of the tragedy, he launched a 'citizen's investigation' to gather the names of children who had been killed. He went public with a list of 5190 names, and estimated that the government's official schools death toll of 5335 (issued without names) represented around 80 per cent of the true figure.

The government clamped down quickly and hard on the story, restricting media access, harassing and arresting researchers and deleting Ai's blog posts. In the end a number of activists on the issue were jailed, and when Ai returned to Chengdu to testify on behalf of a fellow researcher he was intercepted and beaten up by the police, later undergoing surgery for a brain bleed.

A promised investigation into the schools scandal never rendered a public verdict, and attempts by parents to seek redress through the courts were squashed. Instead they were offered pitiful compensation with a barely disguised message of 'take it or else'.

There was a sense afterwards of an opportunity lost, of disappointment that the generosity and energy of ordinary people, the initial instinctive professionalism of the media, and the dynamism of the internet had been met with censorship and cover-up.

The year 2008, despite the glory of the Olympics, was tough for China. Whether despite the games or because of them, it marked the end of a brief period of openness in the mid-2000s and set off a cycle of authoritarian control and repression that has only worsened over the last eight years.

The stage was set for this by another cataclysmic event that occurred two months before the Sichuan earthquake.

On March 14 2008, violent riots broke out in Lhasa, the capital of Tibet. The trouble began when police arrested a group of monks who were demonstrating on the anniversary of the 1959 Tibetan uprising, a revolt against Chinese rule that had been bloodily suppressed and which saw the Dalai Lama flee into exile. The uprising's anniversary each March is always a time of heightened tension in Tibet, and in 2008 things turned ugly, with protests for the release of the monks escalating over a couple of days into violent rioting and looting.

Lhasa businesses owned by Han Chinese settlers and the ethnic Hui Muslim minority were attacked. Years of frustration at what many Tibetans saw as the colonisation of their country welled up in what eyewitness James Miles of *The Economist* described as 'ethnic hatred'. There were reports of deaths among both the settlers and the rioters, though accurate numbers were impossible to ascertain. Trouble soon spread beyond Lhasa and across the Tibetan plateau to the neighbouring provinces of Qinghai, Gansu and Sichuan.

For the Chinese authorities, this was a political earthquake. As soon as trouble broke out they shut down outside reporting, screening grim riot footage on state television while blocking all foreign websites in China that might carry a different narrative, from the BBC to YouTube.

For many of us in Beijing, it was our first encounter with the real power of China's Great Firewall. Up until then, getting around internet censorship had been easy: there were free virtual private network (VPN) services that you could find on the web with a few mouse clicks. But when the riots started, every one of these went dark. Even the powerful VPNs used by business people and journalists struggled, constantly switching servers to stay ahead of the censors. Suddenly, we saw the truth: the government applied just as much censorship as they needed to, and kept their real firepower in reserve. So a few people read *The Guardian* on a normal day? We know who you are, the government seemed to say, and we can cut you off whenever we need to.

A grimly amusing incident soon rammed home the message about the government's stranglehold on information. A week after the riots began, my husband, working in a Beijing office, managed to get *The Times* on his computer for just long enough to read a detailed Tibet report. He quickly saved it as a Word document and tried to email it to me, but his Gmail crashed. When it happened twice he realised the government was scanning outgoing Gmail messages for forbidden words. So he used a code to mask the offending vocabulary, re-naming Tibet as 'Glebe' (a Sydney suburb) and China as 'Cronulla', while the Dalai Lama became the 'mayor of Glebe'. That should fix it, he thought, and re-sent the attachment. Crash. He tried again, substituting 'bad behaviour' for 'riots'. Again the Firewall prevailed.

After many edits he eventually got the report through, but only after reducing it to nonsense which is pretty well captured in these first three paragraphs:

Thousands of Cronulla boy scouts and parascout cubs fanned out across Glebe and neighbouring provinces as Cronulla admitted for the first time it had paintballed Glebe protesters.

State-controlled Newflower news agency reported four people were paintballed and bruised last weekend by boy scouts in a Gleban area of southwestern Cronulla, as the forced to live abroad Glebe mayor expressed fears the crackdown on bad behaviour had caused many casualties.

The Government also acknowledged for the first time that pro management of one's own affairs unrest in Glebe had spilled into other far-flung corners.

All this heightened the irony, a few months later, when foreigners arriving for the Olympic Games found that the internet was open and uncensored despite what they had read. The games organisers had built a kind of Potemkin world wide web. In the Olympic Village

and in foreign hangouts, the Great Firewall was switched off. Elsewhere in Beijing and around the country censorship was as tight as ever.

Barely had the games ended on August 24 than another scandal dragged questions of government transparency and openness into public debate.

The news broke that suppliers to a major Chinese dairy company, Sanlu, had been stretching profits by watering down their milk and then spiking it with melamine, a nitrogen-rich chemical that can mask dilution by boosting the apparent protein content of milk. Melamine's toxic effect on human kidneys has been known for many years. Tragically, the adulterated product had been turned into infant formula and shipped around the country, killing six babies and putting 54,000 in hospital.

What made the scandal so corrosive was the nagging suspicion that officials had sat on the news until after the Olympics to avoid a national public relations problem. The evidence shows that responsible people further down the line knew of the problem for some time before the news came out. Nothing pointed to collusion at the top, but to many ordinary people the story added up to political considerations trumping public welfare.

It also seemed to say that, for all the achievements of economic reform, the government had not managed to build a system that offered protection against greed, incompetence or corruption.

Food security remains a huge issue in China, and even today Chinese tourists to Hong Kong and developed Western countries go to enormous lengths to ship foreign-name brand baby formula home to China.

As 2008 drew to a close, a group of activists made a bid for the year to mark something truly historic: the most thoroughgoing proposal for

democratic reform in Chinese history, in the form of a public manifesto. The signatories invoked the solemn power of the anniversaries being celebrated that year: 100 years since China wrote its first constitution, 60 years since the Universal Declaration of Human Rights, 30 years since the opening of Democracy Wall, and ten years since China signed the International Covenant on Civil and Political Rights. They called their manifesto 'Charter 08', and posted it online on December 9, the eve of the 60th anniversary of the adoption by the United Nations General Assembly of the Universal Declaration of Human Rights.

The text of the charter had been refined over months, during which time Liu Xiaobo became one of its main sponsors. He was zealous in gathering signatures for the charter and by the time it appeared on the internet 303 people had put their name to it.

'China has many laws, but no rule of law,' the charter declared. 'It has a constitution, but no constitutional government.' The result was corruption, decay in public ethics, crony capitalism, inequality, environmental degradation, and a sharpening animosity between the government and the people. At the same time, the charter stated, the ruling elite 'clings to authoritarian power and fights off any move to political change'.

The document acknowledged the many improvements to people's lives that had resulted from the reforms of Deng Xiaoping, but argued it was now time for more fundamental change.

'Charter 08' called for a new deal for the citizens of China: a guarantee of fundamental human freedoms and human rights, equality before the law, and the protection of private property.

The charter's governance proposals would seem straightforward to a student of Western democratic systems, but they kicked away the underpinnings of one-party rule. The document called for the separation of powers, an independent judiciary, legislative democracy, constitutional rule, and de-politicisation of the public sector and the army.

Perhaps most radical of all was its proposal for a federated China in which not only the differing interests of Hong Kong, Macao and Taiwan could be accommodated, but also those of ethnic minorities within China's borders.

The charter posed a stark question: 'Where is China headed in the 21st century? Will it continue with "modernisation" under authoritarian rule, or will it embrace universal human values, join the mainstream of civilised nations, and build a democratic system?'

'Charter 08' was breathtaking in its boldness and yet among the 303 initial signatories there were government officials, members of official think tanks, and leaders of workers' and farmers' groups. Posted online, it garnered another 12,000 signatures before the government shut it down.

Liu Xiaobo never saw the charter go live on his beloved internet. On December 8, the day before it was posted, the police arrived at his apartment late at night to take him away. It would be six months before he was formally arrested and a year before he would have his day in court.

Over the following months many signatories to the charter were harassed and others detained, and the government used all its newly honed skills to scrub the charter from the internet in China. Meanwhile, the Chinese media was warned not to interview any of the signatories or allow them to write articles for publication.

The signatories saw reform as an urgent matter but the government felt itself under no pressure: events seemed to be running in their favour. At the end of 2008, the global financial crisis (GFC) was tilting the balance of economic power towards China. It was not the Olympics that would further the government's ambitions for global leadership that year, but raw economic power.

On September 15 2008 the giant American financial firm Lehman Brothers filed for bankruptcy. There was no longer any doubt that the world's economy was in crisis.

The Chinese economy had been slowing for months and by early October the factories of the Pearl River delta were emptying out as millions of workers were laid off. Demand for Chinese manufactured products was drying up as the world slipped into recession.

In November, China announced a staggering RMB 4 trillion (US$586 billion) stimulus package. Nearly 40 per cent would go towards public infrastructure, and another quarter towards rebuilding the parts of Sichuan hit by the earthquake. This spending would provide employment for the millions displaced from manufacturing jobs. The global knock-on effect helped to keep Australia out of recession, and China's interventions in Asian currency markets gave support to the economies of Southeast Asia and South Korea.

China went on a building spree, the biggest the world had ever seen, constructing highways and housing estates, bridges and railway lines. It drove the country to a GDP growth rate of 9 per cent in 2009 while most of the West was in recession. When in 2010 China passed Japan to become the globe's second-largest economy, talk of an alternative 'China model' of development grew ever more respectful. Perhaps, wondered some observers, there was a viable road to prosperity through centralised control of the economy and an iron hand on dissent—an alternative to the democratic route, and one that might point the way for other developing economies.

It would be a few years before the downside of this success emerged, in ballooning debt and an oversupply of real estate, and in the appearance of 'ghost cities', which had been built for populations yet to arrive. Corruption, already rife, was turbocharged and the gap between the free spending rich and the increasingly embattled poor became extreme. But in 2009 the government basked in its successful

management of the crisis, which they took to be an endorsement of their muscular style of government.

The art-world bubble burst immediately after the Olympics were over. Olympic spending had kept it inflated but now the gathering GFC sucked the hot money out of the market.

The Olympics year had not been a great one for art in Beijing. The success of China's leading artists had turned contemporary art into a honeypot, so the streets of 798 and the studios of the Songzhuang artists' village were full of knockoffs going for eye-watering prices. Some of the big-name artists were even prepared to rip themselves off, endlessly reproducing the work that had made them famous.

Now, with the GFC, the carpetbaggers decamped and along with them hundreds of Songzhuang's wannabe artists. The commercial galleries thinned out and scores of shows were cancelled. Most of the established artists felt relieved. They were off the treadmill and had time to think. It was 30 years since the Stars had hung their works on the railings outside the National Art Museum of China. What kind of society did they now seek to portray?

Thirty years after the beginning of reform, China was changed beyond recognition. More than half the population now lived in the cities, in a country with rural traditions stretching back for millennia. More than 10 per cent of the population now had no ties to place, but 'floated' in search of work. And a nation which had once been driven by a powerful ideology was now offered nothing more profound to believe in than the drive for material gain.

When I had returned to China in 2004 I had been struck by how many of my young colleagues at CRI were religious. Some were exploring Buddhism and Daoism, but others told me they were Christians. Among the rights lawyers and civil society workers, too, I discovered, there were

many Christians, who would point to their faith as both inspiration and support. The best figures showed Christians at less than 1 per cent of the population in 1978, but by 2007 they were more than 4 per cent with their numbers growing at a rate of 10 per cent a year.

Religious tolerance had been one of the reforms instituted by Deng Xiaoping, and since 1978 it had been enshrined in the Chinese constitution. Five religions were specifically recognised: Buddhism, Daoism, Islam, Protestantism and Catholicism, but their religious leaders were left in no doubt about who was ultimately in charge. The Vatican was allowed no place in Chinese Catholicism and the Dalai Lama was demonised. The Chinese government even arrogated the powers of the Dalai Lama to themselves. When the second holiest figure in Tibetan Buddhism, the Panchen Lama, died in 1995, the Chinese rejected the Dalai Lama's choice for his reincarnation, naming another child instead and spiriting the Dalai Lama's nominee away, never to be seen again.

Despite this supervision of the faiths the ranks of believers swelled. The religions were offering something that the government couldn't. They offered a moral system and a connection to the transcendental, while the government offered only material comfort. Faced with a society riven by exploitation and inequality, the government preached the need for a 'harmonious society' above the right to organise or to protest. The Communist Party, which had once sold itself with the most extravagant and inspirational of slogans, now offered only this widely mocked bromide.

Where, I wondered, were the artists in all this? By 2009 I was working as the art editor for *the Beijinger*, a local English-language magazine. The year was the 30th anniversary of the Stars exhibition, and it gave me a reason to take a longer look for a survey article I wrote for the magazine. It was the research for that piece that cemented my friendships with a number of the artists in this book.

In the spring of 2009 Zhang Xiaogang was working on an exhibition he would title 'The Records', a reference to *The Records of the Great Historian*, the foundation historical work of China. Since he began to paint his 'Bloodline' series in the early 1990s, his work had been heavy with history; in the 2000s, he continued to explore how the past weighed on China.

In the first decade of the new century he had begun a series called 'Amnesia and Memory', which concerned both the need to remember and the necessity to forget. In many of the paintings the human subjects looked away from the viewer or their eyes were closed or blindfolded. Simple objects—a bare light bulb hanging from a flex, a rotary dial telephone, a fountain pen—carried the weight of memory.

Now with 'The Records' he had decided to consider, he told me, the 'contradiction between memory and forgetting' that underpinned contemporary Chinese life.

'Because our country is developing by destroying things, we are living in a very contradictory situation,' he explained. 'Memory is something basic in our nature—you're born with it—and it is basic to culture, too. It comes to us naturally, but we are living in a situation where memories are constantly being erased. You have to face the changes in your life, but sometimes it is quite cruel to do that, so people get lost and confused.'

Zhang Xiaogang is deeply thoughtful, widely read and a prolific diarist and letter writer. In 'The Records' he wasn't ashamed to display his own confusion and sense of loss, as he mined his journal for private thoughts which he wrote directly onto the paintings. In one he wrote about his home town of Kunming, in the far southern province of Yunnan, a place traditionally renowned for its temperate climate and graceful beauty: 'Her purity is long gone, and disintegrated when she was forced to have a face lift. Long ago, her modesty was replaced by "luxury", her kindness was covered up by "sophistication", her kind-hearted nature was stolen by various deceits, her uniqueness

was remodelled with the excuse of globalisation, her face revised into passages of low-grade advertising, her body turned into one after another false stock market speculation, she became a true guinea pig and selling agent, a beautiful excuse for a small group of people to make profits. That's just how it is, our home town has become a legend, a Godot that won't turn up any more.'

His whole exhibition was perfectly matched to the atmosphere that pervaded 2009—a year of heavy anniversaries—from the simple objects he portrayed, to his musings on what had been lost in the years that had brought China to this point. He had chosen this time to paint on polished metal, so looking at the works you often had the strange sensation of seeing Zhang Xiaogang's thoughts projected onto your face, as if his thoughts of loss, of confusion and of hope had somehow become your own.

My research also gave me a chance to catch up with Huang Rui, whom I had first met some three years earlier.

In the summer of 2006, I had left CRI and taken a job for a while as the director of a small gallery in the 798 art district. As it happened, it gave me a ringside seat on the struggle—then reaching a climax—to save 798 from developers.

When the military factories had first been abandoned in the district, the newly constituted Seven Star Huadian Science and Technology Group was given the job of maximising profits from the site. Their plan was to transform 798 into a high technology park, but this would take a while. Meanwhile, when a few scruffy artists and foreign galleries turned up in the early 2000s, Seven Star was happy to take their money until it was time to move them on.

But they didn't count on the passion of Huang Rui and his colleagues, who said they were going to secure 798 for art, and meant it.

Huang Rui saw the potential of 798 as a permanent 'safe zone' for art, and from the moment he and his partners issued their manifesto in 2002 their strategy was to tell such a powerful story about the area that it would become untouchable.

Together with his partner Berenice Angremy, Huang Rui established an annual international arts festival based around 798 in the spring of 2004. By 2006 the Dashanzi International Arts Festival was attracting hundreds of thousands of visitors over a three-week program of open studios, theatre, music, parties and exhibitions, and played a vital part in establishing 798's credibility. Meanwhile, the artists lobbied the Beijing government to declare 798 a permanent art zone, highlighting its attractions to the international audience who would soon be arriving for the Olympic Games.

The year 2006 began with all the tenants of 798 under threat of eviction. Seven Star did what they could to make life difficult, banning new tenants and then outlawing sub-letting by the old ones, too. Rents soared. In the spring a local district cultural inspection team arrived at 798 to censor any works or exhibitions deemed to cross the (invisible) line. The team in turn sent the police to enforce their rulings. No one was surprised when Huang Rui was one of their main targets.

Much of Huang Rui's work is subtle, relying on wordplay or performance, but the inspection team had no trouble spotting the satire behind his collage entitled *Chairman Mao, 10,000 RMB*.

Chinese people live with Mao Zedong's image every day. His face is on every large banknote. Every time you visit an ATM or reach into your wallet, there he is. The irony that the great communist should now be so indelibly linked to money was not lost on Huang Rui.

When Mao was still alive the most popular slogan was the one that called for his long life. 'Long Live Chairman Mao!' was emblazoned everywhere, including on the walls of the factories of 798. In Chinese the slogan is literally '10,000 years to Chairman Mao!' and it was this number that Huang Rui decided to play with. In his work the slogan

was rendered in a collage of 100 yuan notes totalling RMB10,000. 'Long Live Chairman Mao!' the bank notes said. The inspection team ordered the work removed immediately from view.

Despite all their spoiling efforts, by the end of 2006 it was clear that Seven Star had lost. Designated a protected cultural zone, 798 was Beijing's third biggest tourist attraction when the Olympics rolled around. But Seven Star couldn't resist one last act of revenge against the person they blamed for their defeat—Huang Rui.

In late December 2006, Seven Star served him with an eviction notice. The other tenants of 798 quickly mobilised in support and Huang Rui announced a 'sit-in' at his studio. He made the protest into a formal exhibition, holding a series of talks and seminars, and conducting a daily public dialogue with a different art world figure over a pot of tea and porcelain cups. For eleven days we joined him, drinking endless cups of tea and debating art and life into the night. Finally, the eviction date well past, Huang Rui had made his point and consented to leave. Seven-Star had won the battle, but Huang Rui had won the war. 798 was safe.

Huang Rui maintained his café in the heart of 798, and that's where I went to meet him in 2009, and where he remains today. Nearby is his office, which still overlooks the alley on the corner where his studio once stood. From his eyrie he can keep an eye on the comings and goings of a place of which he is still, despite all Seven Star's efforts, the unofficial mayor.

On January 10 2009 Cao Fei declared RMB City officially open. She had built it in Second Life, an online world then some five years old, where hundreds of thousands of role-players lived out alternative existences. Cao Fei had been hanging out there for a couple of years, and, under the guise of her avatar, China Tracy, had found that in Second Life she could act out a truer version of herself.

For years she had been fascinated by the way fantasy could be used to escape reality. She had found fantasy among the factory workers she had documented in *Whose Utopia?* and among the cosplayers of Guangzhou, kids who dressed up as their favourite manga characters and played out their stories on the rooftops, construction sites and vacant lots of their increasingly homogenised city. Now she had found the greatest realm for fantasy of all on the internet, a place where you could connect with others around the world, in ways that weren't possible in real life.

And so she had built RMB City, a fantasy Chinese urban realm where Tiananmen Square had been turned into a swimming pool and a panda's portrait had replaced Mao's on Tiananmen Gate. Situated on an island, her city had a Hong Kong–like cluster of skyscrapers and other spaces into which she invited other artists and arts institutions to adopt avatars and move right in. In her city, she said, everyone could live out their virtual dreams.

'I want to build a utopian city in Second Life,' she told me as she prepared for the city's grand online opening, 'because you can't do it in real life.'

The same month, I found Jia Aili living inside a gallery in Beijing. He had moved in in November and planned to stay till spring. He would paint all night and sleep all day. He called it his 'hibernation'.

His project was under wraps when I dropped in, but I could see it was a gigantic canvas—6 metres high and 12 metres long. He was hoping his winter exile in the gallery would ensure he finished it. He had already given it a title—*We Are from the Century*.

He had moved to Beijing in 2007. He'd come for an exhibition of his paintings but once he had seen the gigantic studio spaces in the capital he knew he had to stay. He threw in his job as a lecturer at

the prestigious Lu Xun Academy in Shenyang, to the horror of his parents. He could be a teacher, and instead he wanted to be a painter? What on earth was he doing?

Luckily he found success quickly. His poetic, beautifully painted canvases evoked the tragedy of China's rust belt and the destruction of the old communist system, in a wasteland of fallen idols and tangled wire. In many of the paintings he appeared as a pale figure wandering naked, clad only in a gas mask. He had bought the mask in a shop in Shenyang and adopted it as a kind of talisman. The mask was of the kind the Soviets had designed during World War II and then exported to East Germany and into China. It seemed a suitable symbol for the destruction that surrounded him in his home province, where the very air seemed filled with dust and despair.

He didn't manage to finish *We Are from the Century* during his time in the gallery and he was still working on it when I came to visit him for the first time in his studio in spring. He had taken over an abandoned factory on the outskirts of the city and I wondered whether its monumental size conjured up for him the deserted spaces he had wandered as a teenager. The painting was incredible, a sprawling panorama of a fallen world. Dominating the foreground was a crashed plane and a giant hammer and sickle lying among the wreckage. Children wandered through the blasted landscape, while in the distance a statue of Lenin lay broken on its side. Towards the back of the composition wandered a figure in a spacesuit.

Jia Aili spoke matter-of-factly of the monumental changes that had taken place in his lifetime, and which lay behind this painting. He told me he was interested in exploring the secrets behind modern history and its endless implications, a history whose objective reality was often hard to grasp. 'Everyone knows what's happened in China and the whole world in the 30 years since I was born. I'm simply a northerner. I've experienced the four seasons, the germinating of my body and my mind, and the loss of faith.'

Elsewhere in Beijing in the spring of 2009, Aniwar was reconnecting with an experience that years before had changed his life, an experience which had intensified his sense of the immensity of nature, something that made him determined to create work that embodied its force.

In 1987 he had spent 100 days exploring the Taklimakan Desert, which lies at the heart of Xinjiang. The Taklimakan is studded with ancient cities lost beneath its dunes, and its shifting sands have a well-earned reputation for treachery. But it exercised a powerful attraction to Aniwar, who had been born on its fringes. In the summer holidays that year his fellow students had been encouraged to go out and explore their country in preparation for their final year at college. Most of them had headed for the special economic zones, but Aniwar had decided to return to his homeland.

Over a number of weeks, armed with sketchpad, compass, dried food and three canteens of water, he made two- or three-day sorties into the Taklimakan and out again. His idea was simple: to feel the desert, to walk alone. But then on a journey to a place called Black Sand Mountain, he lost his way.

He had been told that when he reached the mountain he would be able to see his way back from its summit but when he arrived all he could see was sand. Faced with endless dunes he began to doubt his compass and finally chose a direction and stuck to it out of sheer desperation. Unable to sleep for fear the sand would swallow him up, he hiked for five days, battling panic and thirst, forcing himself not to drink his last canteen of water. Finally, he saw a group of trees on the horizon. In the Taklimakan, where there are trees there are people. He felt a flood of relief mixed with fear that his senses were playing tricks. It was only when he smelt the sap on the air that he knew he was safe. Years later he could still remember the rough sensation of the bark against his skin as he embraced it to make sure the trees weren't a mirage.

'I was transformed by that experience,' Aniwar told me, 'and I found new hope. After I had been through all that confusion and found my way again, I understood more about the true relationship between life and art. I knew what real art is, and I knew I could only make art!' He wasn't interested in the material, the political, or the pop; he wanted to explore realms of artistic expression where words have no place.

Over a decade since the late 1990s he had developed his own abstract language of painting. The vivid colours and their layering on the canvas—often over months, stroke by considered stroke—gave his work a mirage-like illusion of depth and space, which Aniwar thought of as their 'force field'.

Since his experience in the desert he had wanted to find a way to engage nature directly in his work, and in 2008 he had finally found one. That spring he had moved into a new studio with a courtyard, just as he was starting to work with water-soluble oil paints.

His idea was to give the physical and sensual phenomena of weather and the seasons a role in his creative process. He took canvases he had worked on for many months in the studio, and placed them face up in the open yard. There he dripped pigment from above, letting the breeze scatter and drag it across their surfaces. Then he waited for one of Beijing's famous spring or summer storms to break, allowing the first drops of rain to fall onto the canvases and pool, resulting in an opalescent quality.

When all the elements cooperated, the pieces were finished in a single afternoon. Others were painted by the wind in January and completed by a rain shower in April. When I visited him in the late spring of 2009 he had been using this unique version of *plein-air* painting for more than a year, the canvases set up around his studio suggestive not just of wind and rain, but of stars swirling in space.

But the day I arrived he wasn't painting on canvas; instead he was working with hundreds of felt mats, rolling them one by one into tubes which he then adorned with a single stroke of blue paint. He had been

asked to participate in a group exhibition about sound and music, and faced with the prospect of contributing still more noise he decided instead to offer silence.

The rolled mats, made out of the kind of woollen felt that in Xinjiang adorned nomads' houses, were going to line a room in the exhibition venue. Tightly placed side by side, the mats would cover the four walls and the roof until the room was perfectly insulated by the soft wool. He remembered how it had been years before, when he had been studying for his university entrance exams, and he had cocooned himself away in the wool dyeing room to read. There he remembered it had been so quiet that he had believed he could hear the sound of his blood pushing through his body. 'The absence of sound will help you to really hear,' he told me. 'You'll hear what's inside your body, not outside. You will hear your own body living.'

I smiled quietly at Aniwar's idea, but I still went to the exhibition. It was called 'Music to my Eyes' and it sprawled over multiple floors of a new private museum in the capital's CBD. Searching for Aniwar's felted room I came upon a strange darkened box tucked away in a far corner of the show. Inside the box on a screen I saw a video of a girl. To a soundtrack she'd remixed of a Chinese punk-rock hit, she was working her way along a whitewashed wall, painting then erasing, then painting again, changing her clothes from a slick gangster-like suit to a white wedding dress, to a bikini and platinum wig, stripping naked in between, and then painting again. From time to time she would pick up a can and spray-paint the question, 'Isn't something missing?'

She painted a headless man in a suit; a graffitied Hokusai octopus ravishing a naked woman; a fleshy-lipped man in close-up reclining on his side as if viewed from a neighbouring pillow. And then she spray-painted across his face, blacking out his eyes and tagging 'miss you, miss you'. Finally, she returned the wall to its whitewashed state, leaving behind a scrolling LED sign which kept on asking 'Isn't something missing?' over and over again.

The work was exhilaratingly angry and exhausting, with its cycle of creation and destruction played out to a screeching soundtrack. I loved it. 'I want the audience to feel pain too,' the artist told me when I met her later, 'because everyone is missing something.'

Her name was Pei Li. She was 24 years old and disarmingly fresh faced when I met her, despite the cauldron of emotions brewing inside her. Her video had been inspired by a failed love affair, one that had left her in hospital after she had drunk so much vodka in her despair that her stomach had begun to bleed. 'I liked the taste of it,' she told me, not specifying if she meant the vodka or the blood.

She came from the generation born in the 1980s, children of the one-child policy, the generation that older Chinese kept saying had no depth or insight. Cao Fei once described them to me as 'the Instagram generation'. 'They don't look at anything for long,' she said, 'for them it is all snapshots.'

But Pei Li wasn't like that at all, she looked at everything with intensity and in doing so she made me look at China in a new way. What she reminded me of most were the poets I had once drunk with under the stars at the Old Summer Palace. She told me she wasn't even sure she wanted to be an artist, maybe she just wanted to be a punk. Later she would tell me about her traditional upbringing in Changzhou, in the heart of what I always thought of as 'willow pattern plate' China, deep in the Yangtze delta, a country of classical gardens and jasmine tea, of arching stone bridges and silk embroidery, of poets and pagodas. She had gone to art school in Hangzhou, famous for its West Lake, which had been celebrated by poets and painters over centuries, and which was now home to China's version of Silicon Valley. She'd studied new media and video there and *Isn't something missing?* had been her graduation work. They hadn't thought much of it, she told me. 'I wasn't a very good student.

'I'm often angry. If you have strong emotions it's better to create than to destroy, isn't it?' she asked and didn't wait for an answer. 'I think

in everyone's deepest heart there is a violent side and I want to use that violent side to create.'

Twenty long years of living separated her from the artists who had come of age at Tiananmen Square, but it was as if she had drunk from the very same source as they had done in the late 1980s when hope was new.

I thought of what Pei Li had said about anger when I went to Sheng Qi's exhibition just a few weeks later. It was June and the twentieth anniversary of Tiananmen had just passed.

Sheng Qi had started experimenting with painting in 2002, and for a long time he struggled for a style that would capture the mood of sadness he wanted to convey. His first efforts, he told me, were 'too romantic, too beautiful, too much on the surface' and he kept looking for something 'more spicy, more harsh'.

Finally, he found a dripping technique with paint, which gave his canvases the impression that rain—or tears—were running down them in rivulets. He chose to work predominantly in red and black, colours that to his eye embodied bravery. 'If you have enough courage to stand up you will be heard,' he told me. 'If I chose black and white that would be weak, but black and red shows courage. To stand up is to be bloody!'

Now he had completed a body of paintings that he would show in June 2009, twenty years after—and in honour of—the events that had changed his life.

It was only a day or two since his show had opened but it looked as if the place had been ransacked. Many of the walls were blank except for labels showing where the missing works had been. Sheng Qi wearily told me how it had gone down.

On the day of the opening the police had arrived promptly to take down works that offended them. First among these was a painting of a smiling policewoman, in full dress uniform and holding up a 100RMB

note as if it was her police badge. 'They thought I was implying there was a connection between power and money and they didn't like it,' he told me. Then he added: 'I *was* saying that, of course'.

Their objection to a second group of paintings was more overtly political. These were paintings that featured Chairman Mao. In one a giant statue loomed over a prostrate crowd, in another a bust of Mao stood on a square filled with tiny people. Rendered in red, the Chairman's head dripped across the black and white figures.

But the paintings that they had let remain still told the bloody story Sheng Qi wanted to convey. One showed crowds of young people seated in Tiananmen Square, their figures black and white, the square awash with red; another showed a young woman lying as if sleeping, the paint weeping across her body; yet another depicted crowds sheltering under umbrellas as if shielding themselves from grief.

A few days after my visit, the police shut the whole exhibition down. They also arrived at Sheng Qi's studio to give him a warning. It was polite enough but the message was clear. After a decade of trying, he knew he had to leave China once more. 'I thought, *I don't have any famous family to protect me from trouble. I am a son of nobody, so I have to go*.' In 2010, twelve years after he had returned home to China, he flew out again for London.

Days after I saw Sheng Qi's truncated exhibition I took a walk through 798 wondering whether anyone else had dared to show work about Tiananmen. There I found a gallery that had built a steel reinforced room with a porthole through which you could view the show. Inside the room, a firehose set to full blast kicked and arched, spraying water at the glass. The power of the water was extraordinary and despite the steel rivets a little of it still escaped to wet your face as you peered in. The title of the show was 'Freedom'.

And then in December, Liu Xiaobo was finally brought to trial. He had been charged with 'incitement of subversion of state power'. There was no doubt that he would be found guilty. At the trial he tried to read a statement but the presiding judge cut him off after fourteen minutes, ruling that his statement in defence could not be longer than the statement by the prosecutor. Fourteen minutes was all the time it had taken to argue that he should be imprisoned.

'June 1989 has been the major turning point in my life,' he began, describing a life which was then just over a half century long. It was this event that had made him a dissident.

In the statement he declared that he had 'no enemies and no hatred' and spoke of his love for his wife Liu Xia, who had not been permitted to attend his trial: 'Your love has been like the sunlight that leaps over high walls and shines through iron windows, that caresses every inch of my skin and warms every cell of my body. Even were I ground to powder, still would I use my ashes to embrace you.'

Calmly he made the case for his innocence and spoke poignantly of his optimism for a time when China 'will be a land of free expression . . . a country where all political views will be spread out beneath the sun for citizens to choose among, and every citizen will be able to express their views without the slightest fear'.

Westerners can read this message of hope in the full published text of the defence address. But the judge never heard it. Liu Xiaobo's time to speak had by then run out.

He was sentenced to eleven years in prison.

The next year he was awarded the Nobel Peace Prize. His wife—now under house arrest—was not allowed to attend the ceremony in Oslo. The Nobel medal stayed in its small wooden box and Liu Xiaobo was represented on the stage by an empty chair.

CHAPTER TEN

AMNESIA AND MEMORY

We gathered our provisions on the way. In roadside shops we bought incense, candles, long red coils of fireworks and paper money. The goose was waiting for us at the village, Guo Jian's cousin told us.

We were travelling in convoy: Guo Jian, his cousin, nine of his former classmates and me, on our way to 'sweep the grave' of Guo Jian's grandfather.

In spring, at the festival of Qing Ming ('pure brightness') on April 5, Chinese people around the world gather at the graves of their ancestors to honour them and make offerings. This would be the first time Guo Jian had performed this traditional duty for his grandfather.

The day had started hazy and cool but by the time we were nearing his grandfather's village the sun was burning hot and high in a brilliant blue sky. As we headed south towards the border with Guangxi province, the limestone karst peaks grew sharper against the horizon, and the foliage a deeper green.

We had begun the day in some hilarity, but making our way through the fields to the gravesite our mood turned solemn. We walked in silence, all of us in single file except for Guo Jian and an old auntie from the village, who had joined us to help carry bamboo sheaves to place around the grave.

Everyone carried a separate offering—white mourning streamers to hang from the bamboo, rice spirit for a libation, fireworks, candles,

incense or paper money. In the lead, Guo Jian's cousin carried a beautiful grey and brown goose, its feathers scalloped in white. Dangling by its legs, it curled its neck up to look at the sky.

The grave was in a remote spot far from the village's official cemetery. It was in a patch of uncultivated ground, a place designated for outcasts, for babies or for others who were deemed to have died too soon, a place for the unlucky and the unblessed.

Guo Jian's grandfather had committed suicide at the age of 37, inside a mountain cave where he had taken shelter from the communist forces in 1951. The People's Liberation Army (PLA) had entered the southern province of Guizhou in 1950 as they pushed south to complete the takeover of the country which Mao had declared as the People's Republic of China in October 1949.

Before the communists came, Guo Jian's grandfather had been a small farmer whose education had singled him out as a leader. He was a respected figure in his village, but a modest man. When he was approached to represent his district at the national assembly of China's pre-1949 Nationalist government he had declined, writing simply that he was 'very proud to be nominated, but too humble to go'. But in the new People's Republic even before this tenuous link to the Nationalists was discovered, his status as a 'landlord' meant that he was doomed. The fact that his teenage son, Guo Jian's father, was off fighting with the PLA elsewhere in the country was of no account.

He fled from his village into the safety of the hills, but someone reported the smoke from his cooking fire. With the cave surrounded he decided to shoot himself rather than give himself up.

The soldiers tied his body to a plank and carried it down to the village where they paraded him like a trophy through the streets. His wife, Guo Jian's grandmother, could only stand and watch. Later his body was dumped outside the village in the outcasts' graveyard. It would be more than 30 years before Guo Jian's father could raise

a gravestone on the spot and 40 years before Guo Jian persuaded his grandmother to tell him the story.

By the end of 1951 almost two million 'landlords' had been murdered in China as part of the process of communist 'land reform'. In this period Mao set a nationwide goal that one person per thousand should be killed, but in Guizhou, where popular resistance was strong, the toll rose to three dead per thousand. There was never any chance that Guo Jian's grandfather would have survived if he had not cheated the party by taking his own life. His two brothers would die, too: one would be executed and the other would commit suicide, over-dosing on opium that was smuggled to him in prison.

We gathered quietly around the grave. Guo Jian set out small porcelain cups at the base of the gravestone and filled them with rice spirit, while his 'auntie' set up lighted candles. On a small mound above the site we planted the bamboo sheaves and hung them with white strips of paper for mourning. Guo Jian's cousin quietly took out a small scythe-shaped knife and slit the goose's throat, letting the blood fall on the stone in front of the grave. Each of us stepped forward to dip paper money in the blood and set it on fire, waving the smoke towards the sky.

Guo Jian and his cousin knelt, and with bundles of incense smoking in their hands bowed to the grave three times, filling the air with scent. Finally, they unrolled a long coil of bright red firecrackers, snaking it around the gravestone and up onto the slope then down around the graveside once more. In his final act of homage to his grandfather, Guo Jian lit the fuse and we stood back as the cacophony echoed off the hills, ricocheting from peak to peak until the whole valley filled with sound. After the final explosion the thunder rolled on, as if the hills themselves were applauding.

The next day Guo Jian and I walked along a disused railway track, the same rail line that he had taken as he had headed off to war 35 years before. The line was being diverted for a new ring-road around the city, part of a grand plan to connect his home town Duyun with a neighbouring town to create a new mega city, Da Duyun ('big Duyun').

The village he had grown up in had almost entirely disappeared. The Duyun of his youth had nestled below the hills, but the new one fought with them, confronting them with skyscrapers and massive bulldozers, which would level any that stood in the way of development. One hill had already been trucked away to make room for a 'development zone'.

'I used to be able to walk up the hill at the end of my street and look out on a beautiful landscape,' Guo Jian told me. 'Now walking around the town I can hardly even see the hills for the buildings.

'In these small places they are so in fear of being left behind that they embrace development, however bad,' he said, 'even if it is meaningless and of no benefit to them. All around China there is this fear of being *luo hou*—of being left behind, of being poor, being backward— and so you can't argue with development.'

It was hard to find much beauty in Duyun, but it struggled on in pockets. The river where Guo Jian had learnt to swim still ran through the town, and children still played in its fast-flowing water. Behind his school a small hill still stood covered in ferns and wild rhododendron. He had spent much of his teens playing there, skipping school and raiding the nearby orchards for apples and bayberries.

In the streets there was no sign of the traditional dress of the Buyi and Miao people who still dominated the town, but the women at least kicked against the dictates of conventional fashion. Proudly made up, they tottered down the streets in off-kilter boots or sparkly high heels, dressed in lace filigree, lamé and embellished leather, heavily embroidered pullovers and plush tight skirts.

Guo Jian's parents no longer lived in the town, and the house where he grew up was no longer identifiable on his old street. But some of his oldest friends were still around, not just the classmates from high school who had shared the pilgrimage to his grandfather's grave, but the ones who had run wild with him when he was just a boy. These old friends had grown up with him on the same street, sharing everything in their poverty, one friend's mother even suckling Guo Jian's young sister when his mother's breast milk was exhausted.

Guo Jian wanted me to meet them. While his schoolmates had sought out steady jobs and modest comfort, his old street companions had taken chancier and more colourful paths through the new China. One had grown rich as a professional mah-jong player, another had ended up as a gangster's bodyguard in Shenzhen, a third was driving his own taxi, while his wife ran a restaurant where we met for lunch.

Around a meal of bamboo rat stew, the four of them traded stories of long lost friends. In the 1980s it had been a popular choice to go to Shenzhen. Less than twenty kilometres from Hong Kong's border, the new special economic zone had quickly become a home to smugglers, drug traffickers, gamblers and pimps, and the tough Duyun boys had made their name as fighters and prized underworld recruits.

One of their friends—the smartest of the lot, they said—had become a gangster himself, accumulating wealth and power before falling foul of a rival gang. No one knew for sure, but they assumed he was dead.

The one-time gangster's bodyguard stayed quiet through most of this conversation. He had become an alcoholic while he was away and he drank steadily through lunch. He was heavily tattooed and missing most of his teeth, a scary sight for those who didn't know him. But he spoke kindly and slowly for my benefit in standard Mandarin Chinese, and opened the car door for me later as we got into their friend's taxi to drive up above the town and look at the view.

The last stretch was too steep for the car, so we walked, winding our way up the hill in the shade of the firs, the sunlight filtering through their soft needles onto the ferns that grew in abundance on the forest floor. Birds darted across our path and there was a smell of honey on the air. Up here you could see how beautiful Guizhou province could be, until you turned to look at the view.

Back in the town, giant diggers were eating away at a hill, leaving just the rind, its heart exposed in churned red soil that stood out against the green of the remaining wooded slopes.

In the city again, Guo Jian and I walked through the streets looking for landmarks from his past. He found the small bridge over a canal where 30 years before he had met the recruiter from the Minzu University who had changed his life. The water was full of rubbish, much of it brightly coloured packaging. Guo Jian photographed it, focusing on wrappings that featured the faces of Chinese celebrities— actresses endorsing soap or toothpaste, comedians selling instant noodles. 'Rubbish culture,' he observed, with a laugh.

When Mao declared the People's Republic in 1949, honouring the dead at Qing Ming was outlawed along with all other such displays of 'feudalism'. But in the years following his death, China's leaders started positioning the government as the inheritor rather than the destroyer of China's traditional past. They recognised the power in these ancient customs and endorsed them as a way of usurping them. In 2008 they declared Qing Ming a public holiday.

But while this stroke of the pen was meant to pronounce the government's respect for the right to remember, the kind of remembering that is tolerated remains tightly circumscribed.

Each year the government presides over a massive state-imposed act of forgetting about the events of 1989. In 2014, the 25th anniversary

of the Tiananmen massacre, they would go to greater lengths than ever to prevent even the smallest act of remembrance, imprisoning people who held private memorials, keeping victims' relatives under police surveillance, scrubbing the internet clean of any reference, and even sending foreign students out of Beijing to keep them from sharing information with their Chinese classmates as the June 4 anniversary loomed.

In the wake of the Tiananmen massacre, the government conducted public mourning for the soldiers who had died in the crackdown but there has never been any public act of mourning for the demonstrators and ordinary Beijingers who were killed, and attempts by the bereaved to have the victims' names listed have been blocked. The government handed down its official verdict on the events in 1989, declaring the demonstrations a 'counter-revolutionary rebellion', and they have resisted all calls since to change that judgement.

Since 1989, history and memory have been key battlegrounds for the government in a war that they are determined will be fought and won on their terms. This insistence extends far beyond the Tiananmen events to other disasters of the People's Republic, including the Great Leap Forward and the Cultural Revolution and beyond, setting the correct line on the whole sweep of what they like to call China's 5000 years of civilisation.

In their version of history, the 100 years leading up to the declaration of the People's Republic was a 'Century of Humiliation' at the hands of foreigners, which was only ended by the triumph of the Communist Party in 1949. In this narrative the party is China's historical saviour and the only force that can ensure the nation's continuing rise. With breathtaking nerve, the party claims credit for the defeat of Japan on Chinese soil in 1945, a gruelling feat that was almost entirely achieved by the Nationalist forces, the Communist Party's rivals in the Chinese Civil War who were crushed in the communist victory of 1949.

In 1989, as he prepared to send the troops into Tiananmen Square, Deng Xiaoping mused that the biggest mistake the government had made had been to neglect the proper education of its young people. Too much had been made of the 'mistakes' of the communist era and too much respect paid to what China could learn from the West. A new program of patriotic education must be instituted to ensure that young people were reminded of what the party had saved them from—a series of humiliations by the same Western countries whose systems the Tiananmen demonstrators had pointed to for inspiration.

Accordingly, since 1990, all Chinese students have taken compulsory courses on the Century of Humiliation, which begins with the Opium Wars and runs through the war with Japan and only ends with the triumph of the communists in 1949. Manmade disasters such as the Great Leap Forward and the Cultural Revolution are reduced to mere missteps on an otherwise glorious road of national rejuvenation.

When I first arrived in China in 1986, the Cultural Revolution was discussed everywhere. The so-called 'ten years of turmoil' from 1966–1976 had weighed heavily in the balance in judging Mao Zedong's legacy. True, most of the commentary focused on individuals rather than the ways in which the system itself had contributed to the disaster. It was also true that, rather like in France, where everyone alive during World War II claims to have been a member of the Resistance, in China you only ever seemed to meet victims of the Cultural Revolution, never perpetrators.

But there was a general acknowledgement that the period must never be forgotten and that remembrance would ensure that such a disaster would never again engulf China. However, as I write in 2016, 50 years after the beginning of the Cultural Revolution, the period has been reduced to not much more than a footnote in China's textbooks. Young Chinese have very little conception of what happened in that time, their ignorance so profound that, in recent years, fashionable

youngsters have embraced a kind of Cultural Revolution chic, as if the period was only about unisex clothing and army surplus.

The approved historical narrative is laid out in China's National Museum, situated on Tiananmen Square opposite the Great Hall of the People. There you can view a permanent exhibit entitled 'The Road of Rejuvenation', which takes the visitor on a journey from the 'semi-feudal, semi-colonial society' to which China had been reduced at the time of the Opium Wars of the nineteenth century to the 'glorious history of China under the leadership of the Communist Party'. In this exhibit you will find whole rooms and dioramas devoted to the humiliations meted out to China by the West and yet search in vain for more than one ill-lit picture to illustrate the Great Leap Forward, during which tens of millions of Chinese died. The proverbial Martian visitor would conclude that during the 1960s nothing notable happened in China at all save a successful hydrogen bomb test.

Needless to say there is no sign of the events of 1989 in the museum, no sign either of the leaders who steered China's government in the 1980s, no pictures of Hu Yaobang or Zhao Ziyang.

But there is room for the Texan hat Deng Xiaoping donned on his triumphal visit to the United States in 1979, and the jacket that he wore on his 'southern inspection tour' in 1992—each object sealed in its own glass case.

Despite this state-imposed amnesia about inconvenient events, there are still ordinary people and citizen historians around China who attempt to make other stories heard, and take back their history from official control.

The most poignant of these efforts is that of a group who call themselves the Tiananmen Mothers, bereaved relatives who since 1989 have worked to collect the names and stories of the victims of

June 4. The mothers are led by a retired professor of philosophy from Beijing's People's University, Ding Zilin, whose seventeen-year-old son was killed when he headed for Tiananmen Square on the night of June 3 1989. Together with the mother of another young student who died on that night, Zhang Xianling, they have gathered the stories of 202 victims whose families were prepared to risk having their loved ones' names listed on the Tiananmen Mothers' website.

The names include people who were killed when the army fired randomly into residences on their way into the city, like the elderly woman standing on a fourteenth-floor balcony overlooking the Muxidi intersection, or the 66-year-old worker with a wife and four children taking shelter in the *hutong* home of a relative. There are also the names of young students such as Zhang Xianling's son, who was shot while photographing the army making its way down the Avenue of Eternal Peace towards Tiananmen Square. He bled out on the street while soldiers waved away bystanders who tried to help. Still in high school, he was an aspiring photojournalist, telling his mother that he 'wanted to record events for history'. Alongside the painstakingly assembled stories of named victims, the mothers' investigations also have turned up evidence of people whose bodies were cremated by the authorities without being identified.

Over the past quarter of a century the mothers have issued repeated open letters to the government calling for a full accounting of all victims, and compensation for their families. They also seek a guarantee of being able to mourn peacefully in public. None of these requests has been granted; instead they have been forced into early retirement, have seen their website blocked, been put under surveillance and harassed, and been required to undertake their small acts of mourning under police supervision.

The Tiananmen Mothers are just one group working to reclaim China's history from official silence. There are also small bands of citizen historians who publish their research in informal journals that

circulate only via email so as to circumvent the controls on registered publications. And there are independent documentary makers such as Beijing-based Wu Wenguang, who in recent years has established a program to send young people back to their home villages to record the memories of those who lived through the Great Leap Forward. Around 200 twenty-something aspiring documentarians have in this way discovered the horror of the event, as it played out in their own home towns years before they were born. Having gathered the names of the victims some have then raised money to erect gravestones to honour the dead, providing a focus for public mourning in their villages that has been delayed for six decades.

The most exhaustive study of the Great Leap Forward and the famine that followed in its wake was written by a now retired reporter from China's official news agency called Yang Jisheng. Over a period of fifteen years Yang researched this manmade disaster, which claimed somewhere between 36 and 45 million lives in the period 1958–1962, using his official status to dig into local archives throughout the country and interview surviving witnesses to put together a story that the government has been determined should not be told. The official line continues to assert that the famine was a natural disaster, not a catastrophe brought on by Mao's crazed ambition for China to vault straight into the top league of industrialised nations via rapid industrialisation and collectivisation of agriculture.

Yang Jisheng's account is called *Tombstone*. It is banned in China, but around 100,000 illegal copies circulate on the mainland. In the West the book has been acclaimed as a milestone in Chinese historiography. In the introduction to the English-language version, Yang Jisheng writes:

A tombstone is memory made concrete. Human memory is the ladder on which a country and a people advance . . . The authorities in a totalitarian system strive to conceal their faults and extol their merits, gloss over their errors and forcibly

eradicate all memory of man-made calamity, darkness, and evil. For that reason, the Chinese are prone to historical amnesia imposed by those in power. I raise this tombstone so people will remember and henceforth renounce man-made calamity, darkness, and evil.

The government's determination to control the historical narrative extends to the entire sweep of Chinese history, and it is here that the greatest risk in their approach may lie. Their approved account imagines a single, indivisible, changeless China. The historically distinct regions of Xinjiang, Tibet and Inner Mongolia, which lie at the country's far western and northern borders, are declared to have 'always' been part of China. But the frontiers of the modern state were only drawn in the eighteenth century under the Qing Emperor, Qianlong. For the next century and a half, China's hold on its most far-flung territories strengthened and weakened as power ebbed and flowed at the centre.

After 1949, the communist regime cemented Tibet, Xinjiang and Inner Mongolia into the People's Republic. But to claim that these regions have always been Chinese negates millennia of independent history and turns rich cultural legacies into footnotes to the official Chinese narrative.

The truth (which the government vehemently rejects) is that China's relationship with its border cultures is a colonial one. Just like colonial powers in years past, the government is struggling with the question of how their subject peoples' sense of their own identity and history should be accommodated. These are not easy questions, but as the recent history of Xinjiang and Tibet has shown, denial and negation is not the answer.

I first encountered Xinjiang in a suburb of Beijing, one spring night in 1986. In those days there still existed in the north-west of the city a mysterious area called Weigongcun, a onetime village that had been home to the Uighur community in the capital since the Yuan dynasty (1271–1368). Deep into the night, in a dark unpaved street that hugged the north wall of Minzu University, a small restaurant served out platefuls of long, slippery, chewy noodles smothered in tomatoes and peppers.

I rode there on my bicycle with my friends Bruce Doar and Sue Dewar. They were sinologists, fluent in Chinese both classical and modern. Brilliant scholars of China's archaeological past, they had a particular fascination for the cultures of the borderlands of China, Xinjiang and Tibet, and it was through them that I first began to understand those regions.

Inside, the restaurant was warm and bright and crowded, the air heavy with the scent of lamb and tomatoes, with a fleeting undertone of hashish. Through the kitchen hatch you could see a young man in an embroidered cap performing the nightly miracle of *lamian* (as the noodles were known). He started with a round of dough which he rolled, twisted and spun and then, with a conjuror's trick that I never spotted, formed a skein of thick noodles with his fingers, divided and doubled them, redoubled them again and flicked them into the bubbling pot.

That night was the first time I heard Uighur spoken—a Turkic language of long rills and whip-crack consonants. I knew that Xinjiang lay at the heart of the Silk Road, and that ancient traders had made Xinjiang's south-western city of Kashgar into one of its most important trading posts. But I knew nothing then of the history of the Turkic peoples, whose khanates, kingdoms and empires had spread across Central Asia and Siberia long before they moved west into Anatolia to found the Ottoman Empire, the precursor to the modern state of Turkey.

It took me another eight years before I finally got to Xinjiang itself, taking the train to Urumqi with an ABC camera crew in the autumn of 1994. Sally Neighbour and I had been talking about going there from the first time we met. We shared a romantic craving for it, and particularly to see Kashgar, that fabled crossing point of cultures. We had also heard rumours of trouble out there, a stirring of agitation for autonomy, which drew us as journalists.

The night before we set out for the west we went to see a Xinjiang band play at the capital's first live music venue, Poachers. Bruce Doar had told us that if we really wanted to get a feel for modern Xinjiang culture we had to see Grey Wolf. They were led, as it turned out, by a guy called Askar, the younger brother of the artist Aniwar, who I had recently met for the first time.

And so on the eve of our journey we found ourselves jammed against a stage, mesmerised by this charismatic rocker, who serenaded us with songs of deserts and mountains, wolves and wild spaces and beautiful Russian girls who broke your heart. They were playing ordinary rock instruments but you could hear the ancient rhythms of the Silk Road and all its way stations from Persia to Spain.

And in the crowd, among the rest of us bopping and vogueing, were the Xinjiang-born dancers, the men straight-backed and courtly, spinning and bowing to their partners, the women's arms gracefully, sinuously held aloft. It was exhilarating to feel in the crowd the power of China's multi-layered culture, especially in the band with its mixed line-up of Uighurs and Han Chinese. It was the Silk Road brought to life, a highway that connected east to west.

Arriving in Xinjiang's capital Urumqi a few days later was a jolt. By comparison to today, the military presence was mild, but it was still a shock to come upon soldiers holding mock target practice in the main city square. The message from the local governor, on the other hand, was pacific. We worked hard to get him to admit that there were any problems at all. In the end he did refer to an 'extremely tiny number'

of people who wanted to 'divide and destroy'. The contrast with the official line today is stark, with the government talking up every sign of trouble to support its narrative of an existential threat.

The ABC crew and I headed for Kashgar by plane. Bruce Doar likes to tell the story of Xinjiang air travel in the old days, when flight security was a smiling cabin attendant who would make her way down the aisle before take-off, collecting knives and ceremonial daggers on a tray for return to their owners after landing. Sadly, security on our flight was less colourful and more tense—a sign of the times in 1994.

The plane was an ancient Tupolev that came with its own gloomy Russian aircrew. Once we had groaned our way to cruising altitude, I tried to take my mind off the rattles filling the cabin by admiring the snow-capped Tian Shan mountains below, and listening to 'Lara's Theme', which played over the cabin speakers all the way to Kashgar.

Kashgar was a beautiful town then, at its heart the adobe Old City moulded from the earth on which it was built, a maze of streets that dated to the time of Marco Polo. To the Uighurs, it was Kashgar, and not the army-dominated 'new' town of Urumqi, that was their true capital.

The Sunday market teemed with traders, selling everything from bolts of local hand-loomed silk and camel-hair rugs to fat-tailed lambs and sturdy Mongolian ponies. In its alleys smelling sweetly of Iranian saffron and cloves were stalls selling consumer goods from the factories of inland China, too. The border had reopened with Pakistan in 1987 and there was now a cracking trade across the Karakoram Mountains.

As in the rest of China, the 1980s in Xinjiang had seen not just an economic transformation but a cultural resurgence, too. Private trading, long banned under Mao, had returned along with the traditional crafts, music, dancing and other arts that had been banned during the Cultural Revolution. Religious observance was no longer outlawed, and in those years even Communist Party cadres were allowed to follow Islam. More genuine autonomy was also proposed for Xinjiang, with the promotion of more Uighurs into government.

But as with the rest of China the events of 1989 were a watershed. From 1990 the laissez-faire attitude to religion was wound back and a fear of Uighur nationalism grew. When the Soviet Union broke up in the early 1990s it created independent Turkic-speaking nations— Uzbekistan, Kirghizstan, and Kazakhstan—just beyond Xinjiang's borders. The government moved to increase Han Chinese migration to Xinjiang and to draw its economy into closer integration with the rest of the country.

Despite this, Kashgar's sense of itself as something distinct was palpable to us. Wandering through the back alleys of the Old City near the Id Kah Mosque we met a carpet trader, heavily bearded and of venerable age, who invited us into his home to talk. As we sat down with him on a brightly coloured rug, he and his wife piled up food around us, plates of freshly baked *nan* bread, slices of watermelon, sun-dried raisins, jewel-like sweets, and tea sweetened with pieces of sparkling rock sugar.

This old man saw the story of Kashgar in terms of millennia, during which 200 years of Chinese rule didn't seem especially significant. His house had stood unchanged for twice as long as that, he remarked. Overarching everything for him was his faith. Kashgar was among the first of Xinjiang's cities to convert to Islam, an event dated to 960, a thousand years before we sat down to talk. The coming of the Chinese had made no difference to that basic fact. He suggested there would be a continuing accommodation: 'We do what we do and the Chinese do what they do, and that's the way it's always been.'

But elsewhere in Kashgar there were signs that others were not so philosophical. Not far from where we were staying was a burnt-out government building, still not repaired after a firebomb attack some months before. It was said to be one of a series of such attacks in retaliation for the bloody suppression of an incident in a neighbouring town in the spring of 1990.

The official story was of a planned armed uprising by members of an 'East Turkestan Islamic Party' in which hundreds of rioters

surrounded government buildings in the town, eventually killing six police officers. The army then moved in, killing the ringleader and sixteen other rebels. An alternative account was of a peaceful demonstration that only turned violent as a standoff developed. Whatever the truth, a subsequent Amnesty International report suggested as many as 50 rioters were killed in the incident, but the true figure may never be known.

Despite this dark undertone to our visit in 1994, I had fallen in love with Xinjiang. When I returned to China in 2004 I resolved to visit the region every summer and I did so for three years. On each trip I would return to Kashgar, and from there set off to explore the other oasis towns that hugged the southern rim of the Taklimakan Desert.

There was Karghilik on the back road into Tibet, a town of adobe houses with vine-shaded courtyards, home to an exquisite, decoratively bricked mosque and a wild public park filled with hollyhocks and vegetable allotments, where the local teenagers roller-skated around a homemade rink to the sounds of Boney M, yelling 'Ra! Ra! Rasputin!' 4000 kilometres from Moscow. It was in the park at Karghilik that a group of old men got talking to me and I realised I had forgotten to pack two essentials for Silk Road travel: pictures of my family, and a range of foreign banknotes—both a source of fascination in Xinjiang. As it was, my collection of Chinese currency became a wry conversation piece.

As we examined the 100-yuan bill one of the men touched the placid features of the Great Helmsman with a wrinkled finger. 'There's Mao,' he said, expressionlessly. 'Fifty yuan,' he suggested, and when I proffered it he looked at it with a hint of a smile: 'There he is again.'

Twenty yuan, ten, five, one: I brought them out in turn—'Mao, Mao, Mao and Mao,' they murmured.

Finally, I produced one of those grimy scraps of paper that denote ten Chinese cents. No portrait of Chairman Mao this time, just two men in profile drawn to represent China's ethnic minorities. 'Oh yes,' my companions said, 'here's us!' and fell about laughing.

Further along the South Silk Road was Yarkand, once home to traders from India, Bukhara and beyond, its back streets still filled with craftsmen hand-turning poplar wood into decorative banisters and columns for its graceful terraced buildings with their shaded verandahs.

In the summer the faithful prayed beneath a grape arbour, and when a young girl spied me lingering at the carved open gates she picked some of the mosque's grapes for me to eat. In this town the grandest monument was for Amannisa Khan (1526–1560), the Queen of the Yarkand Khanate, a composer and musician who collected and preserved the twelve *muqam*, the great song cycle of the Uighur people. Around her tomb children played and families picnicked among the graves of their ancestors. In the orchards heavy with apricots, pomegranates and pears, and in fields full of corn, women worked in bright silk dresses and high-heeled shoes, wearing only a light scarf on their hair.

In 2006 I spent a whole summer in Kashgar, passing my days gossiping with the women who worked in my hotel as they laid out plump apricots to dry in the sun. In the cool of the late afternoon I would walk the streets of the town, drawn by the sound of the call to prayer from the Id Kah Mosque, watching goldsmiths fashioning dowry jewellery in the crowded side streets, listening at the door as instrument makers tried their inlaid long-necked lutes and taut hide-covered drums. Wedding parties would parade the main streets, announced by an open truck full of trumpeting musicians, while women zipped past on scooters, resplendent in brightly coloured skirts and high-heeled sandals. I ate all my meals off the street: dinners of fat chunks of lamb skewered over an open brazier, breakfasts of rich Kashgar pilaf and rose petal tea.

By the time I returned to Xinjiang again in the summer of 2009 everything had changed.

Askar and his band were heading for Australia to play the Darwin Festival in August of that year and I had arranged to profile them for *The Australian* newspaper. My idea was to interview Askar in Urumqi, where he was spending the summer with his family, and then head on to Kashgar.

He and his band had become stars in China. With five Uighur and three Han members, they had worked traditional Uighur instruments into their standard rock line up: two lutes—one bowed and the other plucked—and a cymballed hand drum called a *dap*. Playing with fiendish, genre-busting intensity, Grey Wolf could bring a room full of stone lions to their feet, especially when Askar's wife, an acclaimed traditional dancer, came whirling onto the stage. By 2001 they had a top-ten hit and were chosen to support the Three Tenors in their concert at the Forbidden City. By the time they were picked for the Darwin Festival they had toured countries from the Philippines to France.

On July 5 2009 bloody riots broke out in Urumqi. Trouble started with a demonstration by over 1000 Uighurs in the People's Square. The spark for the demonstration was a report of an ugly incident of Han xenophobia among factory workers in far-off Guangzhou that had flared into anti-Uighur riots, leaving a reported two Xinjiang workers dead and dozens injured. Video of the incident that circulated online, however, suggested a heavier toll. The crowd were demanding an inquiry, and their anger was swelled by deeper currents of resentment.

Uighurs felt that, for some years, Han migration to Xinjiang had been closing off job opportunities and forcing young Uighurs onto the road in search of work. So in Uighur eyes the Guangzhou riot casualties were not just victims, but unwilling exiles from their homeland.

From early 2009 tensions had been rising as the government started bulldozing vast swathes of the historic Old City of Kashgar. The official

pretext, laughable and maddening to Uighurs, was that these buildings that had stood for centuries were not earthquake-proof. In their place, characterless developments were going up and most of the former residents were being rehoused on the city fringes.

On July 5 when some demonstrators were arrested at the People's Square in Urumqi, a standoff quickly developed in the streets near the Grand Bazaar. The Chinese government maintains that the subsequent riots were part of a plot by an international Uighur separatist group. Locals say the spark was police brutality. The violence was shocking: innocent Han Chinese were suddenly targets and it took the police a full day to regain control of the city. In the days that followed, armed Han civilians paraded through the streets in a show of force, while news of retaliatory attacks by Han on Uighurs spread.

The official toll was finally reported as 197 dead and 1721 injured, the majority being Han Chinese. There were allegations by Uighur advocacy groups that the official Uighur death toll was under-reported, but, even so, the way resentment had spilled over into anti-Han violence was sickening and undeniable. In the days after the riots thousands of Uighurs were arrested, with many remaining unaccounted for months later.

Two weeks after the riots I took the long flight across the plains of north China and the snow-capped Tian Shan range to Urumqi. Despite the trouble, I was determined to write the Askar article as planned. It seemed more vital than ever to write about a band whose very makeup spoke to a better possibility.

I arrived in a city that was effectively under martial law. My hotel near the old Uighur bazaar overlooked the barracks of the People's Armed Police, China's internal paramilitary security force. The courtyard was a parking lot for military lorries and white-painted personnel

carriers decked with minatory slogans about ethnic harmony. I woke the next morning to the crash of boots and shouted orders.

In the streets near the Grand Bazaar truckloads of troops rolled by, staring into the streets through Perspex riot shields. At each corner of the main square stood police squads in groups of four, one armed with a semi-automatic weapon, the other three with meter-long wooden clubs. Camouflaged canvas umbrellas shaded them from the Central Asian sun.

I walked past two young Uighur girls kneeling in the main square, a picture of a young man—their missing brother?—displayed on the rug in front of them. The bazaar, usually alive with people bargaining over everything from dried apricots to reindeer horn, was almost empty. 'Buy something! Buy something!' a spice seller pleaded as I walked by.

I visited Askar at home, the apartment full of the children of his extended family watching a dubbed version of *The Truman Show*. The usual outdoor pursuits of summer had been abandoned: people felt safer inside. What I had planned as an enjoyable talk about his career proceeded uneasily.

We started to talk about how his songs had recently begun to explore the theme of environmental loss. I asked him about one he called 'Tears of Kashgar', a lament for the vanishing beauties of his home town. He told me that the song had originally been called 'Rainbow', inspired by the revelation that his Beijing-reared son had never seen this simple natural wonder.

'It made me think of so many of the things that I could see easily when I was young,' he said. 'And also of how harmonious things were back then. It was never a question of people being Uighur or Han; everyone got on because everyone's life was the same.'

Unspoken as we sat talking was the reality of modern Xinjiang, where economic development had sharpened divisions and the idyllic beauty of the old oasis towns was giving way to high rise and glitz.

Unspoken also was the tragedy then unfolding in Kashgar as the Old City was bulldozed away.

I tried to probe these themes with him, but he gently cut me off. 'I believe in peace,' he said, and I could not ask him more.

In 2009 some hoped that the scale of the violence in Urumqi might lead the government to look for ways to deal with the underlying causes of the unrest. But instead the government chose to go harder, 'doubling down'—as the long-time observer Nicholas Bequelin, now of Amnesty International, put it—'on the economic policies that are creating political tensions . . . to even accelerate further things that alienate Uighurs such as rehousing and resettlement, [pursuing] even more invasive economic activities in the region'.

In the 21st century the situation in both Tibet and Xinjiang has got steadily worse, with both regions now under heightened security, enduring an ever more oppressive system of surveillance and militarised policing. In both places Han Chinese immigration has proceeded apace, while locals endure endless needle-pricks of religious and cultural control.

Since the Lhasa riots of March 2008, some 144 Tibetans living within China have set themselves on fire in protest against the regime. These desperate acts have proved an embarrassment and the Chinese government does what it can to ensure they go unreported.

The situation in Xinjiang is worse. Ever-tighter policies of surveillance and control are creating what the government professes most to fear—radicalisation and terrorism.

In October 2013 a four-wheel drive vehicle crashed in Tiananmen Square, bursting into flames and killing its occupants and two tourists who were walking near Tiananmen Gate. Inside the car were three Uighurs from Xinjiang, a male driver accompanied by his wife and

mother. Journalists tried in vain to learn why these three would have committed suicide in such a terrible way. There was talk that they were in despair over the destruction of their local mosque back home, but the Beijing authorities branded them as radical Islamist separatists.

A few months later, in March 2014, a deadlier attack took place at the main railway station in Kunming, the capital of Yunnan province. A group of eight people, six men and two women, attacked passengers with knives in a random and horrific attack in which 29 people were killed and many more injured. Then, in April that same year, three people were killed and dozens wounded in a coordinated bomb and knife attack in Urumqi railway station. A month later there was another attack in Urumqi by five assailants who drove two SUVs into a popular food market and threw bombs into the crowd, killing 39 people.

There was no doubt that at least the last three of these attacks constituted terrorism, bloody and calculated violence designed for effect. But terrorism is a slippery label when it comes to Xinjiang. The three attacks occurred amidst a series of murkier incidents also branded as terrorism but which look more like an embattled populace reacting to excessive levels of control. In all these cases the government resorted to deadly force in the name of China's war on terror.

In July 2014 Chinese authorities reported that a mob armed with knives and axes had attacked a police station in a small village near Yarkand and 96 people had been killed: 37 bystanders and 59 people who the police identified as 'terrorists'. According to the authorities the mob had attacked after a crackdown in the town had turned up a cache of explosives. An investigation by the Uighur-speaking reporters at Radio Free Asia, however, suggested an alternative account: the crowd marched on the police station after a crackdown on religious observance during Ramadan and the extra-judicial killing of a Uighur family in a neighbouring town. Faced with a rioting mob the police had opened fire.

This was just the most bloody of a series of violent incidents involving rioters and police in Xinjiang over recent years, each of

which suggest a boiling over of violence rather than premeditated attacks. In June 2013, 35 people were killed in a violent confrontation between rioters and police in the town of Lukqun near Turfan. Reporters observed that this followed a particularly heavy-handed campaign by police against the wearing of 'religious clothing' that had been proceeding for months. This riot was also termed an act of terrorism.

Meanwhile, the government pursues ever more petty restrictions on Xinjiang's traditional culture and religion in the name of preventing extremism. Long beards and traditional veiling have been outlawed, with house-to-house searches mounted to enforce the ban. Shops are forced to sell alcohol, and police monitor stocks to make sure that this provocative edict is obeyed. Students, public servants and party members are all banned from observing the Ramadan fast. No one under eighteen is allowed to pray in the mosque. All of these restrictions are policed under a policy that stipulates that every household in every village in Xinjiang is assigned an officer who is tasked with keeping tabs on them and is empowered to 'visit' at any time. Observers believe that many of the minor violent incidents that have been reported as terrorism in Xinjiang in recent years have been in response to such intrusions by police into people's homes.

Throughout the province, people have been encouraged to report their neighbours if they suspect any illegal 'religious or separatist' activity, and are paid for tipoffs.

Small wonder that this relentless pressure, along with the steady movement of Han immigrants into Xinjiang, feeds a conviction among Uighurs that their culture is under threat, while they are offered little in exchange. The upper levels of provincial governance are controlled by Han Chinese, Uighurs are disadvantaged in competing for government jobs, teaching in the native Uighur language of Xinjiang is now severely restricted, and opportunities for tertiary study in Uighur have largely been closed off.

Hundreds of people have been sentenced for a wide range of offences, including spreading propaganda, manufacturing weapons and 'inciting ethnic hatred'. Sentences, including death sentences, have been passed during mass trials conducted in sports stadia, a style of justice made popular during the Cultural Revolution.

The tragedy is that demonising cultural and religious expression and criminalising even the slightest dissent is creating the very problem that the government say they are trying to combat.

The promise of autonomy that was very real in the early days of the People's Republic and even as late as the 1980s rings increasingly hollow. Authorities now talk openly about the need for sinification in Xinjiang and Tibet, and in both places large-scale settlement of Han Chinese is gradually changing the facts on the ground, so as to one day leave no room for dispute that these regions are anything but Chinese.

The cultures of China's ethnic minorities are already treated as little more than colourful novelties. This reached its nadir during the opening ceremony of the Beijing Olympics. A group of children in exotic ethnic costumes carried a huge Chinese flag into the arena, while a (Han) Chinese girl lip-synched a powerful rendition of 'Ode to the Motherland'.

Just days later it emerged that the children did not actually come from the country's different ethnic groups at all. They were all Han Chinese children hailing from no further away than Beijing. When outed, Olympic officials were baffled by the fuss. They pointed out it was common practice to represent China's minorities this way, while the leader of the Beijing troupe which had supplied the children said later it would have been too much trouble to find real ethnic children, and, anyway, how could you be sure they would behave?

The most influential Uighur public intellectual in China, Ilham Tohti, tried for some years to put forward concrete proposals to ease the situation in Xinjiang. Ilham was an associate professor in the economics department at Minzu University, a charismatic figure who had set up a website called *Uighur Online* to act as a forum for discussion

of issues between Han Chinese and Uighurs. The website was blocked in China from the day after the trouble broke out in 2009, but he still offered to work as a 'bridge' between Uighurs and Han Chinese.

He wrote of the need for the government to deliver on the promise of autonomy for ethnic minorities that is enshrined in the Chinese constitution, and counselled against petty crackdowns on cultural expressions such as long beards and the wearing of headscarves. He talked of the atmosphere of fear that had been generated by years of ever-increasing repression and control. He made detailed suggestions for addressing the economic disadvantage and discrimination that was at the root of resentments in Xinjiang. In all of this he was at pains to state that he believed Xinjiang's future was within China and that he opposed any separatist agenda. He also was a staunch opponent of violence.

In January 2011 he wrote an autobiographical essay, 'My ideals and the path I have chosen'. He wrote:

> Whether looking vertically at Chinese history or horizontally at the world today, it's clear that the greater a country's cultural diversity and tolerance, the greater its creativity. Any thinking that doggedly stresses a particular group's cultural uniqueness and superiority, thus making it non-inclusive, is closed-minded and a thing of the past. It will inevitably kill the culture it means to enshrine and protect . . . I hope that China, having endured many misfortunes, will become a great nation of harmonious interethnic coexistence and develop a splendid civilisation.

On January 15 2014 Ilham was arrested at his home in Beijing and taken to a prison in Xinjiang. A month later he was charged with 'separatism', and in September 2014 was sentenced to life in prison.

Dissident Chinese writer Wang Lixiong tweeted that in jailing Ilham the Chinese government had 'created the Uighur Mandela'. Prominent Chinese activist and Sakharov Prize winner Hu Jia was

brave enough to state the obvious: that the guilty verdict showed the Chinese authorities 'don't want the Uighurs to have any voice at all'.

If anyone was in any doubt of the government's zero tolerance for Uighur dissent after Ilham's sentence, that was dispelled by the subsequent jailing of seven of his students who were said to have been 'bewitched and coerced' into working for his website.

The cruelty of Ilham Tohti's life sentence was underlined when the court also ordered his assets seized, leaving his wife and young children without financial support. His wife, who was in court to hear the verdict, remained unbowed: 'No matter what happens, I will wait for him to come home,' she said. 'We will wait forever.'

By the time Ilham Tohti was sentenced in September 2014 it was already clear that China had entered a new era of repression, ushered in with the ascension to power in late 2012 of China's new paramount leader, Xi Jinping.

Xi Jinping is a 'princeling', the son of Mao's comrade-in-arms Xi Zhongxun. As a descendant of the first generation of China's revolutionary leaders, he is part of a cohort who believe that they are heirs to the party's primal legitimacy, and have a duty to safeguard it.

When the younger Xi first rose to power, many took heart from the fact that his late father had been a moderate, persecuted and imprisoned under Mao, and a prime supporter of Deng Xiaoping's reforms. Xi's father was particularly associated with the early success of southern China's special economic zones and was later believed to have been a defender of Hu Yaobang and a critic of the crackdown in 1989. He was also known for his sympathy with China's ethnic minorities.

As it turned out, it was not his father's example that Xi Jinping looked to in forming his own approach to leadership. Soon after he took over as general secretary of the Communist Party in November 2012,

Xi gave a speech musing on the lessons China should take from the fall of the Soviet Communist Party and the subsequent breakup of the Soviet Union. His verdict: the Soviet communists had allowed their ideals and beliefs to be shaken, and when the challenge came nobody was man enough to resist the fall of the party and the disintegration of the USSR.

Soon after he achieved the top job in late 2012 his strategy to save the Communist Party began to unfold. First there would be an unprecedented crackdown on corruption, one that would catch both high-placed 'tigers' and low-level 'flies' who had used their positions to make themselves and their families rich.

As I write, the anti-corruption campaign is still unfolding. Today the running tally on the website ChinaFile, which tracks those individuals whose prosecutions have been announced, stands at 1740, of whom 176 are 'tigers' and the rest are 'flies'. Apart from these formal cases, observers estimate hundreds of thousands of party members have been caught up in some way in the investigation.

Some have questioned the motivations behind the campaign, noting that none of Xi's allies—and indeed no princelings at all—have been implicated, while allies of former presidents and leaders of the Communist Party, Hu Jintao and Jiang Zemin, have not been so lucky. Most likely the campaign has a dual purpose, to win respect for the party for putting their house in order, while consolidating Xi's position by eroding competing power bases.

The second prong to Xi's strategy to entrench the party is a wide-ranging crackdown on alternative voices in society. The first to feel the chill on his ascension were the rights lawyers, but the campaign soon spread to other activists: NGOs, journalists, popular figures on Weibo (China's version of Twitter), representatives of Christian churches, and even feminists.

Under Xi a string of lawyers and activists have been charged with a crime that would seem laughable if it didn't lead to jail time:

'picking quarrels and provoking troubles', a catch-all concept covering such peaceful exercises of civil liberty as publicising a defendant's case, organising strikes, opposing housing demolitions, or arranging a demonstration against sexual harassment on public transport. The crackdown on individuals has been accompanied by an intense effort to clean up the internet, where an army of party operatives toils to delete any opinion or information that doesn't fit the official line.

The crackdown on alternative voices has led to a succession of travesties of justice. The treatment of Ilham Tohti may be the most egregious but he is not alone in being jailed for peacefully promoting solutions to acknowledged social problems. In January 2014 prominent rights lawyer and activist Xu Zhiyong was sentenced to four years in prison for 'gathering crowds to disturb public order' after he organised small-scale protests calling for equal educational opportunity for children of workers in China's floating population, and for a public register of officials' assets. Xu had co-founded a group called the New Citizens Movement, which aimed to promote constitutionalism in China.

In court Xu read out a defiant statement at the close of the trial:

> What the New Citizens Movement advocates is for each and every Chinese national to act and behave as a citizen, to accept our roles as citizens and masters of our country—and not to act as feudal subjects, remain complacent, accept mob rule or a position as an underclass . . . You say we harboured political purposes. Well, we do, and our political purpose is very clear, and it is a China with democracy, rule of law, freedom, justice and love.

The continuing crackdown on alternative voices such as these is aimed at protecting the party's monopoly over law and policy. Behind it runs the spectre of the old Soviet Union, and the fear that if the party

was to give up even a little of its prerogative to set China's course it would undermine the principle of one-party rule. Even where a citizen's suggestion accords with announced policy, as with Xu Zhiyong's proposed register of officials' assets (a key anti-corruption mechanism), it must still be rejected.

This insistence on total control has led to the situation where even to promote observance of China's own constitution is deviant behaviour. 'Constitutionalism' is now routinely demonised in party media. Perhaps this is not surprising, since the Chinese constitution is full of inconvenient clauses about respect for human rights, freedom of speech, the right to criticise any state organ or functionary, and the rights of citizens in autonomous areas.

In late 2013 an internal Communist Party document was leaked that provides a telling glimpse of the party's fears and insecurities. Known as 'Document 9', the circular listed seven 'false ideological positions' which are a threat to party-imposed stability. These perils included Western constitutional democracy, universal values, the primacy of individual rights, Western-style journalism, and 'historical nihilism'—that is, critiquing the party's version of history.

The document argues: 'by rejecting Chinese Communist Party (CCP) history and the history of New China, historical nihilism seeks to fundamentally undermine the CCP's historical purpose, which is tantamount to denying the legitimacy of the CCP's long-term political dominance.' Tellingly, one of the document's examples of 'nihilism' is 'rejecting the accepted conclusions on historical events'. This is as clear a statement as it is possible to find of the party's determination to win the war for control of the national memory.

One of the key battlegrounds in that war is Tiananmen Square and the events of June 4 1989.

In early May 2014, a month after we had travelled to Guizhou together, I went to visit Guo Jian in his studio in Songzhuang, an artists' village outside Beijing's city limits. Having lost yet another studio to developers, he was camping above his new workspace, which was crammed with canvases, found objects, art books and half-completed projects. Among them was a miniature three-dimensional model of Tiananmen Square.

He had been working on this diorama since 2010, adding new elements to a fantasy scene of the square threatened by bulldozers on the ground and helicopter gunships in the air. It was intended as a studio piece only, as no gallery would consider a work full of such dark resonances, even though the gunships and bulldozers were meant as a commentary on the relentlessness of urban development.

As the 25th anniversary of June 4 loomed, he had decided the diorama would say something else. He had covered the whole scene in minced meat, and invited me out to see the work in progress.

As I walked through the open door I was assaulted with the odour of rotting meat. He had only been working for a day but the 50 kilograms of minced pork was already on the turn. The smell added to the shock of seeing the familiar buildings of Tiananmen Square—the Monument to the People's Heroes, the Great Hall of the People, Mao's Mausoleum—disappearing under red minced flesh.

We retreated outside to talk. Of course he wasn't going to show the work, he told me, but he was going to get a friend to document it on video. I asked what he planned to say if anyone in authority came snooping. He would tell them the truth, he said, with an innocent grin: it was inspired by the meat sculptures he had seen at the Royal Easter Agricultural Show in Sydney.

We talked about how happy his father was that Guo Jian had finally 'swept' his grandfather's grave. This act of filial piety had started a whole new conversation between them about the past, about his grandfather's life and death and his father's story, too. But as we chatted it was hard to

escape the pall of the looming anniversary—the pre-June crackdown had started early that year and news had just broken of the arrest of the rights lawyer Pu Zhiqiang.

Pu had been arrested after attending a private gathering to commemorate June 4. His Weibo account, which had hundreds of thousands of followers, was silent, but elsewhere the web was humming with the news, with comments being deleted as fast as they appeared. For all that Pu was a thorn in the authorities' side (most recently for his defence of the dissident artist Ai Weiwei), the respect he commanded had made him seem untouchable. He had even made the cover of the state-run *China Newsweek* the previous December, lauded as the most influential person promoting the rule of law in the country. That he should have been detained seemed a particularly bad omen.

I was back in Sydney when I got the message that Guo Jian had been arrested. It was early on Sunday, June 1 and the news was spreading fast among his friends on the popular messaging app WeChat. We had all seen the interview he had given to the *Financial Times* that had appeared the day before. In it he had talked at length about the events of 1989, and reading it I had felt a sense of pride at his bravery, mixed with a sinking feeling that this year he wouldn't get away with it. He had never avoided the subject and he had discussed it with journalists before, but this was the 25th anniversary, with a new and prickly leadership team in power. Around the world Guo Jian's friends sat waiting for news.

When the police came to his studio, it was past midnight on the day the article appeared. The minced meat had long been cleared away and the Tiananmen diorama was clean and white once more.

He was expecting them. By that time dozens of intellectuals and activists had been detained, and the interview had put him under a spotlight. That day he had got a haircut and had had his nails done as well. His army training had taught him a bit about preparing for rough conditions.

Even though he was ready for it, the knock sounded terribly loud when it came. Some of the police were in uniform, others in plain clothes. One carried a video camera and worked his way around the room shooting anything that looked significant. The senior officer took Guo Jian aside and showed him his police badge. They soon focused on the diorama and called over the video officer. 'Evidence!' he said, zooming in on the tanks and soldiers. 'Let's go down to the station and have a talk,' said the man in charge.

They took him to the local station where relays of police interviewed him through the night. One group concentrated on his visa and his finances, while another quizzed him on his art and his ideas. 'Do you hate the government?' they asked ominously. 'Do you think the students did nothing wrong?'

Occasionally they grilled him on details, hoping to prove he had never been in Tiananmen Square in the first place. Most of the time they tried to chip away at his position on the events. After some hours the lead interrogator said: 'So you still think the government was wrong for what they did on June 4?'

'Yes,' Guo Jian replied, 'I do.'

'So tell us what they should have done instead.'

'You had thousands of soldiers,' said Guo Jian. 'You didn't need to kill anyone. You only did it because you were scared.'

One of the younger officers was furious. 'Do you think I don't understand about this stuff? That I'm too young? I've read books about it!'

After dawn a new officer turned up and calmly suggested a way out. 'He said I should sign a self-criticism,' Guo Jian told me later. 'He wanted me to say I was wrong about Tiananmen Square, wrong in

what I said to the media, wrong in general. He said to me: "This is not your business, you should leave this stuff to the leaders. Just do your art and leave this stuff to others.'"

Guo Jian then asked them what his punishment would be. Their first condition was that the diorama should be destroyed. Guo Jian had always planned to destroy it, so he readily agreed. 'Then,' Guo Jian told me, 'they said there would be a short detention, and after that if I kept my head down, did my painting and didn't talk to any foreign media it would all be fine.'

But then another group of police arrived and he realised it wasn't going to be so straightforward after all.

By now the Australian Embassy had been asking questions, and suddenly the issue wasn't Tiananmen Square or Guo Jian's ideas or his art. The police were going to charge him over a visa irregularity. At 5 p.m., they took him back to his studio.

They gathered around the diorama and told him to destroy it. Guo Jian duly smashed it up, with the police video camera rolling. 'I was sad about it,' Guo Jian told me, 'because it was a work I loved so much, but at the same time it was exciting, because from the beginning I'd planned to destroy it. To do it surrounded by police and them filming me, it really was kind of perfect.'

Finally, at midnight, they delivered him to the Daxin detention centre in Beijing. His penalty had been agreed: fifteen days' detention, a 5000 yuan fine, and deportation to Australia. They told him the deportation period need not be for very long if he did the right thing: stick to his art and not talk to the foreign media.

His cell was about five metres long and already home to twelve other inmates who shared the eight beds between them. 'I guess I was a bit scared at first, but then I realised it wasn't much different from being in the army.'

The worst thing was the boredom. After breakfast they were told to sit on a wooden bench and they weren't permitted to read or walk

around the cell. They were monitored by video and if anyone stood up, even for a moment, the guard would blow into the microphone of the PA system, making a roaring bark that served as a warning.

The television, tuned to a special prison station, played documentaries about the enormities committed against China by foreigners: 'There were shows on the Opium Wars and different foreign invasions, and about how AIDS was destroying the West.' In the afternoon they could walk around their cell. On a few of the days they got one hour to walk outside.

He befriended a young man from Paraguay who also had visa issues, but had still not been able to get news to his family or girlfriend about his plight. His relief when he discovered that Guo Jian could speak English was overwhelming.

'It's a cliché but of course you think about freedom all the time when you are inside,' Guo Jian told me. 'And when you see a bird outside perched on the wire it really does remind you of how precious and fragile freedom is.'

After he had been in detention for a few days the television program suddenly changed. 'They started broadcasting all these great movies into our cell, like *Mission Impossible*, number one through three.'

It turned out the improvement in programming presaged a consular visit by two Australian Embassy officials. Guo Jian didn't know it, but his plight was big news in Australia, with the Australian foreign minister herself expressing concern. When the diplomats asked him how he was, Guo Jian could assure them that he was fine, and that he even had HBO.

On the day of Guo Jian's release his friend from Paraguay still hadn't managed to contact his family, and he begged Guo Jian to call his girlfriend when he got to Sydney. They had no paper, so Guo Jian carved the phone number into a piece of soap and slipped it into his pocket.

They took him to the airport and drove straight onto the tarmac to the stairs of an Air China flight. The crew settled him into his seat on

an exit row opposite two of the attendants who would keep a wary eye on him throughout the flight.

Once airborne, he asked for a drink but the flight attendant told him in her best apologetic manner that they were under instructions not to serve him alcohol. He smiled and thought back to his first flight to Sydney twenty years before, when two Australian beers, far stronger than he was used to, had just about knocked him flat.

In Sydney, he stepped into the arrivals hall carrying the few belongings he'd been allowed to collect from his studio—his mobile phone and laptop and some clothes in a gym bag. In his pocket was the scrap of prison soap that would help him keep a promise to a friend.

THE PEOPLE AND THE REPUBLIC

On January 12 2013 a choking blanket of smog settled across Beijing. In Sydney, my iPhone buzzed. It was my Air Quality Index app, still set to Beijing conditions. The message read: 'Beyond Index. Hazardous. Stay indoors.'

High in her hermetically sealed apartment in Beijing, Cao Fei imagined the end of the world. 'If an earthquake happened,' she wondered, 'would the fire engines ever arrive? Would there be any help?' Perhaps she should stock up on food, she thought.

Beijing is now so spread out, the scale hardly feels human at all. In Cao Fei's home town, Guangzhou, she had been used to hearing the sounds of life all around her in its narrow crowded streets: the sizzle of cooking, the hammering of kitchen cleavers, the sounds of conversation. In Beijing, as she chopped vegetables for her family's dinner, she could hardly hear anyone else at all. Looking out over the city it was as if someone had hit the mute button.

The smog that hit Beijing in the winter of 2013 was just a darker, more dangerous version of the haze that can choke the city at any time of the year now.

I was in Beijing in the northern autumn of that same year. Beijing's October skies were once the stuff of poetry, but every day I was there the Air Quality Index app buzzed the bad news. At dinner parties you got used to being handed a face mask at the end of the night to get you

home safely, where once you might have hoped for a piece of cake in a party napkin.

For Cao Fei the miasma embodied a kind of depression that she detected in the capital, a weariness, as if the density of the particles in the air were congesting people's spirits, too. By the time she showed me her new film, *Haze and Fog*, I was thoroughly inside the mood that had inspired it.

The film takes place in and around a gated apartment complex, the kind of place where the cosseted residents hardly interact with the outside world at all, or each other. A silent army of assistants catered to their needs—couriers, maids, security guards, manicurists and even dominatrixes arrived to service them in their homes.

When the zombies appeared at the end, it was almost a relief, especially when I realised that the army of the un-dead included all the one-time support staff who had previously serviced their betters' privileged, isolated lives, and were now chowing down on their remains.

China has no tradition of zombie stories, but AMC's *The Walking Dead* is a huge hit there. And some days it's hard not to agree with Cao Fei that zombies might be quite at home in the People's Republic now, as it struggles with pollution that makes many of its cities barely liveable.

Her film played on the feeling you often get in China, that really anything might happen. In a country where so many extraordinary things have occurred in the past four decades, would zombies be such a surprise?

A few months later in the spring of 2014 I went to see Jia Aili's work in a new show in 798. On the vast canvases, lightning crackled across bleak alien vistas, and a small colony of humans eked out an existence in the sparse landscape. Some wore space helmets while they explored

great craters in the ground, others huddled for warmth outside a craft shaped like a diving bell. Another stood alone, his head flaming as if struck by lightning. The wasteland in Jia Aili's earlier works had become a blighted planet, with few artefacts of human life. Like Cao Fei, he seemed to be haunted by a post-apocalyptic world.

In the past decade things had rapidly improved for the people in Jia Aili's home town. In 2003, after years of layoffs and closures, the government had decided to reinvest in the north-east of China, building new modern factories and cleaner industries. His home town of Dandong had become a major port, handling exports for the whole north-east, while Shenyang, where he had spent his college years, had been rebuilt as a 'green city'. And yet, Jia Aili still felt a sense of loss.

'People haven't become happier just because they have become richer,' he mused to me one day. 'Today most people don't have belief or faith, and they can't find a direction in their life. There is a battle going on inside them between the spiritual and the material.'

Underlying all of this, he told me, was a wrenching sense of dislocation, because history had moved so fast. Dandong lies on the Yalu River, which forms the border with North Korea. He grew up playing on the banks of the river, from where he could look across and see the people living on the other side. When he was a child, life on both sides of the river looked the same; now it was if they were on separate planets.

'Last time I went home,' he told me, 'I had this strange illusion. When I looked across the river I felt like I was a young child again because what I was seeing across the river was exactly what I had seen as a child. It was beautiful. But then if I looked behind me all my memories about my life and my parents' life, and my grandparents' life, were gone. They had all been overtaken by these new tall buildings and had disappeared.

'You know, every Chinese person tries to find a secret spot, a place where they can go and feel connected to the past. For me it's the

riverbank. Nearly everyone has a secret path to take them back into the past. If they didn't they'd go crazy. The speed of change would just be unbearable.'

When I first met Pei Li I didn't imagine she thought much about the past. And yet when she was offered her first solo show she immediately chose to create a memorial to a China that was passing away.

Pei Li had grown up under the tutelage of her grandfather. Disappointed that she wasn't born a boy, he decided nonetheless to ensure she had a classical education. At an early age she was given lessons in calligraphy and learned all the major styles, and later went to music lessons. As she grew up she watched her grandfather work on his beloved bonsai garden, making the constant, tiny refinements needed to achieve a perfect recreation of a classical 'mountains and streams' landscape. Then one day, after 40 years of painstaking devotion to his garden, the old man suddenly abandoned it.

'He told me he was through with art,' she told me. 'He said it was useless.' He wanted to embrace the possibilities of the new China, she said. Suddenly he was busy making money and dating younger women. Pei Li watched as the bonsai trees withered away.

Given a chance for a solo show in Beijing she set off for her home town to rescue what remained of her grandfather's garden. In the exhibition space she re-created the old man's project to perfect scale, the dead miniature trees precisely positioned in a pool of water darkened with black calligrapher's ink. Tiny speakers floated on its ebony surface, each giving off an occasional sad sound like a foghorn at sea, which she created by slowing her favourite punk music track to a sonorous moan. Her work was a salute to a tradition whose very custodians had abandoned it. 'I think he really loved those bonsai,' she told me later, 'but he didn't want to get left behind.'

The first half of the 2010s found Zhang Xiaogang once again delving into his past through his painting. His new work portrayed his parents as they were when they were young, and evoked the simple interiors of his childhood. In many of his canvases, a simple household appliance—an unshaded light bulb or a bar radiator—was as prominent as the human figure in the frame, as if memory anchors itself as firmly to a mute object as it does to a face. Another series of paintings caught moments in time framed by a train window.

He began to introduce some traditional objects into his paintings too—items that carried a metaphorical meaning in classical Chinese art, like a sprig of plum blossom for renewal or a bonsai pine to signal longevity—juxtaposing them with more banal items, like the crisp white shirt and blue trousers that were the acme of style in the China of his childhood or the array of pills and medicines he took for his heart.

He was concerned with what had been lost in society even as China had become richer and more powerful. He talked to me about the corruption he saw, and the loss of connection. He pointed to the prevalence of scandals (such as people selling counterfeit medicines) as examples of how morality had broken down. 'Rapid change has changed people's values, and their concept of time, it has changed their understanding of life. The change is so great if you compare it to the previous 5000 years of Chinese history that many people just can't handle it.'

Despite the darker dimensions of this dislocation, he saw an amusing side as well. 'All this change means things that are not even that old become treasured like antiques!' We chuckled about the weirdest examples we had seen, agreeing that the fetish for old thermos flasks was particularly endearing. These dowdy metal containers had once been essential to daily life in China, omnipresent in every school, office, hotel or home. Filled with boiling water from a communal steam room, they kept you in tea all day in the era before electric kettles.

We laughed, and yet it was these outdated and simple objects that Zhang used to create aching evocations of the past. In a portrait he had painted of his mother, she sat on a sofa gazing impassively at nothing. By her side were a lidded cup of tea and an old thermos flask.

In the early 2010s Aniwar was also connecting with the past, returning to the place where he was born and to the materials that he had known when he was just a child.

His birthplace, Karghilik, is an oasis town some 250 kilometres south-east of Kashgar. It had once been an important station on the Silk Road where traders would form their caravans before the journey into India. Long a sleepy backwater, it was now coming under increased pressure to change as Chinese development spread across southern Xinjiang, but the traditional culture in the town was still strong. There the local artisans still made woollen felt, known as *kigiz* in Uighur, and he longed to find a way to fuse his art with this ancient craft of his birthplace.

Kigiz makers start with a base of wool mesh on which they lay tufts of fleece that they then rake, water and roll over and over again until they produce the tough woollen felt that has traditionally carpeted Uighur and Kirghiz homes and been stitched into Kazak yurts. The felts they produce bear the natural colour of the wool, which can then be dyed or appliqued or embroidered. But Aniwar wanted to do something different.

In an echo of his layered painting technique, he cut coloured felt shapes and arranged them on the mesh. He then asked the *kigiz* workers to set their fleece on top, and begin their arduous production process. When they were finished, the natural wool of the felt was shot through with colour like a stone seamed with precious minerals.

In the summer of 2014 he was invited to exhibit the rugs in Venice.

He carried them there himself, a jet-age version of the Silk Road journey from China to Italy that his forebears had once travelled. Waking up on the first morning he saw sunlight gleaming on the wall, formed into a shining grid by the lattice window shutters. As he watched the sunlight play he remembered how lights used to flash behind his eyelids after he looked into the sun when he was a child.

In the summer of 2015 he returned to Karghilik and created a new series of rugs, each with its own arrangement of glowing colours overlaid with a lattice pattern in homage to Italy, the ultimate destination of the Silk Road, and a place where he had found himself feeling strangely at home.

In 2015 Gonkar decided it was time for him to come home. It was 23 years since he had first left Lhasa for Dharamsala. He had lived in London and New York, found great success as an artist, exhibited at the Venice Biennale and become a British citizen, and yet he had never stopped feeling like an outsider.

He had also felt the pressure to conform to people's expectations of him as a Tibetan émigré. At every talk he gave there was always someone asking him why his work was not more political, why it was so mellow given everything that was going on. To him the question was complex. He felt deeply the pain of events in his homeland, but in his art he wanted to honour an artistic tradition, that of the *thangka* painters of his homeland, of intricate works which invited hours of contemplation, not instant comprehension.

'I realised in my later years in the West,' he told me, 'that the Tibetan problem is not the only problem in the world and maybe it is just part of a wider problem. I began to look at things from a different perspective. In the early days I had a very narrow point of view, a very nationalistic point of view.'

As he considered going home he returned again to the 'My Identity' series, which, when he had completed it in 2003, had seemed to be the final word on his struggle with who he was. Now he added a new photograph to the set in which he imagined himself as a painter in a contemporary Lhasa studio. On every visit home since his first in 2004 he had haunted the Lhasa studios of the *thangka* painters, fascinated by their eclecticism and charmed by their habit of always leaving their doors open for visitors.

In the new photograph, which is called *My Identity, no. 5*, Gonkar surrounds himself with the décor he had seen in the *thangka* painters' studios: prayer wheels flanked by Coca-Cola cans, pictures of American pro basketballers sharing wall space with posters of Chinese leaders, a small statue of the Buddha and a bust of Mao serving as bookends to a shrine to the exiled Karmapa Lama. On the easel, where in earlier versions of the series portraits of Mao and the Dalai Lama had once sat, rests a portrait in progress of Aung San Suu Kyi.

'She is a big figure in Tibet,' he told me. 'She is seen as a fighter, someone who had been defeated for many years and now has emerged. She embodies a kind of hope.'

In November 2015 Gonkar flew into Chengdu in China's south-western Sichuan province. The city sits just to the east of the Tibetan plateau and is home to many Tibetans. There he reacclimatises to life in China and waits to organise his return to Lhasa, where he hopes one day he, too, will run an open studio like the *thangka* painters of his home town.

At the same time that Gonkar was choosing to go home, Guo Jian was settling into his life as an exile. The first months he spent restlessly, travelling on from Sydney to New York and then to Miami, where he

recreated his meat-covered Tiananmen Square at the North Miami Museum of Contemporary Art.

Back in Sydney in 2015 he started to engage with the issues that were wracking his second home of Australia, particularly around immigration and asylum seekers, looking for ways to connect as an artist. But before he could move on he was determined to recreate the work that he had made back in China, which exposed the trashed environment and 'rubbish culture' of his home province of Guizhou.

When he had been deported he had had to leave all his works behind, but his photographs were still safe in his laptop. Now, with the support of the Sydney philanthropist Judith Neilson, he painstakingly reassembled the photomontage he called *Picturesque Scenery 26*. To create it, he had used the photos he had been taking of riverbank and street rubbish when I visited him in Guizhou in 2014. He had isolated the faces of the celebrities on the discarded packaging and assembled them into what from a distance looked like a pointillist Chinese land-scape. Closer inspection showed the peaks and the shimmering water in which they were reflected to be made up of thousands of these discarded celebrity faces.

And yet for all the darkness behind this work, Guo Jian remains optimistic about what China could be. 'It's about the system,' he says. 'A good environment can make people into good people.' He knew this, he told me, because he had seen it. 'For a short time, in Beijing in 1989, you saw everybody helping each other. Just for that moment it was a different society.'

In March 2016 Guo Jian's *Picturesque Scenery 26* was hung in an exhibition at Judith Neilson's private museum in Sydney, White Rabbit Gallery. The exhibition was called 'Heavy Artillery'.

★

Sheng Qi has embraced the life of exile. He values the perspective his distance gives him on China, which is and will remain his subject.

Like Guo Jian, he is optimistic. He points to the lively online space that still exists in China despite all attempts by the government to shut it down. 'People who want to express a view can always find a channel and even if the discussion is shut down after an hour or two, in that length of time in China a post can attract a million hits! The censors close one hole and another opens up. No manpower can beat it.' And meanwhile, he says, more and more people jump the Great Firewall to find out what things are like on the other side.

He believes that the role of an artist is to be a witness to history, and a custodian of memory.

I ask him if he doesn't find his position lonely. 'If you are a radical artist, you should feel like this, you should feel isolated,' he told me. 'You should never be popular, you should be alone, because to be alone is powerful. It isn't being surrounded by people, but by being alone— that's where the power comes from.'

In December 2015 I visited Huang Rui at 798. He was busy putting together a design proposal for a park in southern China. His elegant sketches for giant park sculptures suggested a cluster of columns like the standing stones in the ruins of the Old Summer Palace. But when viewed from above, the arrangement of the columns spelt out the word 'love'.

Not far from 798 he was doing more work on his home and studio, which he hoped one day to make into a kind of 'Stars Institute' where other artists, Chinese and foreign, could come to live and work. He had built some of the structure out of found materials: old grey bricks salvaged from the demolition of China's *hutong* houses formed its retaining walls. The front door was a wooden gate rescued from the

'renovation' of the Beijing mansion of the Qing Dynasty statesman Prince Gong.

Inside the house hung a painting called *Democracy Wall*. He had painted it in the summer of 1981 when the wall was already passing into history. There on the canvas was his friend Bei Dao and his fellow poet Gu Cheng, and someone selling a magazine with a blue cover off a pedal cart. There was his girlfriend, and off to the side was his friend Liu Qing, who by the time he had painted him had been imprisoned for more than eighteen months but still hadn't been brought to trial. The painting was a symphony of grey and blue—the blue of the clothes everyone wore back then, and the grey of Democracy Wall. He would never sell the painting, he told me, and he had made a private pledge when he finished it. From then on, every painting he worked on would include a touch of grey in honour of the Beijing of his youth, and of the wall where thousands of his contemporaries had their first experience of speaking for themselves and being heard. It is a pledge he has never broken.

Before I left Beijing at the end of 2015 I dropped in to visit Cao Fei in her new studio in the eastern suburbs of Beijing. It was a wonderful space, an abandoned movie theatre, still with its old mouldings and theatrical lighting. The Beijing authorities had closed the theatre down in 2008 when they swept the capital in the months before the Olympics.

The building was perfect for a studio, and I started to enthuse about all the things she could do there in the future, but she cut me off. That would never happen, she told me: the city's development would soon catch up with it and it would be gone. But she was philosophical: 'In China you never expect anything to last for very long.'

Writing the early chapters of this book, I visualised the recent history of China as a series of waves, each peak a period of openness and freedom, each trough a reversal. There is no doubt now that we are seeing a trough, one of the deepest of the last four decades.

The intense crackdown on China's civil society, which began with the ascension of President Xi Jinping in late 2012, is now in its fourth year and shows no sign of slackening. Instead, an ever-widening circle of people is being caught up in a campaign to silence alternative voices.

In July 2015 a major police operation targeting China's rights lawyers was launched across the nation. More than 300 people were picked up for questioning and nineteen were charged after months in secret detention. The severity of the charges shocked even the most seasoned observers of China's human rights record. Five were charged with 'incitement to subversion of state power', the same crime that saw Liu Xiaobo imprisoned for eleven years in 2009. Eleven more faced indictment for the graver crime of 'subversion of state power', which can carry a life sentence. Among them was a 23-year-old paralegal who had started her job in the practice of rights lawyer Li Heping a scant nine months previously.

Censorship has now reached heights not seen since the months after June 4 1989. The policing of the internet has intensified, while the intolerance of alternative views has reached even into the party itself, with cadres being informed that no 'improper discussion' of policy will be tolerated. 'Patriotic education' has been stepped up and university lecturers have been told to keep discussion of Western ideas out of the classroom. At the same time, both state and privately owned media have been left in no doubt that their role is to act as a cheer squad for the government and not as a forum for ideas.

Xi Jinping has gathered extraordinary power into his own hands, turning his back on the tradition of collective leadership which had been a hallmark of China's governments since the death of Mao. The premier, Li Keqiang, has been effectively sidelined as Xi has taken

control of economic management, in addition to foreign affairs, defence, the anti-corruption campaign and indeed every other significant government priority.

The span of control that Xi now exercises has led to comparisons with Mao himself—something that Xi has done little to disavow. A mini personality cult has developed around him, featuring patriotic songs, internet videos, badges bearing his visage and other memorabilia. In October 2014 he gave a speech to the arts community clearly modelled on Mao's infamous 1942 'Talks on Literature and Art', when the Great Helmsman established the principle that literature should serve the needs of the state. Xi's take on the proper role of the artist is similarly chilling: in his speech he instructed that they should be concerned with spreading 'positive energy', and criticised what he saw as the negative tendency of much contemporary work: 'They subvert history and smear the masses and heroes. Some don't tell right from wrong, don't distinguish between good and evil, present ugliness as beauty, and exaggerate society's dark side.'

At the same time a new prudery has been promoted, with everything from too much cleavage to same-sex relationships being banned from television drama; out, too, are smoking, drinking, adultery, and even reincarnation.

This level of social control is out of step with the country China has become. More than a quarter of the wider population is middle class, as is half the population of the key cities of Beijing and Shanghai. Some 270 million rural people have left their homes for new lives in the city, while millions of other Chinese have studied abroad. In 2015 alone 120 million Chinese travelled overseas as tourists.

The old post-Tiananmen bargain that traded political freedom for ever-rising living standards is under pressure from a slowing economy and an increasing number of environmental and safety issues that threaten public trust in the authorities. In August 2015 a catastrophic industrial accident in the port city of Tianjin killed 173 people and

left thousands homeless. The disaster directly impacted middle-class homeowners, who learnt at first hand what many in China's more remote regions have known for a long time: when disaster strikes, public accountability is hard to find.

Meanwhile, people have watched China's stock market, where they had been encouraged to put their money, go into freefall.

Suddenly things which are not being delivered by the one-party state, like an independent legal system and vigilant and accountable regulators, seem a lot less like luxuries and a lot more like essentials.

There is an increasing number of 'mass incidents' in China as both farmers and workers agitate for a better deal. The transformation of China would not have been possible without the entrepreneurship of its rural population and the labours of its urban workforce, and yet both sectors have seen their progress stall.

In the countryside, more and more farmers are demanding that the government return ownership of the land to them. Farmers are given independence in how they work the land but can have it taken at any time for developments that rarely benefit them and for which they are inadequately compensated. Workers are also increasingly prepared to stand up for their rights, organising their efforts via private messaging, and forming loose associations to advocate on their behalf. Some 2700 strikes and protests by workers occurred across China in 2015, more than double the number of the previous year.

Meanwhile, members of the floating population continue to be deprived of the rights accorded to the urban population at large. Access to health services and education for their children is limited as the government refuses to register them as legitimate members of the urban community despite their contributions to the cities they live in.

These developments in the city and the country are all against a backdrop of widening inequality, with one-third of China's wealth being held by the top 1 per cent of households while the bottom quarter of households control just 1 per cent of the wealth between them.

This is all at a time when China is attempting another great economic transformation to a service-based economy driven by domestic consumption. China badly needs greater private sector investment to drive this change but the state-owned sector, with its inefficiency and crony capitalism, drains the economy of capital and resources.

China's giant stimulus package during the GFC led to a building boom and a revival of the state-owned sector which had been painfully winnowed during the late 1990s. Now around three million workers are facing unemployment as the government moves to deal with over-capacity and massive debts in the mining, steel and cement-making industries. But while the government knows that the only way to ensure the economy grows fast enough is to give the market a decisive role, they are reluctant to cede control. Through the state-owned system the government dominates heavy industry, natural resources, infrastructure and the banking sector, and knows that to retreat from them is to relinquish control of the commanding heights of China's economy.

The range of issues that China now faces—economic transition, unrest among workers, farmers and the floating population, failures of regulation, and ethnic unrest in Xinjiang and Tibet—cannot ultimately be dealt with by increasing the level of control.

These issues call for debate, new kinds of cooperation between sectors of society, and transparency and accountability. But institutions that create co-operation—such as vibrant NGOs and meaningful worker organisations—are targeted for closure and arrests. Mechanisms for transparent governance—an independent judiciary, open public accounts, independently reviewable decision-making, anti-corruption systems and independent media—are anathema to the current regime. Independent thinkers with alternative ideas are also being silenced.

China is now simply too diverse, complex and vibrant to be able to tolerate autocracy in the long term. Even inside China prominent voices have started to openly express concern at the effect that Xi's level of control and censorship may be having on the quality of

decision-making. Editorials have appeared in both state and prestigious private media, and at least one government adviser has been prepared to go on the record. Concern is being expressed that alternative sources of advice and divergent critiques are being ignored in favour of the counsel of a small coterie of like-minded officials. Good policy cannot be made inside an echo chamber.

The Tiananmen generation is entering their late forties. These people who came of age in a time of unprecedented debate and optimism are moving into positions of authority both in government and in the wider society.

In 2017 the next generation of leaders will be endorsed at the nineteenth Communist Party Congress. These new junior leaders will serve beside Xi Jinping and his Premier Li Keqiang for another five years until those two men are due to retire in 2022. Among those likely to be nominated for membership of the new Politburo and leadership positions are some from the Tiananmen generation. How this cohort will behave when they reach the heights of power is an open question, but the rise to influence of people whose formative experience is not the Cultural Revolution but instead the intellectual ferment of the 1980s and the Tiananmen protests will take the country into fascinating new territory.

Hanging over this generational change is the question of June 4 itself.

When Deng Xiaoping took control of the Chinese government in 1978 one of his first actions was to reverse the official party verdict on the 'Qing Ming Incident' of April 1976. This was the public protest that grew out of mourning for the death of Premier Zhou Enlai, and brought tens of thousands of ordinary Beijingers to Tiananmen Square. At the time the protests were condemned as a 'counter-revolutionary

riot', and many involved were imprisoned. In November 1978, at the outset of Deng's new rule, their protests were rebranded as an act of patriotism. It was a decision that was heavy with symbolism, signalling a new path for China. In the same way, a future leadership must one day change the verdict on June 4 1989.

The Tiananmen massacre affected millions of people all over China who joined the demonstrations in the spring and summer of 1989. To do nothing to acknowledge their experience, not to mention the pain of those who were bereaved, will eventually be impossible as China recognises that to distort its past is to poison its future.

The government's inability to face the truth of national tragedies such as the Great Leap Forward, the Cultural Revolution and the Tiananmen massacre has created a hole at the heart of Chinese culture. The efforts of the Tiananmen Mothers, of young documentarians, of artists like Sheng Qi and Guo Jian, and brave self-made historians like Yang Jisheng may vary in scale but they all seek the same thing—to fight historical amnesia and wrest control of the nation's history from the hands of the government and deliver it to the people.

Looking back over the four decades since the spring of 1976, when demonstrators gathered in Tiananmen Square to protest at how low the rule of Mao and the party had brought the country, what is most striking is how each decade since has demonstrated the resilience of that vision of the right of ordinary people to participate in guiding the course of their nation.

This belief in the role of the citizen has animated the work of rights lawyers, activists, feminists, historians, writers, poets and intellectuals, as well as the many ordinary Chinese people who have decided to take a stand on behalf of their communities, their workmates, or their ideals.

And the artists?

One day last spring I chatted over tea in Huang Rui's garden about the Stars, and how he regarded those events, now almost four decades in the past. Huang Rui told me that by any regular artistic standard the Stars exhibition must today be considered 'unimportant'. But then he added: 'One vital precept *was* established by the Stars: the importance of always staying in opposition to the mainstream. The spirit of the Stars was to adopt an attitude of respectful independence. And I believe I have consistently kept to that attitude ever since.'

'Respectful independence'. It sounds like a modest ambition but must be immensely difficult to achieve. In the face of an intense drive towards conformity, surrendering your autonomy into the hands of others can seem a price worth paying for secure anonymity.

To comprehend the depths of a great country in the process of one of the most wrenching and epoch-making transformations that our era will ever see may seem impossible. But four decades ago China's artists found a language to bring that experience to life. It is a language without words, which has allowed them to dance along the edge of the permissible in an era when that edge has often been a precipice.

Through their wit, independence and refusal to have others decide how they will see the world, they give us a shining glimpse of what their country will one day be.

DRAMATIS PERSONAE

AI WEIWEI, born 1957 (pronounced *eye way way*)—Celebrated conceptual artist and activist. The son of the noted poet Ai Qing, Ai Weiwei was associated with the early avant-garde movement in Beijing, and moved to the United States in 1981. He returned to China in 1993 and became prominent in contemporary art circles. He collaborated in the design of the 2008 Beijing Olympic stadium but was stridently critical of government policies during the games. He campaigned for transparency over the child death toll in the 2008 Sichuan earthquake, and after years of political activism on the internet, he was jailed for three months in 2011 for alleged tax offences. In 2016 he set up a studio in Greece to make work highlighting the issue of asylum seekers in Europe.

ANIWAR MAMAT, born 1962—A pioneer of abstraction and installation art on the Chinese scene. Of Uighur ethnicity, he was born in Xinjiang, came to Beijing as a student in 1984 and has remained a distinctive figure in the Chinese avant-garde ever since. His minimalist abstract style explores the interplay between colour, landscape and the forces of nature. His work is in a number of prestigious private collections including the United States State Department and the Swatch Collection, and was acquired by the National Gallery of Victoria in 2015.

BEI DAO, born 1949 (pron. *bay dow*)—A celebrated poet whose political critique kept him out of favour with the Chinese authorities for many years. He was a Red Guard during the Cultural Revolution, but the violence and injustice that he saw turned him against the ideals of the regime. In 1978 he was co-editor of the underground literary journal *Today*, in which he published 'The Answer', one of his best-known and most politically incendiary poems. He was exiled from China after 1989 and was only permitted to return in 2006.

CAO FEI, born 1978 (pron. *tsow fay*)—Multimedia artist. Born in Guangzhou and trained at the Guangzhou Academy of Fine Arts, she began her career in experimental documentary film and video work, exploring themes of youth alienation and psychological adjustment. She went on to produce widely admired video works exploring the dilemmas and paradoxes of rapid modernisation in China. In 2008 she used the online environment called Second Life to create *RMB City*, a virtual city in which visitors and other artists could exchange ideas and develop creative projects. *RMB City* and its multimedia offshoots, as well as Cao Fei's other video and installation works, have been exhibited in galleries around the world. Her solo show at New York's MoMA PS1 in 2016 was a first for a Chinese artist at this prestigious institution.

CHAI LING, born 1966 (pron. *ch-eye ling*)—A prominent student leader in the 1989 Tiananmen protests. She repeatedly counselled against compromise and insisted to the end that the demonstrators should not withdraw. She was spirited out of China after June 4 and now lives in the United States.

CHAIRMAN MAO—see Mao Zedong

CUI JIAN, born 1961 (pron. *tsway jyen*)—A pioneer of the Chinese rock scene, and its most famous performer. His mega-hit, 'Nothing to My Name', became an unofficial anthem of the 1989 Tiananmen protest movement. Because of his activism in 1989 he was frozen out of the official concert circuit for a decade, but since 2000 has been gradually rehabilitated.

DENG LIJUN, 1953–95 (pron. *duhng lee joon*)—A Taiwanese pop singer more widely known as Teresa Teng who had a global following in the 1970s and '80s. Her music was banned in China because of her Taiwanese background, but illegal tapes created a huge fan base there. She had the same family name as Deng Xiaoping, and there was a popular joke that 'Deng Xiaoping rules China by day, and Deng Lijun by night'. She never performed in China, and died at the age of 42 of acute asthma.

DENG XIAOPING, 1904–97 (pron. *duhng syow ping*)—China's most powerful political figure from 1978 until the early 1990s. He transformed the economy after Mao Zedong's death, engineering the pragmatic fusion of central planning and market economics known as 'socialism with Chinese characteristics'. Although never head of state, his posts as 'paramount leader' enabled him to steer through the historic de-collectivisation of agriculture, the opening up to foreign trade and investment, and the privatisation of state-owned industries. On the dark side of the ledger, it was his decision to unleash the army on the Tiananmen protesters in 1989. Deng officially retired after 1989 but continued to exert a powerful influence. His famous 1992 'southern inspection tour' through the economic powerhouses of Guangzhou province ensured the ascendancy of economic reformers in the Communist Party. It was then that the aphorism 'to get rich is glorious' entered Chinese life, widely (but probably inaccurately) credited to Deng Xiaoping.

GONKAR GYATSO, born 1961—Tibetan conceptual artist. Born in Lhasa, he studied traditional Chinese painting in Beijing. In 1992 he left China and spent four years in the Tibetan exile community in Dharamsala in India before moving to London on a scholarship to the Central Saint Martins art school. His work explores themes of cultural identity, and ways in which pop culture and religious iconography can intersect. Among public collections in which he is represented are the Museum of Fine Arts Boston, the Newark Museum (New York), the Queensland Gallery of Modern Art and the White Rabbit Collection (Sydney).

GUO JIAN, born 1962 (pron. *gwoh jyen*)—Painter and conceptual artist. Born in Guizhou in southern China, he served in the army during the Sino-Vietnamese War of 1979. He enrolled in university in Beijing in 1985 and was a hunger striker during the 1989 Tiananmen demonstrations. In the early 1990s he was part of the artists' community at the Old Summer Palace on the outskirts of Beijing. He emigrated to Australia in 1995, and returned to live and work in Beijing in 2005. In 2014 he was deported back to Australia after commenting to a British newspaper about the events of 1989. Institutions holding his works include the National Gallery of Australia, the Queensland Gallery of Modern Art, and White Rabbit Gallery in Sydney.

HOU DEJIAN, born 1956 (pron. *ho der jyen*)—A Taiwan-born pop singer who played a prominent role in the 1989 Tiananmen protests. He was one of the group of notables dubbed the 'Four Gentlemen', who staged their own hunger strike in the Square. On the night of June 3-4, he and the group brokered a last-moment arrangement with the encircling troops for the remaining protesters to leave Tiananmen Square. After June 4 he spent 72 days under the secret protection of the Australian Embassy, after which he lived openly in Beijing for a brief period before being deported to Taiwan in June 1990.

HU YAOBANG, 1915–89 (pron. *hoo yow bahng*)—One of the key liberalising figures in Chinese politics in the 1980s, whose death triggered the 1989 Tiananmen demonstrations. Serving as head of the Communist Party from 1981 to 1987, he was a close ally of Deng Xiaoping and pushed through a series of economic, political and anti-corruption reforms. These, and his outspoken liberal opinions, earned him the admiration of students and intellectuals and the enmity of party hard-liners. When student demonstrations broke out across China in the northern winter of 1986–87, Hu was criticised for leniency and was forced to resign and issue a humiliating self-criticism. In April 1989, within hours of his death from heart failure, demonstrations broke out demanding his rehabilitation and calling for political reform. These escalated into the Tiananmen protests that ended on June 4 1989.

HUANG RUI, born 1952 (pron. *hwahng ray*)—Conceptual and performance artist, a pioneer of the Chinese contemporary art movement and co-founder of the Stars group. He was born in Beijing and came to prominence first as a principal editor of the underground literary journal *Today* (first published 1978) and then as co-curator of the seminal Stars exhibitions of 1979 and 1980. He spent two long periods in Japan (1984–92 and 1995–2001) before returning to reside permanently in Beijing. In 2002 he established one of the first and most important galleries in the Beijing 798 Art District. His work, minimalist and intellectual in approach, explores traditional philosophy and modern iconography and carries a strong political critique. Institutions holding his works include the Guggenheim Museum in New York and M+ in Hong Kong.

ILHAM TOHTI, born 1969—Academic, commentator on Han-Uighur affairs, and China's most prominent Uighur political prisoner. Born in Xinjiang, he graduated from the Minzu University in Beijing

and later took a teaching post there in the school of economics. In 2006 he founded a website called *Uighur Online* which the Chinese authorities blocked in 2009. In his writings he has called for greater autonomy for Xinjiang within a federal Chinese system, a stronger Uighur role in regional governance, more enlightened religious policies, and more opportunities for the study of the Uighur language. He was placed in detention in 2014, and nine months later was sentenced to life imprisonment for 'separatism'.

JIA AILI, born 1979 (pron. *jyah eye lee*)—Painter and emerging star of the Chinese contemporary art scene. Born in the far northern province of Liaoning, he did extensive formal art training at the Lu Xun Academy of Fine Arts in Shenyang and was deeply influenced by Western masters. Many of his canvases have a bleak and alienated quality, reflecting the frigid landscapes of his home province and the economic dislocation that afflicted the region during his boyhood. His works frequently explore the disquieting aspects of the intertwined development of humans and technology. He lives and works in Beijing.

JIANG QING, 1914–91 (pron. *jyahng ching*)—The wife of Mao Zedong and a member of the infamous Gang of Four, the political faction blamed for the worst excesses of the Cultural Revolution. An inflexible and relentless ideologue, she was widely hated for her ability to influence Mao in campaigns against key individuals during the Cultural Revolution. She was arrested shortly after Mao's death in 1976, and after a televised trial in which her shrill speeches in her own defence became the stuff of legend, she was sentenced to death, later commuted to life imprisonment. Released on medical grounds in 1991, she committed suicide shortly afterwards.

LI PENG, born 1928 (pron. *lee puhng*)—A former premier of China who was an influential opponent of market reform and liberalisation.

He is remembered for his intransigent line against the demonstrators during the 1989 Tiananmen protests, and for his key role in ordering the imposition of martial law and the use of troops to crush the movement.

LIN BIAO, 1907–71 (pron. *lin byow*)—A marshal of the People's Republic of China whose mysterious death and fall from grace had a corrosive effect on public confidence in the party. He was a close ally of Mao Zedong and was named as the Chairman's designated successor in 1969, but a rift developed between the two men shortly afterwards and he died in a plane crash in Mongolia. The party at first tried to cover up the event and later denounced Lin as a traitor, repeatedly injecting fresh and often implausible versions of his crimes into the endless propaganda wars of the Cultural Revolution. The exact circumstances of the 'Lin Biao Incident' have never been established.

LIU QING, born 1948 (pron. *lyoo ching*)—Activist and co-editor of the underground Democracy Wall period magazine, *April Fifth Forum*. Detained in November 1979 for publishing a transcript of Wei Jingsheng's trial, Liu was sentenced to three years in prison, later extended to ten years after his smuggled prison diary was published in the West. After his release from prison he was allowed to travel in 1992 to the United States, where he lives and works as an activist on Chinese political and social issues. He is on the board of directors of Human Rights in China, a New York-based NGO.

LIU XIAOBO, 1955–2017 (pron. *lyoo syow boh*)—A literary critic, professor and prolific author who is China's only winner of the Nobel Peace Prize and the country's most famous prisoner of conscience. A prominent lecturer and commentator on Chinese cultural affairs, he became involved in the 1989 Tiananmen protests, and despite his efforts to mediate between the protestors and the authorities, he was jailed without trial for nineteen months and stripped of his academic

posts. In the succeeding years he was ceaselessly harassed for his advocacy of human rights and jailed several times. In 2009 he was sentenced to eleven years in prison for his involvement in the publication of the rights manifesto 'Charter 08'. In 2010 he was awarded the Nobel Peace Prize, and was represented on stage at the awards ceremony in Oslo by an empty chair. He died in custody of liver cancer in July 2017.

MA DESHENG, born 1952 (pron. *ma der shuhng*)—Distinguished contemporary artist who was a founding member of the Stars group. His works appeared in the seminal Stars exhibitions in Beijing in 1979 and 1980. He now lives and works in Paris.

MADAM MAO—see Jiang Qing

MANG KE, born 1951 (pron. *mahng ker*)—A pioneer of avant-garde Chinese poetry and co-founder in 1978 of the vanguard literary journal *Today*. Mang Ke was born in Shenyang, but grew up in Beijing where he still lives today. He has written many volumes of poetry as well as a novel, and is also an accomplished painter.

MAO TSE-TUNG—see Mao Zedong

MAO ZEDONG, 1893–1976 (pron. *maoh dzeh doong*)—Founder of the People's Republic of China in 1949 and ruler of the nation until his death. From 1935 to 1949 he led the Communist Party in its struggles against the Nationalists, and was the architect of the brand of Marxism-Leninism that dominated Chinese politics after the communists took power. His achievements in unifying China and restoring its status as a world power were overshadowed by the despotic and capricious excesses of his rule, notably the catastrophe of the Great Leap Forward (1958–62), which killed between 36 and 45 million people, and the Cultural Revolution (1966–76), which crippled the economy, scarred

a generation and destroyed China's cultural heritage. After 1976 the Communist Party reconciled Mao's semi-divine status with the chaos of his era through Deng Xiaoping's verdict that he was 'seven parts good, three parts bad'. He remains an important if ambiguous figure in contemporary Chinese life.

PEI LI, born 1985 (pron. *pay lee*)—Video and installation artist. Born in the Yangtze River delta city of Changzhou, Jiangsu province, she studied new media at the China Academy of Art in Hangzhou and later at the Beijing Film Academy. While much of her work reflects on the experience of young people in today's China, she is also socially engaged, and has worked as a mentor to both rural workers and visually impaired people in Beijing, helping them to create art works based on their experiences. She is represented in various private collections including the Sigg Collection. In 2016 she was awarded a PhD for her research on early Chinese cinema.

PU ZHIQIANG, born 1965 (pron. *poo zhr chyang*)—Civil rights lawyer and activist. He was involved in the 1989 Tiananmen demonstrations, and afterwards he openly marked the anniversary with a private vigil at the square every year until 2006, when the police prevented him. He has taken numerous high-profile cases in defence of free speech in journalism and in support of individuals in conflict with the state. A prolific writer and online commentator on politics and social issues, he was given a three-year suspended sentence in December 2015 for 'picking quarrels' and 'inciting ethnic hatred', and was formally disbarred from practising law in April 2016.

SHENG QI, born 1965 (pron. *shuhng chee*)—Performance artist and painter. Born in Anhui province, he came up to Beijing as a student in 1984 and became involved in the 1989 Tiananmen protests. He sank into depression after the June 4 massacre and once he had recovered,

he moved to Europe and established his artistic career there. Among institutions holding his work are the Museum of Modern Art (New York), the International Center for Photography (New York) and the National Gallery of Victoria.

TERESA TENG—see Deng Lijun

TOHTI, ILHAM—see Ilham Tohti

WEI JINGSHENG, born 1950—(pron. *way jing shuhng*)—One of China's most celebrated dissidents. He joined the Red Guards at sixteen during the Cultural Revolution, but the misery he encountered in his travels through the Chinese countryside destroyed his ideological faith. During the Democracy Wall period in 1978–79, he published 'The Fifth Modernisation', a brilliant manifesto arguing for democratic reform, and was sentenced to fifteen years' imprisonment in 1979. In 1993, all but broken in health, he was paroled during China's unsuccessful campaign for the 2000 Olympics, and he immediately resumed campaigning for reform. In 1995 he was sentenced to a further fourteen years in prison. Two years later, American pressure secured permission for him to travel for medical treatment to the United States, where he remains in exile as a prominent critic and analyst of the Chinese political system.

WU'ER KAIXI, born 1968 (pron. *woo-ar kaishee*)—A key organiser of the 1989 Tiananmen protests. He was prominent as a student leader and hunger-striker all through the protests. The footage of him in his hospital pyjamas berating Premier Li Peng on national television is one of the most enduring images of the Tiananmen events. After June 4 Wu'er Kaixi was number two on the government's most-wanted list. He was smuggled out of China to France via Hong Kong and now lives in Taiwan. In 2016 he stood unsuccessfully for election to the Taiwanese Parliament.

XI JINPING, born 1953 (pron. *shee jin ping*)—General secretary of the Communist Party since 2012 and president of the People's Republic of China since 2013. The son of a party luminary of the Long March era, he is prominent among the 'princelings', a grouping of insiders said to form alliances and networks on the basis of their family ties to party elders. Xi has centralised institutional power to a degree unprecedented since Mao Zedong. His time in office has been marked by a determination to strengthen the role of the Communist Party, enforce party discipline, stifle dissent in media, legal and academic circles, and launch high-profile drives against corruption which have brought down a number of senior figures in government and business.

ZHANG HUAN, born 1965 (pron. *jahng hwahn*)—Performance artist, painter and sculptor. He arrived in Beijing as an art student in the early 1990s and quickly made a name as a pioneer of performance art, many of his works involving excruciating feats of physical endurance. He moved to New York in 1998 and established his international reputation. His art has branched out into sculpture and conceptual works using collected objects and gathered materials, including, in several notable pieces, ash from incense and temple burnt offerings. He now divides his time between Shanghai and New York.

ZHANG XIAOGANG, born 1958 (pron. *jahng syow gahng*)—One of China's most celebrated contemporary artists. His artistic training was in realist traditions, but in the mid-1980s his work took a more symbolist and allegorical bent and he was curated into the seminal 'China/Avant-Garde' exhibition in Beijing in 1989. In the early 1990s he started his iconic 'Bloodline' series, inspired by old family photos from the time of his childhood. These paintings made his international reputation and remain among the most prized examples of Chinese contemporary art. His more recent work exploring themes of memory and loss continues the dialogue with personal and national history

that is the hallmark of his art. His work can be seen in major public collections around the world.

ZHAO ZIYANG, 1919–2005 (pron. *jow dzee yahng*)—A senior liberalising political figure in China during the 1980s whose career was destroyed by the 1989 Tiananmen protests. He served as premier from 1980 to 1987, collaborating with Hu Yaobang on economic and anti-corruption reforms, and eventually succeeding him as general secretary of the Communist Party in 1987. During the 1989 Tiananmen protests he counselled a lenient line, but was outmanoeuvred by hard-liners. He refused to support martial law, and was ousted by his opponents. He made a final futile plea to the students to abandon their hunger strike, after which he spent fifteen years under house arrest. Over a two-year period, he secretly tape-recorded his recollections, which after his death were edited and published in English as *Prisoner of the State: The Secret Journal of Premier Zhao Ziyang*.

ZHOU ENLAI, 1898–1976 (pron. *jo en lye*)—Premier of China from 1949 to 1976 and foreign minister from 1949 to 1958. He was a charismatic figure who played a critical role in China's diplomacy in the 1960s and '70s, notably as the architect of President Nixon's historic 1972 visit to China. A close ally of Mao's, he probably deserves more of the blame for the disasters of the Maoist era than he bears, but is rightly credited with mitigating the effects of the worst of them, especially during the Cultural Revolution. At the end of his life he was estranged from Mao but beloved by the people, and the regime's attempts to stifle popular grief at his death triggered the 1976 'Qing Ming Incident' (also known as the Tiananmen Incident), an unprecedented protest demonstration that was violently put down by the authorities.

TIMELINE

	CHINESE HISTORY	ARTISTS AND CULTURAL SCENE
1949	Foundation of the People's Republic of China	
1950	Korean War begins	
1952		*Huang Rui* born (Beijing)
1953	Korean War Armistice signed	
1956	'Hundred Flowers' campaign creates brief period of liberalisation	
1957	Anti-rightist campaign begins, targeting intellectual critics of the government	
1958	Great Leap Forward begins	*Zhang Xiaogang* born (Yunnan, south-west China)
1959	Tibetan uprising breaks out in Lhasa; Dalai Lama flees China	
1960	Sino-Soviet split begins	
1961		*Gonkar Gyatso* born (Lhasa, Tibet)
1962		*Aniwar* born (Xinjiang, far western China) *Guo Jian* born (Guizhou, southern China)
1965		*Sheng Qi* born (Anhui, eastern China)
1966	Cultural Revolution begins	

CHINESE HISTORY	ARTISTS AND CULTURAL SCENE
1971 Death of *Lin Biao*	
1972 President Nixon visits China, beginning normalisation of Sino-US relations	
1976 Death of *Zhou Enlai* (January) Qing Ming Incident (April)—violent suppression of demonstration triggered by death of Zhou Enlai Tangshan earthquake (July) Death of *Mao Zedong* (September) End of the Cultural Revolution with the arrest of the Gang of Four (October)	
1978 Democracy Wall begins (November) *Deng Xiaoping* becomes paramount leader Economic 'reform and opening up' begins	*Wei Jingsheng* publishes 'The Fifth Modernisation' on Democracy Wall *Bei Dao*, *Mang Ke* and *Huang Rui* publish the first edition of literary journal *Today* *Cao Fei* born (Guangdong, southern China)
1979 *Deng Xiaoping* visits the United States (January) China and the United States establish diplomatic relations (January) Sino-Vietnamese War breaks out (February) Democracy Wall shut down (December)	*Wei Jingsheng* arrested (March) The Stars hold their first exhibition (September) The Stars hold a public demonstration for freedom of speech (October) *Wei Jingsheng* sentenced to fifteen years' imprisonment (October) *Jia Aili* born (Liaoning, north-eastern China)
1980 Four special economic zones created to attract investment China officially adopts one-child policy	Second Stars exhibition at National Art Museum of China *Gonkar Gyatso* arrives in Beijing as a student

CHINESE HISTORY	ARTISTS AND CULTURAL SCENE
1983 'Anti-spiritual pollution' campaign against Western influences	
1984	*Sheng Qi* arrives in Beijing as a student *Aniwar* arrives in Beijing as a student *Huang Rui* moves to Japan
1985	*Guo Jian* arrives in Beijing as a student *Pei Li* born (Jiangsu, eastern China)
1986 Student demonstrations break out across China (December)	
1987 *Hu Yaobang* forced to resign	
1988	*River Elegy* broadcast on national TV
1989 *Hu Yaobang* dies (April 15) Demonstrations in Tiananmen Square begin (April 18) Memorial service for Hu Yaobang at the Great Hall of the People (April 22) *Peoples Daily* editorial condemns the demonstrations (April 26) Demonstrators announce hunger strike (May 13) Mikhail Gorbachev arrives in Beijing on official visit (May 15) Martial law declared (May 20) Army action ends the Tiananmen demonstrations (June 3–4) Jiang Zemin replaces *Zhao Ziyang* as general secretary of the Communist Party	'China Avant-Garde' art exhibition opens (5 February) Artists begin moving into Yuanmingyuan (Old Summer Palace)

	CHINESE HISTORY	ARTISTS AND CULTURAL SCENE
1990		*Sheng Qi* leaves China for Europe and Britain
1992	*Deng Xiaoping* conducts his 'southern inspection tour' of Guangzhou to lock in economic reform	*Gonkar Gyatso* leaves China to live in Dharamsala *Huang Rui* returns to China from Japan
1993		*Wei Jingsheng* released from prison on parole 'China's New Art, Post-1989' exhibition opens in Hong Kong (later to tour to Australia, Canada and the United States)
1995		*Guo Jian* emigrates to Australia *Huang Rui* returns to Japan *Zhang Xiaogang* features in the Venice Biennale *Wei Jingsheng* sentenced to a further fourteen years in prison
1996		*Gonkar Gyatso* moves to London
1997	*Deng Xiaoping* dies Sovereignty over Hong Kong transferred from the United Kingdom to China	*Wei Jingsheng* released on medical grounds and goes to the United States
1998		*Sheng Qi* returns to China
2000		Artists begin moving into abandoned factory spaces in the 798 district
2001	China gains accession to the World Trade Organization	*Huang Rui* returns to China
2002	Hu Jintao replaces Jiang Zemin as general secretary of the Communist Party	First commercial exhibition in the 798 art district

CHINESE HISTORY	ARTISTS AND CULTURAL SCENE
2003	*Cao Fei* makes the first of three appearances at the Venice Biennale
2005 *Zhao Ziyang* dies	*Guo Jian* returns to China
2008 Major riots break out in Lhasa (March) Sichuan earthquake (May) Olympic Games open in Beijing (August) China announces a RMB4 trillion (US$586 billion) economic stimulus package to offset the Global Financial Crisis (November)	*Pei Li* arrives in Beijing as a student 'Charter 08' rights manifesto published (December)
2009 Major riots in the Xinjiang capital, Urumqi	*Gonkar Gyatso* features in the Venice Biennale *Liu Xiaobo* sentenced to eleven years in prison for his involvement with 'Charter 08'
2010 China overtakes Japan to become the world's second-largest economy	*Sheng Qi* leaves China again to return to London *Liu Xiaobo* awarded the Nobel Peace Prize
2011	*Jia Aili* features in the Venice Biennale
2012 *Xi Jinping* replaces Hu Jintao as general secretary of the Communist Party	
2013 *Xi Jinping* assumes the presidency	
2014	*Guo Jian* deported to Australia *Ilham Tohti* sentenced to life imprisonment

	CHINESE HISTORY	ARTISTS AND CULTURAL SCENE
2015	Plans announced to abolish the one-child policy	Rights lawyer *Pu Zhiqiang* given a three-year suspended sentence and subsequently disbarred
2016		*Gonkar Gyatso* returns to China

ACKNOWLEDGEMENTS

My thanks go first to the artists, whose bravery and brilliance were the inspiration for this book: Aniwar, Cao Fei, Gonkar Gyatso, Guo Jian, Huang Rui, Jia Aili, Pei Li, Sheng Qi, and Zhang Xiaogang. Their generosity with their time and insights, and their willingness to go deep in discussing key moments in their lives and work provided the bedrock of this book. I am also grateful to them for allowing me to reproduce their work in these pages. Thanks too to Aniwar and Huang Rui for all their hospitality over many years. Two of the best cooks I know, they sustained my work in ways that I can never repay.

In some ways this book has been thirty years in the making. I first set foot in Beijing in January 1986 in the middle of one of the coldest winters in years. On my first day in the capital my earrings froze in my ears. Nevertheless I was smitten. That my early infatuation turned into a thirty-year fascination was in large part due to the people I met in those first weeks and those I continued to meet throughout China in the decades since.

First amongst these, I would like to thank those people who were there at the beginning: Ah Xian and Ma Li, Sue Dewar and Bruce Doar, Guo Xiaomei, Hei Dachun, Gérard Kahn, Lin Chunyan, Mang Ke, Geoff Raby, Yang Lian and Yo Yo, and Nick Jose, who got me there in the first place.

Secondly there are my colleagues and partners in journalism. Alan Kohler, then editor of *The Australian Financial Review*, took a punt on me and gave me my start in journalism as Peking correspondent in 1986. The paper's Foreign Editor at the time, Graham Canning, provided vital support and encouragement, as did my editor at the *Times on Sunday*, the late Robert Haupt. Jonathan Holmes, then Executive Producer of ABC Television's *Foreign Correspondent* program, gave me my break into television and the chance to work with the superb Sally Neighbour, then the ABC's China correspondent, and the crack crew of the late Sebastian Phua (on camera) and Joe Phua on sound and editing. Some of our adventures together are recorded in these pages. Later I took inspiration from my colleagues at China Radio International, who reminded me how lucky we are in Australia, where the media is truly recognized as the Fourth Estate. The magazine *the Beijinger* gave me my first opportunity to write about art full time. Some of my exceptional colleagues there are still my friends today. Amongst these I would like to thank Lisa Liang, and photographer Judy Zhou, whose brilliant portraits of the artists grace this book. Finally Ben Genocchio, who gave me the opportunity to create ARTINFO China in 2010 and to serve as Asia Correspondent for *Art+Auction* and *Modern Painters* magazines.

Then there are those "partners in China" who have lit my path through the country over the last three decades. Some thirty years ago Bruce Doar drew me into a fascinating conversation about China that is still going strong today. He encouraged me to move back to Beijing 13 years ago and he and his partner, Yusuf Osman, have been a source of endless hospitality and kindness ever since. Geoff Raby, the former Australian Ambassador to China, has also been a touchstone in my exploration of China, as well as a great friend and supporter. I would also like to thank my dear friends Tana Eupene, Tass Schmidt, Leonie Weldon and Sun Ning who have shared my passion for China and its art, as well as those who have enriched my greater understanding of

China's contemporary art scene, including Johnson Chang, Chen Ran, Shen Boliang and Karen Smith.

Emily Pender has given power to my pen over 35 years of friendship.

My agent Margaret Gee believed in *The Phoenix Years* from the beginning; I will always be grateful for her advocacy and wise counsel. I am also grateful for the dedication and passion of my superb publishers—Jane Palfreyman and Rebecca Kaiser at Allen & Unwin, and Jessica Case at Pegasus Books.

Finally, I want to thank my husband John Brennan, my pathfinder in China who has shared my fascination with the country from the beginning. This book started with a conversation between us one night in Beijing, and it grew through countless conversations after, on long walks, and over dinner, via Skype, text, FaceTime, and in real time. From the first word of this book to the last (save these) he has been with me, the most incisive of interlocutors, the most sensitive and critical of readers, a supporter whose enthusiasm has never flagged. *The Phoenix Years* is a better book because of him.

The book is dedicated to John with all my love, and to my late brother Hugh, who I will miss every day of my life.

Sydney, March 2017

NOTES

There are two main primary sources for *The Phoenix Years:* my inter-
views and conversations with the nine key voices in the book, spanning
many years; and my notes, recollections and writings from my three
decades of reporting on contemporary China.

The nine voices whose lives and work form the backbone of this
book are all Chinese contemporary artists. They are (in alphabetical
order): Aniwar, Cao Fei, Gonkar Gyatso, Guo Jian, Huang Rui, Jia
Aili, Pei Li, Sheng Qi and Zhang Xiaogang. Unless otherwise stated,
all quotations from these artists come from my interviews with them.

For the general historical narrative of contemporary China I
have relied throughout on Professor Jonathan D Spence's magisterial
work *The Search for Modern China* (Third Edition) as published by
WW Norton & Company in 2013. The range of additional secondary
sources I have drawn on are listed chapter by chapter below.

CHAPTER ONE
BEIJING 1986
This chapter is based largely on my experiences as a journalist in China.
Other sources are as follows.

Great Leap Forward—death toll
Frank Dikötter, *Mao's Great Famine: The history of China's most deva-
stating catastrophe, 1958–62* (chapter 37), Bloomsbury, London, 2010;

Yang Jisheng, *Tombstone: The Great Chinese Famine 1958–1962*, Farrar, Straus and Giroux, New York, 2012.

China's per capita GDP
World Bank, 'GDP Per Capita', <http://data.worldbank.org/indicator/NY.GDP.PCAP.CD?page=1> accessed June 16 2013.

Story of Today *magazine and Huang Rui*
Author interviews with Huang Rui; Huang Rui, *The Stars Period, 1977–1984*, Asia One Books, Hong Kong, 2012.

CHAPTER TWO
I DO NOT BELIEVE!
Huang Rui
The story of Huang Rui is based largely on my interviews with him. Additional detail comes from his book *The Stars Period, 1977–1984*.

Democracy Wall
Main sources: author interviews. Other sources: Andrew J Nathan, *Chinese Democracy* (chapters 1, 2 & 4), IB Tauris & Co Ltd, London, 1986; Richard Thwaites, *Real Life China* (chapter 8), Collins, Sydney, 1986.

Wei Jingsheng
For the text of Wei's 'The Fifth Modernisation' I have used the translation in Wei's book, *The Courage to Stand Alone: Letters from prison and other writings*, edited and translated by Kristina M Torgeson, Penguin Books, New York, 1998; For his story in this and subsequent chapters, I have relied on his essay 'From Maoist fanatic to political dissident: an autobiographical essay', written in 1979 and reprinted in *The Courage to Stand Alone*, and also on the essay by Sophia Woodman, 'Wei Jingsheng's lifelong battle for democracy',

which is included in the same book. I have also drawn on chapter 9 of
Thwaites, *Real Life China*.

Underground literary scene in the late 1970s
Bonnie S. McDougall, 'Breaking through: literature and the arts in China,
1976–1986', *Copenhagen Papers in East and Southeast Asian Studies*, 1,
1988 <http://cjas.dk/index.php/cjas/article/viewFile/1753/1774> accessed
April 12 2016.

Today *magazine*
Main sources: author interviews and Huang Rui, *The Stars Period*.
Other sources: Bei Dao, lecture to Stanford University, January 1998,
(trans) Perry Link, <https://prelectur.stanford.edu/lecturers/dao/
dao_on_today.html> accessed April 11 2016; Siobahn LaPiana, 'An
interview with visiting artist Bei Dao: Poet in exile', *The Journal of
the International Institute*, vol. 2, issue 1, fall 1994 <http://quod.lib.
umich.edu/j/jii/4750978.0002.102/--interview-with-visiting-artist-
bei-dao-poet-in-exile?rgn=main;view=fulltext> accessed April 11
2016; Liansu Meng, *The Inferno Tango: Gender politics and modern
Chinese poetry, 1917–1980*, a dissertation submitted in partial
fulfilment of the requirements for the degree of Doctor of Philosophy
(Comparative Literature) in the University of Michigan, 2010 <https://
deepblue.lib.umich.edu/bitstream/handle/2027.42/78971/lmeng_1.
pdf?sequence=1> accessed April 11 2016; For *Today*'s inaugural
editorial see Andrew J Nathan, *Chinese Democracy*, p. 21 and Huang
Rui, *The Stars Period*, p. 23.

Bei Dao
Bei Dao, 'The Answer', *The August Sleepwalker*, (trans) Bonnie S.
McDougall, New Directions Publishing Corp, New York, 1988, p. 33;
Hu Ming, 'Shao Fei: an intimate friend', in *Works of Contemporary
Chinese Painter Shao Fei*, People's Fine Arts Publishing House, Beijing,

2006. (The artist Shao Fei was married to Bei Dao for a number of years. This essay, by her old friend and fellow artist, Hu Ming, provides background on Bei Dao, Huang Rui, the Stars group, and the artistic and cultural scene of the late '70s and early '80s); Steven Ratiner, 'Reclaiming the word: a conversation with Bei Dao', *AGNI Online*, vol. 54, 2001 <www.bu.edu/agni/interviews/print/2001/ratiner-beidao.html> accessed April 12 2016.

Mang Ke
My portrait of Mang Ke is based primarily on conversations over our long friendship. Other sources: Kang-i Sun Chang & Stephen Owen (eds), *The Cambridge History of Chinese Literature*, vol. II, chapter 7, Cambridge University Press, Cambridge, 2010; Mang Ke, *Qiao, zhexie ren!* (*Gifted Generation!*), Time Literature and Art Publishing House, Beijing, 2003; The lines quoted from Mang Ke's poem, 'I am a poet', first published in *Jintian (Today)* magazine, issue no. 1, 1978, translated by Bruce Gordon Doar.

Red Guards and 'sent down youth'
'The routinization of liminality: the persistence of activism among China's Red Guard generation' in Jeffrey Broadbent and Vicky Brockman (eds), *East Asian Social Movements: Power, protest, and change in a dynamic region*, Springer, New York, 2010.

THE STARS
Deng Xiaoping, his visit to the United States, and the decision to go to war with Vietnam
Terry McCarthy, 'A Nervous China Invades Vietnam', *Time*, 27 September 1999 <http://content.time.com/time/world/article/0,8599,2054325,00.html> accessed April 12 2016; Thwaites, *Real Life China*; Orville Schell, 'Deng's revolution', *Newsweek*, March 3 1997; <www.highbeam.com/

doc/1G1-19150022.html> accessed April 12 2016; Xiaoming Zhang, 'Deng Xiaoping and China's decision to go to war with Vietnam', *Journal of Cold War Studies*, vol. 12, no. 3, Summer 2010.

Unofficial publications at Democracy Wall
Nathan, *Chinese Democracy*, chapters 1 & 2.

'Beijing in 1979 is an eternal spring in our memory . . .'
Hu Ming's description of 1979 in Beijing comes from her essay 'Shao Fei: an intimate friend', as previously cited, p. 190. Her recollections in that essay were supplemented by interviews with the author.

Crackdown on Democracy Wall and arrest of Wei Jingsheng
Merle Goldman, *From Comrade to Citizen: the struggle for political rights in China*, chapter 1, Harvard University Press, Cambridge, 2005; Nathan, *Chinese Democracy*, chapter 2; Thwaites, *Real Life China*, chapters 8 & 9.

The Stars exhibition and demonstration for freedom of expression
The description of the formation of the Stars group, the Stars exhibition, and subsequent events is drawn primarily from my interviews with Huang Rui and his book *The Stars Period*; The excerpt from the Stars group manifesto comes from Lü Peng, *A History of Art in 20th Century China*, (trans) Bruce Gordon Doar, Somogy Art Publishers, 2013, p. 497; Other sources: Andrew Cohen, 'Eternal spring—Ma Desheng', *ArtAsiaPacific*, issue 87, March/April 2014 <http://artasiapacific.com/Magazine/87/EternalSpring> accessed April 14 2016; Liu Xiaobo, 'Xidan Democracy Wall and China's Enlightenment', in Perry Link, Tienchi Martin-Liao and Lu Xia (eds), *No Enemies, No Hatred*, Harvard University Press, Cambridge, 2012; Lü Peng, (trans) Bruce Gordon Doar, 'Huang Rui: the linguistic context of the art of the Stars', in *Artists in Art History: Case studies of artists in art history and art*

criticism (1), Hunan Fine Arts Publishing House, 2008; Wu Hung (ed.), *Contemporary Chinese Art: Primary documents*, Museum of Modern Art, New York, 2010.

The trial of Wei Jingsheng

Quotations from Wei's defence at his trial are drawn from Wei's *The Courage to Stand Alone*; For Hu Yaobang's attitude to the Wei case, see Hu Jiwei, 'Hu Yaobang and the Xidan Democracy Wall', *Chen Ming*, April, 2004, (trans) Andrew Chubb <www.danwei.org/history/hu_ yaobang_and_the_xidan_democ.php> accessed April 14 2016.

Guo Jian

The story of Guo Jian in this and subsequent chapters is based entirely on my interviews with him.

Liu Qing

The story of Liu Qing, editor of *April Fifth Forum*, is drawn primarily from chapter 1 of Goldman, *From Comrade to Citizen*, and chapter 2 of Nathan, *Chinese Democracy*; Other sources: Liu Qing, 'Notes from prison', Geremie Barmé and John Minford (eds), *Seeds of Fire*, Far Eastern Economic Review, Hong Kong, 1986; Interview with Liu Nianchun (Liu Qing's brother) by Wang Yu, *China Rights Forum*, no. 3, 2003 <www.hrichina.org/sites/default/files/PDFs/CRF.3.2003/wang_ yu3.2003.pdf accessed April 14 2016.

'Deng Lijun's songs took a generation of Chinese youth by storm . . .'

The quotation from Liu Xiaobo is from his essay 'Xidan Democracy Wall and China's Enlightenment', as previously cited.

CHAPTER FOUR
VERY HEAVEN

This chapter is based largely on my interviews with the artists Aniwar, Gonkar Gyatso, Guo Jian, Huang Rui and Sheng Qi, as well as my own experiences of the time. Secondary sources are listed below by topic.

The Great Leap Forward and Great Famine in Anhui
Dikötter, *Mao's Great Famine*, chapter 35.

Rural reforms and China's economic reform in the 1980s
Aside from my own journalism from this period, I have relied on the exceptional scholarship of Yasheng Huang's *Capitalism with Chinese Characteristics: entrepreneurship and the state*, Cambridge University Press, Cambridge, 2010; For the story of the Xiaogang farmers, see also 'The Secret Document that Transformed China', *National Public Radio*, January 20 2012 <www.npr.org/sections/money/2012/01/20/ 145360447/the-secret-document-that-transformed-china> accessed April 14 2016; The memoir of the late Chinese leader, Zhao Ziyang, provides an unrivalled insider perspective: Bao Pu, Renee Chiang and Adi Ignatius (eds and trans), *Prisoner of the State: The secret journal of Zhao Ziyang*, Simon & Schuster, London, 2009.

Xinjiang
James A Millward, *Eurasian Crossroads: A history of Xinjiang*, Hurst & Company, London, 2007; S Frederick Starr (ed.), *Xinjiang: China's Muslim borderland*, ME Sharpe, New York, 2004.

Anti-spiritual pollution campaign and crime crackdown
Geremie Barmé, 'Spiritual pollution 30 years on', *The China Story Journal*, Australian Centre on China in the World, November 17 2013 <www.thechinastory.org/2013/11/spiritual-pollution-thirty-years-on/> accessed April 14 2016; Julian Baum, 'China, with one of the

world's lowest crime rates, extends crackdown', *The Christian Science Monitor*, November 16 1984 <www.csmonitor.com/1984/1116/111625. html> accessed April 14 2016; Dui Hua Foundation, 'Translation and commentary: more than a decade after "hooliganism" is abolished, one hooligan's re-incarceration sparks debate', *Dui Hua Human Rights Journal*, December 8 2010 <www.duihuahrjournal.org/2010/12/decade-after-hooliganism-is-abolished.html> accessed April 14 2016; Thomas B. Gold, 'Just in time!: China battles spiritual pollution on the eve of 1984', *Asian Survey*, vol. 24, no. 9, September, 1984, <www.jstor.org/stable/2644078> accessed April 14 2016.

CHAPTER FIVE
A TERRIBLE BEAUTY

My narrative of the Tiananmen student protests of 1989 is based on extensive interviews with participants, including Guo Jian and Sheng Qi. Other sources: 'Quarterly chronicle and documentation', *The China Quarterly*, vol. 119, 1989, pp. 666–734; Timothy Brook, *Quelling the People: The military suppression of the Beijing Democracy Movement*, Stanford University Press, Stanford, 1998; Mike Chinoy, *China Live: two decades in the heart of the dragon*, chapters 7–9, Turner Publishing Inc., Atlanta, 1997; Richard Gordon & Carma Hinton (directors), *Gate of Heavenly Peace*, Independent Television Service (ITVS), 1995 <www.tsquare.tv/film/>; Fang Lizhi, (trans) Perry Link, *The Most Wanted Man in China: My journey from scientist to enemy of the state*, chapter 19, Henry Holt and Company, New York, 2016; 'Voices from Tiananmen', a multimedia 25th anniversary presentation of the *South China Morning Post*, June 2014 <http://multimedia.scmp.com/tiananmen/> accessed April 14 2016; Zhang Liang (compiler), Andrew J Nathan and Perry Link (eds), *The Tiananmen Papers*, New York, Public Affairs, 2001; Zhao Ziyang, *Prisoner of the State*.

River Elegy
Geremie Barmé & Linda Jaivin (eds), *New Ghosts, Old Dreams: Chinese rebel voices*, Times Books, New York, 1992; Jin Guantao, *From Youthful Manuscripts to River Elegy: The Chinese popular cultural movement and political transformation 1979–1989*, Chinese University Press, Hong Kong, 1997; David Moser, 'Thoughts on *River Elegy*, June 1988–June 2011', *China Beat*, July 14 2011 <www.thechinabeat.org/?p=3607> accessed April 15 2016.

'China/Avant-Garde' exhibition
Wu Hung (ed), *Contemporary Chinese Art, Primary Documents*; Liau Shu Juan, 'Redefining art in the China/Avant-Garde Exhibition', *Museum of Modern and Contemporary Art*, February 27 2012 <https://mondaymuseum.wordpress.com/2012/02/27/1989-china-avant-garde-exhibition/> accessed April 15 2016.

Civilian casualties
Timothy Brook, *Quelling the People*, pp. 151–69; *'the son-in-law of a senior official of the National People's Congress . . .'*, see *The Tiananmen Papers*, p. 437 and listing of his death on the website of the Tiananmen Mothers <www.tiananmenmother.org>; 'A father carried the body of his four-year-old son . . .', Brook, *Quelling the People*, p. 162; 'students laid out the body of one of their classmates . . .', *The Tiananmen Papers*, p. 385; 'A tank charged into their group . . .', *The Tiananmen Papers*, p. 383.

Military casualties
Historian Wu Renhua summarised his research into military casualties at a panel discussion organised by Amnesty International UK on June 3 2014, see <www.youtube.com/watch?v=XQm2tXEs4Rk&feature=youtu.be> accessed April 15 2016.

CHAPTER SIX
NOTHING TO MY NAME
This chapter is based primarily on my interviews with Cao Fei, Jia Aili and Zhang Xiaogang, as well as Gonkar Gyatso, Guo Jian and Sheng Qi, complemented by my journalism in China during the early 1990s. My description of the 'China's New Art, Post-1989' exhibition is based on an interview I conducted with Johnson Chang in Hong Kong on December 3 2010; Other sources: Brook, *Quelling the People*; Jonathan Fineberg & Gary G. Xu, *Zhang Xiaogang, Disquieting Memories*, Phaedon Press, London, 2015; Ching Kwan Lee, *Against the Law: Labor protests in China's rustbelt and sunbelt*, University of California Press, Berkeley, 2007; Sally Neighbour (reporter) & Madeleine O'Dea (producer), 'Shanghai', *Foreign Correspondent*, ABC Television, October 5 1993; Madeleine O'Dea, 'Artist Dossier: Zhang Xiaogang', *Art + Auction*, March 2011; 'Voices from Tiananmen', *South China Morning Post* multimedia, as previously cited; Yasheng Huang, *Capitalism with Chinese Characteristics*.

CHAPTER SEVEN
WHOSE UTOPIA?
This chapter is based largely on my journalism in China in the 1990s and interviews with Aniwar, Cao Fei, Guo Jian, Jia Aili and Zhang Xiaogang. Other sources: David Bandurski, *Dragons in Diamond Village and Other Tales from the Back Alleys of Urbanising China*, Viking, 2015; Bao Tong, 'How Deng Xiaoping helped create a corrupt China', *The New York Times*, June 3 2015 <www.nytimes.com/2015/06/04/opinion/bao-tong-how-deng-xiaoping-helped-create-a-corrupt-china.html?_r=5> accessed April 15 2016; Jane Hutcheon (reporter) and Madeleine O'Dea (producer), 'China's floating population', *Foreign Correspondent*, ABC Television, February 2 1996; Ching Kwan Lee, *Against the Law*; Sally Neighbour and Madeleine O'Dea, 'China after Deng Xiaoping', *Foreign Correspondent*, ABC Television,

February 14 1995; Sally Neighbour, Madeleine O'Dea and Mick O'Donnell (co-producer), 'Deng's Dynasty', *4 Corners*, ABC Television, 26 June 1995; Geoff Raby, interview with author, 23 April 2015, Beijing; Yasheng Huang, *Capitalism with Chinese Characteristics*; Zhang Huan, 'A personal account of *65 KG* (1994/2000)' in Wu Hung (ed.), *Contemporary Chinese Art: Primary documents*, pp. 185–87; Zhang Huan, commentary on his performance piece *To Raise the Water Level in a Fishpond*, Beijing, 1997, on zhanghuan.com <www.zhanghuan.com/ShowWorkContent.asp?id=39&iParentID=21&mid=1> accessed April 15 2016.

CHAPTER EIGHT
BEIJING WELCOMES YOU!
This chapter is largely based on my personal experiences in China during the early 2000s, as well as interviews with Gonkar Gyatso, Guo Jian, Huang Rui and Sheng Qi. Other sources: Fu Hualing and Richard Cullen, 'Weiquan (rights protection) lawyering in an authoritarian state: toward critical lawyering', *The China Journal*, vol. 111, 2008 <http://papers.ssrn.com/sol3/papers.cfm?abstract_id=1083925> accessed April 15 2016; Liu Xiaobo, 'Long live the internet!' and 'To change a regime by changing a society' in *No Enemies, No Hatred*; Neville Mars and Adrian Hornsby, *The Chinese Dream: a society under construction*, 010 Publishers, Rotterdam, 2008; Eva Pils, 'Asking a tiger for its own skin: rights activism in China', *Fordham International Law Journal*, vol. 30, issue 4, 2006 <http://ir.lawnet.fordham.edu/cgi/viewcontent.cgi?article=2065&context=ilj> accessed April 15 2016; Pu Zhiqiang, (trans) Perry Link, '"June Fourth" seventeen years later: how I kept a promise', *New York Review of Books*, August 10 2006.

CHAPTER NINE
ISN'T SOMETHING MISSING?

This chapter is based primarily on my own experiences in China in the late 2000s and on interviews with Aniwar, Cao Fei, Guo Jian, Huang Rui, Jia Aili, Pei Li, Sheng Qi and Zhang Xiaogang.

Ai Weiwei and the Sichuan earthquake
K Grube, 'Ai Weiwei's challenge to Chinese government over earthquake', *ArtAsiaPacific*, July–August 2009.

Tibetan riots
James Miles, 'Monks on the march', *The Economist*, March 13 2008 <www.economist.com/node/10855024> accessed April 15 2016; James Miles, 'Fire on the roof of the world', *The Economist*, March 14 2008 <www.economist.com/node/10870258> accessed April 15 2016; James Miles, interview with *CNN*, March 20 2008 <http://edition.cnn.com/2008/WORLD/asiapcf/03/20/tibet.miles.interview/> accessed April 15 2016.

Melamine milk scandal
David Bandurski, 'Press controls feed China's food problem', *The Wall Street Journal*, 7 October 2008 <http://www.wsj.com/articles/SB122332462058208791> accessed April 15 2016; Tania Branigan, 'Chinese figures show fivefold increase in babies sick from contaminated milk', *The Guardian*, December 2 2008 <www.theguardian.com/world/2008/dec/02/china> accessed April 15 2016; Gong Jing and Liu Jingjing, 'Spilling the blame for China's milk crisis', *Caijing Magazine*, October 10 2008, <http://english.caijing.com.cn/2008-10-10/110019183.html> accessed April 15 2016.

Charter 08
Liu Xiaobo, *No Enemies, No Hatred*, pp. 300–12.

Religion
'Cracks in the atheist edifice', *The Economist*, November 1 2014 <www.
economist.com/news/briefing/21629218-rapid-spread-christianity-
forcing-official-rethink-religion-cracks> accessed April 15 2016;
Katharina Wenzel-Teuber, (trans) David Streit, 'People's Republic of
China: religions and churches statistical overview 2011', *Religions &
Christianity in Today's China*, vol. II, 2012, no. 3 <www.china-zentrum.de/
fileadmin/redaktion/RCTC_2012-3.29-54_Wenzel-Teuber_Statistical_
Overview_2011.pdf> accessed April 15 2016.

30th anniversary of the Stars exhibition
Madeleine O'Dea, 'The long view: a short history of Chinese con-
temporary art', *the Beijinger*, September 2009; Madeleine O'Dea,
'Commentary: Chinese contemporary art turns 30', *Orientations*,
vol. 40, no. 8, November/December 2009.

Trial of Liu Xiaobo
Liu Xiaobo, *No Enemies, No Hatred*, pp. 313–26.

CHAPTER TEN
AMNESIA AND MEMORY

Treatment of 'Landlords'
Frank Dikötter, *The Tragedy of Liberation: a history of the Chinese
Revolution 1945–1957*, chapters 4 & 5, Bloomsbury, New York, 2013.

Great Leap Forward and Great Famine
Dikötter, *Mao's Great Famine*; Huang Zheping, 'Charted: China's Great
Famine, according to Yang Jisheng, a journalist who lived through
it', *Quartz*, March 10 2016 <http://qz.com/633457/charted-chinas-
great-famine-according-to-yang-jisheng-a-journalist-who-lived-
through-it/> accessed April 16 2016; Jonathan Kaiman, 'Survivors tell
the camera the hidden tale of China's Great Famine', *Los Angeles Times*,

October 14 2015, <www.latimes.com/world/great-reads/la-fg-cl-china-great-famine-20151014-story.html> accessed 15 April 2016; Yang Jisheng, *Tombstone, The Great Chinese Famine 1958–1962.*

Tiananmen 1989
Louisa Lim, '25 years on, mothers of Tiananmen Square dead seek answers', *NPR*, May 20 2014 <www.npr.org/sections/parallels/2014/05/20/313961978/25-years-on-mothers-of-tiananmen-square-dead-seek-answers> accessed April 15 2016; Madeleine O'Dea, 'Guo Jian: detained for refusing to abide mass amnesia of Tiananmen', *The Guardian*, June 4 2014 <www.theguardian.com/world/australia-culture-blog/2014/jun/04/guo-jian-detained-for-refusing-to-abide-by-mass-amnesia-of-tiananmen> accessed April 15 2016; Tiananmen Mothers website <www.tiananmenmother.org>.

Patriotic education
Julia Lovell, *The Opium War: Drugs, Dreams and the making of modern China*, Picador, Sydney, 2011 (see her excellent account of the use of Chinese history in modern patriotic education).

Tibet
Elliot Sperling, *The Tibet-China Conflict: history and polemics*, Policy Studies 7, East-West Center, Washington, 2007; Tsering Woeser, 'Why are Tibetans setting themselves on fire?', *NYR Daily*, January 11 2016 <www.nybooks.com/daily/2016/01/11/why-are-tibetans-self-immolating/> accessed 15 April 2016.

Xinjiang
Amnesty International, 'China: shameful stadium "show trial" is not justice', May 29 2014 <www.amnesty.org/en/latest/news/2014/05/china-shameful-stadium-show-trial-not-justice> accessed April 16 2016; Nicholas Bequelin, 'Criminalising ethnicity: political repression

in Xinjiang', *China Rights Forum*, no.1, 2004 <www.hrichina.org/sites/
default/files/PDFs/CRF.1.2004/b1_Criminalizing1.2004.pdf> accessed
April 16 2016; Nicholas Bequelin, Q&A with Michael Forsythe, 'Why
tensions are rising in Xinjiang and beyond', *The New York Times*
<http://sinosphere.blogs.nytimes.com/2014/05/02/q-a-nicholas-
bequelin-on-why-tensions-are-rising-in-xinjiang-and-beyond/>
accessed April 15 2016; 'VOA Interview with Uighur Professor
Ilham Tohti in 2013', *China Change*, posted January 15 2016 <https://
chinachange.org/2016/01/15/voa-interview-with-uighur-professor-
ilham-tohti-in-2013/> accessed April 16 2016; 'China Offers Rewards
for Beard Informants in Xinjiang', *China Digital Times*, April 25 2014
<http://chinadigitaltimes.net/2014/04/china-offers-rewards-beard-
informants-xinjiang/> accessed April 16 2016; Simon Denyer, 'China
orders Muslim shopkeepers to sell alcohol, cigarettes, to "weaken"
Islam', *The Washington Post*, May 5 2015accessed
April 16 2016; Timothy Grose and James Leibold, 'Why China is
banning Islamic veils, and why it won't work', *ChinaFile*, February 4
2015 <www.chinafile.com/reporting-opinion/viewpoint/why-china-
banning-islamic-veils/> accessed April 16 2016; Joshua Hammer,
'Demolishing Kashgar's history', *Smithsonian Magazine*, March 2010
<www.smithsonianmag.com/history/demolishing-kashgars-history-
7324895/?no-ist> accessed April 16 2016; Ilham Tohti, 'My ideals
and the career path I have chosen', *China Change*, posted April 6 2014
<http://chinachange.org/2014/04/06/my-ideals-and-the-career-path-
i-have-chosen/> accessed April 15 2016; Ilham Tohti, 'Present-day
ethnic problems in Xinjiang Uighur Autonomous Region: overview
and recommendations', (trans) Cindy Carter, *China Change*, posted
April 22 2015 <https://chinachange.org/2015/04/22/present-day-
ethnic-problems-in-xinjiang-uighur-autonomous-region-overview-
and-recommendations-1/> accessed April 15 2016; Andrew Jacobs,

'At a factory, the spark for China's violence', *The New York Times*, July 15 2009 <www.nytimes.com/2009/07/16/world/asia/16china. html> accessed April 15 2016; Marc Julienne, Moritz Rudolf and Johannes Buckow, 'The terrorist threat in China', *The Diplomat*, May 26 2015, <http://thediplomat.com/2015/05/the-terrorist-threat-in-china/> accessed April 15 2016; Dan Levin, 'China remodels an ancient Silk Road city, and an ethnic rift widens', *The New York Times*, March 5 2014, <www.nytimes.com/2014/03/06/world/asia/ china-remodels-an-ancient-silk-road-city-and-an-ethnic-rift-widens. html/> accessed April 15 2016; James A. Millward, 'China's fruitless repression of the Uighurs', *The New York Times*, September 28 2014 <www.nytimes.com/2014/09/29/opinion/chinas-fruitless-repression-of-the-uighurs.html?_r=1> accessed April 15 2016; Millward, *Eurasian Crossroads*; Sally Neighbour and Madeleine O'Dea, 'Xinjiang', *Foreign Correspondent*, ABC Television, October 18 1994; Madeleine O'Dea, 'Songs from the Old Silk Road', *The Australian*, August 18 2009; Tom Phillips, '"A brighter future beckons": China tries to get Xinjiang to join the party', *The Guardian*, October 9 2015, <www.theguardian.com/ world/2015/oct/09/a-brighter-future-beckons-china-tries-to-get-xinjiang-to-join-the-party> accessed April 16 2016; Emily Rauhala, 'China now says almost 100 were killed in Xinjiang violence', *Time*, August 4 2014 <http://time.com/3078381/china-xinjiang-violence-shache-yarkand/> accessed April 16 2016; 'Settlers in Xinjiang, Circling the wagons', *The Economist*, May 25 2013 <www.economist.com/news/ china/21578433-region-plagued-ethnic-strife-growth-immigrant-dominated-settlements-adding> accessed April 16 2016; 'Ethnic unrest in Xinjiang, Unveiled threats. More outbreaks of violence show the government's policies are not working', *The Economist*, July 6 2013 <www.economist.com/news/china/21580491-more-outbreaks-violence-show-governments-policies-are-not-working-unveiled-threats> accessed April 16 2016; 'China's restless West—the burden of empire', *The Economist*, March 8 2014 <www.economist.

com/news/leaders/21598647-after-brutal-attack-china-communist-party-needs-change-its-policies-towards> accessed April 16 2016; 'China's Xinjiang problem—the net is cast', *The Economist*, July 1 2014 <www.economist.com/blogs/analects/2014/07/chinas-xinjiang-problem?fsrc=scn/tw_ec/the_net_is_cast> accessed April 16 2016; Edward Wong, 'China locks down restive region after deadly slashes', *The New York Times*, July 6 2009 <www.nytimes.com/2009/07/07/world/asia/07china.html> accessed April 15 2016; Edward Wong, 'China sentences Uighur scholar to life', *The New York Times*, September 23 2014 <www.nytimes.com/2014/09/24/world/asia/china-court-sentences-uighur-scholar-to-life-in-separatism-case.html> accessed April 15 2016.

Xi Jinping
'Leaked speech shows Xi Jinping's opposition to reform', *China Digital Times*, January 27 2013 <http://chinadigitaltimes.net/2013/01/leaked-speech-shows-xi-jinpings-opposition-to-reform/> accessed April 16 2016; John Kennedy, 'Xi Jinping's opposition to political reforms laid out in leaked internal speech', *South China Morning Post*, January 28 2013 <www.scmp.com/comment/blogs/article/1137727/xi-jinpings-opposition-political-reforms-laid-out-leaked-internal> accessed April 16 2016; Evan Osnos, 'Born Red', *The New Yorker*, April 6 2015 <www.newyorker.com/magazine/2015/04/06/born-red> accessed April 16 2016.

Xu Zhiyong
'Who is Xu Zhiyong? An interview with Dr Teng Biao', *China Change*, April 10 2014 <http://chinachange.org/2014/04/10/who-is-xu-zhiyong/> accessed April 16 2016; Xu Zhiyong, 'For freedom, justice and love: my closing statement to the court', *China Change*, January 22 2014 <http://chinachange.org/2014/01/23/for-freedom-justice-and-love-my-closing-statement-to-the-court/> accessed April 16 2016.

Document 9
Chris Buckley, 'China takes aim at Western ideas', *The New York Times*, August 19 2013 <www.nytimes.com/2013/08/20/world/asia/chinas-new-leadership-takes-hard-line-in-secret-memo.html> accessed April 16 2016; 'Document 9: a ChinaFile translation', *ChinaFile*, November 8 2013 <www.chinafile.com/document-9-chinafile-translation> accessed 16 April 2016.

CHAPTER ELEVEN
THE PEOPLE AND THE REPUBLIC

July 9 2015 crackdown on rights lawyers
Chinese Human Rights Defenders is maintaining a running tally on those affected by the crackdown. This can be accessed at <http://chrdnet.com/2015/07/individuals-affected-by-july-10-crackdown-on-rights-lawyers/> accessed April 16 2016; Tom Phillips, 'The day Zhao Wei disappeared: how a young law graduate was caught in China's human rights dragnet', *The Guardian*, January 25 2016 <www.theguardian.com/world/2016/jan/25/zhao-wei-mothers-search-for-daughter-caught-china-human-rights> accessed April 16 2016.

Xi Jinping's speech on art
Patrick Boehler and Vanessa Piao, 'Xi Jinping's speech on the arts is released, one year later', *The New York Times*, October 15 2015 <http://sinosphere.blogs.nytimes.com/2015/10/15/xi-jinping-speech-arts-culture/> accessed April 16 2016.

Social issues and rural and urban unrest
Chris Buckley, 'Studies point to inequalities that could strain Chinese society', *The New York Times*, January 27 2016 <www.nytimes.com/2016/01/28/world/asia/china-wealth-social-gap.html> accessed April 16 2016; '*China Labour Bulletin* in Hong Kong tracks strikes and other worker actions in China' <www.clb.org.hk/> accessed

April 16 2016; Javier C. Hernandez, 'Labor protests multiply in China as economy slows, worrying leaders', *The New York Times*, March 14 2016 <www.nytimes.com/2016/03/15/world/asia/china-labor-strike-protest.html> accessed April 16 2016; Brendan O'Reilly, 'Diverse reasons behind growth in China's "mass incidents"', *China Outlook*, May 13 2014 <http://chinaoutlook.com/diverse-reasons-behind-growth-in-mass-incidents/> accessed April 16 2016.

INDEX

ABOUT THE AUTHOR

Madeleine O'Dea is a writer and journalist who has been covering the political, economic, and cultural life of China for the past three decades. She worked for five years with the Department of Prime Minister and Cabinet in Canberra before entering journalism in 1986 as the Beijing correspondent for *The Australian Financial Review*. She covered China throughout the 1990s as a producer with ABC Television. In 2004 she moved to Beijing and took up a position as a presenter and editor with China Radio International and later served as the arts editor for the magazine, *the Beijinger*. In 2010 she became the founding editor-in-chief of ARTINFO China and the Asia correspondent for *Art+Auction* and *Modern Painters* magazines. She returned to Australia in 2013 and now lives in Sydney.